Antoine-Louis Barye, Sculptor of Romantic Realism

ANTOINE-LOUIS BARYE
Sculptor of Romantic Realism

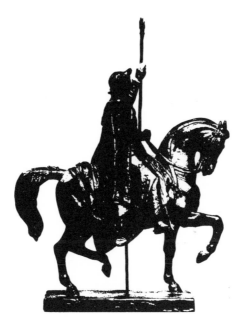

Glenn F. Benge

THE PENNSYLVANIA STATE UNIVERSITY PRESS
UNIVERSITY PARK AND LONDON

For Hella, Britta, and Sean

Library of Congress Cataloging in Publication Data

Benge, Glenn F.
Antoine-Louis Barye, sculptor of romantic realism.

Includes bibliography and index.
1. Barye, Antoine-Louis, 1796–1875.
2. Romanticism in art—France. I. Title.
NB553.B4B46 1984 730′.92′4 83-43031
ISBN 0-271-00362-6

Contents

WITHDRAW

List of Illustrations

Group 3

Group 4

Monumental Sculpture

Group 7

71. *Walking Panther (Une Panthère, bas-relief)*, unframed bronze relief
72. *Stalking Jaguar (Jaguar)*, terra cotta
73. *Greyhound Devouring a Hare (Levrette rapportant un Lièvre)*, bronze
74. *Lioness of Algeria* or *Lioness of Senegal (Lionne d'Algérie; Lionne du Sénégal)*, bronze
75. *Seated Basset (Un Chien Basset assis)*, bronze
76. *African Buffalo (Buffle)*, bronze
77. *Dromedary of Egypt, Harnessed (Dromadaire harnaché d'Egypte)*, bronze
78. *Listening Stag (Un Cerf, la tête levée; Cerf qui écoute)*, bronze
79. *Caucasian Warrior, Equestrian (Guerrier de Caucase)*, bronze
80. *Horseman in Louis XV Costume (Piqueur en costume Louis XV)*, plaster
81. *Half-Blood Horse (Un Cheval demi-sang)*, bronze
82. *Turkish Horse (Un Cheval turc ... sur plinthe carrée)*, bronze

Group 8

83. *Charles VI, Surprised in the Forest of Le Mans (Charles VI dans la forêt du Mans)*, plaster and wax
84. *Roger Abducting Angelica on the Hippogriff (Angélique et Roger montés sur l'Hippogriff)*, bronze
85. *Tartar Warrior Checking His Horse (Un Cavalier chinois; Guerrier tartare arrêtant son Cheval)*, bronze
86. *Greek Rider Seized by a Python (Cavalier attaqué par un Serpent)*, cast plaster
87. *Amazon, Equestrienne (Une Amazone)*, bronze
88. *Ape Riding a Gnu (Un Orang-outang monté sur un Gnou (antilope); Singe monté sur un Antilope)*, bronze
89. *Bull Attacked by a Tiger (Un Taureau et un Tigre)*, bronze
90. *Bull Hunt (La Chasse au Taureau sauvage)*, bronze for the *surtout de table* of the Duke of Orléans

Group 9

91. *An Arab Horseman Killing a Lion (Un Cavalier arabe tuant un Lion)*, bronze
92. *Two Arabian Horsemen Killing a Lion (Deux Cavaliers arabes tuant un Lion)*, bronze
93. *An Arab Horseman Killing a Boar (Un Cavalier arabe tuant un Sanglier)*, bronze
94. *Wounded Boar (Sanglier blessé)*, bronze
95. *Python Attacking an African Horseman (Un Cavalier abyssinien surpris par un Serpent; Cavalier africain surpris par un Serpent)*, bronze
96. *Python Killing a Gnu (Python et Gnou)*, autograph bronze for the *surtout de table* of the Duke of Orléans

Group 10

Group 11

145. *Minerva (Minerve)*, gilt bronze
146. *Juno (Junon)*, gilt bronze
147. *Nereid (Une Neréide)*, bronze
148. *Three Putti Bearing a Clamshell (Trois Enfants supportant une Coquille)*, two paired groups, parcel-gilt bronze

Drawings

149. *Milo of Crotona*, after Puget
150. *Face of a Feeding Lion*, after Rubens
151. *Faun Carrying an Ox*, after Visconti
152. *Studies of a Boar*
153. *Studies after John Flaxman's Divine Comedy Illustrations*
154. *Skeleton of a Stag*
155. *Forepart of a Flayed Tiger*
156. *Feline Predator Feeding*
157. *Gavial Crocodile*
158. *Face of a Tiger*
159. *Toying Lion*
160. *Stalking Lion*
161. *Head of a Lioness*
162. *Julia, Daughter of Augustus; Standing Nude*
163. *Phidian Frieze of Riders*
164. *Borghese Mars*
165. *Phidian Theseus from the Parthenon*
166. *Boy with a Goose*
167. *Antiquities after Roccheggiani*
168. *Enthroned Apollo-Napoleon*
169. *Standing Bull; Seated Figures Rejoicing*
170. *Standing Mars*
171. *Napoleon as Mars*
172. *Apollo Crowned by a Winged Victory; Venus and Psyche*, after Hamilton Collection and Raphael, respectively
173. *Two Seated Figures Framing a Medallion*
174. *Pediment with Two Crowning Victories*
175. *Napoleonic Pediment*
176. *Napoleonic Pediment*
177. *Napoleonic Pediment*
178. *Deer Biting Its Side*
179. *Indian Elephant*

Comparanda

Barye's technical practices are examined, as these are accessible in the several extant types of models and bronze castings. Criteria of connoisseurship of interest to collectors and investors are derived from an analysis both of Barye's very few autograph bronzes, and of the artisan-produced bronzes in their full panoply—from the rare works of Honoré Gonon and Sons, to the fairly numerous castings produced for Barye and Company by Ferdinand Barbedienne, to bronzes cast by less famous men whose monograms and foundry stamps are now cryptic. Barye used terra cotta for sketches of certain designs to which he imparted a robust and ragged style that surely captivated Carpeaux and Rodin. Cast plaster models, reusable replicas of his fragile originals in wax or clay, were the rule for Barye's editions of small bronzes. A unique feature of Barye's technique was his addition of a deep layer of wax to a plaster model, thus allowing its surface detail to be refreshed before the making of each new mold, a procedure that accounts for the myriad small variations among bronzes of the same figure. Models of bronze were used occasionally, and were sometimes designed with great intricacy; for example, *Tiger Devouring a Stag* is comprised of some twelve separate components, all removable so as to facilitate the casting in pieces of so complex a form.

Within Barye's exquisitely controlled romantic realism lies another level of concern than allegory, say, or emotional expression, or truth to nature, for he created many compositions as purely formal variations upon certan motifs. His design variations were utterly abstract, and often remarkably independent of literal subject matter, as they embraced quite disparate creatures. (My Group 5, for example, includes such unlikely bedfellows as a tiger, doe, wolf, lion, bull, and elephant.) Yet the inner continuity of Barye's oeuvre is best revealed in precisely such groupings of related designs, despite their initial aspect of implausibility. In fact, it is tempting to see Barye as far ahead of his time in this pronounced concern with abstract design manipulation, to see him as presaging, say, Rodin's decorative repetitions of slightly varied figures, such as the *Three Shades* and their parent *Adam*, created for the *Gates of Hell* about 1880.

Since one measure of an artist's standing is economic, readers of this book will be interested to know that the value of Barye bronzes in the international art market increased greatly during the decade of the 1970s, in certain instances by six or seven times. The price of *Lapith Combating a Centaur* (h. 29 inches) rose from $688 in 1966 to $4,500 in 1978; that of *Tiger Devouring a Gavial* (h. 20 inches) rose from $650 in 1970 to $3,150 in 1978. More modest but still substantial gains mark the price of *Listening Stag* of 1838 (h. 7 ¾ inches), which brought $1,134 in 1970 and $5,040 in 1979. *Orangutan Riding a Gnu* proved a recent favorite among investors, fetching $5,287 in April 1978, $11,700 in December 1978, and $16,100 in June 1980 (Source: E. Mayer, *International Auction Records*, Paris, 1967 et seq.). A more significant testimonial to Barye's standing is the amount of his work on exhibit in the major galleries of the world.

The abbreviations in this text should be explained at the outset. References to sales catalogues issued by Barye and Company during the artist's lifetime, and by Barbedienne after Barye's death, consist of the initial letters of the street address of the sales outlet, or of the proprietor's name in the case of Barbedienne, and a date whenever one appears. The catalogues and their abbreviations are as follows:

Catlogue des bronzes de Barye/ rue de Boulogne, no. 6 (Chaussée d'Antin), Paris / Années 1847–1848. ——1*er* Septembre 1847. (107 works. Abbreviated *CRB47.*)

Bronzes de Barye/ En vente dans ses magasins/ rue Saint-Anastase, 10, à Paris (Marais). (113 works. Abbreviated *CRSA.*)

Catalogue des bronzes de Barye/ 12, rue Chaptal (Chaussée d'Antin), Paris. (113 works. Abbreviated *CRC.*)

Catalogue des bronzes de Barye/ Statuaire, Exposition universelle de 1855, Médaille d'Honneur/ rue des Fossés-Saint-Victor, 13, Paris. (152 works. Abbreviated *CRF55.*)

Catalogue des bronzes de Barye/ Statuaire, Exposition universelle 1855, La grande Médaille d'Honneur/ quai des Célestins, 10, Paris. (197 works. Abbreviated *CQC55.*)

Catalogue des bronzes de A. L. Barye, Statuaire, Exposition universelle de 1865, La grande Médaille d'Honneur, quai des Célestins, 4, à Paris. (230 works. Abbreviated *CQC65.*)

F. Barbedienne, *Oeuvres de A. L. Barye*/ Bronzes d'art/ 30, boulevard Poissonnière, Paris, 1893. (137 works. Abbreviated *CFB93.*)

F. Barbedienne, Editeur. Leblanc-Barbedienne, Succ*r*. *Oeuvres de A.-L. Barye*, 30, Boulevard Poissonnière, Paris. (Abbreviated *CFBLB.*)

Another frequently encountered abbreviation is that of the exhibition catalogue of the Barye Monument Association of New York, whose funds paid for the American monument to the sculptor, installed on the Boulevard Pont Sully of Paris in 1894:

Catalogue of the Works of Antoine-Louis Barye, The Barye Monument Association of New York, American Art Galleries, New York, 1889. (Abbreviated *NYBMA89.*)

Acknowledgments

It is a pleasure to recall the kind assistance and good counsel I have received from many quarters during the course of my work on Barye. In Paris, I am especially indebted to Mr. Jean Favier, directeur général des Archives Nationales de France; Mr. F. Dousset, inspecteur général, Archives Nationales de France; Mr. Jean-René Gaborit, conservateur en chef, and Mlle. Anne Pingeot, conservateur, Département des sculptures, Musée du Louvre; Mr. Maurice Sérullaz, conservateur en chef, Mme. Arlette Sérullaz and Mlle. Lise Duclaux, conservateurs, Cabinet des dessins, Musée du Louvre; Mmes. Riquet and Dragomir, Bibliothèque du conservation, Musée du Louvre; Mr. G. LeRider, conservateur en chef, and Mmes. Roquefeuil and Aghion, Cabinet des médailles, Bibliothéque Nationale; the staff of the Musée du Petit Palais; and Mme. Germaine Tureau, administrateur du service, Service de Documentation Photographique de la Réunion des Musées Nationaux.

In Rome, I am grateful to the directors and staffs of the Bibliotheca Hertziana, the Biblioteca Apostolica Vaticana, the Gabinetto Nazionale delle Stampe, the French Academy, and the American Academy.

In the United States, I am indebted to the directors and staffs of numerous research libraries: Harlan Sifford, University of Iowa, Iowa City; Ms. Ivy Bayard, Temple University; the University of Wisconsin at Madison; the University of Chicago; the Newberry Library; the New York Public Library; Princeton University; Harvard University; the University of Pennsylvania; Bryn Mawr College; Muriel L. Toppan, Walters Art Gallery; Johns Hopkins University; the Peabody Institute of Baltimore; and the Library of Congress.

I am grateful to Dr. Richard H. Randall Jr., former director, Dr. William R. Johnston, assistant director, Miss Winifred Kennedy, former registrar; Mrs. Ursula McCracken, and the staff of the Waters Art Gallery, Baltimore. I wish to thank the staffs of the Baltimore

Museum of Art, the Maryland Institute, the Corcoran Gallery of Art; Dr. Evan Turner, former director, Mrs. Barbara Sevey, librarian, Dr. Elizabeth A. Anderson, Public Programs Coordinator, Dr. Ted Katz, chief, division of Education, the Philadelphia Museum of Art; Miss Carolyn Pitts, archivist, Fairmount Park Art Association; Dr. Dewey Mosby, former curator of Western Art, Mrs. Andrea P. Aran, Terry Ann R. Neff, and Susan F. Rossen, the Detroit Institute of Arts; Mrs. Jeanne L. Wasserman, honorary curator of sculpture, Arthur Beale, director, Center for Conservation Studies, Fogg Art Museum, Harvard University; Dr. Charles Millard, chief curator, Hirshhorn Museum and Sculpture Garden, Washington, D.C.; Dr. Anthony Janson, chief curator, Indianapolis Museum of Art; Mrs. Jane Horswell, Sladmore Gallery, London; Robert F. Kashey, Shepherd Gallery, New York; and Stuart Pivar.

Among my academic colleagues, I am very grateful to Professor Diane M. Kelder, editor, and Barbara Berg, managing editor of the *Art Journal*; to Professor Ruth Butler, University of Massachusetts, Harbor Campus who read an earlier form of this work; Professor Frank Trapp, Amherst College; Professor Albert E. Elsen, Stanford University; Professor Linda Nochlin, Vassar College. For assistance with photography I am grateful to Rebecca Michaels. I am indebted to the late Professor H. W. Janson, New York University, for his encouraging support of my research. Finally, I wish to thank Professor Robert L. Alexander, University of Iowa, Iowa City, for having introduced me to the art of Barye.

For two grants-in-aid for research in Paris, I am grateful to Temple University; and for a grant toward the cost of photographs, I am indebted to David Pease, former dean of the Tyler School of Art, Temple University, Philadelphia.

1

Sculpture in an Age of Yearning

Il a une façon fière, énergique et rude, qui en fait comme le Michel-Ange de la Ménagerie.

Théophile Gautier[1]

At once personal, subtle and complex, the romantic-realist sculpture of Antoine-Louis Barye reflects the yearning, turmoil, anguish and triumphs of his age. As a student of the Baron Antoine-Jean Gros, Barye admired that painter's messianic figurations, *Napoleon at Arcole* and *Napoleon on the Battlefield at Eylau.* Inducted into the army as a young man, Barye actually experienced the hope, idealism, and despair out of which grew the Napoleonic legend. Théodore Géricault's awesome painting, *Raft of the Medusa,* was shown in the Salon during Barye's first year as a student in the Ecole des Beaux-Arts, at a time when his own art was a tentative reflection of the baroque rhetoric of Pierre Puget and the neoclassical elegance of John Flaxman. An indelible mark was made upon Barye by Géricault's abandoned voyagers, a grotesque pyramid of the dead, the dying, and those still clinging to life and hope. Such struggle and pathos would resurface in Barye's combats of exotic beasts a decade later, his most memorable romantic imagery. The lions, tigers, and crocodiles captivated Barye as they did his friend Eugène Delacroix, and not merely as unusual subjects for positivist scientific study, but as emblems of passion and cruelty, as creatures capable of expressing a full range of the nuances of human feeling. Auguste Comte's positivism, his empirical notion of reality, coupled with such transcendental and moralizing poetics as those of Mme de Staël, Bernardin de Saint-Pierre, and Victor Hugo echo in the romantic dualities of Barye's sculpture. The music of Chopin, Liszt, Paganini, and Berlioz resounded in the Paris of Barye, romantic music compelling in its color and emotional eloquence. Hector Berlioz wrote his haunting *Funeral and Triumphal Music* for the procession to the unveiling of the July Column cenotaph in 1840, a monument dedicated to the fallen heroes of the Romantic Revolution of 1830, the very cenotaph for which Barye created his splended *Lion of the Zodiac.* Barye worked under an almost kaleidoscopic succession of

political climates: as an artisan with the goldsmith to Napoleon Bonaparte; as a portraitist and miniature sculptor to a young prince, the Duke of Orléans; as allegorist and animal sculptor to the Bourgeois Monarch himself; and later as a central sculptor for the New Louvre Palace, that vast and operatic undertaking of Napoleon III.

Unfortunately, we know almost nothing of Barye's personal life. He kept no diaries, wrote no letters of any intricacy, and apparently impressed his contemporaries as a man of few words. Nor have Barye's children shed any light on his life, although he evidently fathered eleven. Yet Barye's sculptural oeuvre of more than 230 designs is as articulate a statement as any artist has made. As a complement to the visual material, the serious student or collector of Barye soon longs for an exclusively literary source, one with the richness, say, of Delacroix's *Journal*, as an aid in reconstructing Barye's intellectual and personal life. However, a study of Barye is quickly forced to center in his artistic works.[2] The autobiographical aspect of his art, which probably would reveal a rich level of significance, remains far less accessible.

An Overview of Barye's Art

Barye's artistic development falls into three fairly distinct phases: the scientific and artistic preparation of the 1820s, the brilliant romantic achievements of the 1830s, and a more conservative turn toward academic themes and style from the 1840s through the 1860s. Late in his career, Barye reiterated concepts that he had explored some forty years earlier, as though the cycle of his artistic development had returned to its origins in a final note of affirmation.

Antoine-Louis Barye was born in Paris on 24 September 1796 to Pierre Barye, a goldsmith from Lyons, and his wife, Marguerite. Barye's formative years were spent goldsmithing, first in the atelier of his father, and about 1810 with the brilliant Guillaume-Martin Biennais (1764–1843), goldsmith to Napoleon. In this context Barye's innate sensitivities to art forms in miniature, to high standards of craftsmanship, to the twin sources of the goldsmith's art—nature and the art of antiquity—were nurtured and sharpened. He delighted in such things for the rest of his career. It is instructive, for example, to observe how an ancient carved cameo of an equestrian lion hunter (*Fig. 203*) that Barye knew in the Caylus Collection in Paris, was transformed into his elegant small bronze *Arab Horseman Killing a Lion* (*Fig. 91*), or how an ancient cameo, *Bull Pawing the Earth*, inspired his small bronze of the same title (*Figs. 204, 65*). In the atelier of the goldsmith Biennais, and later as a student in the Ecole des Beaux-Arts, Barye came to know the various engraved anthologies of antiquities, such as those of Pietro Santi Bartoli and Lorenzo Roccheggiani. This stimulating imagery complemented his knowledge of the antiquities in Paris, and he would return to these miniature forms and engravings again and again.

Briefly, in 1816, Barye studied with Baron François-Joseph Bosio (1769–1845), a neoclassical sculptor who executed monumental forms with a goldsmith's precision and finish, as in

his life-size work in silver, *Henry IV as a Child* (1824) in the Louvre.[3] The viewer particularly notes its exquisite surfaces, the polished planes of the child's face, and the finely chased detail of the doublet. Perhaps in reaction to Bosio's rather overrefined and inexpressive art, Barye soon turned to instruction under Gros (1771–1835), a romantic colorist of the first rank. Baron Gros had painted the unforgettable *Napoleon in the Pesthouse of Jaffa* and had traveled to Egypt as Napoleon's battle painter. Gros's expressive freedom, vibrant color, and sculpturesque mode of composing tiny groups of combatants within larger battle panoramas had a lasting effect on Barye.

Barye began to study animal anatomy seriously in these years—in the ménagerie of the Jardin des Plantes, in Baron Georges Cuvier's famous Cabinet d'Anatomie Comparée of the Muséum d'Histoire Naturelle, and in the Parisian dog markets. His drawings record many dissections, a study of dioramas and preserved specimens, and a reading of scholarly works on zoology and comparative anatomy. A brief letter written by the painter Delacroix to Barye on 16 October 1828 strongly implies that both artists attended the dissection of a lion: "The lion is dead—Come at a gallop—It is time to get to work—Let me hear from you."[4]

During the 1820s, a period of artistic and scientific preparation, Barye explored divergent extremes of style, as in the delicate painterliness of the lion in the medallion *Milo of Crotona Devoured by a Lion (Fig. 1)*, the neoclassical stances and idealizations in *Hector Reproaching Paris (Fig 4)*, the hieratic formality of *Eagle and Serpent (Fig. 14)*, and the literal naturalism of *Stag, Doe, and Nursing Fawn (Fig. 7)*. His breadth of interest is demonstrated in two dated works that frame this first decade of artistic production. *Milo of Crotona Devoured by a Lion* of 1819 is a painterly low-relief in miniature scale, like a Renaissance medallion enriched with quotations from Rubens, Pierre Puget, and neoclassical art. *Poised Stag* of 1829 *(Fig. 12)*, one-third life size, combines a mood of pathos and exhaustion with the tradition of the hunting trophy and the natural-history display. Themes central to Barye's art already appear in the 1820s: mythological combats, heroic figures, single animals, the hunt, and the struggle of predator and prey.

The brilliant inventions of the 1830s, perhaps the artist's finest period, show Barye's concern with subtler aspects of style and mood. The understatement of the chilling and exotic *Tiger Devouring a Gavial Crocodile (Fig. 22)*, shown at the Salon of 1831, dramatically announced his work to the public. The academic critic Etienne Delécluze predictably maintained that Barye's animal imagery existed in a "less elevated mode" than that of the human figure, but he hastened to add that it was nonetheless "the strongest and most significant work of sculpture of the entire Salon."[5]

Barye's most famous monumental work, *Lion Crushing a Serpent* of 1832 *(Figs. 23 and 24)*, was conceived as an allegory of Orléanist triumph and created for the circle of royal intellectuals and followers. The lion and serpent in fact originate in the adjacent constellations of Leo and Hydra, seen on the star charts used in ship navigation. They symbolize the astrological and thus the celestial and divine impetus given to the July Revolution of 1830.[6] Ultimately this struggle would place Louis-Philippe on the French throne. Barye's romantically heightened emotional statement and the novelty of his humanized animal protagonists have a freshness that transcends the rather dry norms for such allegories. By contrast, the conventional neobaroque realism of François Rude's *La Marseillaise* relief on the Arc de

3

Triomphe, with its academic Roman costume, seems intolerably prosaic. Of *Lion Crushing a Serpent*, the romantic poet Alfred de Musset marveled:

> What vigor and verism! The lion roars, the serpent hisses. What rage is in that snarling mask, in that sideward gaze, in the bristling fur of its back! What delicacy in that paw set upon the prey! . . . Where could Barye pose such models? Is his studio a desert of Africa or a forest of Hindustan?[7]

The opposition, however, numbered not only envious artists and irritated critics but also certain political enemies of the Bourgeois Monarch, who focused their bitter tirades upon the sculpture. The notoriety colored Barye's reputation as a *romantique*.

Between 1834 and 1838, at the request of the Duke of Orléans, Barye created an ensemble of nine sculptural groups for an elaborate table decoration. Prominent in these small bronze groups were five animal-hunt designs set in exotic lands or in remote historical periods: the hunts of the bull, lion, bear, tiger, and elk (*Figs. 90, 104, 125, 127, and 128*). These were accompanied by four animal combats, three of which are extant: *Python Killing a Gnu* (*Fig. 96*), *Tiger Overturning an Antelope* (*Fig. 98*), and *Lion Devouring a Boar* (*Fig. 114*). For the critic Gustave Planche, the animal hunts embodied both the "laws of the imagination, and the laws of science" in their rare "agreement of exactitude and invention." Planche found in them a "freedom of invention that seduces us at first glance; and a purity, a verity of form that well confirms our first feeling."[8]

The concept of this *surtout de table* ensemble sustained certain essentials of the aristocratic tradition of the master goldsmiths of the eighteenth century. In fact, the hunts initially were to be cast in silver rather than bronze. Yet Barye departed significantly from that tradition by freeing his miniature sculpture from the earlier, even antique notion that such forms must embellish a useful object, such as a soup tureen. Thus his small bronzes existed as a freely expressive mode, as a major rather than a minor art, similar to certain freestanding small bronzes of ancient and Renaissance times. The five hunts reveal Barye's goldsmithing experience as well as his attainment of an intricately decorative, almost pyrotechnical stylistic display. Sadly, the ensemble of the five hunts was rejected from the Salon of 1837, a year after the critical tirades against *Lion Crushing a Serpent*. In answer to the complaint of his disappointed son, King Louis-Philippe is reputed to have said, "I have created a jury, but I cannot force them to accept masterpieces!"[9] Wounded, Barye chose to ignore the Salon, sending no works until 1850, although for him that was a period of both great artistic fecundity and awesome financial duress.

Unlike the miniaturizing, jeweler's intricacy of the style of the hunts—and thus revealing the range of Barye's interests during the 1830s—his small relief plaques *Walking Leopard* (*Fig. 62*) and *Walking Panther* (*Fig. 71*) exhibit a classical planarity, economy, and restraint. Mood in Barye's works of the 1830s encompassed the agony in *Wounded Boar* (*Fig. 94*), the playful dreaminess of *Bear in Its Trough* (*Fig. 115*), and the horrible tension in *Elk Attacked by a Lynx* (*Fig. 134*). His handling of surface and mass ranged from the architectural cubicity of *Python Killing a Gnu* (*Fig. 96*) to the delicately enriched painterliness of *Lion Devouring a Doe* (*Fig. 119*). The numerous studies of single animals in small scale, such as *Bull Pawing the Earth* (*Fig. 65*), *Striding Lion* (*Fig. 66*), and *Indian Elephant Running* (*Fig.*

69), are engagingly animated with humanizing touches and imply narrative episodes. The combat of predator and prey was given memorable form in such groups as *Tiger Devouring a Gavial Crocodile* (*Fig. 22*) and *Panther Seizing a Stag* (*Fig. 133*). Equally moving counterparts of Barye's delineations of agony and struggle are found only in the art of contemporary painters, such as Goya's *Disasters of War* etchings, the wounded and dying soldiers in Gros's *Napoleon at Eylau* (1808), the abandoned voyagers of Géricualt's *Raft of the Medusa* (1817–18), or the fallen heroes of Delacroix's *Liberty at the Barricades* (1830), all in the Louvre. The foremost painters rivaled Barye in their balance of romantically savage intensity and plausibility. Among sculptors he was unequaled. For Barye, it was as though an animal protagonist were an actor presenting an emotional situation, at once eminently human yet detached from human conventions, the emotion more sharply focused for that detachment. Barye offered a means of contemplating pure, subtly refined feelings, a means of indulging the irrational, in a totally romantic way.

From 1835 to 1840 Barye created a monumental bronze relief for the cenotaph of the July Column in the Place de la Bastille in Paris. The official documents call it *Lion of the Zodiac Relief* (AN F^{13} 1244), identifying it as the second version of the allegory embodied in *Lion Crushing a Serpent*. However, here a better known accessory motif, the equatorial band of the sun's path through the Houses of the Zodiac, was substituted for the more learned Serpent of Hydra used in the first variation of 1832. The writer Charles Saunier termed the relief

> Barye's greatest masterpiece of the period of Louis-Philippe. . . . The noble lion of the Place de la Bastille . . . guards the entrance to the commemorative column of the July Days of 1830, with the same fervor as the *Marseillaise* by Rude, on the right pier of the Arc de Triomphe de l'Etoile. . . . Even from far off, as one looks toward that vast square, it is majestic—inscribed with authority. . . . And to consider its expressive qualities . . . [it is] a gem of monumental sculpture. No mere accumulation of details. On the contrary, [there is] a synthesis of energy declared by the grand outlines framing its authoritative relief, a harmonious muscular strength, which yet could be surpassed ten times over by its awesome rage. And with all that, it manifests the truth within its noble beauty. Here the sculptor unites Assyrian art with something still greater.[10]

On 15 May 1845 Barye established Barye and Company, in partnership with the entrepreneur Emile Martin, to produce and sell his small bronze designs. Serving middle-class patrons, it was a successful operation that Barye maintained until 16 May 1857.[11] Barye and Company posed problems of connoisseurship seen in European art for the first time, such as the autograph question intrinsic to the issuing of multiple casts of a sculptor's original design and the practice of numbering successive casts taken from a particular model.

Barye's last monumental work for the July Monarchy was the bronze *Seated Lion* of 1847 (*Fig. 27*). Intended as a mate for the earlier *Lion Crushing a Serpent* (1832) and probably designed at that time, it was placed nearby, on a garden terrace of the Tuileries Palace. Perhaps in response to the criticism of an excess of detail leveled at the earlier bronze, Barye simplified the surfaces of this design. Sensing in this the loss of a vital expressive dimension, Gustave Planche ascribed its different quality to careless artisanship:

The lion of 1847 has suffered under an excess of chasing; whereas we see the lion of 1833 just as the artist had conceived it . . . the later lion has been defaced by . . . the riffler file. The appearance of baldness is most noticeable on the rear portions rather than the front ones. . . . If [only] Honoré Gonon had cast the second, as the first had been achieved.[12]

Four major stylistic modes or distinct trends appear in the late art of Barye, almost as there had been during the exploratory 1820s. About 1840 Barye evolved a kind of public academic style, one lucid and classically restrained, at times even austere. It was a style suited in precedent and tone to such noble subjects as the marble *Saint Clotilde* for the Church of the Madeleine in Paris and the four personification groups and apotheosis pediment for the New Louvre. *Saint Clotilde* (*Fig. 26*) emulated ancient Roman sculpture, as well as paintings by Raphael and Ingres, in the gesture, drapery, and idealized face and hands. Barye's personification of *Strength* for the New Louvre, 1854–56 (*Fig. 35*), was based upon such ancient figures as the *Torso Belvedere* and the Hellenistic *Seated Boxer* (Rome, Museo delle Terme), and upon the neoclassical figure *Strength in the Guise of Hercules*, created by Guillaume Boichot for the porch of the Panthéon in Paris in the 1790s. Barye's other three personifications were purely formal arabesque variations like Michelangelo's seated *ignudi* on the Sistine Chapel ceiling.

It is a fascinating sign of the complexity of Barye's outlook that the tendency of style of his four personification groups of the 1850s is miniaturistic, despite the monumental scale of their execution. Barye had departed from miniaturism as early as 1831 in the tiny but expansively designed relief plaques *Walking Leopard* (*Fig. 62*) and *Walking Panther* (*Fig. 71*). He carried over the monumentality of these tiny plaques into the large design for *Lion of the Zodiac Relief* in 1835 (*Fig. 25*). Thus Barye could work in either stylistic mode, monumental or miniature, and at either monumental or miniature scale. No doubt the miniaturism of his personifications of 1854 was a deliberate choice, one in harmony with the almost rococo relief style of Hector-Martin Lefuel's pavilion façades, which they were to decorate. Furthermore, as a complement to the cool classicism of the human figures, the animal attributes of his four groups express romantically heightened emotions, a carry-over of one of Barye's earliest predilections. His late, academic-classical works surely reflect a deeply ingrained classical sentiment. The four personifications, in fact, embrace the best of both of the romantic and classical directions.

A second late mode is a personal miniature style growing out of the baroque designs of the mid-1830s. It appears in the richly decorative surfaces, the painterly nuances of modeling, and the plastic vigor of small bronzes such as *Ocelot Carrying a Heron* (*Fig. 101*) and *Lion Crushing a Serpent, Reduction No. 1* (*Fig. 109*). This freer style is an effortless, expansive transcendence of intricately detailed and sometimes burdened compositions of the 1830s, such as *Two Bears Wrestling,* (*Fig. 123*) and *Elk Hunt* (*Fig. 128*). At its finest, this late style rivals the beauty of the small-scale terra cottas by Bernini and Claude-Michel Clodion.

A third late mode shows a monumental and simplified style for larger bronzes, as in *Jaguar Devouring a Hare* (*Fig. 29*), shown at the Salon of 1850. The blockiness, expressive boldness of handling, and gravity of tone in this work led Théophile Gautier to coin his famous epithet, terming Barye a "Michelangelo of the Menagerie." However, within the

total design concept, the hare's pelt is treated in the earlier, intricately detailed miniaturizing style. The hare's richly linear surface provides a dramatic contrast with the simplified forms of the jaguar. The four animal combats of 1869 in Marseilles reflect this powerful style, for they balance a hieratic, even lordly quality of mood with a simplified yet scientifically plausible anatomical structure.[13]

Barye developed a fourth style about 1851 in the virtuoso sequence of ninety-seven decorative masks for the cornice of the Pont Neuf. Monumental, plastic arabesques mark the full, often florid forms of the masks (*Figs. 31 and 32*). Their sometimes devilish visages and their linear richness of movement are almost neobaroque, perhaps echoing the style of *Satan* by Jean-Jacques Feuchère (1807–52), a splendid bronze cast in Paris in 1850.[14] The range of mood conveyed in the masks, their decorative invention, and the variety of artistic sources they encompass make them one of the richest and most exploratory of all Barye's late works.

Barye died on 25 June 1875 at nine o'clock in the evening. His funeral cortege was comprised of the immediate family, a military escort suited to an officer of the Legion of Honor, several members of the Institute of the Ecole des Beaux-Arts, and the artists Jean-Léon Gérôme, Léon Bonnat, and Jean-Louis-Ernest Meissonnier. Elegies were read by Henri Delaborde, president of the Commission consultatif de l'union centrale des beaux-arts pour l'industrie, and by the Marquis de Chennevières, director of the Ecole des Beaux-Arts. Barye was buried in the Père Lachaise cemetery.

BARYE'S ARTISTIC POSITION

To place Barye in the art and thought of his own time, the serial production of his works, his aesthetic, his knowledge of the European artistic tradition, his relation to the *animaliers*, and his impact upon three later giants of French art—Carpeaux, Rodin, and Matisse—must be analyzed. At first glance, the documentation of the ninety-first and ninety-second cast of Barye's candelabrum and the ninety-fifth cast of the tiny *Hare with Lowered Ears* recorded in Emile Martin's *Journal* of the accounts of Barye and Company would seem to support a view of Barye as important in reestablishing the reputation of the minor arts.[15] Yet the real significance of these quantities of his most popular bronze designs was social. Barye saw such limited mass production as a democratic gesture, as a legitimate appeal to the new bourgeoisie. His position was in part a reaction against the aristocratic tradition that had supported him until the declining years of the July Monarchy in the late 1840s.

A related point involves the new practice of numbering successive casts or proofs of a given design, a practice initiated by Barye and Company.[16] Numbering casts to indicate proximity to or remoteness from an autograph "master bronze" reflected the aspiration of the middle-class *amateurs* of the nineteenth century toward an aristocratic exclusivity of claim to an artist's production. In fact, this aspiration soon brought a halt to the practice of numbering casts; obviously the casts with high numbers had less prestige, regardless of the

quality of the proof. The first sales catalogue of Barye's bronzes, dated 1847, carries a note at the bottom of the last page stating that "chaque bronze porte d'une façon apparente, le numéro de l'épreuve et le poinçon de l'auteur."[17] The note is omitted from the next two sales catalogues, of 1855 and 1865.

It is unjust to equate Barye's serial bronzes of this era with the commerical output of a house such as Barbedienne, where an army of six hundred artisans turned out countless table-size reductions of Michelangelo's *David*. Barye's small bronzes were produced in limited numbers, and each cast possessed a high level of technical quality and artistic integrity; they were never conceived as reductions. In short, they were in a class by them-selves, in a new category altogether, which posed new questions of value. The problem of editions in bronze of a sculptor's design remains unresolved nearly a century and a half later. And this question is distinct from the vexing additional problems of value posed by Barye's romantic choice of animal protagonists.

Barye's aesthetic embraces romanticisms, neoclassical traits, and academic values, all of which contribute to the richness and scope of his conceptions. Barye's predators devouring their living prey indulge the emotions in a romantic way of course, but they also embody a romantically moralizing point of view, like those held by Bernardin de Saint-Pierre, Mme de Staël, and Victor Hugo. The *Oeuvres complètes* of Bernardin de Saint-Pierre appeared in Paris in 1834 and was surely known to Barye, for the author was a former director of the zoo in the Jardin des Plantes and one of the "masters of genuine poetry" for the archromantic Mme de Staël. Bernardin de Saint-Pierre maintained that a carnivorous animal in devouring its prey alive committed a sin against the laws of its own nature.[18]

Mme de Staël (1766–1817), the chief interpreter of the new romantic aesthetic that had evolved in Germany during the hegemony of classicism in France under Napoleon, delineated two important romanticisms for Barye. She valued an art that placed emotion at the service of morality, an art that evoked the "tears that move to virtue."[19] She also prized an art capable of discriminating among subtle nuances of feeling, rather than merely presenting extremes of violence or movement.[20] Clearly there is restraint in Barye's struggling protagonists, and it is precisely the sort of refinement and nuance called for by Mme de Staël.

Victor Hugo (1802–85), writing in the preface of his play *Cromwell* (1827), elaborated his notion of the "grotesque" in art and life, championing Evil as the eternally fascinating, infinitely varied foil to the monotony of the Good and the Beautiful.[21] The satanic spectacle of Barye's lordly yet sinister tiger biting into the genitalia of its repugnant prey, a gavial crocodile, would surely have impressed Hugo as an eloquent image of the machinations of evil. It is tempting to see in Barye's feeding predators a parallel to the hideous repast of Dante's Ugolino, a prime example of the grotesque for Hugo.

Neoclassical traits, with a close emulation of specific antiquities, are evident in the art of Barye. His choices of antique models ranged from isolated details to single animals to ideal human figures, such as the *Borghese Mars* (*Fig. 164*). He often copied antique details which can be seen in stylized hair taken from the *Apollo Piombino* for his hero in *Theseus Combating the Minotaur* (*Fig. 107*). He also emulated larger compositional formats, such as the Roman sarcophagus reliefs that underlie the twin riders of his *Lion Hunt* (*Figs. 104, 239,*

and 240). Barye's knowledge of neoclassical art also can be seen in his drawings after John Flaxman's illustrations of Dante's *Divine Comedy* (*Fig. 153*), as well as in the relief *Hector Reproaching Paris* (*Fig. 4*), which was largely inspired by Flaxman's engravings for the *Iliad*.

Academic commitments are intrinsic to Barye's art. The scientifically accurate anatomy of his animals reflects an empirical, positivistic fascination with natural form, one of the main tenets of the academic view as it was propounded in the writing of Etienne Falconet (1716–91),[22] Emeric-David (1755–1839),[23] Quatremère de Quincy (1755–1849),[24] and John Flaxman (1755–1826).[25] Yet Barye never allowed mere factual data to outweigh the expressiveness of his artistic imagery and its larger emotive, moralizing, or narrative point. For example, after measuring an elephant, Barye lengthened the spine of the Indian elephant for his *Tiger Hunt* group when he found that its true dimension could not support the howdah of hunters he had created!

Quatremère de Quincy pointed out that anatomy should be studied "after works of art, after anatomical models or displays, and after books or treatises written on the subject."[26] This admonition was closely followed by Barye, who mastered animal and human anatomy through direct observation, studied the masterworks of the past, and read scholarly essays treating his creatures. As for the artistic tradition, for example, Barye embraced Flaxman's view of the excellence of hunting scenes by Rubens, scenes inspired by Leonardo and more powerful than those of antiquity.[27]

Geometrically harmonious compositions that express degrees of emotions, almost as though exemplifying academic rules, often occur in Barye's work. An extreme is *Horse Attacked by a Lion* (*Fig. 105*) shown at the Salon of 1834, a design constructed within a strict grid of parallel and right-angle lines. Numerous other designs are contained within a square or triangle. Barye's late decorative masks for the Pont Neuf are an elaboration on Charles LeBrun's categories of physiognomical types, a fulfillment of the promise of that earlier academic system.

Barye's drawings yield impressive documentation of his artistic awareness of ancient, Renaissance, baroque, rococo, and neoclassical works. Indeed, his eclecticism is a major fascination of his art, and it constitutes a major study in its own right. This monograph depends heavily upon the evidence of the drawings.

Barye's liberation of animal sculpture during the 1820s and 1830s inspired a small school of followers, the *animaliers*.[28] Miniature bronze animals were the special metier of artists such as Christophe Fratin (1800–64), Pierre-Jules Mêne (1810–79), Emmanuel Frémiet (1824–1910), and Jules Moigniez (1835–94). Without exception, however, these sculptors cultivated excesses basically contrary to Barye. Extremes of verism, pictorialism, and an astonishingly antisculptural fragility of form, as well as sentimentality and melodrama, typify their work, and they never attained the dignity, monumentality, and expressive vigor of Barye. Comparisons of representative designs by the *animaliers* easily affirm Barye as the obvious master and innovator. See, for example, the anatomical implausibility, the silliness of Fratin's *Dancing Bear*; the unsettling, "stopped-action" pictorialism of Mêne's *Two Setters and a Mallard*; the sentimenality of Frémiet's *Cat and Two Kittens*; and the unsculptural fragility of Moigniez's *Two Swallows*.[29]

Barye contributed to the tradition of variations upon the ancient *Seated Hercules*, a

2

A Gathering of Energies:

The Early Works, 1819–30

Barye's artistic energies coalesced in his works from 1819 to 1830 and culminated in *Tiger Devouring a Gavial Crocodile,* the marvel of the Salon of 1831. The style in the earliest works followed three divergent paths: the painterly, the naturalistic, and the hieratic. These three directions merged in the combats of predator and prey created in 1829 and 1830, which marked Barye's early artistic maturity.

EXPLORATION, 1819–29

Two signed and dated works frame the period of 1819–29: *Milo of Crotona Devoured by a Lion* of 1819 (*Fig. 1*), a relief medallion executed while Barye was studying at the Ecole des Beaux-Arts, and a radically different image, *Poised Stag* of 1829 (*Fig. 12*). The change of taste represented in these works is dramatic, for Barye was beginning to turn from an emulation of art to an imitation of nature. The potential that is evident in the minuscule lion's mask of 1819 is more fully realized in Barye's larger, freestanding stag. The vicious intensity of the feeding lion is no less persuasive than the human pathos of the harried stag, pausing for an instant in its desperate flight. The uncompleted narrative situation evoked by the stag is powerful and dramatic in a baroque sense, for a pack of hounds seems about to burst into view. This recalls Bernini's marvelous *David* (Rome, Borghese Gallery), where the hero is already hurling the fatal stone toward a Goliath who threatens, yet is still unseen by

a spectator. Barye would use this baroque psychological and spatial device in many animal portraits.

The stance of Milo is a heroic convention derived from ancient Greek models, and one widely seen in neoclassical art. Yet the stance of the stag—shoulder lowered, foreleg drawn up, head thrown back—goes beyond convention in its keen articulation of mood. Not only is the animal modeled as a relief form, but numerous anatomical elements are related with parallel axes. Open shapes described by the stag's legs are carefully and asymmetrically balanced. The long contour line of the lower side of the jaw, throat, and trunk continues without interruption to the left rear hoof, which dominates the side view. Thus Barye has not simply imitated nature. Indeed, the geometrical aspects of his design show an almost self-conscious artfulness, an aspect of invention rather than pure mimesis. The scale of the stag, one-third life size, further asserts an abstraction from nature, as will the still smaller scale of much of Barye's oeuvre.

The dramatic increase in size, from the tiny medallion of 1819 to the large stag of 1829, reflects Barye's increasing confidence. The larger format is more powerful by departing from the confines of the art of the goldsmith, by implying a relationship to architecture, and by aspiring toward monumental dimensions. A more boldly romantic point of view is clear in the choice of an animal rather than human subject. As Luc-Benoist pointed out, the roles of animal and human protagonists were reversed in the romantic scheme of values, with the human figure given a subsidiary place or omitted completely.[1] Contrasts in theme are seen in the two works in that mythological narrative is set against anatomically accurate naturalism. At the level of style, a painterly quality is contrasted with a starkly clarified tactile quality, although a vestige of the painterly taste of 1819 survives in the lush fleece of the stag's neck.

By 1829 several aspects of Barye's art had become clear: the transformation of the sedate, antique format of the small bronze animal portrait to one more emotional and persuasive through an increase in size and a sharpening of narrative implication; a composition of gestures along rather severe geometrical patterns; a supreme mastery of animal anatomy; an intuitive ability to heighten implications of mood; a careful study of artistic precedents; and a technical capacity to cast fairly large pieces successfully. Still, a slight stiffness or awkwardness remains. Not until the 1830s will Barye achieve the sense of liberation, expansiveness, and expressive ease of his mature art.

Apart from the implications of these two works, three major stylistic tendencies emerge in other, undated works of this decade: (1) a painterly handling, ranging from vigorously plastic modeling to an atmospheric delicacy of relief, the relief often reminiscent of certain paintings by Leonardo or Rubens; (2) an imitative naturalism, in the spirit of the natural-history display; and (3) a hieratic, ritually formal quality, reminiscent of the stylized ritual art forms of ancient Egypt. In all three styles, with respect to the animal subjects, there is an engaging humanization, a focus upon the mood or state of awareness conveyed by the animal.

Among the three early portrait medallions, a clear progression is seen in the movement away from the painterly costume and the atmospheric effect, as in *Portrait of a Young Girl* (*Fig. 2*), toward more abrupt, blocky spatial planes and an increasingly larger presentation

of the sitter's head, as in *Young Man in a Beret* (bronze, signed and dated 1823, d. 12 cm; Louvre, RF 1931).[2] These traits are boldest of all in *Portrait of the Founder Richard* of 1827 (*Fig. 11*), a design where the sitter's head and neck alone fill the field. Since it lacks any painterly quality, this medallion comes closest to certain ancient coin prototypes. The stylized treatment of the hair in *Young Man in a Beret*, the tufts swept forward with the ends brought up to fluid, waxy points, is similar in feeling and rhythm to the still more vigorously plastic treatment of the dogs' fur in *Two Spaniels on a Cushion*, (*Fig. 5*). The painterly trend may well be the earliest distinct direction within the development of Barye's style.

Group 1: The Painterly Style

Painterly modeling during the 1820s, as in the works in Group 1, ranges from atmospheric, even impressionistic handling in *Two Spaniels on a Cushion* (*Fig. 5*), with its shadow-creating pockets, melting masses, and fluid, waxy surfaces, to the more conventional contrasts of handling in the tiny *Hercules with the Erymanthean Boar* (*Fig. 3*), its smoothly muscled Hercules set off by the lush modeling of the bristled boar. Still more delicate than the boar's surface is the vaporous, atmospheric quality of the girl's upper back in *Portrait of a Young Girl* (*Fig. 2*), a chiaroscuro reminiscent of Leonardo. Another image, the far plane of the lion's hind leg in *Milo of Crotona Devoured by a Lion* (*Fig. 1*), has a slightly bolder yet delicately modeled presence.

Milo of Crotona Devoured by a Lion (Fig. 1), Barye's earliest dated work, tells a moralizing story from antiquity of the prideful athlete punished by death, the official theme set for the medallion competition of 1819 at the Ecole des Beaux-Arts, in which Barye won an honorable mention.[3]

A shaggy lion bites deeply into Milo's left thigh, but the athlete is powerless to flee or to defend himself, for his fingers are caught fast in a cleft tree, which he so arrogantly attempted to break apart. Milo sinks slightly under the impact of the lion, his body a long curved line, the left leg extended and frontal, the right leg flexed and in profile. This balletic, unreal stance recalls the conventions of ancient Greek and neoclassical art. Milo's facial expression of classical reverie is inappropriate in light of the lion's snarling mask and raking claws, recalling Luc-Benoist's observation that animals had replaced humans as the protagonists of romantic art. As a design, the clearly defined contours and muscles of Milo contrast with the subtly developed spatial illusion of the lion, which is evident in the boldness of its face and forepaw, set against the shadowy delicacy of its belly and left hind leg, that just behind the cleft tree. The plinth of Barye's relief suggests Hellenistic bases with abbreviated landscapes, like those of the thematically similar *Marsyas* figures in the Uffizi. It is as though Barye created a relief image of a work conceived in the round. Such plinths also appear on the ancient coins and cameos that he studied.

Barye sketched Pierre Puget's famous marble *Milo and the Lion* in the Louvre[4] in two drawings on an album page (*Fig. 149*). To the right of the page he stressed the attenuated

proportions of the marble, a Mannerist canon that Barye replaced with a classical one, both in his medallion and in the powerful drawing at the center of the page. The latter drawing fixed the motifs of Milo's extended leg and his straightened arms pulling at the caught hand. However, Barye reversed the upper body of the drawn figure for his relief and altered its violent tone to one of classical restraint.

Another drawing, *Face of a Feeding Lion* (*Fig. 150*), after a painting by Rubens, documents the source for this motif, one repeated in several later works, as Rubens's *Lion Hunt* in Munich. Beyond the swirling turmoil of the Rubens painting is an echo of Antonio Canova's grieving lions that shed human tears, romantically humanized elements of his famous papal and aristocratic tombs. Even the conventional stance of Milo has a counterpart in Canova's *Hercules and Lichias* (Rome, Galleria d'Arte Moderna).[5]

Portrait of a Young Girl (*Fig. 2*), a profile bust, displays a format popular in the early Renaissance.[6] The boldly modeled face contrasts with the atmospheric disappearance of the plane and contour of the girl's upper back and with the tighter and often subtler variations of texture in the hair and costume. The pensive mood, the delicate yet sensual fullness of the facial type are reminiscent of ancient Greek coin profiles and of certain paintings of Leonardo, Raphael, and Giorgione in the Louvre. Barye's susceptibility to that classical style, and to its contemporary academic translation in the art of Ingres, would later emerge in the marble *Saint Clotilde* of 1840–43 (*Fig. 26*).

Surface damage is visible in the melted area of the girl's hair, a passage with the highest relief projection. Heat has smoothed this passage, destroying its sense of autograph touch. A closely related drawing, inscribed *Mère de Barye* (Walters Art Gallery, 37.2326), also uses this strict profile format and exhibits a similar delicacy of mood, economy of touch, and sensitive textural play within the costume.

Hercules with the Erymanthean Boar (*Fig. 3*) shows Hercules completing his third Labor: to capture alive the ferocious wild boar of Mount Erymanthos.[7] Hercules strides boldly forward, the subdued boar resting on his shoulders, its legs in the air and its head jutting forward like the visor of a fantastic helmet. Two long arcs dominate this design: those of the boar and of the back and extended leg of the hero. The angles of the flexed arms and the right leg of Hercules contrast with these long curves. The motif of the flexed and extended legs of the hero is twice repeated in the fore and hind legs of the boar. Textural play marks the smooth muscle of the hero versus the lush pelt of the boar, resembling that of the slightly earlier *Milo of Crotona*.

A drawing for this composition, *Faun Carrying a Sacrificial Ox* (*Fig. 151*), is definitely based upon a Dionysian sarcophagus relief, illustrated in Visconti's *Musée Pie-Clémentin* (Milan, 1820, vol. 5, tav. VII), which Barye studied while at the Ecole des Beaux-Arts. At first glance, this drawing suggests the archaic Greek vase painting *Hercules Carrying the Boar*. However, Barye's drawing omits areas of the faun's legs, which are hidden by other forms in the relief, confirming this figure as its source. The tiny bronze departs from this ancient source by placing the hero and animal head to head and back to back.

Two studies of a recumbent boar (*Fig. 152*), apparently made from the live animal, capture motifs used in the bronze—the boar's open mouth and the contrast of the flexed and extended legs. A third study on the page, *Standing Boar*, is related to another bronze of the 1820s (Baltimore Museum of Art, Lucas Collection, 66.7.70).[8]

The ancient small bronzes *Hercules Combating the Nemean Lion* and *Hercules Combating the Cerynean Stag* in the Caylus Collection (vol. 6, pls. XXVII: I, II; vol. 5, pl. CVIII: I) provided dramatic precedents for his exquisite Hercules group. Delacroix's treatment of this theme in his 1852 fresco for the Salon de la Paix bears a close resemblance to Barye's much earlier bronze.[9] More vertical in design, Barye's Hercules bears his load more lightly, although with a touch of archaic stiffness. Delacroix's hero bows more deeply, in a low arc harmonious with the containing line of its lunette. That Delacroix in the 1850s should return to an image created by Barye in the 1820s is characteristic of his sustained interest in Barye's art.

Hector Reproaching Paris (*Fig. 4*), a neoclassical relief sketch, won first prize in the sketch competition of 1823 at the Ecole des Beaux-Arts and is preserved there in the Salle des grands prix de sculpture.[10] The sketch was inspired by John Flaxman's suite of engravings for Homer's *Iliad*. The engravings appeared in 1802 with an Italian text, in 1805 in an English edition, and later with French titles.[11] Barye's awareness of Flaxman is certain, for it is documented by his page of drawings (*Fig. 153*) of figures taken from two of Flaxman's illustrations for Dante's *Divine Comedy*, *Dante Fallen to the Earth* and *Schismatics Fleeing* (*Figs. 206 and 207*). *Hector Reproaching Paris* merges several figures and motifs from Flaxman's engravings for the *Iliad*, particularly from the composition for this very episode, *Hector Chiding Paris* (*Fig. 208*). The text of George Chapman's *Iliads of Homer* (book six, lines 330 and following), illustrated by Flaxman, describes Hector's urging of Paris to leave Helen's side and to enter the battle to defend Troy.[12] Paris is still seated in Barye's relief, although his right hand touches the cuirass beside his chair in a gesture symbolic of his preparation for battle. Helen stands beside Paris, her right arm resting across his shoulders. Two women appear at the extreme left, behind Paris and Helen, signifying the setting as the women's quarters.

The resemblances of Barye's design to Flaxman's are clear. Barye retains the basic elements of this planar composition, with Hector standing at the right, addressing Paris and Helen at the left. However, he transposes the positions, creating a seated Paris and a standing Helen. This alteration more accurately reflects the text, for the poem states that Helen "stood at hand." Yet Barye also departs from the text where Flaxman does not, since his Paris lacks an archer's bow. Barye's figure of Hector is shown more frontally, with the lance in his left hand rather than in his right and with his circular shield more visible. Interestingly, Barye retains the form of Hector's legs too precisely, for the contour outline of the proper *right* leg of Hector becomes that of the proper *left* leg of Barye's figure. In fact, the angle of the legs of Barye's figure is so like that of Flaxman's as to convey an inaccurate notion of hip structure, since a frontal view replaces one in profile. The cuirass on the floor at the center of Flaxman's design becomes a circular shield for Barye. It rests against an

altar table or half-column, its rounded contour echoing Hector's shield. The three major protagonists as well as the two women are further embellished with quotations from other engravings in Flaxman's cycle.

In Barye's relief the motif of Hector's extended right arm as he implores Paris to fight appears in the figure of Polydamus in Flaxman's *Polydamus Advising Hector to Retire from the Trench* (pl. 21). Polydamus holds his lance in his left hand, like Barye's Hector. Barye modifies the gesture slightly by turning the palm of the extended hand toward the spectator, even as he retains the spreading of the thumb and fingers, which appears in the engraving.

Flaxman's *Departure of Briseis from the Tent of Achilles* (*Fig. 209*) contributes several motifs. Achilles is shown as seated and nude, his arms passively folded across his chest. Bayre reversed this seated Achilles to create Paris, just as he reversed the standing Briseis at the center of the composition to create Helen. Paris folds only one arm across his chest, however, and his right arm dangles at his side. Formally, this echoes the pendant arm of Helen beside him, and it signals his uncommitted mood while also implying that he is about to take up his cuirass in response to Hector's urging. Beside Flaxman's Achilles is a round shield, a motif that Barye retains but places at the center of his design, its ornament changed from the Medusa head of the engraving to an undulating serpent. Barye transposes the scabbard of Achilles to the costume of the standing Hector. The beautiful Briseis turns her face toward Achilles, her profile shown directly above her exposed, frontal shoulder. It is precisely this relation of profile and frontal shoulder that appears in Barye's Helen.

Barye's juxtaposition of a seated Paris beside a standing Helen no doubt comprises a visual pun on the fateful scene of Flaxman's *Judgment of Paris* (*Fig. 210*). It is deliberately intended to evoke that germinal moment in the story of Paris's love for Helen and thus of the genesis of the Trojan War. Barye's Helen is a Venus type of course, and she is clearly an amalgam of Flaxman's Venus and Briseis. In another inversion, Barye's Paris withdraws his arm to take the golden apple from Venus, whereas Flaxman's Paris extends his arm. Barye's Helen is so like Flaxman's Venus, although reversed, that the alteration of the gesture of her reaching right arm to an arm resting across the shoulders of the seated Paris has a notable awkwardness. Even the mass of drapery falling from the shoulder of Barye's Helen seems to demand the extended forearm of Flaxman's Venus.

The gesture of Helen's arm thrown across the shoulders of the seated Paris occurs in Flaxman's *Venus Disguised Inviting Helen to the Chamber of Paris* (pl. 7). The maiden at the extreme right places her arm across the shoulders of the woman beside her, a position rhythmically repeated by the third woman of the group. A cluster of coinlike female faces in profile, like those of the two attendant women at the far left of Barye's relief, appear in Flaxman's engraving *Andromache Fainting on the Wall* (pl. 34). The close proximity of the two women on the far right in the engraving almost implies the slight overlapping seen in Barye's relief.

Two Spaniels on a Cushion (*Fig. 5*) portrays the dogs as alert and watchful, a mood suited to the animated sparkle of the surfaces of this design. The antisculptural quality of the long

18

fur led Barye to model it with an impressionistic softness, blurring the transitions from the form of the lower dog to that of the pillow, and from dog to dog. The tiers of tufted fur catch the light in a shimmering, rhythmical vibration.

Group 2: Imitative Naturalism

A positivist philosophy is clear in the realism of Barye's animal designs of the 1820s. Stances and compositions in the works in Group 2 emulate actual animal behavior, either observed in the Jardin des Plantes or studied in scientific texts such as those of Baron Georges Cuvier and F. M. Daudin. The tiny *Turtle on a Base* (*Fig. 6*), precisely life size, presents a *trompe l'oeil* joke—even a joke on realism itself as an artistic style—through its meticulous detail. For a brief moment Barye sought to rival nature, almost as the young Michelangelo had sought to rival the sculptors of Roman antiquity with his early *Drunken Bacchus.* In nineteenth-century France, Edgar Degas would take such ultrarealism a step further and dress his *Ballerina of Fourteen Years*, a wax model for a bronze, in a real tutu, a silk ribbon, and a horse-hair wig.[13]

Other works by Barye closely approach the solely depictive intent of the natural-history display, that of certain small bronzes of the Renaissance, and works of the eighteenth-century porcelain masters and goldsmiths: the lyrical and tranquil *Stag, Doe, and Nursing Fawn with a Tree* (*Fig. 7*), and the restless, alert *Walking Stag, Right Hind Hoof Raised* (*Fig. 8*). Both also reflect the antique concept of a species portrait, but one heightened by the zoological precision of the artists of Barye's era.

Of the three early medallion likenesses discussed above, *Portrait of the Founder Richard* (*Fig. 11*) is the least painterly in style and the boldest in its sculptural simplifications of planes and volumes, and it is therefore included in Group 2.

A range of compositional formats occurs in this group: the literal naturalism of a casual placement of animals, as in *Stag, Doe, and Nursing Fawn with a Tree*; the strict planarity of *Walking Stag, Right Hind Hoof Raised*; and the pyramidal masses of *Seated Boar* (*Fig. 9*) and *Fallen Stag* (*Fig. 10*).

Turtle on a Base (*Fig. 6*) displays the scientifically accurate realism of the 1820s.[14] The design of this exquisitely positivistic "paperweight," to use the pejorative term coined by one of Barye's critics, owes a debt to the veristic sculptural miniatures of the eighteenth-century master goldsmiths, such as the splendid silver turtle on a saltcellar by Thomas Germain, dated 1734–36.[15] *Turtle* is one of relatively few designs of the 1820s that Barye continued to offer in his sales catalogues of bronzes from the 1840s on.

Stag, Doe, and Nursing Fawn with a Tree (*Fig. 7*) is elaborately literal in the relation of the animals to each other and to their setting.[16] Its concept lies somewhere between a natural-history diorama and the lyrical miniatures of the eighteenth-century porcelain masters. One recalls the aptness of Delacroix's brief characterization of Barye in a letter of 1828 as a

"sculpteur paysagiste," a landscape sculptor of rustic and pastoral subjects.[17] The intently feeding stag and the alert, watchful doe exemplify the humanizing touch Barye lent to many of his animal protagonists during the 1820s.

The drawing *Stag Feeding at a Tree* (Louvre, RF 4661, fol. 4v) is closely related to the attitude of the bronze stag as it reaches up to nibble the leaves above its head. Another, unusually precise drawing, *Family of Deer, Squared* (Louvre, RF 4661, fol. 23r), shows profile views of a stag in recumbent and standing positions and outlines of a standing doe and fawn, systematically noting their relative sizes. Of the grid pattern, only the intervals of one-half centimeters along the baseline are constant, serving precisely to control the relative lengths of the animals. The long horizontal lines of the grid are not measured units, but they pass through fixed reference points in the animals' anatomy, such as the top of the skull of the standing stag, and the top of the ear and the juncture of the neck and chest of the recumbent stag. The profile view of the doe corresponds in height, at the very tip of its raised ear, with the top of the skull of the standing stag. The fawn, however, is drawn to scale and has no corresponding points in the horizontal grid.

An ancient bronze stag in the Vatican (*Fig. 211*) holds its flexed left foreleg and tilts its head upward, just as Barye's stag does in this group. The doe standing beside it has a small bronze counterpart in the Caylus Collection (*Fig. 212*).

Walking Stag, Right Hind Hoof Raised (*Fig. 8*), an example of the realism of the 1820s, reflects Barye's positivist enthusiasm for zoological particularities in the stance and other details of the animal, possibly an axis deer.[18] A stately carriage and the stag's alert watchfulness are impressive. The flowing arabesque of the antlers is echoed in the undulating contours of the animal's head, neck, and body. A rippling contour reminiscent of Rubens runs along the underside of the body from the chin to the extended left hind leg. Another such contour appears above the neck and shoulders. These cursive contours contrast with the angular forelegs and the raised rear leg. *Walking Stag* is another 1820s design that Barye continued to offer in his later sales catalogues.

A study of *Head of an Axis Deer* (Walters Art Gallery, 37.2127A) accurately records this species, with its long, slender antlers, slender nose, and distinctive patches of woolly fleece at the cheeks and mane. Whether the drawing was made after a live animal or a prepared display is difficult to determine. The hunting-trophy overtones of the design no doubt echo the English "sporting taste" current in France in this period.

An ancient Roman bronze, *Stag's Head Boss*, with a great antler tree and long raised ears, was in the Caylus Collection (*Fig. 213*), an important precedent for the trophy level of meaning called up by Barye's bronze stag.

Seated Boar (*Fig. 9*), with its tiny, realistic figure, has a crisp, richly textured surface, achieved with both incised lines and raised ridges. A superbly captured sense of easy alertness pervades the animal. Strict geometry is apparent in the straight line of the boar's spine, so strongly accented with a tuft of bristles, in the echoing triangles of the braced forelegs, and in the silhouette of the head in profile. The boar is placed on a round base, and it is clearly a mate to the more dramatic *Fallen Stag* (*Fig. 10*).

The well-known Roman copy of a Hellenistic *Seated Boar* in Florence is surely the source of Barye's small bronze. His boar has the same posture, the hind legs set to the right, the ears raised, the head erect and turned to the right. The base has been altered from a rectangle to a circle. The mood of Barye's bronze sets it apart from the more objective literalism of the antique one and thus shows his interest in subtle states of human feeling. A *Boar's Head Boss* in the Caylus Collection (vol. 7, pl. XLVI: IV) was known to Barye. The motif of the boar's head boss was current in the art of the eighteenth-century master goldsmiths, as in the *Terrine Dish* of 1733–34 by Thomas Germaine and Robert Joseph Auguste's *Oil Jar Lid* of 1784–85.[19]

Fallen Stag (Fig. 10), almost melodramatic, is an unrestrained extreme found only in Barye's earliest, exploratory works. The stag has fallen, exhausted, its left foreleg feebly braced, seemingly incapable of raising the animal, although poised for the attempt. The implications that an unseen pack of hunter's hounds have harried this stag is an example of the quintessentially baroque desire to establish a continuity between the symbolical realm of the work of art and the real ambience of the spectator.[20] Narrative implications of the hunt and a focus upon a fallen stag would remain favorite themes for Barye in the 1830s.

Portrait of the Founder Richard (Fig. 11) no doubt depicts the same "Richard, fondeur" documented in Emile Martin's *Journal* in an entry dated 31 March 1851—a testament to the long duration of his friendship with Barye.[21] The style of the portrait avoids the sweetness, the elaborate costume treatment, and the atmospheric delicacy of the earlier medallion, *Portrait of a Young Girl (Fig. 2)*. Instead, it is robust in its directness and alertness, exhibiting a notion of idealized masculinity. In dramatic presence it rivals the best portrait medallions of David d'Angers, Barye's contemporary. In sculptural vigor it may surpass them. Perhaps the only disjunction in Barye's earlier medallion is the contrast between the unreal treatment of the hair and the naturalness of the face. While the hair avoids the mechanical tightness and uniformity of, say, the collar of the young girl, it retains too completely the rough marks of the technique of its execution. Against this, the vividly natural flow and juncture of the planes, volumes, and muscles of the face are too starkly dissimilar. In this respect, the subtler unities of the works of David d'Angers are to be admired.

Poised Stag (Fig. 12) is at a more imposing scale and with a more restrained expression a treatment of the same protagonist, narrative idea, and feeling statement that Barye had articulated in his earlier, tiny *Fallen Stag (Fig. 10)*. Here the stag pauses in flight, as though listening to pursuing hounds or perhaps gasping for breath. A comparison of this bronze with a series of three related drawings in the Louvre (*Fig. 154* and RF 4661, fols. 11r and 12r) reveals just how effective Barye was in his effort to portray accurately the skeletal and muscular structure of the real animal, and to state more subtly than before the narrative and emotional levels of significance.

The first contour drawing of *Poised Stag* (folio 11r) overstates the expressive motifs of the animal sinking to earth as though exhausted, its left foreleg extended far to the front, its overlong neck craning upward, its head thrown back. A correction of this initial drawing

appears in two measured anatomical studies, probably made from a specimen in the Cabinet d'Anatomie Comparée or the Muséum d'Histoire Naturelle. One of the two, *Stag's Skull* (folio 12r), records the intricate forms of the bone structure. A lateral view dominates the drawing, a sign of the artistic importance of the silhouette contours of the animal, as well as the use of the conventions of zoological notation. Two smaller studies on the skull page note details of the rooting and branching of the antlers, viewed in profile and dorsally.

The second drawing, *Skeleton of a Stag* (Fig. 154), notes the larger dimensions and proportions of the entire animal seen in profile. Elaborate attention is paid to the bone structure of the legs, shown both laterally and frontally. The whole animal is shown in a posture very like that of the final bronze, except more extreme. Its exaggerations of the falling line of the back and shoulders and of the forward reach of the foreleg convey an inappropriate suggestion—not of fatigue, but that perhaps a tree has fallen on the animal. A small, sensitive contour study of the neck and backward-tilted head appears at the right of the total view. The study records an angular relationship, precisely that of the final bronze. Compared with the neck and head of the total view, drawn in faint outline, the smaller study is more natural and plausible than the craning, overlong neck of the total image. These three drawings document how Barye carried his concept from an initial mode of theatrical extravagance to one of a more mature understatement, one both moving and more believable with respect to the limits of the animal's anatomy.

Group 3: The Hieratic, Ritually Formal Style

One group of animal compositions of the 1820s possesses a hieratic quality of stance or movement, a ritual stiffness that occasionally becomes wooden. The compositions in Group 3 are abruptly geometrical and often use parallel lines, grid systems, or crossed diagonals as the means of organizing gestures, axes, planes, and silhouettes. A sense of an obtrusively artificial or contrived pose is usually evident, along with a largely unresolved conflict between a two-dimensional surface pattern and a three-dimensional development of masses and voids. Nonetheless, Barye's increasing capacity to command the facts of anatomy and to delineate and focus the dramatic aspect of a narrative episode becomes apparent during the 1820s.

The ancient flying gallop convention is seen in *Stag in a Flying Gallop* (Fig. 13). Ritualized compositions of opposed adversaries in the classical ancient mode are seen in several of Barye's small predator and prey groups, such as *Eagle and Serpent* (Fig. 14) and *Eagle and Chamois* (Fig. 15).

Stag in a Flying Gallop (Fig. 13) presents an extreme flatness that is atypical of Barye's designs.[22] Its strictness recalls the ancient low-relief *Antelope in a Flying Gallop*, on an alabaster urn in the Caylus Collection (vol. 1, pl. LXXX: X). The long, slender neck and head and the attenuated body of Barye's stag have an aristocratically unreal quality, not unlike that of the ancient relief, and perhaps with overtones of the art of Cellini as well. The echoing of the long, curved lines of the neck, belly, and back of the stag is similar in both

the alabaster urn and Barye's bronze, as is the perfectly horizontal axis of the ears, head, and snout. On the alabaster relief the tips of the antelope's hind hooves just touch the ground, a motif omitted from Barye's bronze but reiterated in his drawing *Running Muntjac Deer* (Walters Art Gallery, 27.187; h. 10.5 cm). In the bronze the stag's hind legs are thrown fully to the rear and raised high, almost exactly as in the antique prototype.

Eagle and Serpent (Fig. 14) strikingly combines a bannerlike, heraldic formality of design with anatomically precise naturalism.[23] Inconsistencies of spatial illusion, typical of this trend of the 1820s, are evident in the way the eagle projects outward from the background plane. This plane is felt as a surface, while the landscape elements of the design—the hillock and the neutral background area—imply a greater atmospheric depth. Perhaps the intention is to create the sense of a high, isolated crag seen against the sky. Yet the sculptural impact of the eagle and serpent is so strong as to detach it, disjunctively, from the possibly continuous illusion of deep space. Vertical parallel lines in the eagle's tail plumage are echoed in the striations of the rock face. The tufts of feathers counter the tighter rhythms of the snake's scales, repeating the freer accents of the buttered texture in the grassy hillock. The coils of the serpent echo the long, curved contours of the wings. Such internal rhythms create the larger, two-dimensional unity of the relief. Lively narrative touches are seen in the faces of the battling predator and prey and in the half-opened wings of the eagle.

The drawing *Alighting Eagle* (Walters Art Gallery, 37.2179A) shows the lowered and opened tail plumage and its balancing counterpart, the lowered, menacing head of the eagle. While the wings in the drawing are more open than in the relief, and viewed from above rather than laterally, the contour line of the farther wing is similar to that of the relief, where the same line parallels more closely the long arched line of the eagle's tail plumage, back, and extended neck and reiterates the heraldic pose.

Eagle and Chamois (Fig. 15) [24] envinces a strong psychological animation. It is as though the eagle were flapping its wings to menace and drive away some competitor for its prey. The eagle's open wings are the dramatic focal point as well as a formal statement of the dominant angles of the grid that organizes the design. Main contours and axes are parallel, as in the eagle's right wing, the chamois' extended fore and hind legs, and several contours in the square rock toward the right. Intersecting these diagonals are the parallel lines of the eagle's left wing, the contour of the neck and jaw of the chamois, and two edges of the square rock. A classical symmetry of design is also apparent, a quality not always coequal with the heraldic. For example, the two square blocks of stone at either side have roughly identical visual weight, and the tilted block reiterates the diagonal grid, while the other block classically repeats the edges of the rectangular field. Setting off the cubic and rectilinear qualities of these balanced boulders are the several arching contours of the foreground and middleground edges of the grassy hilltop.

Typical of this early style are the inconsistencies of spatial illusion: the powerful space-creating effect of the open wings versus the strangely flattened dimension of the chamois, whose carcass seems to dissolve into the rock; and the awkward relation of the eagle's

talons to its prey and to the surface of the rock, ambiguous passages that are neither clearly flat nor clearly three-dimensional.

A drawing for *Eagle and Chamois* (Louvre, RF 4661, fol. 6r) offers a key to some of the spatial ambiguities in that it shows the long parallel lines crossed at angles to create the grid of the final design. Expression and geometrically governed order are the goals of the drawing, rather than anatomical accuracy, especially for the distinctly vague form of the eagle, which might be of cotton wool rather than flesh, bone, and feathers. The chamois, however, is drawn with a precision suggesting the study of an actual specimen. In particular, the head of the chamois is longer and more elegant and its volumes more full, with a sense of skeletal logic that is not found in the chamois of the relief.

The open wings of the eagle, and the articulation of the legs and talons were scrupulously corrected in the bronze, which also subdues the motif of the open beak. The beak is not that of a shrieking bird, but of an almost ritually formal or heraldic head shown in perfect profile. In the drawing, the rock masses have the several levels and main contours shown in the relief. With greater clarity than the bronze, the sketch shows the carcass of the chamois wedged into a small crevasse, a placement that is not well conveyed in the relief itself.

Owl with a Mouse (*Fig. 16*) shows a predator with its prey clutched in its talons.[25] The owl's mood is richly developed; it is easy, slightly forbidding, and meditative. The design has an almost perfect axial symmetry, heraldic in effect yet free of the contrived contrast of frontal wings with a body in profile, as in *Eagle and Serpent* (*Fig. 14*). The landscape setting is abbreviated to a single boulder, its smallness heightening the expanse of the owl's wings. A lush, rhythmical cascade of feather tufts ornaments the front of the owl's body, the tiers echoing the strata of feathers in the wings. The mouse is reduced to a kind of arabesque that complements the arching contours of the feathers and edges of the wings.

A drawing of studies of an owl (Walters Art Gallery, 37.2178A) records several images related to this sculpture. The two large studies of the owl's head show the twin concentric circles of feathers superimposed upon the triangle described by the points of the beak and the twin, earlike tufts of feathers—motifs clearly present in the bronze owl. Two faint sketches at the bottom left and center of the page show the owl with wings opened, clutching its prey in its talons. In the left drawing, however, the prey is a coiling serpent, which confirms the close conceptual relationship of this design in the round with the contemporary relief *Eagle and Serpent* (*Fig. 14*). An early precedent for Barye's owl, possibly known to him, is the porcelain *Little Hawk Owl*, created in Chelsea about 1752.[26]

Stork on a Turtle (*Fig. 17*), a novel heraldic composition, illustrates two fundamental mechanisms in Barye's art: his translation of an ancient model by means of scientifically accurate realism, and his desire to free miniature animal sculpture from its ornamental limitations. The source of Barye's design is an ancient bronze oil lamp (*Fig. 214*) that he knew from Lorenzo Roccheggiani's illustrated anthology *Raccolta di cento tavoli*. Although these two creatures occur in the same natural environment, and their combination may simply reflect the ancient artist's observation of nature, it is possible that the artist intended to symbolize the Four Elements: the lamp's flame (fire), the implied flight of the bird (air),

its diet of fish (water), and the amphibious turtle (both earth and water), or even of the cthonic realm of the underworld, since the turtle burrows in the ground to hibernate.

A key to the transformation of the stylized creatures of the ancient lamp into Barye's realistic sculpture is his drawing *Studies of a Stork* (Walters Art Gallery, 37.2190B), made from nature. It shows the stork in frontal and profile views, its neck tucked against the body, rather than extended as in the ancient sculpture. In the profile view the angle of the beak to the axes of the body and legs is the same as in the bronze. The stork in the drawing is more compact and therefore more readily cast and less fragile. A pointed tuft of feathers jutting from the breast of the bronze stork simplifies the ragged crest seen in the drawing, a hornlike form that reiterates the silhouettes of the beak and tail plumage. This tiny turtle is related to the larger *Turtle on a Base* (Fig. 6).

Two ancient Egyptian images in the Caylus Collection afforded precedents for Barye's stork design. A fragment, the head and neck of a bronze ibis (vol. 5, pl. XI: I), has the detailed modeling of the eye and beak reflected in Barye's stork. A heron cameo (vol. 3, pl. V: III), carved in black agate, shows the bird standing on one leg with the second leg raised but still visible, somewhat like Barye's drawing and another small bronze, *Stork and Serpent* (Worcester Art Museum, Massachusetts.)[27]

CRESCENDO, 1829–30

During this brief but crucial period, Barye's artistic energies came into sharp focus, transcending the exploratory and hesitant traits of the 1820s to display the power and impact of an early artistic maturity. Splendid in their own right, the four predator designs of 1829 and 1830 also clearly prefigure *Tiger Devouring a Gavial Crocodile* and *Lion Crushing a Serpent* of 1831 and 1832, monumental works that launched Barye's career in Paris and marked him with the stamp of notoriety and creative rebelliousness that he would never lose.

Group 4: Dramatic Predators

The related compositions in Group 4 contrast a vertical planarity and stiffness in the predators with their fluid, twisting prey. A long, descending axis typically organizes the form of the predator, highest at the haunches and lowest at the head, as in *Tiger Devouring a Stag* (Fig. 19) and *Panther Attacking a Civet Cat* (Fig. 20). This motif is simply reversed in the rising line of *Jaguar Devouring a Crocodile* (Fig. 21). There is an almost constant use of the motif of the predator's mouth clamped into the flesh of its prey, tearing at it, a motif derived in part from Rubens and already seen in the *Milo of Crotona* medallion of 1819 (*Fig. 1*). Some of Barye's anatomical drawings of feline skulls also delineate widely opened jaws. A static quality marks the standing predators in *Tiger Devouring a Stag* and *Panther Attacking a Civet Cat*. In each case, this stiffness is dramatically heightened by the gesture of the

predator's tail, either lashing tensely or lying passively, and by the rolling contours of their feline silhouettes. Such rolling, fluid motion of line is given a three-dimensional embodiment in the gathered, spherical muscles of the crouching jaguar in *Jaguar Devouring a Crocodile*. Figure and base are distinct entities, rather than synthesized, in the designs in Group 4.

Tiger Devouring a Stag (*Fig. 18*), a unique proof, uses an extremely unusual substitute for bronze, a kind of plastic made of scrap copper shavings held in a resin medium.[28] The plastic animal forms are mounted on a base rim of bronze. The surface of the animals, seeming more like wood than bronze, lacks the reflective brilliance and iridescence of bronze. Soft lead solder binds to this material, for the projecting left foreleg of the stag is soldered to the fabric of the main casting. The plastic is used for the upper surface of the base, which is soldered to the bronze rim of the base, with large amounts of lead applied to the juncture from beneath. The plastic does not seem to flow freely in the mold; numerous patches are evident, covering gaps in the fabric on the right rear thigh and left foreleg of the tiger and on the stag's legs. Antlers apparently were never attached to the stumps integrally cast with the stag's head.

Considered as a design, apart from the technical interest of the casting material, *Tiger Devouring a Stag* is a culmination of several earlier avenues of research—the species portrait, the animal combat, and the larger scale of the *Poised Stag* of 1829 (*Fig. 12*). New is the superb articulation of a narrative moment both vicious and pathetic, one considerably beyond the efforts at such episodic force in works of the 1820s. A sense of pathos in the dying stag is contrasted with the relentless, almost mechanical action of the feeding tiger. The silhouette of the group has what Sir Kenneth Clark would term the "contained, cameo quality of ancient art." Excessive particularity is nowhere evident in the large and planar form of the tiger. Yet a trace of the hieratic woodenness of the 1820s is still present in the relationship of the two animals. Barye would create a foil to this quality in the fluid, swirling form of *Two Bears Wrestling* about 1833 (*Fig. 123*).

The bold, angular rhythms and blocky volumes of the legs of the tiger convey a dramatically new dimension of power and weight, a sign of Barye's growing maturity. The angles of the legs often parallel each other in a tight unity of design. Contrasting with the blocky limbs of the tiger are the stag's spindly legs and the cursive arabesques of its antlers.

An insight into Barye's elaborate scientific preparation for his sculpture about 1830 can be gained from the group of related anatomical drawings in a sketchbook in the Louvre (RF 8480). The tiger is based on the following studies, as are the other tiger designs of 1830 and later. The word *tigre* is inscribed on all of the following album pages. Folio 1r shows a measured contour drawing of segments of bones and a study of a hip joint. Folio 1v presents contour drawings with measurements of the ears and nostrils. Folio 2r shows the head viewed in profile and detail studies of the juncture of the nostrils and upper lip. Folio 3r shows two drawings of an extended claw, frontally and in profile; it also shows the extended forepaw in the dorsal view. Folio 3v (*Fig. 155*) shows three drawings of the flayed upper torso and the forelegs of the tiger, emphasizing the larger, simple shapes of the

exposed muscle groups. Folio 4r portrays the flayed head and neck and a study of a fang. Folio 4v contains five fine contour drawings, with measurements, of a dorsal view of the skull and of several cross-sections taken through it. Folio 5r shows the flayed tiger, minus the hind legs, viewed in profile. Folio 5v shows an extended hind leg, with indications of the joints and skeletal configuration. Folio 6r shows the flexed hind leg, with the hip and tail visible as well. Folio 6v shows two drawings of the flayed upper torso in profile, one with the left foreleg drawn back, the other with the foreleg flexed. Folio 7r presents two drawings of the head with the jaws opened wide, one in profile, one frontal. The frontal view suggests not only the gaping jaws of the animal combats of the 1830s, but even the menacing tiger attribute of the personification figure *Order* of 1854–55 (*Fig. 37*) for the Cour du carrousel of the New Louvre and the late tiger groups of 1869 for Marseilles. Folio 7v shows the animal's trunk. Folio 23v, which is not inscribed *tigre*, shows the ears of a tiger in a delicate, coloristic drawing style.

The same sketchbook also contains drawings of the stag. Folio 10r, inscribed *cerf de malabar*, contains various measured and pure contour studies of anatomical details, such as the snout and nostrils. Two drawings show a dorsal view of the head. One was made from the specimen before its dissection, with a mass of shaggy fur visible on the underside of the neck, and with the long lines of the antlers. The other is a measured drawing of the same dorsal view of the skull, its line elegantly economical. Folio 17v, inscribed *élan*, shows the hind leg and body in profile. Folio 18r, inscribed *élan, taure, ratel*, shows four drawings of the stag's hind leg and hoof. Folio 18v, inscribed *élan femelle*, shows four studies of the hind leg and hoof. Folio 19r, inscribed *élan femelle*, shows the head in profile and dorsal views, and a three-quarter view of the nostril and lip area. Folio 19v, inscribed *élan male*, shows two studies of the head, a profile and a dorsal view. Folio 21v shows drawings of the skeleton in profile, minus the head, with emphasis on the articulation of the legs. Folio 22r shows two studies of the head, a dorsal and a profile view.

Given the sustained intensity of the direct study of animal specimens recorded in these drawings, it is not surprising that Barye made plaster casts of portions of specimens under study, such as the right forepaw of a lion, a flayed cat, and a panther's snout, shown in the Barye exhibition of 1956–57 at the Louvre.[29] These would also enhance his mastery of animal form and structure.

Tiger Devouring a Stag (*Fig. 19*), compared with the larger version (*Fig. 18*), nearly twice the size, has a flatter and more shallow treatment of the massed muscle groups of the tiger's legs, shoulders, and back.[30] The lush fullness of the muscles has been transformed by a tighter, dryer, more graphic kind of handling. However, a certain gain has been made in elegance, crispness, and intensity of impact in this exquisitely transcribed smaller variation. As a species, the stag has long ears, unlike those of the larger version, and one wonders whether the larger ears are merely a substitution for an extremely fragile and thus frequently broken element of the sculptor's model.

Technically, this bronze model represents a fascinating extreme of miniaturistic intricacy in that it is composed of no less than twelve removable elements, now held together with

screws for display purposes. Traces of fresh red sand on the interior of the shell confirm its use as a model for sand molds. The separate elements are described in Chapter 6 under "Unique Bronzes."

A contour drawing of a stag's head and neck, *Stag with its Head Thrown Back* (*Fig. 154*), which was discussed earlier in connection with *Poised Stag* (*Fig. 12*), is very closely related to the contours and angles of the head and neck of this stag, as are the adjacent, precise studies of the skeletal structure of the legs, shown in profile and frontal views.

Panther Attacking a Civet Cat (*Fig. 20*) differs from *Tiger Devouring a Stag* (*Fig. 19*) in that its composition reveals a desire to separate rather than merge the forms of the two protagonists.[31] The result is a corresponding increase in the clarity and impact of the silhouette. The panther is flat-sided and abruptly planar, and the axes of its staggered forelegs lead directly into the axes of the shoulders and hips of the civet cat. A tension is established in the panther by the long, bold, undulating line of its arched back and the countercurves of its tail, set against the rigid parallels of its braced legs. Dramatically focal are the unsheathed claws of the panther's left forepaw, pinning the civet cat. The civet bends under the impact, its face in a snarl of pain. By contrast, the stony, impassive gaze of the panther is more like a sphinx than a carnivorous beast.

A free and imaginary compositional drawing in the Walters Art Gallery (37.2124) shows a feline predator clawing at the head of a fallen elephant. The upward swinging line of the long tail of the predator, so expressive a sign of the animal's excitement and tension, and the rhythmical double arches of the predator's neck and back suggest those of *Panther Attacking a Civet Cat*.

Three rapidly made drawings after a live cat, *Feline Predator Feeding* (Baltimore Museum of Art, Lucas Collection, Barye Album, fols. 21v and 26v), records a similar profile view of an animal that Barye perhaps studied in the Jardin des plantes. On folio 21v, the cat feeds with its forepaws resting on the ground and its hindquarters raised to perhaps one-third of the height of the animal, the essential motifs of *Panther Attacking a Civet Cat*. A merging of two rapidly made contour studies on folio 26v may well have yielded the pose of the bronze panther. The lower of the two studies shows the same elevated hindquarters and reaching forelegs as the bronze, but with a different, concave line along the back, a line perhaps too playful for the gravity of mood Barye would develop. The same angular, rising line of the middle of the panther's back in the bronze occurs in the upper drawing of folio 26v, but it shows the animal fully recumbent, not as pinning its prey. Thus in this merging of two dissimilar poses to create a powerfully silhouetted design, the demarcation becomes indistinct between invention and an accurate presentation of natural data. Typically for Barye, expressive concerns have held sway.

In preparation for a watercolor, Barye made two squared drawing after a plaster model or perhaps after a completed bronze (Walters Art Gallery, 37.2071, and 37.2072). The drawings explore slightly different scales, narrative moments, and distances between predator and prey. One shows the panther actually pinning the civet cat, while the other shows it still stalking its victim. These drawings record Barye's mode of accurately translating a

sculptural design into the form of a painting, and one at a different scale from that of the original sculpture. An unfinished drawing of a panther's head, inscribed *panthère* (Louvre, RF 8480, fol. 2v), shows the major angle at the juncture of the two planes of the top of the skull, viewed in profile. A well-preserved plaster model of this design is in the Louvre (RF 2724, OA 5757; h. 11.5, l. 25.3 cm; Louvre *Cat.*, 1956, no. 15).

Jaguar Devouring a Crocodile (*Fig. 21*) has a low silhouette dominated by the gently rising line of the jaguar and by the energy of its compressed, swirling, spherical modeling.[32] The swinging curves of the crocodile, bent backward in its struggle, are repeated in the tensely arched tiger's tail. The widely opened jaws of the crocodile are a pathetic foil to the steady and irrevocable closing of the jaguar's massive jaws, as is the crocodile's feeble attempt to push away the jaguar's head with its foreleg. This contained silhouette is nearly unsuccessful, but it is relieved by the accents at either end of the design: the gaping jaws of the crocodile and the great loop of the jaguar's tail.

The heavy arabesques of this spherically modeled design are close to the quality of movement captured in the series of rapid contour drawings made after *Feline Predator Feeding* (Baltimore Museum of Art, Lucas Collection, Barye Album, fols. 26r, 26v, 27r, and 27v). In fact, the position of this jaguar can be placed halfway between the seated and recumbent poses shown in two drawings on folio 27r (*Fig. 156*) and on folios 26r and 27v. Folio 26r depicts the foreleg in a crouching stance, with the elbow raised quite high, as in the bronze. In this drawing the long, arched line of the cat's neck and head is closer to the bronze than any other drawing. Even the lashing tail has a similar feeling. Only the arrangement of the hind legs is missing from this sequence of drawings.

A certain freedom and softness in these studies coincides with their difference of function from the dissection studies of a tiger discussed in connection with *Tiger Devouring a Stag* (*Fig. 19*). An excess of an unreal sphericality of form in this bronze, in fact, suggests that the design was created prior to the dissection experience and the skeletal drawings. Perhaps this softness of effect led Barye to attend the dissection and to pursue the osteological investigation in 1828 or 1829. Subsequent to these studies, the form of the monumental *Tiger Devouring a Gavial* of 1831 would manifest a total and sparkling command of the skeletal and muscular anatomy of both animals, a mastery that may have been achieved by overcoming the problems of this very design. A similar sense of clarified and accurate anatomical depiction links the tigers of *Tiger Devouring a Stag* (*Fig. 19*) and *Tiger Devouring a Gavial Crocodile*.

The scientific preparation for this crocodile and those that would follow is recorded in the elaborate table of measurements entitled *caïman de surinam* on folio 7r of the Barye Album in the Lucas Collection. Also, a measured contour drawing of a crocodile's skeleton extends across two facing pages in the Louvre Barye Album (RF 8480, fols. 11v and 12r). In a lateral view attention is devoted to the delicate and intricate forms of the leg bones. An important complement to these osteological studies are the notations of the patterns and textures of the crocodile's hide, so delightfully captured in the series of gavial crocodile drawings in the Barye Album in the Lucas Collection (*Fig. 157* and fols. 4v, 5v, and 6r).

Alternative views of the interrelation of the designs in Group 4 should be reiterated. For example, assuming a consistent development from the softer, spherical style to the planar, anatomically accurate one, the actual sequence of the designs might be *Jaguar Devouring a Crocodile, Panther Attacking a Civet Cat*, and *Tiger Devouring a Stag* (1830). That is, as a transitional group from the 1820s to the 1830s, the definitely dated work may be the last rather than the first. Of course, only *Tiger Devouring a Stag* of 1830 offers a fixed point, yet the hypothesis that it is the late design of the group is tempting. A second view would maintain that Barye created an antiscientific style in the spherical forms of the jaguar group—that he was not yet fully committed to a precise recording of zoological data. A third interpretation might hold that Barye simply preferred a softer, rounder style for his jaguars of this period and a crisper, more planar style for his tigers, possibly an artful amplification of basic qualities he sensed in the forms of the live animals.

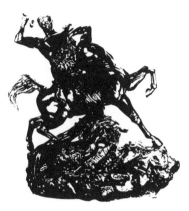

3

Grandeur Attained:

The Monumental Sculpture, 1831–69

Barye's dream was to be known as a *sculpteur statuaire*, rather than a sculptor only of small bronzes. His Salon entries of 1831 and 1833, *Tiger Devouring a Gavial Crocodile* (*Fig. 22*) and *Lion Crushing a Serpent* (*Fig. 23*), were his credo pieces, the fruition of all that he had learned and felt as an artist. The first is an essay in satanic violence; the second is an allegory of the struggle and triumph of the July Revolution and of the House of Orléans couched in astrological imagery. Barye would treat a full range of subjects at monumental scale, working with both the carving and modeling processes at various times. In addition to animal groups, he created ideal human figures, such as the marble *Saint Clotilde*, of 1840–43 (*Fig. 26*), and equestrian bronzes, such as *Napoleon I as an Equestrian Roman Emperor* of 1865 (*Fig. 51*). By 1855, when Barye had become a central sculptor for the Cour du Carrousel decorations of the New Louvre Palace of Napoleon III, the masthead of his sales catalogue of small bronzes proudly displayed the term STATUAIRE (*CRF55*).

A Spectacle of Evil and an Allegory of Royal Triumph

Tiger Devouring a Gavial Crocodile of the Ganges (*Fig. 22*) was exhibited as a plaster and won a second medal in the Salon of 1831.[1] It captures a moment in the death struggle of two satanic creatures. The tiger bites deeply into the flesh and genitalia of the writhing crocodile and glares viciously into its eyes. A sense of muscular tension in the tiger, that of muscle pulling against bone, contrasts with the slither of the gavial. Enormous extended claws pin and pierce the crocodile, similar to those in the artist's feline dissection drawing *Claw-Retracting Mechanism* (Walters Art Gallery, 37.2219). The wrinkled contours around

the bridge of the nose and the eyes of the tiger are superbly expressive, conveying an almost human mood, and are evidence of an unerring mastery of anatomy. The flesh and muscle in the tiger's mask flow elegantly into accents of contour line and into the raised tufts of fur at the ears and cheeks. Textures sparkle and dance. Barye treats the bristly tiger's pelt with linear incisions, varying the length and directions by which they follow the undulating surfaces. An oily sheen, a pneumatic, slightly distended quality of surface marks the gavial, nicely contrasted with the stippled and graphic treatment of the tiger's pelt.

Cursive outlines of grasses and leaves on the base echo the flow of movement and contour in the struggling creatures. A broken, shimmering rhythm of light reflected from the base counters the tighter rhythms of the textures of the tiger and crocodile. Despite the freedom of the reflections from the base and the accurate plant forms, the base seems stylized. Its heraldic, almost tapestrylike aspect suggests the Carpet of Flowers motif in Northern Renaissance paintings of the Madonna in Her Garden, that magical balance of real elements and an unreal effect.

The anatomical verism of these creatures is dazzling. Yet the unrestrained action and the almost ritual formality of the sphinxlike tiger forcibly remove it from mere imitation of nature and stamp it as an expressive symbol. Conceived perhaps as lifesize, the bronze is memorable in its impact and presence. Barye's tiger is somehow more perfect, more heroic than nature, and his gavial is more sinister.

In *Salon de 1831*, Gustave Planche wrote of *Tiger and Gavial:*

> There is a rage in this voracious tiger, and suffering in the crocodile that feels its fangs. Yet I would reproach Barye for smothering the life of these animals beneath a multitude of details minutely reproduced. I would like it a hundred times better were its details fewer. . . . The complication of the . . . execution gives the work an inevitably dry and hard character.[2]

It is likely that these critical observations led Barye to work in a less detailed style almost immediately, as in the two miniature relief plaques dated 1831, *Walking Leopard* (*Fig. 62*) and *Walking Panther* (*Fig. 71*). This simplified style reached a superb culmination in the design of the relief *Lion of the Zodiac* of 1835–40 for the July Column (*Fig. 25*). Planche's remarks, however, did not dissuade Barye from continuing to work in his decoratively elaborate style, such as that of *Elk Hunt* (*Fig. 128*) and many other small bronzes of the 1830s.

One example of the refinement of Barye's expressive modes in works of the 1830s is the way he imbues feeling in the tiger, which is more subtle than in his drawing *Tiger's Face*, with its enormously enlarged demonic eye (*Fig. 158*). The giant eye is a crude symbol similar to the hypnotic, melodramatic gazes of Henry Fuseli's lunatics and visionaries. Barye no doubt knew the art of Fuseli, who was often praised as a brilliant professor of painting by his colleague John Flaxman, whose engravings Barye studied avidly. But Barye's delicately controlled expression of feeling separates his art from the more primitive and often sentimental manner of such later eighteenth-century romantics as Fuseli. One recalls Mme de Staël's pointed advocacy of expressing nuances of feeling and avoiding violent extremes. From the romantic point of view, the bronze was a sensation at the Salon of 1831. For

Delacroix, as he would later record in his journal, merely the sight of such exotic creatures could engender a sense of emotional transport.[3] Also intrinsic to *Tiger Devouring a Gavial* was a moral level of interpretation, as an image of the awesome animal violence in nature. One recalls in particular the moralizing interpretations of Bernardin de Saint-Pierre, Mme de Staël, and Victor Hugo.

Predictably, the critic Etienne Delécluze voiced a typical academic rejection of Barye's animal protagonists in his review of the Salon of 1831. For Delécluze, *Tiger and Gavial* existed in a "less elevated mode" than imagery of the human figure. His was simply the traditional notion of the relative merit of various subjects in art, animals ranking low on the scale, along with still-lifes, as presumably the least challenging to an artist. Nonetheless, the sheer excellence of Barye's sculpture also led Delécluze to judge it the "strongest and most significant work of the entire Salon."[4]

As for the popular accessibility of its meaning, *Tiger and Gavial* apparently remained too exotic for the Parisian Salon audience. Its evocations of Indian jungles or perhaps of the tradition of French trade connections with India, which long had rivaled those of the famous British East India Company, were hardly at the center of public attention in 1831. In a sense, Barye's sculpture was too scholarly, too arcane, too remote from the topical and from established academic values. As for a possible political meaning, one might strain to find in *Tiger and Gavial* a vague analogy to the recent revoluntionary struggle of 1830. Yet the exclusively satanic tone and protagonists of his sculpture were politically inappropriate. Nonetheless, the vigorous reactions of the Salon reviewers to *Tiger and Gavial* thrust Barye into the limelight of the Parisian artworld, launching his career and attracting the notice of men who would become his chief patrons of the 1830s: the young Duke of Orléans and his father, King Louis-Philippe, the Bourgeois Monarch.

Barye's drawings toward 1830 allow a glimpse of his elaborate preparatory method. Like that of Leonardo or Michelangelo, his was now a classical approach, with the final image based upon many compositional sketches and preliminary studies of isolated motifs or anatomical details. This very elaborateness of method may reflect Barye's desire to create a Salon masterpiece in his monumental *Tiger and Gavial*, a work capable of firmly establishing his reputation. There is even an aspect of scientific pedantry about Barye's method, a distinctly academic tendency toward an ostentatious display of knowledge. His approach sustained the tradition of eighteenth-century empiricism, but it lent his forms an even greater degree of precision, an unmistakably positivistic quality of emphasis.

One drawing of the series made from nature, *Feline Predator Feeding* (*Fig. 156*), captures the silhouette of a recumbent feeding tiger, its head raised and drawn slightly backward, its forepaws extended to pin its prey, the long lines of its neck, rump, and tail arranged in a similar, angular configuration. Related anatomical drawings of the flayed musculature and the skeleton of a dissected tiger (*Fig. 155*) are discussed in connection with *Tiger Devouring a Stag*, in Group 4.

Barye's scholarly study of the unusual gavial crocodile, a creature never again to be depicted in his sculpture, is documented by the partial references to zoological works in the album in the Lucas Collection, as George Heard Hamilton pointed out.[5] On folio 6v, the heading "dimensions du petit gavial" accompanies a measured drawing taken directly from

Daudin's *Histoire naturelle... des reptiles.* On folio 11r are references to a "histoire des reptiles par Daudin" and to a "memoire de Cuvier sur les crocodiles . . . cahier des annales du muséum d'histoire naturelle," which may refer to either of Cuvier's scholarly works of 1807 and 1808. Hamilton suggests that Geoffroy Saint-Hilaire's essay of 1825 on the gavial also may have been known to Barye.

A representative selection from Barye's many crocodile studies in the Lucas Collection album follows. A drawing of the strange baseball-like snout of the gavial with frontal, lateral, and dorsal views appears on folio 4r. Measured contour drawings of the crocodile's foreleg, jaws, and hind leg appear on folio 3v. Contour studies of complex areas of the hide's pattern—at the joining of the legs and body, at the top of the head, and in the ridges and pointed fins along the tail—are on folios 4v, 5v, and 6r. Measured contour drawings of the body and skull shown in lateral and dorsal views appear on folios 5r (*Fig. 157*), 12r, 11r, and 17r. Two tonal drawings apparently were made for a painting, one of the hide pattern and another of the entire creature shown as though swimming in a tank, on folios 10v and 19r. Three pages of elegant contour studies of tropical plants, probably made in the Jardin des Plantes, appear on folios 12v, 13r, and 14r. They are related to the low-relief pattern of scattered vegetation on the base of *Tiger and Gavial* and also may be related to the exotic landscape settings of some of Barye's watercolors.

A small Egyptian bronze, *Alligator Deity* (*Fig. 215*), may have provided Barye with an antique precedent. Of course he preferred a romantically satanic mood to the stateliness of the ancient bronze. A crocodile also appears on an Egyptian turquoise scarab in the Caylus Collection (vol. 4, pl. XIII: I).

Lion Crushing a Serpent (*Figs. 23 and 24*) was shown as a plaster in the Salon of 1833.[6] An awesome, snarling lion pins a serpent with its forepaw. The head of the serpent is drawn back, its jaws open in challenge, as though in the moment before it would strike. Barye captures a charged second in this encounter, an instant of nearly human reflection. It is a moment rendered dramatic by its contrast with the irrational rush and frenzy of the struggle that will follow. The lion's nervous alertness is vividly conveyed in details like the sympathetic, partial extension of the claws and the position of the tip of the tail. The energy and tension of the coiled serpent echoes in the folds and whorls of the lion's pelt. The rippling, rhythmical surface of the bronze is alive with excitment. The lion's face is so expressive that it must be regarded as a masterpiece of Barye's early maturity. This sculpture would remain unsurpassed in its balance of finely articulated feeling, wholly convincing anatomy, and decorative richness of modeling, texture, and line.

The monumental lion is essentially relaxed in its seated position, as though merely toying with the serpent. In a curious way this glance dramatizes the vulnerability of the lion's eye itself: the serpent could strike that eye in one flashing thrust. The relaxed posture of this lion is radically different from, say, the violent exertion in *Panther Attacking a Civet Cat* (*Fig. 20*). This narrative moment is more finely attuned and more subtly orchestrated.

In *Lion Crushing a Serpent* meaning is conveyed at several levels, although its primary concept no doubt was intended to flatter the July Monarchy. Significantly for the primary meaning of Barye's bronze, toward 1832 and 1833 there arose a climate of widespread

discontent with the very government the Romantic Revolution had helped to install in power. One artistic example of the bitter opposition to the July Monarchy is Honoré Daumier's satirical lithograph for the journal *La Caricature* of 15 December 1831.[7] In Daumier's print, "Louis-Philippe as Gargantua" devours items of graft while he defecates special privileges. His remarkable extreme of contempt for the crown earned Daumier a fine of 550 francs and imprisonment for six months. In this context of criticism, Louis-Philippe's circle supported Barye's unusual sculptural imagery. In contrast with Daumier's Gargantua, Barye's royal lion connotes only positive traits, the lion as a symbol of strength, courage, and fortitude.

The specific link of Barye's bronze with the revolutionary days of July 27–29, 1830, and thus with Louis-Philippe's accession to the throne of France, occurs in the traditional imagery of the astrological Houses of the Zodiac. Leo and Hydra, shown as a lion and serpent on celestial navigation maps, were the constellations that ruled the heavens during the revolutionary days of July.[8] Thus Barye's bronze symbolized the celestial impetus and sanction given the triumphant struggle of the July Revolution and hence to the rise of Louis-Philippe. The dynastic Orléanist reference was easily understood by its French audience, and Barye's innovatory handling of the two constellations transformed them into a romantically stirring combat of wild animals.

The source of Barye's metaphor is mainly visual. *Christ-Child as King (Fig. 216)*, one of John Flaxman's illustrations of Dante's *Il Paradiso*, combines the very images of triumphant kingship with the constellations Leo and Hydra. Flaxman's Hydra is also shown as a vanquished Serpent of Evil, precisely the meaning of Barye's allegorical serpent pinned beneath the royal lion's paw. Furthermore, the infancy of this Christ-King would connote the early state of the July Monarchy under Louis-Philippe, its promise and potential. Dante's text also offers an appropriate parallel: In it he recounts the birth under the sign Leo of the illustrious Cacciaguida, who opens a "golden age" in the history of Florence, just as the creation of the July Monarchy would do for France. Thus Flaxman's illustration and Dante's text provided Barye with the astrological, moralizing, and dynastic bases for his allegory of royal triumph. (Another Flaxman engraving, *Thetis Entreating Zeus to Honor Achilles*, reinforces the impact of these two constellations upon Barye, for Leo the Lion and Hydra the Serpent both appear in the upper background of this illustration for Homer's *Iliad*.)

The plaster original was purchased from the Salon of 1833, cast in bronze at the king's request, and reexhibited as a bronze in the Salon of 1836 as one of the few works given the *carnet* citation "(M.d.R.)—les commandes ordonnés par le Roi." Thereafter it was installed on a terrace in the garden of the Tuileries Palace. In fact, the purchase by the crown, the casting in bronze, and the conspicuous placement were fateful events in Barye's career, for they came to symbolize an official acceptance of animal sculpture as a major artistic mode. These events angered the academically oriented critics and provoked the jealousy of Barye's artistic competitors, even providing a target for the barbs of the political opponents of Louis-Philippe. Barye's notoriety in the Parisian art world was established by the vicious criticism leveled at this bronze. Gustave Planche asked sarcastically, "How is it possible that the Tuileries has been transformed into a zoo?" An anonymous writer said, "Imagine using the Gardens for a menagerie! —Only the cage is missing!" Victor Schoelcher noted an "odor

of the menagerie." Perhaps the most mindless thrust of all was aimed by a safely anonymous writer who said, "Barye's type of [animal] sculpture had developed because it was so easy and so popular."[9]

With an eye to Barye's decoratively elaborate realism, the critic Charles Lenormant objected to an "overworked impression" in *Lion Crushing a Serpent*. While he admired the artist's laborious attention to "all the details of the hide and fur," he was "continuously distracted by minutiae." Similarly, setting the tone for Lenormant's remarks, Planche had already written of *Tiger Devouring a Gavial* in 1831: "I would reproach Barye for smothering the liveliness of these animals beneath a multitude of minutely reproduced details." Of course these observations disparaged a major decorative dimension of Barye's bronze, in its effect not unlike the elaborate detail of an engraving by Dürer. *Jaguar Devouring a Hare* (*Fig. 29*), shown at the Salon of 1850, comprises a mockery of these ever-handy recipes; although the jaguar itself has a powerfully simplified, rolling development of surface, the domical forms pointedly set off the exquisite linear detail and texture of the hare's pelt. That is, the contrast of an accented miniaturism of surface detail was fundamental to its total expressive concept. With respect to the earlier bronze, *Tiger Devouring a Gavial*, Planche simply did not understand that its restrained action was intended to abet the sense of a reflective, humanized mood in the tiger. He ascribed the stillness of the group to a wrong cause—an overburden of surface detail—and thus missed its expressive point.

The rich surface texture of Honoré Gonon's lost-wax cast of *Lion Crushing a Serpent* is essentially a linear one, with subtle transitions recorded in the movement from intaglio or graphic combing to the positive, projecting ridges and tufts of the pelt. Large whorls enliven several simple planes, as at the left shoulder and the lower midback of the lion. Over the base, surface texture is more fluid and knobby, and line is used only as an occasional accent.

Barye's early interest in organizing designs by means of regular geometrical units is apparent in the use of two perfectly vertical planes for the front and left sides of the focal image of the lion's head, and in the strictly triangular form of the sculpture's silhouette when seen from the left front or right rear (cf. *Fig. 111*). Within this triangular silhouette, a parallelogram occurs in the negative form described between the lion's forelegs and between the base and the underside of the chest and throat. The foil to this is the silhouette entirely of flowing arabesques when the work is viewed from the right front or left rear. A dramatic tension between the two types enlivens the design.

Several original drawings related to this bronze are extant. A page of studies of a toying lion (*Fig. 159*), is basic to the monumental conception. The lion at the botton center takes a mirror reversal of the pose of the bronze, with the lion's head lowered slightly and the paw of the weight-bearing foreleg placed just ahead of the hind paw. Similar in drawing and bronze are the nearly vertical frontal plane of the lion's head and the rolling, arabesquelike contours of the tail, haunches, back, and shoulder. Even the shape of the patch of vertical bristles atop the shoulder is indicated in the drawing. At the right, in a slightly smaller drawing is a second motif of the monumental design—the sideward tilt of the lion's head, which brings the plane of its left side into a nearly perfect vertical line, repeating the verticality of the front of the head, as on the bronze. The direct relation of this page of

drawings to the monumental group and to two small bronze versions—those with the serpent pinned beneath the lion's forepaw and beneath its hind paw—documents their intimate conceptual connection. It is as though the great difference of scale was a conceptual irrelevancy for Barye at this moment in his career, and it affirms the interdependence of his miniature and monumental designs.

The scientific basic of Barye's masterful command of the lion's anatomy is well documented. Escholier cites a brief note written by Delacroix to Barye on 16 October 1828: "The lion is dead—Come at a gallop—It is time to get to work." Evidently the two artists took part in a dissection of a recently dead lion.[10] Furthermore, the inscription *lion du cabinet*, on an exquisite measured contour study, *Skeleton of a Lion* (Walters Art Gallery, 37.2167),[11] documents Barye's study in the Cabinet d'Anatomie Comparée, established in Paris in the late eighteenth century by Baron Georges Cuvier.

Two measured drawings of a snake's head (Walters Art Gallery, 37.2125B) record lateral and dorsal views directly connected with the snake of this bronze group. In the lateral view several aspects are like the bronze: the angle of the opened jaws, the triangular web of tissue at the hinge of the jaw, the undulant line of the tongue, the number and spacing of the teeth, and the size, placement, and contour of the eye. The dorsal view shows the long ridges linking the eyes and nostrils, the narrowing of the throat behind the hinge of the jaw, and the tapered shape of the head.

A Bronze Relief for the July Column

The first concept entertained for a monument in the Place de la Bastille was radically different from the classical form of the July Column (named for the July Revolution) that was eventually constructed there under the July Monarchy between 1835 and 1840. A colossal elephant was long contemplated as the central image of the monument, and in the early documents its setting was regularly referred to as a fountain. In fact, an elephant image was actually constructed of wood and gesso, somewhat in the manner of a sculptor's model for a colossal bronze. Visible near the Place de la Bastille for many years, the huge elephant enjoyed great fame.

Among the early documents is a letter to the architect, Mr. Alavoin, dated 2 October 1816, seeking official permission to view the elephant from within its guarded enclosure.[12] The request was made on behalf of an "American family" about to depart from Paris for the United States. The family expressed "great curiosity" about the elephant fountain. Some years later, a request for an official visit by one Comte de Hauterine was recorded, suggesting that the appeal of the colossus was by no means limited to foreign tourists.[13] Whimsically enough, among the preserved documents there is a proposal to embellish the colossal elephant, offered by one Mr. Bruner fils, that would place a lighted gas torch in the tip of the elephant's trunk.[14]

Exposed to the weather for years, the elephant model deteriorated badly. In August 1833 Alavoin proposed to the Director of Civic Buildings a scheme to preserve the plaster model by giving it an oil coating, which also would lend it the color of a bronze.[15] In light of the

model's deterioration and the staggering cost of so large a bronze, a Mr. Denis suggested that it be constructed of mortar and cement.

As late as December 1837, some two years after the official decision to abandon the elephant fountain idea, Joseph-Henri-Jean Bonnamy fils proposed a complex scheme to use the still-standing elephant and to accompany it with four other giant pachyderms—a rhino, a tapir, an urodonte, and a hippo.[16] In his enthusiasm for the elephant fountain, Bonnamy would have all five pachyderms carry elaborate, decorative obelisks on their backs, creating one of the spikiest silhouettes in all of Paris. These beasts, he explained, were to be understood as symbols of French enterprise in various colonial territories, from Algiers to Madagascar to the Dutch East Indies. Indeed, his literary program had a remarkable flexibility, and one suspects that Mr. Bonnamy revealed too clearly a taste for expediency as an official habit of mind, of the sort that led to the coining of the epithet Bourgeois Monarchy.

The long-cherished elephant fountain was finally set aside by the Municipal Council of Paris on 2 April 1835, and a new cenotaph function was decreed for the monument to be constructed in the Place de la Bastille. King Louis-Philippe and his architect, Joseph-Louis Duc (1802–79), chose to raise a new column to commemorate the citizen-revolutionaries who fell in the revolution of July 1830. The remains of the heroes were translated to the July Column cenotaph on 18 April 1840.

Lion of the Zodiac (*Fig. 25*) was the relief chosen as the focal motif in the program of the July column, and at least three reasons can be adduced for this choice. First, a well-known classical tradition reaching back to the early Greeks associates lion images with tomb decorations, perhaps as generalized symbols of the courage of the deceased. Second, the lion is appropriate to the memory of those who fell in late July, for that period falls under the aegis of the constellation Leo. The official archival documents, in fact, refer to a "Lion of the Zodiac," and Barye symbolized this meaning in the star-studded, equatorial band of the path of the sun through the Houses of the Zodiac, rising across the background of his lion relief. Third, Barye and Duc were impressed by an engraving of an ancient Roman tomb crowned with a colossal lion relief, which the July Column reflects.

Duc's concept of the July Column is similar to the imperial Roman cenotaph-columns of Trajan and Marcus Aurelius and to the more recent Colonne de la Grande Armée of Napoleon. In each, a colossal shaft rises from a rectangular mausoleum chamber. Duc's colossal July Column thus returns to the earlier Napoleonic mode of Barthélemy Vignon's Church of the Madeleine and to the Arc de Triomphe de l'Etoile by Jean-François Chalgrin. The July Column is a prime example of the cultivation of the imperial monumental tradition pursued by the Bourgeois Monarchy. The same impulse led Louis-Philippe to sponsor François Rude's colossal relief for a pier of the Arc de Triomphe from 1833 to 1836. Rude's *Departure of the Volunteers of 1792* was a thinly veiled reference to the Romantic Revolution of 1830.

Duc departed from both the ancient and the Napoleonic imperial precedents, however, by not using a helical narrative relief to decorate the column. He substituted for this the motif of four collars encircling the shaft at regular intervals. The horizontal lines and

rhythmical force of these four rings culminate in the great drum at the base of the monument, a drum like the podium of an ancient round temple in its scale and proportions, and even in the profile of its cornice. Duc's collared column echoes a favorite motif of sixteenth-century mannerist architects, such as Giulio Romano, Palladio, Serlio, and Ammanati. Other precedents were seen on royal architecture in Paris: the columns of Philibert de l'Orme's Tuileries Palace, and those of several of Nicholas Ledoux's Toll Houses. Duc also predicts Lefuel's use of the collared column motif on the quai façade of the New Louvre in the 1850s, a design conceived in an imperial spirit for Napoleon III.

The decorative collars divide the shaft of the July Column into five drums, or fields. The tallest of the three are smooth rather than fluted, providing a surface for the inscribed names of the fallen heroes. A florid scrollwork fills the collars with low-relief embellishment, and Barye's *Lion's Head Bosses* punctuate the collars. In movement and feeling the arabesques call to mind the bronze frieze on the plinth of Verrocchio's *Colleoni Monument* in Venice.[17] In keeping with such Italianate or Renaissance overtones, the lion's head bosses suggest Andrea Pisano's bronze doors for the Baptistry of the Florence Cathedral.[18]

Antique motifs traditionally associated with tombs and sarcophagi are the garlands on the faces of the rectangular base of the July Column and the strigilation of the background behind Barye's *Lion of the Zodiac* relief. Classical Roman stone-cut letters form the commemorative inscription on the tablet above the lion and the names of the fallen on the column's shaft. Barye's lion relief itself has a specific source in Bartoli's engraving of an ancient Roman tomb near Tivoli (*Fig. 217*), a tomb illustrated in the anthology *Gli antichi sepolchri ovvero mausolei Romani et Etruschi* (Rome, 1768). The actual lion relief from Tivoli, carved in marble and measuring about five by nine feet, today is housed on a landing of the great stair of the Palazzo Barberini in Rome. Since the Roman lion strides toward the right, not toward the left, as in Bartoli's engraving and Barye's relief, it is clear that Barye and Duc saw the engraving. The ancient relief is similar to Barye's in that the head of the lion tilts outward from the background plane at roughly a thirty-degree angle; the lion's near legs are brought forward, while the farther legs are toward the rear. The Roman lion's head is boldly modeled and is only slightly compressed in its lateral dimension, again like Barye's. A charmingly mannered, baroque restoration has been made to the right hind paw and the tail's tassel. In fact, Barye scrupulously avoided the baroque stylization of the lion's mane shown in Bartoli's engraving, rather like a powdered periwig, in favor of a more veristic handling. The roaring look of the open mouth and the narrowed opening of the eye are similar in Barye's relief and in the Roman lion. Only the position of the rear legs of Barye's lion is reversed, in keeping with the system of nearly parallel lines by which he organized not only the lion's legs but also the band of the zodiac.

As a source for the July Column, Bartoli's engraving has significance for both the sculptural decoration and the architecture of the monument. In the engraving the Roman tomb is crowned with a colossal relief of a walking lion uncannily like Barye's in its elevated and focal placement and in the direction of its movement. In Barye's relief the horizontal confines of the frame above and below the animal nearly touch it, exactly as on the antique precedent. Their closeness to the lion lends a sense of compression to the vertical dimension of the design, a dramatizing touch heightened by Barye's omission of

the vertical frames just before and behind the ancient lion. The result of this design manipulation is an expanding baroque spatial effect before and behind the lion, vividly aiding the sense of its smoothly continuous movement, a feeling contrary to the static, contained quality of the ancient relief. Within this baroque sense of continuing action, there is a peculiarly nineteenth-century emphasis upon nearly photographic verism. The lion seems to be restlessly pacing along a narrow ledge in its cage, about to leap into the real space of the spectator.

The placement of the ancient lion relief, at a level just above the ground story, is similar to the relation of Barye's lion relief to the circular podium of the ground story of the July Column. Duc simply substituted this drum for the triumphal arch of Bartoli's engraving. He also inverted the arched line across the top of the lion relief in the engraving, transforming it into a suspended garland. He replaced the spiral volutes at the corners of the relief with traditional French symbols, Barye's *Coqs gauloises.* Barye's lion relief decorates one face of a cubic cenotaph chamber, from which rises the inscribed shaft, precisely the relationship of cenotaph and column in the columns of Trajan and Marcus Aurelius.

As for the authenticity of Bartoli's "ancient" tomb design, it is revealing that he described the tomb as "now destroyed," precluding any verification of his engraving. In fact, he claimed several drawings by the seventeenth-century artist and architect Pietro da Cortona as the source of his image. Bartoli thus managed to shift responsibility for authenticity onto the shoulders of a long dead but reputable artist. In the engraving a considerable disjunction of style separates the lion relief and the triumphal arch of the ground story. And of course the size of the human figures standing in the arch, relative to the lion relief, is radically inaccurate. Bartoli expanded the lion relief to nearly three times its actual size, with a Piranesian dash of romantic grandeur. Possibly he synthesized two unrelated drawings of antique fragments into this enormous, imaginary structure.

A comparison of the relief *Lion of the Zodiac* (*Fig. 25*) with the miniature relief *Roaring Lion* (*Fig. 63*) reveals a reversal of the leg positions and an alteration of the *Roaring Lion*'s rather stylized, parallel vertical lines governing the far forelegs and lower hind legs. Barye now arranges these lines as gently converging diagonals, with a more veristic final effect. Yet a rolling arabesque, like the outline of *Roaring Lion*, is still vivid in the upper contour, reaching from the nose to the tip of the tail. The trunk of the monumental lion, however, is more rectangular than that of the miniature, and the muscle groups of the shoulder and ribcage areas are flatter. The domical, flexed muscles of the miniature are absent, and there is a new sense of physical tension in the lines and cords of the striding lion's legs and paws. The motif of the edge of the mane bristling like a brush around the curve of the top and front of the shoulder is similar on both lions. An almost twofold increase in the relative size of the silhouette of the lowered head and shaggy mane creates a far heavier, more menacing creature in the monumental relief.

A small sketchy contour drawing of a stalking lion (*Fig. 160*) offers a delightful and acute analysis of the stance of the animal seen in motion, inching its way down an incline. Despite the varying degrees of formality and naturalism among Barye's several lion portrayals, all retain the intensity and power of this quick contour drawing. The stride pattern of the bronzes, however, in every case emulates the formal, ancient prototypes rather than the

naturalism of this drawing. This lion's raised, bent forepaw, stopped for an instant while walking, and the high tail are so naturalistic as to heighten our awareness of the ritual gravity of Barye's *Lion of the Zodiac.* This drawing of a lion in motion is an important complement to the antique images of *Striding Lion,* such as the carved cameo and the small bronze in the Caylus collection (*Figs. 218 and 219*).

Dissection drawings were surely undertaken for this and for the related allegory, *Lion Crushing a Serpent* of 1832 (*Fig. 23*), also a "Lion of the Zodiac" image. The suite of lion drawings was made from zoological specimens or displays, showing various stages in the dissection of examples of both genders. Now dispersed, the group can be reconstructed from drawings in the Walters Art Gallery, in the Louvre, and from several published by Roger Ballu in 1890, the present locations of which are unknown.

Three pages of drawings are mainly studies of lions' heads. One page, inscribed *Lionne de l'Amiral Rigny* (*Fig. 161*), is exquisitely precise and supplemented with measurements. It shows the lateral and dorsal views, with the flesh still on the skull. Considerable redrawing is evident about the eyes, possibly since they were closed in death and thus unsuited to Barye's taste for a dynamic, fearsome predator. The proportional intervals of the muscle groups around the eyes and the bridge of the nose are recorded with a surgical accuracy.

A second page of drawings, *Lion's Head* (Walters Art Gallery, 37.2037A), is inscribed with measurements not only of arithmetical intervals but also of the basic angle of the intersection of the planes at the top and front of the skull. The two lateral views show the jaw both open and closed and the relationship of the contour of the skull and mandible to the external conformation of the flesh, rather like an X-ray photograph.

On the third page, the lateral views of a lion's head (Walters Art Gallery, 37.2219) stress the outer contours, with some hesitation around the eye. Possibly this page is preliminary to the more elaborate one on the first page, a study intended to gain mastery over the general form of the head. At the right of the page is a diagrammatic, structural analysis of the claw-retracting mechanism of the paw, a system of pivoted connecting links, like a machine. This delicately precise drawing is accompanied with measurements.

A fourth page, inscribed *Lion de l'Amiral Rigny* was published by Ballu in 1890. It records the appearance of the flayed animal, presented in terms of its larger masses of skeletal muscle and its simplest shapes. Even the measurements are those of the larger proportions and dimensions, rather than particular areas or details of anatomy. This drawing is an objective record of factual data and is almost devoid of expressive concerns.

A fifth page, also inscribed *Lion de l'Amiral Rigny* and published by Ballu, shows the animal with its head lowered onto its forepaws rather than raised in the air, as on the preceding page. The muscle masses are delineated with a planar quality, an abrupt relief-like projection strongly reminiscent of Barye's style in 1831, as in the tiny relief *Walking Leopard* (*Fig. 62*). Barye goes beyond a notation of visual data with his heightening and simplification of modeling and contour into the abrupt and angular forms of the drawing. An expressive style transforms the character of the drawing into that of the tiny sculptural relief. Style in this drawing contrasts with that of the preceding page, and even with the cursory quality of the small sketch at the upper right of this same page, confirming an expressive function, despite the presence of many measurements.

A sixth page is an exquisite pencil drawing inscribed *Lion du cabinet* (Walters Art Gallery, 37.2167).[19] It records the skeletal conformation and numerous dimensions of the specimen in a more abstract and quantified way than the preceding studies. The numerous measurements noted in ink are in part presented in a formal table at the upper right. Surgical precision, coupled with artistic elegance, marks the contour drawings of several views of the skull—lateral, frontal, and dorsal—arrayed like a formal zoological plate.

A seventh drawing, inscribed *la tête de la lionne* (Louvre, RF 4661, fol. 20r), records the entire skeleton in profile view with numerous measurements. It includes all of the ribcage, the complete shoulder, hip, and leg structures, and the skull with jaws opened. On an overleaf Barye lightly traced the schematic outlines of the skeleton, as though by holding the page against the light, and recorded more measurements, including a formal table at the upper left and even the detail of a section through one vertebra.

The eighth drawing presents views of a lion's hind leg, shown half-flexed and in profile, and a lion's foreleg, shown frontally (Louvre, RF 8480, fol. 13r). It shows the legs in exactly the same position and is drawn in precisely the same style as the monumental *Lion of the Zodiac*, with that very measure of rectilinear simplification of contour and blocky planarity.

A Great French Saint

Saint Clotilde (*Fig. 26*), a monumental marble carved from 1840 to 1843, was created for the first chapel on the right in the Church of the Madeleine. Saint Clotilde (475–c. 545) was Queen of the Franks and a daughter of Chilperic, king of the Burgundians. As the wife of King Clovis, she was responsible for his conversion to Christianity. Upon the death of Clovis, she retired to a monastery in Tours. Saint Clotilde and King Clovis were buried in the Church of the Holy Apostles, on the site of the present Panthéon in Paris.

Wearing her royal crown, Saint Clotilde stands with a downcast gaze, as though looking toward worshippers in the chapel below. Hers is a mood of sadness, of reflection, even a poignant sense of restrained restlessness or unease—a psychological richness well embodying Barye's capacity for understatement and for the lyrically beautiful. With her left hand she dreamily fondles a cross worn at her neck. Her right hand crosses her body at the waist to touch the folds of her cloak gathered about her hip. Such qualities of mood were realized in Barye's tiny portrait medallion reliefs of the 1820s (*see Fig. 2*), and they would remain viable for him some thirty years later. The compelling psychology of *Saint Clotilde* stands in the great tradition opened by Donatello's *Prophets* for the Campanile of the Florence Cathedral. Apparent, too, are the outward resemblances to types in ancient Roman sculpture and to works of Raphael and Ingres.

The stance of *Saint Clotilde*, the arrangement of her arms, and even her dreamily sad mood occur in the ancient Roman sculpture *Julia, Daughter of Augustus*, which Barye recorded on three album pages (*see Fig. 221*). The first page, of two side views (Louvre, RF 8480, fol. 32r), captures the larger, simple shapes of the classically proportioned figure and the fall of its drapery. The second page, of two more completely frontal views (Louvre, RF 8480, fol. 31v), explores more intricate drapery contours and imparts a notably taller, more

slender canon of proportion. The third version (*Fig. 162*) is extremely attenuated and manneristic in its tall, willowy body and tiny head and hands, and it delineates simpler, more unified drapery. The latter drawing is the most economical of line and the most delicate in touch and feeling of the three pages of studies. It evokes the special aura of elegance and restraint present in the marble.

At the upper right of the same page is a tiny contour outline of a standing female figure. It actually comprises two separate, fragmentary studies of the figure, not a single, continuous one: a study of the head and shoulders and a slightly displaced (to the right) study of the waist, hips, and legs. Barye translated these notations of contour and proportion into his three-dimensional plaster model *Standing Female Figure* (Louvre, RF 2219, h. 22 cm; Louvre *Cat.*, 1956, no. 98, pl. VII). These forms are also closely related to the style of the nudes of his Three Graces group (*Fig. 144*). The position of the left arm is higher in the sculpture than in the drawing, however. This assimilation of an ancient Roman sculpture to Barye's developing concept of Saint Clotilde is an example of the interdependence of his miniature and monumental designs.

In contrast with the third, ethereal version of *Julia, Daughter of Augustus* (*Fig. 162*), a fourth related drawing lacks its special elegance but shows a similar pose, documenting Barye's study of this ancient type. To judge from the inscription on the album page, this drawing of a standing female figure (Louvre, RF 6073, p. 16) was made after an illustration of a fresco at Herculaneum. However, it shows a different, more matronly woman, one rather thick of waist, a far cry from the almost Botticellian figure in the third drawing. Furthermore, the fresco figure wears a shawl that billows out in the wind, rather than a cape drawn tightly across the front of the body, thus differing substantially in costume from the Roman sculpture.

The costume of the ancient marble *Julia, Daughter of Augustus* (*fig. 221*) reveals the figure's relaxed left leg and largely obscures the right leg within a vertical, columnar mass of drapery. Over this is drawn an outer cape, given a rising, diagonal hemline, which passes over the knee of the engaged leg. Barye lowered this diagonal hemline in *Saint Clotilde* so that it actually touches the ground. His decision omits the ancient motif of a light fabric pulled taut across the body. Instead, the cape in *Saint Clotilde* is longer, fuller, and heavier. In its quality of line and rhythm, its special opulence of form, the gathered cape suggests certain drapery designs of Raphael's later period *Tapestry Cartoons* and his *Saint Cecilia* altarpiece.

The unusual motif of a spherical weight attached to the hem of the cape worn by Barye's Saint Clotilde, directly below the right hand placed at her hip, appears in two small studies of drapery (Walters Art Gallery, 37.2227B). The weight in the hem, suspended directly beneath the hand that gathers and supports the drapery, points up the beautiful fall of the cape. The classically ideal facial type of *Saint Clotilde* occurs in a tiny but elaborately modeled drawing of a Raphaelesque head of a woman (Louvre, RF 6073, p. 66). The simple oval form of the face, the hair parted at the center of the forehead and drawn to either side in undulating lines, the classically continuous line of the ridge of the eyebrow and the bridge of the nose, the cupid's-bow lips, and the spherical tip of the chin appear in both drawing and sculpture. The same facial type and hair style appear in the drawing *Seated*

Female Nude (Louvre, RF 6073, p. 51); it is closely related to Barye's small bronze goddesses (*Figs. 144–147*), another link of his miniature and monumental forms.

The precise clarity of the face of Saint Clotilde and the almost too delicate pose of her hands are similar to the works of Ingres toward 1840. Ingres's exquisite *Portrait of Comtesse d'Haussonville* (New York, Frick Collection) uses this same ancient stance and arm position. A lyrical drawing by Ingres, the standing nude *Stratonice* of c. 1839 (Tours, Musée des Beaux-Arts), also uses the ancient arrangement of the arms as they were in the sculpture *Julia, Daughter of Augustus*. Since Ingres was an eminent academic artist in France, the influence of his contemporary works must be regarded as significant for Barye.

Apart from the effectiveness of its mood, *Saint Clotilde* has an exaggerated differentiation of textures: the austere neoclassical purity of the face and hands; the shimmering, insistent, mechanically rhythmical texture of the knit blouse; and the slightly rumpled, sailcloth look of the cape gathered before the body. The heavy crown, somewhere between the sort worn by Charlemagne and that of an ancient Tyche, is set upon a filmy, diaphanous cowl, taken from the vocabulary of Fra Filippo Lippi and Botticelli. One explanation of these marked qualitative differences in the marble—surprising differences in light of Barye's sensitivity to nuances of surface and texture in his bronzes—is that their exaggeration counteracts the gloom of the badly lighted niche in which the figure is placed. In that setting, and viewed at the usual distance, perhaps only an overstatement of such textures would be legible.

Animal Images for the Tuileries Garden and the Jena Bridge

Seated Lion (*Fig. 27*) shows the lion holding its head high and drawn back slightly.[20] Its forepaws rest side by side, in a stance at once wholly natural and elegantly hieratic. It has a pose almost like the ritual poses of ancient Egyptian sphinxes and the cat deities in the Caylus Collection. Yet Barye's taste for naturalism lends the animal a vivid sense of alertness and a romantically engaging quality of nearly human reflectiveness. An aristocratic mood suffuses its mask, one distant, slightly disdainful, perhaps sad. The subtle understatement of this feeling enhances the impact of the boldly monumental design, which seems to rise and expand as it moves upward, as though to take full advantages of its large scale.

The clarity of *Seated Lion*, together with the economy and gathered force of its textural contrasts, would fulfill the precepts of the theoretical treatises of Emeric-David.[21] Gustave Planche preferred this *Seated Lion* of 1846 to Barye's earlier *Lion Crushing a Serpent*. In his 1851 article in *Revue des Deux Mondes*, Planche pompously assured his readers that Barye's earlier lion was merely facile, while the later one was monumental. He asserted that in the later work the sculptor "understood" the "necessity to divide the image into large masses."[22]

Despite Planche's wish to contrast the two lions as a demonstration of Barye's artistic maturation, a modern viewer is more intrigued with their resemblances. The internal stylistic evidence, and that of several drawings generic to both designs, suggests that the supposedly late lion in fact may have been nearly contemporaneous with the design of 1832. Only subtle touches of simplification in the mask of *Seated Lion* and in the slightly balder quality of the texture of its pelt argue in favor of a later date. The archival documents cited

by Lami as proof of its commission in December of 1846 can no longer be retrieved. Possibly they only record payment for the casting in bronze of a long-extant sculptor's model—one created in the mid-1830s but passed over in favor of casting the politically significant *Lion Crushing a Serpent.*

A photograph of the plaster model for *Seated Lion*, published by Janneau,[23] reveals that the profile contours—the back, haunches, belly, shoulder, and mane—are conceived in the flowing, arabesque-contour mode of *Roaring Lion* (*Fig. 63*), a style definitely of the 1830s.

Other evidence in favor of an early date for *Seated Lion* exists. A profile drawing, *Head of a Lioness* (*Fig. 161*), formed part of the suite of dissection drawings inscribed *Lionne de l'amiral Rigny,* used for both *Lion Crushing a Serpent* of 1832 and *Lion of the Zodiac* of 1835–40. This profile is almost precisely that of *Seated Lion*, except for a slightly greater depth in the distance between the top of the skull and the bottom of the jaw, possibly a change related to the difference of gender in the bronze. The contours, proportions, and the motif of the drooping line of the mouth are otherwise identical. Only the decorative form of the male's shaggy mane was added.

A second page of early drawings (Louvre, RF 6073, p. 41) is generic to both the monumental *Seated Lion* and the small bronze *Seated Lion, Sketch* (*Fig. 116*). (An early date for this page is signaled by the profile view of *Egyptian Buffalo*, its stance typical of many of Barye's animal images of the late 1820s and early 1830s. This species of buffalo appears as the hunter's bait in *Lion Hunt* of 1837 [*Fig. 104*]). Along the right margin are three studies of a seated lion. The uppermost of the three is a profile view, with the lion's head drawn back and raised quite high, much like the formal, nearly Egyptian pose of the large *Seated Lion*. The slightly arched contour of the lion's back is captured in the hesitant, interrupted lines of the sketch, as is the echoing play of the mane contours at the back and top of the lion's head and in the cascade of fur at the front of its chest. The second study is a frontal view, with the lion's head turned somewhat further to the left than in the monumental *Seated Lion*. The asymmetry of the drawing is repeated in the lion's hind legs, for the left is drawn further forward and sideward than the right. These touches strongly suggest a lion recorded while in motion. The lowest study of the three is a profile view, similar to the small bronze *Seated Lion, Sketch*. The lion's gaze is intently forward, its neck extended and head low. Altered to a still more perfectly horizontal line than that of the drawing is the upper contour of the lion's mane. This horizontal is echoed in the shorter contour of the lion's mid-back. In the drawing both these contours are set parallel, if not perfectly horizontal.

With respect to internal stylistic evidence, the lush cascade of the mane in *Seated Lion* is conceived in a manner like the mane in *Lion Crushing a Serpent*. In addition, a swirling pattern of intaglio lines flows over the pelt of the late lion, as it does over the lion of 1832, although Barye made this pattern shallower in the later form. Still, the smoother pelt in *Seated Lion* could be the result of the ravages of weather and the acid pollutants of the heavy traffic along the Seine. Of course a subtle measure of simplification is also apparent in the absence of the raised lozengelike forms about the snarling lips and nostrils of the early lion. Perhaps this particular change can be linked with the different mood of the protagonist, rather than with the style of a later period.

A certain simplification of surface is apparent in *Seated Lion*, but it is hardly great enough to mark it incontestably as a work of a decade later than *Lion Crushing a Serpent*. It is a design feasible for Barye in the mid-1830s. Barye's two bronze lion sculptures were displayed at the same *quai-side* of the Tuileries Palace garden, their proximity no doubt underscoring the logic of their similar styles.

Colossal Eagle Reliefs (*Fig. 28*) were created as decorations for eight piers of the Jena Bridge in Paris. These striking, heraldic designs were completed in 1849 and served, in their enormous scale, as a fitting finale to the decade Barye had begun with his monumental public commission, *Lion of the Zodiac*. Technically, the eagles are mechanical enlargements and reversals made after original sculptor's models in plaster. They are cut into the projecting ends of several large pieces of ashlar masonry, which are cemented into and continuous with the masonry courses of the bridge.

The symbolic eagles have open wings and carry giant laurel wreaths as though wedged between their wings and bodies. In their talons are stylized thunderbolts, patterned after the ancient Eagle of Zeus types. Beneath the thunderbolt is a fluttering ribbon or banner, a Roman motif of the sort Donatello and Mantegna often used. Despite the heraldic character of the reliefs, Barye's mastery of nature is apparent in the zoological plausibility of the feather patterns and textures, especially around the head, body, and legs.

In an ancient oil lamp decoration, illustrated in Bartoli's *Le antiche Lucerne sepolchrali figurate* (Rome, 1729), a small bronze *Eagle of Jupiter* looks sideward, holds its wings open, and grips a stylized thunderbolt in its talons, as does Barye's. Another image in Bartoli's anthology shows an eagle with open wings carrying an imperial portrait bust (*Fig. 222*), an image of apotheosis and precisely the miniature source Barye would translate to monumental scale for his apotheosis pediment for the Sully Pavilion of the New Louvre. The decoration on another oil lamp in Bartoli's anthology provided a model for Barye's lyrical small bronze *Recumbent Greyhound*.

A page of Barye's studies of an eagle (Louvre, RF 6073, p. 53) treats the underside of the eagle's open wings in three separate drawings, capturing the principal shapes of the wings and the order of their several strata of feathers. A second page (Louvre, RF 6073, p. 49) shows an eagle with its wings fully opened (lower left); half opened (upper left center); fully closed, with the eagle preening its left wing (upper left); and three faint sketches of the profile, frontal, and three-quarter views of the perching bird with open wings (right center). At the right of the page is a drawing of one arched bay of a bridge, clearly not the Jena Bridge, emphasizing a large keystone in the arch and pilasterlike masses of quoins in the piers at either end of the bay. Perhaps the accented keystone was considered by Barye early in the Jena Bridge project as an alternate location for his *Colossal Eagle Reliefs*. Rather than a bridge, perhaps the latter image represents an arched window head, like those of the recently refurbished façade of the Old Louvre Palace, where such keystones were heightened with beautifully carved grotesque masks. The masks clearly had an impact on Barye's conception of his group of ninety-seven *Decorative Masks* (c. 1851) for the nearby Pont Neuf.

Two Diverse Works for the Salon of 1850

Jaguar Devouring a Hare (*Fig. 29*) was shown in plaster in the Salon of 1850.[24] With a romantically compelling gruesomeness as well as zoological accuracy, the jaguar bites into the entrails of the living hare. This is a quiet instant after the frenzy of pursuit, the moment before an agonizing death. A low triangle contains the silhouette of the group, and the base also has a wedgelike form, its highest point beneath the head of the jaguar. This serves to elevate the focal motif of the feeding jaguar's face. Textures are elegantly differentiated and contrasted: the bushy pelt of the hare, the soft smoothness of the jaguar, and the flinty, prismatic aspect of the rocky base, its austerity relieved with passages of combed or raked hachure. Over the jaguar's body, the muscles are given a dense, spherical, flowing quality, with deeply incised lines used sparingly as accents to clarify a particular muscle or ligament and to lend a calligraphic punctuation to the roll and flow of its form. Unifying elements are the repeated arched contours of the jaguar's neck and the hare's body, which echoes the rolling spiral of the jaguar's tail; the repeated angles of the hare's ears and forelegs; the alternation of the jaguar's extended and retracted forelegs; and the parallel lines of the jaguar's right forepaw and the hare's left hind leg beside it.

The drawing *Feeding Feline Predator* of about 1830 (Baltimore Museum of Art, Lucas Collection, Barye Album, fol. 26r) closely resembles the bronze, for it shows the low crouching position of the jaguar as it bites its prey, the flailing arabesque of its tail, the forepaws alternately extended and drawn back, its belly on the earth, and both hind legs drawn in under the flanks. Only the arch of its back needs to be flattened and the line of the base tilted for the drawing to duplicate the bronze.

The position of this large jaguar is much like that of the small bronze *Jaguar Devouring a Crocodile* (*Fig. 21*). A comparison of the two indicates that the smaller predator is modeled more simply, as a series of spherical masses largely without the elegant, enriching play of linear accent so sensitively used in the design of 1850.

Well received in the Salon of 1850, *Jaguar Devouring a Hare* moved the eminent critic Théophile Gautier to write:

> With what feline voluptuousness this ferocious beast pins in its powerful paws the poor, trembling hare, which, its ears laid back and its eye round with terror, awaits the *coup de grâce*! Its back arches, its lips draw back, shivers of pleasure run over its skin like ripples in water; its muscles start, its whole being revels in the orgasm of cruelty about to be enjoyed. . . . Mr. Barye does not treat these beasts from a purely zoological point of view. . . . He exaggerates, he simplifies, he idealizes the animals and their deal of style; he has a fiery fashion, energetic and bold, in fact like a Michelangelo of the menagerie.[25]

A fascinating cast of this design, from the technical point of view, is in the Louvre (RF 1553). The several, separately cast bronze elements are attached only by means of screws, and the seams have not been hammered over and disguised, thereby revealing Barye's method of subdividing the total form to facilitate its casting in bronze.

Theseus Combating the Centaur Biénor (*Fig. 30*) was shown in plaster in the Salon of 1850.[26] Only Ovid names the centaur Biénor in recounting the Battle of the Lapiths and Centaurs, and he gives a vivid description of the centaur's death. In *Metamorphoses*, Book XII, Ovid tells how Theseus rode on the back of Biénor during the battle, holding it by the hair and killing it with the blows of his club. The rugged Theseus, clearly divine and invincible, calmly sits astride the helpless centaur, his left hand pressing the side of the centaur's head and neck, inducing a paralyzing pain. The centaur's agony is well conveyed in his spasmically extended foreleg and his unforgettable grimace. Theseus' right arm and club are raised for the death blow to the centaur's forehead. The motif of Theseus' left hand pinning the head and neck of the centaur is taken from Giambologna's monumental marble *Hercules Killing Nessus* of 1594 (Florence, Loggia dei Lanzi).[27]

This large variation upon a small sketch created roughly ten years earlier, *Lapith Combating a Centaur* (*Fig. 106*), introduces striking changes. The new form depicts Theseus with a classical canon of proportion, very different from the unreal attenuations and distortions of the earlier Lapith. The first version has a ragged, isolating quality of silhouette, an outline that tends to expand horizontally. Replacing this is a vertical, regularized design, carefully built upon the ancient Greek Golden Section. It is organized by the strictest mathematical grid yet seen in the art of Barye, surely an ultimate gesture in the academic direction, well complementing the classically normative naturalism of the hero.

The design of the base also has been altered considerably from the earlier version. Much taller and more planar, it is brought up closer to the belly of the centaur, compressing the negative form between those elements to a smaller dimension. Rather than a large opening to punctuate the composition, isolating the figure from the base, the effect now is to draw both together, almost with a relieflike sense of continuity. The branches of evergreen accent the center of the base and introduce a spiky rhythmical motif, echoing the stylized tufts of the centaur's hair. The rhythm of the strata of the rock repeats that of the swag of drapery and the folds of flesh at the centaur's waist. They repeat the angles of certain elements of the centaur's raised foreleg and counter with right angles the line of his extended foreleg. The general flow of the rocky base leads the eye toward the front edge, where the rising line leads to the focal area, the head of the anguished centaur.

Barye's submission of an enlarged animal combat on the pattern of his concepts of the 1830s, together with the large Theseus group to the Salon of 1850 as his only sculptural entries surely amounted to a final assertion that his romantic animal imagery was worthy to stand beside conventional academic subjects. His choice of monumental scale for both designs is also meaningful, a reflection of his sense of himself as a *sculpteur statuaire*.

Salon critics predictably were responsive to the touches of academic polish and precision lavished upon the Theseus group. Albert de la Fizelière would go so far as to say he had not seen a stronger work in the entire Salon of 1850, includng Barye's own *Jaguar Devouring a Hare*. In his appreciation of the Theseus group, Gautier dwelt at length on an analogy with the Phidian sculptures of the Parthenon,[28] but he did not view the Theseus as the finest design of the Salon, thus maintaining his position that the romantic imagery of Barye was finally the most significant.

A bronze proof of this much-admired academic design was installed at the crown of the

Monument to Barye, erected by American sponsors in 1894, on the Ile Saint-Louis, on the Boulevard Henri IV.[29] Interestingly, the designer, in consultation with the patrons, surely, placed *Theseus Combating the Centaur* highest in the registers of the monument, higher even than *Lion Crushing a Serpent,* a more innovative work by far. This constitutes an unwitting acceptance of the conventional academic hierarchy of subject matter in art, which had led critics to view Barye's animal imagery as "less elevated" than that of the human figure. Thus Stanislas Bernier's monument ironically enshrines not Barye's real artistic contribution, but rather the entrenched, preconceived scale of values that he battled against throughout his career. It is a monument to academic values in the guise of a monument to Barye. Properly, the places of the two bronzes should be reversed.

The principal artistic sources are discused under *Lapith Combating a Centaur (Fig. 106)* in Group 9. Beyond those earlier sources, the new measure of realism that replaces the spherical, stylized musculature of the earlier centaur may reflect an awareness of the stone copies after bronze centaurs, ancient works in Rome's Museo Capitolino of precisely the same scale as Barye's.

The timing of the appearance of both the animal and mythological combat groups in the Salon of 1850 suggests that they may have been intended as allegorical references to the February Revolution of 1848. The allegorical precedents offered by Barye's *Lion Crushing a Serpent* and *Lion of the Zodiac* as symbols of the July Revolution of 1830 were surely of moment to the official circles that advocated this purchase of two of Barye's designs for France.

Faces as Arabesques for the Pont Neuf

Decorative Masks (Figs. 31 and 32), an extensive series in stone created (c. 1851) for the cornice of the Pont Neuf, are a delightful surprise in Barye's late work.[30] Ignored in previous critical discussions of the artist's work, they are astonishingly rich and impressive, easily one of his most imposing late works. Placed as bosslike accents at the bases of volute brackets or consoles beneath the continuous horizontal line of the cornice itself, the masks are set roughly one meter apart, the full length of both sides of the bridge. (The strongest masks are those near the *Henri IV Equestrian* by François Lemot.) Sensitively adjusted to their location beneath a volute, the masks are composed of clusters of volutelike arabesques, moving freely in three-dimensional space. It is as though the rolling but constrained motion of the volutes continues within the forms of each mask, where it is amplified and elaborated and where it may now erupt as a curling lip, an arching brow, a ringlet of hair, or the coil of a satyr's horn.

The masks remain within the realm of decorative fantasy. Occasionally they possess a light, restless quality of animation, like certain stucco arabesques in the interiors of rococo *hôtels.* Yet their embellished forms also betray Barye's unerring mastery of the skeletal structure and intricate muscular anatomy of the human head. See, for example, the drawing *Flayed Human Head* (Walters Art Gallery, 37.2332B), which documents his study of a cadaver, or a head from an illustrated handbook. It is as though the challenge to capture

49

the delicate modeling and structure of a portrait mask, which had concerned Barye in the 1820s and 1830s, has been transformed from the dimensions of a coin to the scale of architecture, and this transformation has been paralleled by a change in the feeling of the work, from the delicacy of early Mozart to the intensity of late Beethoven.

In terms of the evolution of Barye's late style, and of the inner balance or relation of its varied trends, his contemporary *Jaguar Devouring a Hare* is similarly bold and forceful, but it conveys a different sense of grandeur and majesty in its restraint—a mood that perhaps served to counterbalance the playful frivolity, even the extravagent drama of some of the masks. As well, the sense of line moving boldly in space, that of the powerful interaction of hollows and projections in the masks, builds upon but transcends the baroque spatial vigor evident in the late *Eagle Taking a Heron (Fig. 100)*.

The endless fecundity of arabesquelike variation and the high level of artistic quality in the masks suggest parallels in the art of Picasso or Matisse, virtuosos at creating variations on a theme, or in the dizzying number of variations upon the motif of the seated figures that fill Michelangelo's Sistine Chapel ceiling. Among the cast of characters or types Barye assembles are *Christ, Buddha, Hercules (Fig. 31)*, a *Triton, Bacchus, Medusa*, a *Gargoyle*, the fabulous *Flower-Petal Demon (Fig. 32)*, perhaps from a Gothic drollery, *Oceanus, Silenus*, a mustached *Goth*, horned satyrs, and several leering Satans. Ancient Assyrian and Babylonian motifs, even Balinese dragons and Japanese Noh-play masks, are among the more exotic sources emulated.

The masks embody a consciously orchestrated array of emotions and moods, ranging from the lyrical and even silly through dreamily reflective types, quizzical ones, and those in the grip of terror and rage. In general, however, the masks are ponderous in mood, and their main vocabulary is that of the romantically demonic and grotesque. Precedents are Charles LeBrun's engravings of different physiognomical types, an elaborate effort of academic systematization. The engravings were no doubt known to Barye, whose acquaintance with seventeenth-century art was both extensive and sympathetic. Another source Barye found in the stylized heads of Gods, Giants, and Titans in John Flaxman's engravings for Hesiod's *Theogony* (Plates 34–36), especially in their strongly outlined eyes and lips, and the linear masses of their hair.

The special quality of surface and design in the masks strongly suggests that the originals were quickly achieved in clay, from which cast-plaster positives were made. From these, the final stone masks were carved by assistants using pointing machines and power drills.

In place below the cornice of the bridge, the masks have a bold impact. Their stark registration is heightened by the baldness of the surrounding ashlar masonry surfaces. Interestingly, this is an effect just the opposite to that of Lefuel's façades of the New Louvre, which melt and shimmer under their burden of flickering arabesques, their encrustations of decorative relief. On the Pont Neuf there is a clear, almost harsh focus upon the masks, whereas on the New Louvre there is a proto-impressionist haze, a painterly dissolving of clear structure and hard plane.

Probably Barye sought a certain unity in his masks with those in the nearby ground-story windows of the Old Louvre Palace, just a few hundred yards from the Pont Neuf. Installed as keystones in the arcuate window heads of the quai and Rue de Rivoli façades, the Old

Louvre masks are identical in scale to Barye's and may have inspired his series, although they are much flatter in plastic treatment and are solely satyr types. Furthermore, they do not possess the range of invention, source, and mood evident in the Pont Neuf masks, or their fullness and largeness of handling.

MONUMENTAL SCULPTURES FOR THE NEW LOUVRE

When Emperor Louis Napoleon's chief architect, Louis T. J. Visconti, died almost at the outset of the New Louvre project, his charge was given over to Hector Martin Lefuel (1810–81). Lefuel awarded Barye not only four stone personification groups, but two Naponeonic pedimental reliefs as well, one in stone and one in bronze. *Napoleon I, Equestrian, in Coronation Robes*, the four personifications for the Cour du Carrousel—*Strength, Order, War*, and *Peace*—*Napoleon I Crowned by History and the Fine Arts*, and *Napoleon III as an Equestrian Roman Emperor* (Figs. 33–44) were Barye's major state commissions of 1854–62.

Emperor Napoleon I, Equestrian, in Coronation Robes (Fig. 33), a presentation model in plaster and wax, is inscribed *Vu et approuvé Visconti* and can therefore be dated to 1853, the year of both the project's onset and Visconti's death.[31] The handsome, slender, short-haired Napoleon of the glamorous paintings by Jacques-Louis David and Antoine-Jean Gros sits regally upon his spirited steed. The lines of the horse's arched tail, tightly curved neck, and the particular angles of its raised legs are dynamic in their contrast with the stable pyramid of the seated Napoleon. The slowness of the horse's pace is conveyed in the angles to the horizontal of the two planted legs, which tilt inward as though captured precisely at a moment of balance, rather than one when both are pressing rearward, as with the mount of the youthful Napoleon in *General Bonaparte* (Walters Art Galery, 27.161).

The emperor wears a crown of laurel and a short, high-collared cape of ermine around his shoulders. Upon the cape is displayed the great chain and medallion of the Legion of Honor. Beneath the ermine is a long, heavy embroidered cape, the outside of which has an overall *rinceaux* pattern of arabesques; the lining is accented with tiny, widely spaced fleurs-de-lys. Napoleon holds a tall scepter crowned with the Imperial Eagle in his raised right hand. The base of the scepter rests on his right thigh. The gesture of the arm holding the scepter is distinctly reminiscent of the slightly more casual pose of Edme Bouchardon's bronze *Louis XV, Equestrian* (1757–63, destroyed 1792).[32] Perhaps the Louvre collection of some one hundred and seventy drawings made by Bouchardon in preparation for his *Louis XV* was placed at Barye's disposal. Also in the Louvre were a number of artists' drawings after the ancient *Marcus Aurelius* in Rome, and probably Marcantonio Raimondi's engraving of it, which reflects the same proportional relation of a large rider to a small horse. If Napoleon were to stand beside his mount, he would be as tall as its ear, a distinctly unreal scale relation. Barye knew this ancient convention of proportion, as his drawing *Phidian Frieze of Riders* (Fig. 163) from the Parthenon demonstrates.

The uniform coating of wax applied to this plaster model appears to have been added after the fact, since the plaster itself was brought to a very high level of finish. Possibly the wax was intended only to impart the appealing color of a small bronze to the white proof. Yet surely a water-base pigment or a varnish would have lent it such color without masking the innumerable details incised into the plaster, such as the horse's precisely braided mane, for example, which is completely obliterated by the layer of wax. Most of the wax would likely have been removed, had Barye given the work its final refinement. An earlier model apparently exemplifies this technique, *Elephant and Rider* in the Louvre (RF 1578: h. 69 cm), a fragment of the more intricate *Tiger Hunt* group of 1836. The plaster elephant-model is virtually free of wax except for the embroidered hem of its saddle blanket. The latter appears as a uniform layer of wax applied to the plaster, its intricate relief pattern cut with the aid of a stencil. Barye's equestrian model of 1853 thus demonstrates a preliminary stage in this method of creating finely detailed surfaces, one prior to the final cutting of pattern and texture.

Although no documentary evidence has come to light, probably Visconti's notion of the place of Barye's projected equestrian in the decorative scheme for the court of the New Louvre was not shared by his successor, Hector-Martin Lefuel, and thus the commission was never carried out. In fact, Barye's neglect of the final refinement of detail in the outer layer of wax on the model also suggests that other projects were of greater urgency.

It is interesting that Barye's *Napoleon* bears an inscription to the effect that it was approved by Visconti, who had designed the Tomb of Napoleon in the Church of the Invalides in 1842. His career was thus symbolically linked with the Napoleonic legend, a fabric of traditions that Napoleon III carefully sustained and embellished during the Second Empire. Indeed, Barye would design two Napoleonic pedimental reliefs between 1854 and 1861 for Louis Napoleon's ambitious New Louvre project, works probably substituted for this equestrian. It is possible, in light of the absense of documents citing this specific equestrian, that Visconti actually viewed the work in the present, partly finished state, rather than as the master bronze Barye might next have made, and that Visconti inscribed his approval during his last days, without having completed the official contract.

Four Personifications for the Cour du Carrousel

Strength, *Order*, *War* and *Peace* (*Figs. 34–41*) represent the great duties of the nation, the government, and the citizen, in a way similar to the program of personification figures devised for the porch of the Pantheon by Quatremère de Quincy about 1792.[33] A parallel to that concept of the Napoleonic period would be in keeping with Napoleon III's embellishments of the Napoleonic legend.

Today the stone personification groups in situ on the pavilion façades of the New Louvre are dirty and badly eroded. Hence the discussion here focuses instead on the well-preserved plaster casts of the early sketches (Louvre RF 1579–82; h. 26–28 cm), images first made of clay, and upon the bronze casts of the presentation models (h. 1 m) made by Barbedienne.[34] The bronze proofs discussed were given to the city of Baltimore by William T. Walters, and

were installed in Mount Vernon Square about 1886. They accurately duplicate Barye's plaster presentation models (Louvre RF 1558–61), used as the basis for the final stone enlargements installed on two pavilion façades of the Cour du Carrousel. Thus the bronze casts in Baltimore are referred to as models in the ensuing discussion.

Each personification group comprises an adult male, a young boy, and an animal, as well as several lesser attributes. Barye's use of an animal as the chair or throne of all four figures has important precedents in the French translation of Cesare Ripa's *Iconologie* (1644), a standard reference since the Renaissance. The lion, in fact, provides a throne for two personifications in Ripa: *Clémence* (2: 114), and *Magnanimité* (1: 132) (*Fig. 225*), just as does the lion of Barye's *Strength*.

At the level of style, all four preliminary sketches (h. c. 26 cm) differ significantly from the models (h. 1 m) in that they have quite Mannerist exaggerations of posture and attenuated proportions. The sketch of *War* (*Fig. 38*), for example, displays an arrangement of the fingers in the focal motif of its right hand with a preciousness and overrefined elegance typical of *maniera* designs of sixteenth-century Italy. The final models of the four personifications temper such excesses and reflect instead a classical canon of proportion and an appropriate restraint of feeling and movement. The latter qualities are surely related to the impact of Barye's close scrutiny of the *Borghese Mars* (*Fig. 164*) and a plaster cast of the Phidian *Theseus* (*Fig. 165*).

Strength (*Figs. 34 and 35*), the germinal figure in the series, actually holds the key to the entire ensemble, for Barye conceived them as a series of formal variations upon the ancient *Seated Hercules* and the related, Hellenistic *Seated Boxer*. It obviously displays the attributes of Hercules—the club and the lion—and takes his seated posture. It recalls the medieval moralizing tradition of *Hercules as Fortitude*, so well exemplified on the carved pulpits of Nicola and Giovanni Pisano. Renaissance emblems sustain this tradition, and the lion as the attribute of a Virtue appears in several Ripa medallions: *Vertu de corps et de courage* (2:83) is actually shown as Hercules with the lion, boar, and club; *Raison* (1:166) as Minerva, leads a bridled lion; *Raison d'éstat* (1:166), again as Minerva, pets a tamed lion; *Valeur* (1:192–93) caresses a lion. Even a temperament, *Le Colérique* (1:52–53), is personified as a striding male nude with a sword and lion. Finally, the virtue *Magnanimité* (*Fig. 225*) is seated upon the back of a recumbent lion in the same relation of animal attribute and human figure seen in *Strength*.

Another source for Barye, also reflecting the moralizing tradition, was the colossal plaster, *Strength as a Seated Hercules* (c. 1792) by Guillaume Boichot, the neoclassical sculptor. It was one figure in the ensemble of allegorical sculptures called for in Quatremère de Quincy's program for the porch of the Panthéon: *La Force sous l'emblème d'Hercule*.[35] Probably Barye also knew the small bronze of Boichot's design, first exhibited in the Salon of 1795.

The sketch of *Strength* (*Fig. 34*) depicts the humorous mood of the young boy, who looks like a street urchin barely able to conceal a smirk. His mood and easy stance are altered in the final model (*Fig. 35*) to ones reflective yet alert, changes lending gravity and decorum. The angles of the limbs in the sketch of *Strength* are sharper than those of the model,

although Mannerist attenuations are apparent in the long thighs of this preliminary figure. The drapery thrown over the left forearm in the sketch is omitted from the model, and the club tilts outward more sharply in the model. The boy's hair stylization is like the tousled locks of the boy in *Order*, rather than the classical Greek headband and tight snailshell curls in *Strength*. The lion, watchful but tranquil, stretching its neck as it looks out from behind the figures, apparently conveys a potential for awesome strength and courage, rather than an overt demonstration. The plinth is octagonal and displays an intricately developed rocky base, placed upon it as a second stratum, which provides a sculpturally effective support for the feet of both figures.

Order (*Figs. 36 and 37*), the second of the first pair of personifications, also offers a Christianizing moral level of meaning that parallels the idea of Hercules as Fortitude. The left hand of Order rests upon the hilt of a sword with a cruciform pattern, symbolically pointed at the heart of the subdued tiger. The cruciform sword, in fact, is ritually presented to the viewer, much as a priest might present the cross for veneration. The sword is clearly not used as a weapon. Interestingly, the cruciform sword is omitted on the final stone enlargement of the design and on the bronze reductions of the figure offered in three sizes in Barbedienne's catalogue of 1893, an omission perhaps betraying a misunderstanding of its iconographical significance or exhibiting a secular distaste for its Christian implications. Of course, other reasons for the omission may obtain: perhaps the stone enlargement was damaged, and perhaps the small bronze sword was omitted to forestall its easy theft. The snarling tiger in the sketch of *Order* (*Fig. 36*) is serpent-like, suggesting a medieval dragon of the sort beneath the feet of the triumphant Saint Margaret on the right wing of the *Portinari Altarpiece* by Hugo van der Goes (Uffizi) or in Raphael's *Saint George Killing the Dragon* (Louvre). Even the hair stylization of Barye's *Order* is Gothic rather than antique. A tiger lies at the feet of *Sévérité*, the virtue of Purity or Correctness, as a symbol of vices overcome, surely an appropriate precedent in the French version of Ripa (2:170).

Order is seated upon the back of a subdued tiger, its vicious jaws still agape and threatening, as Order cooly pins its neck to the ground, under heel. The mood of the figure is a classical reverie, recalling the *Spear Bearer* of Polyclitus. The figure suppresses chaos with the sureness and ease of an absolutely powerful divinity. The striking motif of the tiger's gaping jaws is much larger in the sketch, underscoring its origins among medieval dragons. The tiger in the model is altered with a classically suitable measue of zoological exactitude.

A young boy rests against Order's right hip, which is covered by a swag of drapery. The boy holds a book in his lowered right hand and places his left foot upon two other books. His gaze is downcast, not so much in a mood of sadness as in one of reflective contemplation, perhaps amplifying the point of the books as attributes. The placement of his feet echoes the composition of Michelangelo's princes for the Medici Tomb.

The plaster sketch (*Fig. 36*) shows the essentials of the poses of the final model (*Fig. 37*), but in the sketch man and boy are more Mannerist in their attenuated proportions, and their gestures are rigid and sharp. Fuller classical proportions and more smoothly harmonious angles are developed in the final model, recalling those in Barye's drawings of the

Borghese Mars (*Fig. 164*) and the *Phidian Theseus* (*Fig. 165*). The plinth of the model is octagonal, with touches of an irregular landscape surface in the shallow mound beneath the boy and below the right foot of Order.

War (*Figs. 38 and 39*) introduces an alert mood, although one tempered by a classical quality of restraint. The figure reaches toward his sword in a scabbard at his left side while he looks off into the distance toward an enemy on his right, a motif of directly opposed rotating movements reminiscent of Michelangelo. Virtually the same twisting torso and opposed thrusts also occur in an ancient small bronze *Male Nude* (*Fig. 223*), which Barye knew in the Caylus collection. Even the contrast of one nearly extended leg with the other flexed leg, also used by Barye, complements the directly pertinent upper body and arm arrangement of the small bronze. Typically, Barye's form is a mirror-image reversal of the ancient source. Also echoing Michelangelo is the narrative idea of the *War* group, the notion of a resting soldier responding suddenly to the warning that the enemy is near. This is in the spirit of Michelangelo's projected fresco *Battle of Cascina* for the Palazzo Vecchio in Florence, intended for the wall opposite Leonardo's *Battle of Anghiari*. In keeping with the mood of alarm, the boy of Barye's group trumpets vigorously, and the recumbent horse looks keenly outward, one foreleg already extended as though it were about to scramble to its feet. Yet *War* also implies a sense of potential, perhaps of a victory already attained and not merely the action of an ongoing battle. War's great helmet is on the earth, a trophylike symbol, just beside the alerted horse's head, and he wears the victor's crown of laurel. Significantly, for a notion of potential, his sword is still undrawn.

In the sketch of *War* (*Fig. 38*) the angles of the composition are more abrupt and are more jarringly related than in the final model. The boy's trumpet-holding arm is a reversal of the right arm of War, that arm reaching to unsheath the sword, but the pointed elbows echo each other exactly. The boy's stance suggests the neoclassical, heroic convention for adult male figures, seen in the art of David and Fuseli and in the center of François Rude's monumental relief *Departure of the Volunteers of 1792*, 1833–36, for the Arc de Triomphe de l'Etoile. Rude's central figure of a boy, like Barye's still-younger *putto*, wears only a helmet and thus remains an essay in the ideal nude. The boy's stance was known to Barye even in a lyrical work of antiquity, *Boy with a Goose* (Louvre), carefully recorded in his drawing (*Fig. 166*). Typically, Barye's figure is a reversal of the ancient *putto*. The base of the model of *War* omits the octagonal plinth seen in the first pair of personifications, using instead an irregular, rocky landscape form. The preliminary sketch, however, retains the octagon as the lowest level of the base, just beneath the abbreviated landscape.

The contrasting compositions of *War* and *Peace* suit their opposite themes. *War* has a swirling, horizontally expansive aspect, while *Peace* has a pyramidal form, a stable harmony.

Peace (*Fig. 41*) suggests the lyrical figure of Paris as a shepherd in the forests of Arcady above Athens, leaning upon his crook as he sits upon the back of a recumbent ox and listens to the music of the flautist *putto*. The *putto* recalls images of satyrs, playing the ancient double pipe. A comparison with the sketch of *Peace* (*Fig. 40*) which more clearly reflects

Barye's artistic sources, reveals the putto to be based upon the satyr-*putto* standing beside Michelangelo's *Bacchus* (Florence, Bargello), a figure munching grapes rather than playing the pipes. The resemblance in the placement of the legs, the strong rightward twist of the torso, and the position of the arms as they hold the flute is pronounced.

Barye altered the hunched posture in the sketch to a more naturalistic, reposeful, upright one in the model. The proportions of the sketch relative to those of the model are more attenuated and Mannerist, especially in the small size of the head. Clear in the sketch is the way the muscular back reflects the ancient *Torso Belvedere*, although in a reversed position, as was customary for Barye's quotations from ancient sources. The *Torso Belvedere* no doubt was an important source for all four of Barye's groups, just as it had been for Boichot's neoclassical predecessor, since it was a long-admired example of the ancient *Seated Hercules* type. Barye took the face of *Peace*, as well as its hair stylization and the downward tilt of its head, from the classical Greek athlete, such as the well-known *Resting Discus Thrower*.

The French translation of Ripa cites several ancient coins and medallions that symbolized peace. A medallion of Sergius Galba (1:140) shows an enthroned male figure, and Ripa likens his image to that of Hercules punishing the audacious and meddlesome. Thus it relates to the germinal *Seated Hercules* for Barye's four groups, and provides an important moralizing source.

The animal attribute in *Peace*, the domestic ox or bull, is a traditional symbol of the fertility of fields in times of peace. The ox or bull denotes the abundance of the earth in the famous allegorical relief of *Tellus* on the Ara Pacis of Caesar Augustus in Rome. There the seated personification figure, an earth-mother type, appears directly above the recumbent ox or bull, in the very sort of spatial relationship made still more compact in Barye's sculptural group. Barye knits the animal and human images into one, making of the ox a throne. Similarly, a seated male nude—in this instance Apollo—appears directly above two recumbent oxen, after the manner of the *Tellus* relief, in John Flaxman's engraving for Hesiod's *Days*, *The Happy Man*. For Barye to seat the nude male directly upon an ox was a simple change, after the pattern of several personifications in Ripa. Furthermore a moralizing interpretation of this creature occurs in a Ripa medallion of the Virtue *Fermeté* or Constancy (2:122). The base of the sketch of *Peace*, an octagonal plinth, is altered in the bronze cast of the model to a freer, less severely architectural form, in the mode of the abbreviated landscape-bases of Hellenistic sculpture.

The Apotheosis Pediment

Napoleon I Crowned by History and the Fine Arts (Fig. 42) is a stone relief created for the gabled pediment of the Sully Pavilion of the New Louvre.[36] This 1857 work is focal among the six monumental sculptures Barye produced for Hector-Martin Lefuel's façades, and it is the only one of Barye's two imperial reliefs to survive the destruction of September 1870 and May 1871, episodes in the Franco-Prussian War and the Paris Commune.[37] The theme of the relief is a prime example of the calculated elaboration of the Napoleonic legend typical of

the Second Empire propoganda of Napoleon III,[38] who sought to enhance the somewhat dim aura of his own regime by sharing in that of his uncle, the first Napoleon.

The condition of the documents related to Barye's pediment (*AN* F[21] 1750) suggests that they were hastily executed. Possibly this was linked with a need to meet the many stringent deadlines of the operatic dedication ceremony.[39] Louis Napoleon, emperor of the French, dedicated the newly expanded Louvre with solemn processions, declamations, and an evening banquet on 14 August 1857. The 15th of August was declared an imperial holiday. In a mood of great celebration, the theaters of Paris gave free performances, and the new buildings and gardens were opened to the public. It is difficult to believe, despite the evidence of the letters of contract, that a work of the scale and intricacy of Barye's pedimental relief could have been commissioned less than four months prior to the official dedication ceremony. The documentation, in relation to the norms of the commissioning and execution of such works, almost seems to be after the fact. Barye received final payment for the completed pediment on 11 June 1857 (*AN* F[21] 1750), little more than a month before the ceremony, and the initial letter of contract is only dated 2 March 1857 (*AN* F[21] 1749).

According to the contract, Barye agreed to create a model at one-third scale for the approval of the administration and to execute the final stone pediment by 30 April for the sum of 30,000 francs. The quarried stone was to be delivered to Barye. He would defray the cost of the model, but the props and scaffolds necessary for the execution of the stone pediment would be provided by the administration. Upon completion of the model, Barye would be paid 10,000 francs. A marginal note on the contract indicates that Barye would draw a second 10,000 francs when the architect felt the work was half-completed. A penalty clause, unique in the preserved Barye documentation, stated that a fine of 50 francs per day would be subtracted from the final sum if the pediment was not completed on time. Should the delay exceed three months, the administration would purchase the model for 10,000 francs. It would be free to charge another artist with its execution and would not be required to pay for any completed portion of the pediment. Upon acceptance of the completed pediment, the artist would receive the remainder of the 30,000 francs.

The subject of Barye's pediment is appropriate to its location on the central axis of the Cour du Carrousel, facing toward the Arc du Carrousel and the center of the Tuileries Palace façade (the palace was destroyed in May 1871). Official documents of 1857 (*AN* F[21] 1749) describe the pediment as "a bust of Napoleon I placed on a half-column, framed and crowned by two allegorical figures of *History* and the *Fine Arts*, with the attributes of each of the allegorical figures in the extreme corners of the tympanum."[40]

To this academic "machine" Barye imparted the somber aura of a shrine or tomb, a tone of ritual gravity wholly unlike the rococo frivolity of many of the motifs of Lefuel's façade below, such as the voluptuous Caryatids, the trophy cascades, and the attenuated female figures framing the oculi of the first story. By contrast, the apex of Barye's pediment holds a colossal bust of a laurel-crowned Napoleon I, recalling Roman funeral effigies. The rough proportions of a sarcophagus mark the central, projecting segment of straight entablature supporting his portrait bust. In addition, the seated personification figures are back to back, and their framing of a central effigy is much like that of *Times of Day*, which frame the

princes on Michelangelo's Medici Tomb. There are two apotheosis symbols in this pediment: The star at the center of Napoleon's forehead places him in the celestial realm, and his portrait bust is symbolically carried into the heavens on the back of an eagle with open wings (the eagle's head has since broken off). Thus Barye's pediment presents an apotheosis of Napoleon I and, by way of their dynastic connection, even an apotheosis of Napoleon III. The gravity of tone in Barye's pediment thus has several specific points of origin.

At the right of Napoleon's bust, a draped figure of *History* regards her book and accessory *putto*. (The right arm of *History* is broken, and only fragments of her right hand support her chin, in an Italianate gesture of pondering. The *putto's* right lower leg is also broken.) Beside *History* is a relief of her attributes, pieces of ancient armor, symbols of the military prowess of General Bonaparte. At the left of the emperor's bust, a figure of the *Fine Arts* strikes a *kithara*, her *putto* attentive to her music. On the low-relief background are kraterlike vessels, a tambourine, musical pipes, and a cornucopia, symbolizing the fecundity of the several arts. Small animal sculptures are prominent in each of the attribute reliefs, a copy of the ancient *Seated Boar* (Louvre) beside *Fine Arts* and a swan as the crest of a helmet beside *History*. These surely refer to Barye's earlier mode of small sculpture, just as they symbolize earth, air, and water, the all-encompassing expanse of Napoleon's empire.

Barye knew the antique apotheosis motif of a portrait bust carried on the back of an eagle as the relief decoration of an ancient oil lamp illustrated in Bartoli's *Le antiche Lucerne* (*Fig. 222*). Just as he had done with the *Colossal Eagle Reliefs* for the Jena Bridge (*Fig. 28*), Barye again transposed an ancient miniature source to monumental scale. He no doubt also knew the famous ancient marble *Apotheosis Portrait of Claudius* illustrated in Bartoli's *Admiranda romanorum antiquitatum* (Rome, 1693), where the eagle and portrait bust manifest the same iconographical tradition. In fact, Barye recorded the bust of Claudius in a drawing (*Fig. 167*) based upon another anothology, Lorenzo Roccheggiani's *Raccolta di cento tavole* (Rome, 1804).

Barye's female personifications are variations upon the traditional Venus and Cupid type, and they clearly resemble an emblem figure in the French translation of Ripa, a standard handbook of iconography. The Ripa medallion, *Charmes d'amour*, (*Fig. 226*) shows a seated Venus, her knees drawn up, playing a harp. Cupid stands at her feet, holding the bust of a deity before her. The bust held up by Cupid suggests the bust of Napoleon, and both are located on the central axes of their respective designs. *Charmes d'amour* and the Cupid bear a striking resemblance to Barye's *Fine Arts* with a *putto*. A *kithara* very like Barye's—in the complex scrollwork framing the strings—is held on the lap of a Muse in Flaxman's engraving for the *Iliad*, *Homer Invoking the Muse*, a figure Barye simply reversed for *Fine Arts*. (Flaxman varied his Muse a second time for Plate 22 of Hesiod's *Theogony*, but there gave her a simpler instrument.) Thus Barye cast his personification *Fine Arts* in the guise of a neoclassical Muse.

Other motifs from Ripa enrich Barye's personifications. The figure of History writes in a large book for posterity, and *une pierre carrée* is near her, doubtless a motif Barye merged with the cubic *cippus* of the pediment.[41] Yet Barye's borrowing was selective, omitting several elements of Ripa's figure of History—the large wings, the glance behind her toward

posterity, and the winged figure of Saturn carrying her book on his back as a sign of her triumph over Time. The motifs of the exposed left breast and the cornucopia in *Fine Arts* appear in Ripa's medallion *Paix* (1:138). The star in Napoleon's crown occurs in Ripa's medallion *Le Matin* (2:176), not as an apotheosis symbol, but as the Morning Star. A crown of laurel is placed on the head of a seated personification figure by a winged genius in Ripa's medallion *Rome Victorieuse* (2:142), precisely the action of several of Barye's early pediment drawings.

Barye's pediment is carried out in a flat, low-relief mode, in harmony with the restrained spatial impact of Lefuel's façade. The strictness of Barye's pediment, in fact, shows an overconcern with preserving a classical continuity of surface and a sense of rational order. Barye's severe style is the opposite to that of Lefuel's early project drawing for the Sully Pavilion pediment, which shows a cluster of figures bursting upward from the confines of the triangular tympanum, almost like a geyser, conceived in an expansive baroque style.[42] Yet within Barye's classical restraint there is a key neobaroque element, the rhythmical silhouette created in the darkness just beneath the raking cornice, where the heads of Napoleon and the Allegories, the attributes, and the *putti* gleam against the shadowy background.

An ultraclassical painting by Ingres provided Barye with another source: *The Apotheosis of Homer* (1827), a "grande machine" painted for the Salle Clarac in the Louvre.[43] The relation of Ingres's two seated female personification figures, *Iliad* with a sword and *Odyssey* with an oar, immediately suggests Barye's pediment, where the figures framing a *cippus* are similarly seated and back to back. On the temple pediment at the background of the painting is the motif of an apotheosis, a portrait bust being carried aloft by a soaring eagle. Barye merged the gabled pediment of the background with the two personification figures of the foreground in his pediment.

While the final form of Barye's pedimental relief focuses upon a portrait bust placed atop a half-column and flanked by seated personification figures, the drawings show that he considered at least four alternative compositional formats: (1) Napoleon as an enthroned Apollo, (2) Napoleon as a standing figure of Mars, (3) a medallion portrait of Napoleon, and (4) the final three-dimensional bust on a half-column. Most of the drawings are concerned with figurative imagery, for only three show the Palladian motif of a narrow pedimental triangle placed within a wider triangle.[44] Design fragments appear in the margins of the larger drawings, suggesting that more studies than the few now known were actually created for the project. Thus an exact sequence for the drawings remains elusive, but it is not as important as the interest of their record of the process of Barye's image selection, formation, and refinement. Both allegorical and purely visual concerns interact in the imagery of the drawings.

Napoleon Enthroned. Barye's drawing of the enthroned *Apollo-Napoleon* (*Fig. 168*) shows the emperor with an aureole and lyre, unusual attributes marking him the God of Light and Inspirer of the Arts. Symmetry is evident in the attendant groups of three figures, like mirror images at either side of the throne. In both groups two heads of seated figures are tangent to the raking cornice, and the head of the third figure is at the level of the knees of

the seated Apollo-Napoleon. The latter relationship allows a unifying, sweeping movement across the entire group. Two small triangles, roughly similar to the larger triangle of the gabled pediment, are created in the arrangement of the heads of the two groups of accessory figures, a strictly classical, internal reflection of the external limits of the composition. The group of heads, placed just below the raking cornice, predict that tenebrist effect in the final pediment, where the heads shine from the shadows, reminiscent of Caravaggio.

In contrast with the geometry of the triangles of three heads and the cubic throne is the rhythmical play of the rolling, undulant contours of the accessory figures across the lower half of the pediment. Their fluid, swirling motion calls up the painting of Rubens, and that "secret survival of the rococo" apparent in certain drawings by Géricault.[45] These figures also reflect the compact spacing and cursive outlines of the five seated Muses in Flaxman's frieze-like *Jupiter and the Muses*, an engraving made for Hesiod's *Theogony*. Their movements echo something of the neobaroque opulence of Lefuel's façade, as well.

Barye's enthroned musician-Apollo, flanked by symbolical accessory figures, stands in a long tradition of such imagery. This *Apollo-Napoleon* recalls the famous *Enthroned Zeus* of the west pediment of the Parthenon. That ancient image was emulated by Barye's teacher, the goldsmith Biennais, in his small relief, *Napoleonic Pantheon*[46] and was reflected in several recent paintings by Ingres: *Enthroned Emperor Napoleon* of 1806 (Paris, Musée de l'Armée), *Jupiter and Thetis* of 1811 (Aix-en-Provence, Musée Granet), and *Apotheosis of Homer* of 1827 (Louvre). An enthroned Zeus with a circular aureole about his head appears in no less than three engravings by John Flaxman: *The Council of the Gods* and *Zeus Sending the Evil Dream to Agamemnon*, both for the *Iliad*; and *Council of Jupiter, Minerva, and Mercury*, created for the *Odyssey*. Raphael's fresco *Parnassus* (Vatican) and Michelangelo's Medici Tomb (Florence, San Lorenzo) are two famous Renaissance variations of the image. Raphael's seated female figures at either side of his Apollo resemble the personifications of Barye's pediment, especially in the forced or pseudo-archaic frontality of their shoulders and torsos, so like that of Barye's *Fine Arts*. Michelangelo's *Notte* also displays such frontality of the shoulders, as well as the arrangement of the legs in Barye's *Fine Arts*.

Another type of enthroned figure that Barye considered derives from the image of Bacchus and Ariadne as it appears in the miniature sculpture for a terrine dish designed by Biennais and executed by goldsmith Jean-Charles Cahier.[47] One of Barye's versions of this format is the calm *Seated Embracing Figures* (Walters Art Gallery, 37.2258B),[48] in which both figures look toward their right as they embrace. This study might have provided either a foreground or background cluster of figures, if we assume that these obviously male and female figures would represent History and the Fine Arts. Another version of this motif is *Seated Embracing Figures* (Louvre, RF 6073, p. 20). Here the man and woman are seated almost back to back and turn vigorously toward each other for their embrace and kiss. The erotic tone of this image seems so far from the funereal pediment as to constitute a side step from the commission pursued for its own inherent interest. More appropriate in their tone of simple jubilation are the four variations in *Seated Figures Rejoicing* (*Fig. 169*). This design also might have served as a background or foreground motif to accompany the focal image of Napoleon.

A related album page showing *Seated Napoleon Crowned* (Louvre, RF 4661, fol. 3r), with

a Winged Victory kneeling rather strangely behind the throne,[49] contains two images of significance: the ruled outline of the left half of the gabled pediment, positively linking the drawings with the development of the relief, and an image of *Standing Napoleon Crowned*. In the latter, the Winged Victory stands directly behind Napoleon and peers out from behind his right side, an image which affords a transition to the next type explored by Barye.

Napoleon as a Standing Figure. Two studies of a standing nude male take on the guise of *Napoleon as Mars (Fig. 170)*. The attributes of a plumed helmet, flowing cape, lance, and shield clearly convey the idea of Mars, the archetype of General Napoleon. Both studies also explore different modes of coronation. The left one shows a Winged Victory flying in from the upper left, her arms outstretched, to place the crown on the head of Napoleon, who looks upward to receive it. The deeply arched body and extended arms of this hovering Victory closely follow the lines of John Flaxman's *Iris*, an engraving for Hesiod's *Theogony*. The right one shows a kneeling personification figure, largely hidden behind the shield Mars rests on the ground at his side. Victory kneels as a humble supplicant and reaches upward to place the crown on the head of Mars. A definite link of this album page with the evolving conception of the pediment is the fully recumbent figure at the right, perfectly composed to fill the corner of the pedimental triangle.

A standing Mars appears on an album page in the Louvre *(Fig. 171)*. It is framed in a circular field like a medallion, a suitable geometric alternative to the pediment triangle. Mars brandishes a sword in his right hand and holds two lances and a round shield in his left. The operatic tone of this figure and its conventional stance strongly suggest the histrionic bombast of the heroes of Henry Fuseli.

The ancient source of another drawing, Barye's *Apollo Crowned by a Winged Victory (Fig. 172)*, can be identified by means of the inscription "Hamilton" at the top of the page. Barye recorded the image from an illustrated anthology of antiquities in the collection of the Honorable William Hamilton, British Envoy to the Court of Naples, published in 1767 and 1785 *(Fig. 227)*. The proportions of Barye's drawings of the figures in this elegant red-figure vase painting are taller and more slender than those of the source, and he introduces a choppy, more angular kind of contour, quite unlike the smooth flow of the original. The appropriateness of this act of coronation to the literal theme of the pediment is self-evident. Even the stylized feather pattern of the wings of the genius had an impact upon the wings of the pedimental eagle. Two recumbent Renaissance Venus types on the lower register of the page served as preliminaries to the seated personification *Fine Arts*, whose bosom is sensuously emphasized and who faces the same direction, unlike her heavily cloaked foil.

Medallion Portraits of Napoleon. Three drawings employ a medallion form, evidently considered as an alternative to the final three-dimensional bust of Napoleon. This choice of image would emphasize the theme of the apotheosis of Napoleon, yet with a quality too tomblike to be appropriate for a palace façade. In addition to many ancient precedents on sarcophagi, Barye would have known such modern examples as Bernini's medallions for the Chigi Chapel tombs (Rome, Sta. Maria del Popolo), Antonio Canova's reliefs for the tomb of

the Archduchess Maria Christina (Vienna, Franziskanerkirche), and Tiepolo's fresco medallion *Apotheosis of the Prince-Bishop* (Würzburg, Residenz).

Barye's drawing *Two Seated Figures Framing a Medallion* (*Fig. 173*) arranges the figures in a way that implies the triangular field of the pedimental tympanum without straining to confine them within it. An easy contrast of semirecumbent and seated postures for the personifications is explored in the drawing, as is a contrast of open and closed arrangements of the limbs. The figures are conceived as sensuous, lyrical nudes, with vigorously swinging contours and a Mannerist canon of proportion, much in the spirit of the nudes of Ingres. The ancient Greek or Empire style hair treatment of these two nudes is seen again in Barye's pedimental drawing *Two Crowning Victories* (*Fig. 174*). A certain inner rhythm of contour and an essentially planar or two-dimensional quality of energetic expansiveness in this pencil study are shared with the drawing *Enthroned Apollo-Napoleon* (*Fig. 168*), which suggests a similar moment for both in the developing concept of the pediment.

A second study, *Two Recumbent Figures Framing a Medallion* (Louvre, RF 8480, fol. 29v), contrasts not the closed and open limbs of the previous drawing, but a front and back view of the left and right figures, respectively.[50] The two nudes rest upon scroll volutes, the large ends of which create a raised base for the medallion. The tightly arched arabesque contours of the drawing are closely unified with the circular medallion. Against these motifs plays the rectangular form of the sarcophagus element beneath the nudes, corresponding to the projecting segment of the cornice on the final pediment. The feeling of the drawing is that of an ornate sarcophagus lid.

A third drawing for a medallion pediment (Louvre, RF 8480, fol. 24v) shows only the right half of the design. A recumbent nude female appears to swoon against the medallion, her figure in a plane just behind it, as though she were presenting it to the viewer as well as mourning the passing of the emperor. Atop the medallion is a ram's head, suggesting ancient altar decorations, and the related funereal motif of the *boukrania*. Just beneath the line of the raking cornice, a sequence of five circular shapes suggests the heads of five mourning figures or those of celebrants, visible just behind the recumbent female. Molding profiles, possibly considered for the cornices of the pediment, appear at the left of the page.

The Portrait Bust of Napoleon. Barye's tiny drawing of the left half of the Napoleonic pediment (*Fig. 175*) may record an early stage in the studies for the pediment, since it isolates the several elements called for in the official title: the portrait bust; the act of coronation by a flying Victory; the semirecumbent, framing personification figure; and the cartouche of attributes in the corner of the tympanum. The distinctness of these elements is quite unlike the synthesizing emphases of most of the other compositional drawings. This tiny composition adopts the light-value shape of the dais and steps of Ingres's *Apotheosis of Homer* for the steps and *cippus* beneath the portrait bust of Napoleon.

Barye's interest in rhythmically animating the space just beneath the projecting ledge of the raking cornice marks the vigorous ribbonlike undulations of the body of a flying Victory who crowns Napoleon with laurel. The energy and rhythm of Victory are carried into that same zone of the final pediment by the seated *putto*, the arms of the lyre, and the head of the figure in *Fine Arts*.

Two major movements developed in this drawing are the echoing of the larger contours of the flying Victory and those of the semirecumbent *Fine Arts* and the rhythmical repetition of spherical forms—in the attribute group, the head in *Fine Arts*, and the twin globes of the head and shoulders of the bust of Napoleon. A radiating motif occurs in the jutting periphery of the attribute cluster and, on a larger scale, in the axis across the knees of *Fine Arts*, in the line of her head and left arm, and in the vertical axis of the bust of Napoleon. The latter lines coverge in a geometrical center, just below the base line of the pediment on its central axis.

Another Napoleonic pediment drawing at the larger scale (*Fig. 176*) shows in the upper register a symmetrical pair of seated personification figures with their backs almost directly against the portrait bust on the central axis. The seated figures are large, filling the pedimental field, as on the final design in stone. Erasures in the form of a diamond shape are seen around the bust, indicating that Barye experimented with the seated figures so as to show them twisted about and crowning the bust with a laurel wreath held in their farther hands, while placing their lower hands together at the front of the pedestal. An excessive, Mannerist twisting of the two figures resulted, lending a more forced and artificial tone to the composition than would be appropriate for a mood of classical understatement, the mood of harmony and restraint achieved in the final form.

Suggestions of the curved tops of folded wings appear behind the shoulders of both personifications, and the curved contours of a lyre appear on the lap in the figure in *Fine Arts*. Wings are a proper attribute of a History figure, but not of Fine Arts, according to Ripa's *Iconologie*. In fact, Barye omitted wings even from the figure of History in the final pediment, quite negating the emphases of this drawing, demonstrating a free attitude toward these specifics of earlier iconography. Barye actually called this figure *Sciences* in a letter written only nine years later, in 1866 (*AN* F^{17} 3578).

Napoleon's portrait bust is treated at the same scale as the heads of the framing personification figures, but its pedestal or *cippus* is much lower than that of the tiny drawing (*Fig. 186*). To fill the gap, the shoulders and torso of this bust are correspondingly lengthened. Thus the bust and pedestal continue to fill the central vertical zone of the design, and the single step of the *cippus* is extended laterally to provide a platform for the seated personifications.

In the central register of the drawing, within the sarcophaguslike contour of the projecting entablature, are two faint images of accessory figures, possibly History or Fine Arts. At the left a recumbent female figure extends a hand to crown Napolion's bust, and at the right is a slightly larger male figure, recalling Michelangelo's seated *ignudi* on the Sistine ceiling. In the lowest register of the drawing is a recumbent Winged Victory, closely fitted into the shallow triangle of the right corner of the tympanum.

The central triangle created by Barye's personifications in the final pediment, and in such drawings as Figures 175 and 176, is very similar to that in *Sea Divinities*, the frieze-like engraving by John Flaxman for Hesiod's *Theogony*. At the center, Nereus and Doris embrace, forming an isosceles triangle, while nereids cavort at either side, their billowing rhythms like those of the attendant figures in Barye's drawing (*Fig. 168*).

In a large drawing for the Napoleonic pediment (*Fig. 174*), two Winged Victories crown

the bust of Napoleon in a nearly perfect mirror-image design. The feather-pattern of the Victory on the right, with five rows of long wing feathers, appears in John Flaxman's *Aphrodite Wounded in the Hand, Conducted by Iris to Ares*, an engraving made as an illustration for the *Iliad*. Barye apparently merged these images of Victory with those of History and Fine Arts. The large, rich shapes of the open wings of the Victories fill the pedimental triangle in a way reminiscent of the wings of the defeated Giants on the great baroque frieze of the Altar of Zeus at Pergamum (Berlin). An echo of the dramatic shapes and rhythmical enrichment of these open wings survives in the Napoleonic eagle of the final pediment.

Napoleon's bust is now at a slightly larger scale than that of the heads of the Victories, suggesting the boldly hieratic differentiation of the final design. The bust is placed upon a tall, tapering base, like that of an antique herm. A swinging, energetic rhythm and counter-rhythm fill the great contours and gestures of the design.

A key aspect of the stone relief appears in the last of the four large drawings for the Napoleonic pediment (*Fig. 177*), the hieratic, colossal bust of Napoleon beside the life-size adult personifications and their childlike accessory figures—the *putto* of Fine Arts on the left and a small Victory, apparently standing just behind History and shown crowning Napoleon. The relationship of Barye's standing Victory and seated History suggests Michel-angelo's Sybils and Prophets on the Sistine Chapel ceiling, with their paired, smaller atten-dant figures, like ancient inspiring Geniuses. The latter stand similarly, just above and behind the principal figure, and by their small scale serve to heighten the monumentality of the Sybils and Prophets. The *putto* on the left of Barye's drawing is beside the feet of the seated personification figure, as are both *putti* of the pediment, a motif with a distinctly Venetian overtone. It suggests the Cupid formerly at the feet of Giorgione's *Sleeping Venus* (Dresden), before the restorations of 1843 removed it, and that of Titian's early variant, the drunken Bacchante in *Bacchanal of the Andrians* (Prado).[51] There the *putto* provides comic relief as it urinates on the leg of Titian's compelling and insensate Bacchante. Unlike Barye's final pediment, however, the personifications of the drawing are seen in a three-quarter view, which creates a deeper spatial ambience than Barye finally desired, since his stone figures are held in a plane strictly parallel with the major plane of the façade itself. In the final pediment even the standing *putto* is purified of its voluptuous rhythms and echoing contours. It is given an abruptly rectilinear pattern of gestures that is architectural in severity. Both the stone *putti* are rigid elaborations on Michelangelo's *Giorno* (for the legs) and *Crepuscolo* (for the frontal shoulders and similar direction of the gaze). Another *putto*, barely legible at the extreme right of Barye's drawing, appears to be seated, as are both *putti* in the final pediment.

The step beneath the *cippus* of the bust has disappeared. The personifications and their *putti* rest on a base line of the tympanum. The *cippus* has a nearly cubic configuration, very like the final version, which is further purified by the removal of the cornice shown in the drawing. The shoulder mass of the bust is even more reduced in the final form, to a lip or rim around the base of the neck, a touch reminiscent of that romantically fascinating colossal fragment, *Head of Constantine* (Rome, Capitoline Museum), and a touch with other counterparts in Roman portrait sculpture at conventional scale.

Thus the drawings reveal that Barye's evolving concept of the apotheosis pediment embraced seated and standing figures of Napoleon in the guises of both Apollo and Mars. A medallion portrait was considered, as well as a bust on a *cippus*. The personification figures were Winged Victories and lyrical nudes with Renaissance overtones, before reaching their Ripa-inspired, Venus-like final form. The mood of Barye's pediment attains a ritual gravity, well suited to this sacred, ultimate moment in the Napoleonic legend.

The Riding Academy Pediment

Napoleon III as an Equestrian Roman Emperor (*Figs. 43 and 44*), a monumental bronze relief for the Riding Academy façade of the New Louvre Palace, was commissioned by Emperor Napoleon III in 1861. Installed above the entryway facing the Seine, it was at once a portrait, a reflection of his love of horsemanship, and, by its Roman garb, the sign of his imperial station and dynasty. The offical contract describes the bronze relief as one and a half times life size (*AN* F[21] 1749). Unfortunately, it was destroyed in September 1870 or May 1871 during the Franco-Prussian War and the Commune. We know its design only from two extant drawings: one is an architect's presentation drawing (*Fig. 43*) in ink washes and color, showing the entire Riding Academy façade (Louvre, Office of the Architect-in-Chief); the other is a faint tracing, probably made from a similar type of architect's presentation drawing or from a small sculpture intended as a presentation model (*Fig. 44*). Barye's two flanking figures in stone, the semirecumbent River Gods (*Figs. 46 and 48*), survive intact on the attic story, although they now frame a more recent relief by Antonin Mercier.

Several equestrian projects concerned Barye in this period. From about 1860 onward he developed his designs for the Bonaparte Family Monument at Ajaccio, Corsica (*Figs. 50 and 51*). He was awarded the commission for a monumental bronze equestrian (*Fig. 49*) for the city of Grenoble in 1862, a project he would abandon in 1866. An undated letter (*AN* F[21] 485), apparently written soon after 1861, advocated Barye as the best artist for an equestrian figure of Charlemagne in Roman garb for the New Louvre courtyard. Thus equestrian projects were very much in the air for Barye, and Roman garb, symbolically aligning the Second Empire with the glory of the ancient and the Napoleonic empires, was central in their concepts.

Louis Napoleon's mustache and beard are visible in the tracing after a model of the relief (*Fig. 44*), a distinctive portrait touch. So strongly emphasized, his likeness and the ancient garb call up the realm of the costume ball. Of course antique precedents for this existed, since Constantine the Great had had his likeness carved into the reliefs from the earlier eras of Trajan and Hadrian that were pirated for his own triumphal arch in Rome.

Echoes of Barye's contemporary equestrian project for Ajaccio are clear in the contours of the horse's breast and hindquarters and in the identical angles of the three weight-bearing legs. The horse's head is rather short, suggesting an Arabian and marking a return to a still earlier work, the model of *Napoleon I, Equestrian, in Coronation Robes* (*Fig. 33*), approved by Visconti before he died in 1853 but never executed in bronze. Perhaps the latter reminiscence was intentional and even nostalgic for Barye. An early motif, the hieratic convention

of the horse's stance, appears on Barye's *Striding Lion* (*Fig. 66*), a small bronze of 1830–35, where the animal's forelegs create the equal sides of an isosceles triangle and the lower hind legs are set exactly parallel with them.

A new influence on this relief is an engraving by Noël Lemire of Edme Bouchardon's *Equestrian Monument to Louis XV*, destroyed during the French Revolution.[52] This is evident in several details: the long curved line of the underside of the horse's breast, barrel, and flank, a line rising more sharply from the breast to the flank than is true of any other equestrian by Barye; the arrangement of the rider's arms, with the right hand raised and resting on the end of a long general's staff, transformed into Barye's scepter; the placement of the sword, indicated in faint contours on the tracing (*Fig. 44*); and in the rather large size of the rider, since this figure of Napoleon III would be as tall as the eye or ear of the horse were he to stand beside it.

As for the architectural setting of the relief, the presentation drawing of the façade (*Fig. 43*) reveals that the relief was installed in a round-headed field, slightly higher than it was wide. At either side the relief was framed by piers decorated with paired pilasters having fluted shafts and Corinthian capitals. In the frieze zone of the straight entablature directly above Barye's relief is a large rectangular tablet inscribed in Roman stone-cut capital letters, NAPOLEON III, EMPEREUR. Below this was a second line of text, now obliterated. In fact, the architect's presentation drawing indicates three lines of text below the first, although they are illegible. The springings of the arch and its keystone project strongly in relief against the curve of the round-headed opening. Spandrels at either side of the arch hold decorative reliefs of ancient symbols of triumph—the laurel wreath and palm branch—appropriate both to the horsemanship of Louis-Napoleon and to his imperial station. Just outside the paired pilasters, at the springings of the arch, are Barye's two River Gods (*Figs. 46 and 48*), executed in stone. Framed in the arcuate, broken pediment above this attic story, two more seated figures in the same scale as the River Gods flank an escutcheon of Napoleon III. The heraldic device is crowned by an eagle with open wings, similar to Barye's small bronze *Eagle on a Rock* (Walters Art Gallery, 27.570; h. 9 ¾, w. 13 ½ inches; 24.8 by 34.4 cm).[53]

The general effect of Lefuel's façade is one of an elaborately compartmentalized treatment, conceived in the additive mode of the sixteenth-century designs of Giulio Romano, Michelangelo, Ammanati, Vasari, Pirro Ligorio, and Palladio. (See also the engraving by du Cerceau of the Entrance of the Chateau of Écouen, ca. 1555–60, designed by Jean Bullant, its third story crowned with an equestrian figure in an arcuate field; in Blunt, 1970, pl. 58A.) It is not as flat as the façade of the Cancelleria in Rome (c. 1484) but rather it has accents of more plastic detail, characteristic of the sixteenth-century architects. Lefuel's concept thus is not a vigorously plastic sort of neobaroque, and its contained two-dimensionality clashes with Antonin Mercier's explosively neobaroque relief later installed in the lunette. The dynamism of Mercier's relief is out of key with the rest, although it was a well-intentioned effort to enliven an otherwise classicistically frozen ensemble of motifs.

One effect of the rather heavy framing that surrounds Barye's equestrian relief is to counter any feeling of monumentality in his design. His relief seems more like a toy soldier than a monumental imperial portrait. In the uncomplimentary setting of Lefuel's façade, Barye's relief is a mere arabesque, of no greater final significance than the panels of

decorative interlace in the frieze above the pilasters. Possibly the contrast between the bronze and the surrounding stone might have lent it greater impact. Yet the strange visual competition between the meaningless projecting keystone of the arch, and the focal portrait of the emperor just inches beneath it marks a decreased emphasis upon sculpture by the architect.

Barye no doubt knew the imperial equestrian relief, set in an arcuated field, in the *Ludovicus Magnus* pediment above the entrance to the Hotel des Invalides, executed by Liberal Bruant in 1671–76. Yet more space and air surround this baroque horse and rider than appear in the more compressed field of Barye's design. A truly baroque sense of the vastness and continuity of space is dramatically present in Bruant's relief. The field of the Bruant relief is curved or coved inward from a projecting rim, similar to the stacking rim at the edge of a coin, or like the coved field of Michelangelo's coinlike relief *Pitti Family Tondo* in the Bargello. The latter device apparently was not used in Barye's bronze relief, to judge from the evidence of the extant drawings. The gait of the baroque horse shows two hooves off the ground, the far rear and near front, the favorite stance of the French since the late sixteenth-century relief *Charles IX, Equestrian* in the Louvre,[54] and a stance frequently used by Barye. However, the horse of Barye's *Napoleon III* has a more stable gait, since all four hooves touch the ground. As a total image, Barye's relief has the aspect of an ancient carved cameo, a miniature rather than monumental look. Of course the treatment of the coved background of the Invalides relief probably derives from a miniature source as well, one perhaps suggested to the baroque sculptor by the coinlike overtone of the very format of an arcuate relief. Barye's relief has a firm stance, a crisp silhouette, and a tightly compressed spatial ambient that mark its more strictly classical mode.

The River Gods. The relation of Barye's *Napoleon III Equestrian* relief and the two flanking *River Gods* (*Figs. 46 and 48*)[55] on the former Riding Academy façade of the New Louvre, comprises a variation upon Michelangelo's Piazza del Campidoglio in Rome, a famous vista probably known to Barye in the engraving by Etienne Dupérac. Barye's cluster of images presents a view from the top of Michelangelo's ramp looking into the piazza, with the *Equestrian Statue of Marcus Aurelius* (although turned in profile) framed between the two ancient *River Gods* at the back of the piazza against the double stairway to the Conservators' Palace. Michelangelo of course loved the River God image and varied it many times— in the bronze nudes of the Sistine Chapel ceiling and most memorably perhaps in *Four Times of Day* for the Medici Chapel in San Lorenzo in Florence. The latter variations were some of the most germinal and inspiring of all Michelangelo's works for later artists. Even Carpeaux's projects for the Flora Pavilion pediment of the New Louvre (1863) reflect the impact of Michelangelo's River God variations.[56]

Plaster casts of Barye's small, initial *River God* sketches (*Figs. 45 and 47*) survive, as do the larger, highly refined, plaster *River God* models (*Figs. 46 and 48*), used as the basis of the enlarged final versions in stone. Nails with round heads have been hammered into one plaster sketch (Louvre, RF 2007) at the shoulder, elbow, wrist, and knees, a sign that it also was used for mechanical enlargement, since the nails would serve to locate principal fixed points of the composition from which other measurements might be determined. The

sketches and models provide an insight into Barye's refinement of these accessory figures, the genesis of the final forms that flanked his imperial relief in bronze.

In the River God sketches the poses are more forced and the proportions more Manneristically attenuated, with smaller heads, hands, and feet, than the final plaster models. A key to the transformation of their Mannerist forms into the classical proportions of the final models is found in Barye's drawings after a plaster cast of the Phidian *Theseus* from the pediment of the Parthenon (*Fig. 165*), and in drawings after the *Borghese Mars* in the Louvre (*Fig. 164*). *Theseus* is semirecumbent, a pose like that of Barye's River Gods, and offers a superb embodiment of the classical canon of ideal male beauty. Barye's drawing underscores the way in which the axis of the right thigh of *Theseus* is essentially at a right angle to the axis of the shoulders, a physically plausible, even comfortable position. Nonetheless, a certain Mannerist style is evident in the position of the right thigh of both Barye's sketch and model (*Figs. 47 and 48*), which is pulled or forced into a plane more parallel with that of the chest and shoulders, heightening the sense of dramatic torsion or compression in the torso. Such twisting is more extreme in the sketch, which is violently rotated to achieve a plane for the shoulders that would be perfectly parallel with the plane of the façade behind it. There are several classical changes from the sketch to the model. The sharp, sideward gaze is altered to a more natural, downward direction. The position of the right arm, the flexed arm holding a staff lightly against his chest, changes to a more open and relaxed angle, one not pressed so tightly against the side of the torso.

A rather free attitude toward the specifics of iconography becomes apparent in these figures, affirming their essentially decorative role, one similar to that discerned in the relation of Lefuel's setting and Barye's imperial equestrian relief. The attributes of the sketch of the right figure differ from the simple, overturned vase of the final model. They appear to be a miniaturized, ancient ship's stern and a helmsman's rudder, somewhat intricate embellishments that were dropped from the simpler final version. This attribute may be connected with the appellation *The Flood*, which was given to one of the sketches in the earlier literature. The sketch of the left figure appears to rest against a tree stump. The crowns in the models are dissimilar, although not as they were differentiated in the early sketches: In the right-hand sketch the figure appears to wear a helmet, with stylized curls of hair jutting from beneath the rim, whereas in the left-hand sketch the figure wears a helmet with a vertical ridge raised over the crown, perhaps a dim echo of the plumed helmet of the *Borghese Mars*, and curls of hair are visible beneath the rim. No helmets appear in the models, and the crowns are of stylized wheat (left figure) and laurel (right figure). In their present state, subsequent to the destruction of 1870–71, the stone River Gods no longer lean upon overturned vases, as do the models, for the hands directly above the vases are missing on both. Perhaps a later restoration is responsible for the fact that the left figure now leans upon a tied sack of grain. The right figure appears to have the same attribute, although it is not so clearly defined.

Barye's final stone River Gods stand out strongly in three-dimensional space, for they are silhouetted against the slate roof that slants away behind them. They are not absorbed into the main surface of the façade in quite the same way as the imperial equestrian relief was.

LATE MONUMENTAL WORKS

Two Equestrian Bronzes and a Portrait Tondo

General Bonaparte, Equestrian (*Fig. 49*) was created for a monument in Grenoble, a project Barye abandoned in 1866.[57] A middle-aged, slightly jowly General Napoleon rides a stately battle horse. He sits tall and holds the reins in his left hand, while his right is folded and rests jauntily on his hip, exactly the posture of the earlier small bronze of the youthful *General Bonaparte* of about 1847 (Walters Art Gallery, 27.161; h. 32 cm).[58] Napoleon's face, in a classically reflective mood, has sculpturally exaggerated, deeply indented hollows around the eyes, areas brought up to sharp linear ridges over the cheekbones, a treatment very different from the realism of Barye's plaster sketch published by Janneau. The figure of Napoleon seems ill-proportioned, with a long upper body and short legs, perhaps an ill-conceived attempt to compensate for the spectator's low angle of vision onto the final monument. Realism dictated the proportional relation of the rider to his horse, as was true of the earlier version, for Napoleon would be about as tall as the throatlatch of his steed were he to stand beside it. His Arabian horse is small headed, long necked, and spirited, of the same type ridden by the youthful counterpart. A different touch is the curling forelock that falls just above the horse's right eye. The musculature appears to be slightly more generalized than its precedent of the 1840s, preserving something of the crudeness of refinement so apparent on the unfinished sketch. Details are elaborately worked out, however, in the horse's trappings and rider's costume.

Barye's original sketch published by Janneau was executed in a plastic wax or clay, and it lacks certain detail embellishments of the bronze, such as the fringed saddle blanket and holster and the horse's reins and bridle. Other relatively fine details are present, however, such as the mass of the horse's forelock curling past its right eye, the stirrups, the shape of the saddle blanket, and the ribbon tied at the dock of the horse's tail. Long, curved planes left in the pliable wax or clay by a scraping tool are clearly visible at the upper part of the horse's neck.

In his 1937 article André Dezarrois published a photograph of an elaborately detailed and rather different small bronze, which he termed the original model for the Grenoble monument. It is a strange image, with a horse not characteristic of Barye's, one with a much longer head, similar to Verrocchio's horse for his *Colleoni Monument* (Venice, SS. Giovanni and Paolo), a type reiterated in François Lemot's *Equestrian Henri IV* on the Pont Neuf (*Fig. 228*). The horse of the small bronze also has a disproportionately short trunk relative to its height, and its hindquarters seem too small for the front portion of its body. The gait of this horse, however, is identical to those of the related sketch illustrated by Janneau and the small bronze illustrated by Dezarrois. Fine details on the small bronze are elaborate—in the horse's trappings, in the costume of Napoleon, in the striations of the horse's mane and tail, in the development of its shoulder and flank muscles, and the tendons, ligaments, and veins of its legs. An ancillary consistency in all three versions of the Grenoble project is the

distinctive shape of the plinth, a rectangle with projecting arcuate ends at the front and back. Possibly this format was determined by the architect named in the documents, Charles Questel, but it also surely reflects the precedent of Michelangelo's base for the *Equestrian Statue of Marcus Aurelius* in Rome.

The reasons for Barye's abandoment of this major state commission are not clear. Surely they were substantial, for Barye stood to receive 30,000 francs for the completed model alone. Perhaps the demands of his other two monumental commissions of this period were too great; Barye was already sixty-five years old in 1862, the year he was awarded the Grenoble commission. Between 1860 and 1865 Barye created *Napoleon I, Equestrian* (Fig. 51) for the Bonaparte family monument in Ajaccio, surely a demanding work in itself. In 1861 and in the years immediately following, Barye created *Napoleon III Equestrian, as a Roman Emperor* (Fig. 43) for the Riding Academy façade of the New Louvre, another demanding project. Stories to the effect that the mayor of Grenoble attempted to dictate artistic matters to the sculptor, thereby insulting him or causing him to lose interest in the project, may be true. Plausible as well is the idea that the Comte de Nieuwerkerke, Superintendent of Fine Arts, may have preferred the art of Emmanuel Frémiet, to whom he later awarded the commission. In any case, Barye's letter of 16 April 1866, declining the commission, is all too typical of our sculptor of few words, for it does not reveal the real reasons for his abandoning the monument. Barye says only that "the owner of my studio in the rue Mouffetard, having given me permission, now tells me that it is not possible [for me] to begin the large undertaking of the equestrian statue of the Emperor Napoleon I for the city of Grenoble. The result of this is that I [must] renounce the execution of the work." Of course it is hardly plausible that another studio could not have been found long before 1866, had it been Barye's wish to do so.

Upon receiving Barye's letter of rejection, the Ministry of Fine Arts awarded the commission to Frémiet, whose rapidly completed equestrian was dedicated in 1868. His was an ill-fated sculpture, however, for it was knocked from its pedestal and broken in pieces during the uprisings just two years later.

Napoleon I as an Equestrian Roman Emperor (Figs. 50 and 51) was created for the Bonaparte family monument in the Place du Diamant, Ajaccio, Corsica.[59] Dedicated in 1865, the work shows a general similarity to *Marcus Aurelius* in Rome, which was surely implicit in the imperial concept of the monument from the outset. Resemblances are felt in the gait of the horse, with three legs firmly placed on the ground, and in the sweep of the emperor's long cloak as it falls over the horse's back. Barye's tiny drawing *Roman Equestrian Figure* (Walters Art Gallery, 37.2051) probably was made after the reliefs of the Column of Trajan. It documents another distinctly Roman source, studied for its details of costume.

Intriguing are the personal, expressive departures from these precedents. Barye's movingly elegant horse transforms the alert horse of Marcus Aurelius into one whose almost human mood is introspective and compellingly sad, thus well suited to a funeral cortege and to a commemorative function. Barye achieved this by altering the attitude of the horse's head to one looking downward rather than forward or upward, and by adjusting the angle

of its raised foreleg, which appears to be dropping rather than rising. The figure of Napoleon also looks downward slightly, the chin drawn inward, in a subtle but effective echo of the attitude of the horse's closely bridled head. This adds to the overtone of stoical resolve apparent in the rider, who sits almost rigidly in a ritual rather than naturalistic posture. The cloak or chlamys worn by Napoleon falls with a robust plastic vigor. Its lines, tubular folds, and deep hollows have a different quality than the almost graphic look of the light, wet-drapery treatment of the cape of Marcus Aurelius. It is different, too, from the generally flatter, more planar handling of the great coronation cloak worn by Barye's *Emperor Napoleon I, Equestrian* of 1853 (*Fig. 33*).

The horse is marked by a beautiful new quality in the prismatic elements of its contours, by the tension introduced through this accent of contrast within the major outlines of the design. Other internal contours, as at the sides of the neck and hindquarters, subtly parallel the outer lines. The horse's legs are deeper from front to back than before. They are plastically extended in a plane parallel with the major relieflike plane of the entire monument, and the definition of their ligaments and muscles is more pronounced, in a way that echoes the deep folds of the rider's cape. The legs of the horse are slightly taller than those of Barye's earlier works, adding a touch of the elegantly unreal to this image. Despite the ritual mood of the whole, the proportional relation of rider and horse is a naturalistic one. The rider is not a hieratic giant, as is Marcus Aurelius. The horse's stylized, clipped mane and tied forelock suggest a source in the Hellenistic bronze quadriga horses above the portal of San Marco's in Venice. Those famous bronze horses were displayed with great pomp on the gate piers of the Tuileries Palace in Paris from 1802 to 1807. In addition, the details of mane and forelock have an austerity like François Lemot's bronze *Quadriga* of 1808 for the Arc du Carrousel in the court of the Louvre Palace.

Barye's monumental bronze *Napoleon I as an Equestrian Roman Emperor* is placed atop a sarcophaguslike base of stone at the center of the Bonaparte family monument. He is attended by the figures of his four brothers, standing on a lower level, at the corners of the stone base. The figures *Joseph, Lucien, Louis,* and *Jerome* wear the ancient toga, and in fact they are the creations of four other sculptors. Napoleon, as a triumphal emperor, wears a crown of laurel, chlamys, and armor while holding an orb of dominion in his right hand. The orb is surmounted by a miniature Winged Victory holding two laurel crowns in her outstretched hands, as though to crown the two brothers standing at either side of Napoleon's horse.[60]

As a whole, the Bonaparte family monument is inert and unhappy. Clearly the multiple authorship was not well coordinated. Distinct differences in personal style are evident among Barye's equestrian figure and the orator-portraits by other artists. The four portraits of the brothers display subtly disharmonius choices of ancient precedent. A final blow is dealt to the design by the heavy, bald podium of stone, so lacking in the elegance of detail, surface, and refinement of proportion evident in the bronzes. In sum, it is a frozen academic "machine," which clumsily betrays the division of labor underlying its execution. Worthy of contemplation, nonetheless, are several other aspects of the design.

In the setting of this monument, Barye's horse and rider literally seem to diminish before one's eyes to the scale of a small bronze. One wonders whether this miniaturizing quality of

design was the artist's preference or instead was the consequence of the mechanical enlargement of the original plaster, created at one-third scale, a superbly effective size for the image.

The narrative concept of the monument—a solemn truimphal procession, an apotheosis—has a great potential for dramatically engaging action, both physical and psychological, and it cries out for a baroque treatment. Yet the rich potential for movement and expression remains untapped, the result of the designer's return to a pure neoclassical style, the style of the Empire period. Even Barye's horse is posed and balanced rather than in motion; for example, it does not use Verrocchio's animating device that places two-thirds of the horse ahead of the midpoint of its plinth.[61] There is a stasis, like that of a pyramid, rather than the eloquent rush and levitation of a work like Bernini's *Vision of Constantine* (Saint Peter's, Scala Regia). These four standing orators might spring to life were they given the psychological presence of Donatello's *Prophets* or Rodin's *Burghers of Calais*. Nonetheless, beyond the condition of stasis, a certin psychological unity is developed in the way the imperial rider and his brothers gaze downward into the realm of the spectator. The spectator does not see them with their eyes raised in awe before the godhead, but in a somber mood, one more akin to the dejection of Meissonnier's famous painting *Napoleon's Return from Russia*. Somehow the Roman costume does not fit the mood.

Perhaps a key to the central organizing idea and the iconography of this monument is to be found in an effect somewhat apart from the miniaturizing tendency of Barye's horse and rider, but one intrinsically related to it, which, had the monument succeeded, might have comprised its essential point: a kind of delicacy and restraint, an almost wraithlike insubstantiality reminiscent of the Ossianic quality of numerous paintings of the Empire period. *The Song of Ossian* was a favorite book of Napoleon's. The romantically operatic dream visions of Girodet's *Shades of the French Heroes . . . Welcomed into Elysium* of 1800 (Malmaison) and David's *Distribution of the Eagles* of 1804 (Versailles), leading paintings of the age, no doubt appealed to Barye's romantic taste, just as they would appeal as appropriately ideal Napoleonic propaganda.[62] Conceived as a parallel, say, of Girodet's vision of a celestial assembly of the French immortals, the program for the Bonaparte family monument might be termed "The Shades of Emperor Napoleon Bonaparte, and of His Four Brothers, Entering into Elysium."

That the blind poet Ossian as well as several other chief characters are omitted from the monument seems to be the unfortunate consequence of an excess of classical brevity, for their presence would well temper and enrich its almost mechanical severity. The dour mood of the bronzes might have taken on a more engaging sweet-sadness, like that of Girodet's shades of the French heroes. In its realized form, however, only an undercurrent of Ossianism is perceptible.

The stance of Barye's horse is a clear mirror image of Donatello's *Gattamelata* and Verrocchio's *Colleoni*, its right foreleg raised, but with its right hind leg brought forward rather than the left one, as on the unreal *Marcus Aurelius*. A transcendental, visionary point no doubt underlies the absence in Barye's horse and rider of the lordly, earth-bound grandeur of *Gattamelata* and the expressionistic psychological intensity of *Colleoni*. Barye's work pointedly avoids these traditional emphases for commemorative equestrian figures, yet it

avoids being merely decorative. His elegantly wraithlike *Emperor Napoleon* is best placed somewhere between the dream of an Ossianic Elysium and the stoical clarity of the Davidian pageants.

With respect to the place of this design in the development of the equestrian monument in nineteenth-century France, it is fascinating to observe that Carpeaux at this very moment followed an exactly contrary, grandiose, neobaroque mode in his *Monument to Marshal Morency* for the competition of 1864.[63] However, even as Carpeaux's design reacts against the classicist starkness of the Bonaparte family monument, it also returns precisely to Barye's horse types of the 1830s for the crown of his monument—horses like those of *Charles VI, Surprised in the Forest of Le Mans* (Fig. 83), *Tartar Warrior Checking His Horse* (Fig. 85), and *Greek Rider Seized by a Python* (Fig. 86). Significant, too, is the debt of Auguste Rodin's undated plaster model *Monument to General Lynch* (Paris, Musée Rodin) to the very horse types refined by Barye.

Emile Diaz (Fig. 52), a late relief tondo, was created about 1860. It differs from the comparable early medallion reliefs, such as *Young Man in a Beret* of 1823 (Louvre *Cat.*, 1956, no. 107)[64] and *Portrait of the Founder Richard* of 1827 (Fig. 11), in that it shows a surer command of the bone structure of the skull, evident in the relation of the projecting cheekbone and the complex group of forms about the eye of the subject. This late relief has a generally harder effect and a bolder simplication of the grand planes of the forehead and cheek. This differs from the softer, almost pneumatic simplifications of *Young Man in a Beret* and from the more delicate, painterly modulations of relief in *Portrait of the Founder Richard*. The neck musculature in *Emile Diaz*, however, is strangely oversimplified, even unreal, as is the ornamentally regular form of the shirt collar—perhaps deliberate accents of stylization intended to heighten the impact of the realistic mask or to echo the abstractness of the tondo format.

The original tondo decorates a grave monument in Père Lachaise cemetery, which records that the subject died in 1860. The inscription on the tondo shows an unusual mixture of capital and lower-case letters, EMiLE DiAZ. This peculiar lettering, including the crudely shaped letter Z, appears on the plaster model preserved in the Louvre (RF 1571). The bronze proof, in fact, shows that the dots over the letters *i* were larger at first, and that those areas on the model had been patched, making them smaller. Perhaps this reflects the typical signature of the deceased. The highest relief projection of the design measures about 2¼ inches (5.7 cm) from the background surface.

Animal Images

Recumbent Greyhound (Fig. 53) is an exquisitely refined, somewhat large design and a newly invented form, rather than a mechanical enlargement.[65] It does, however, return to the hieratic mode of Barye's work of the 1820s, such as his small bronze *Lion and Lioness* (Walters Art Gallery, 27.89). *Greyhound* is classically contemplative in mood, and its natural hieratic quality has been heightened to a sphinxlike formality. Yet this is relieved with

a certain grace and a tension in the long lines, which are personal touches completely unlike the ancient sphinx prototypes. Possibly this and its mate are related to the life-size marble *Recumbent Greyhound*, noted by Lami (p. 78) as a work of 1868, commissioned by Comte de Nicolaï.

The Four Animal Combats for Marseilles. In 1869 Barye received a commission to create four groups of predators with prey in stone and at monumental scale (1.3m) for the entryway of the Palais de Longchamp in Marseilles: *Lion and Boar, Lion and Ibex, Tiger and Doe,* and *Tiger and Gazelle.*[66] Unfortunately, the actual works in stone have deteriorated badly, and the best evidence as to their character is the series of old Giraudon photographs of the cast-plaster presentation models reproduced in Stuart Pivar's *Barye Bronzes* (pp. 137–40).

To judge from the photographs, the presentation models appear to be slightly less than one meter high, given the relative size of such details as tool marks and the ridges left along the mold-separation lines. In every case, their style has the unmistakable quality of a mechanical enlargement made from a smaller model, probably an original executed at a less taxing scale, roughly 20 by 35 cm, and later enlarged in clay with the aid of a Collas machine or a similar device. From the large clay model molds were taken, which yielded the cast-plaster positives photographed by Giraudon. These were used as the basis for the final enlargements in stone.

There is a sleekness or flatness of surface transition in these models, as though the plastic accents are somehow underplayed and in need of emphatic heightening for their new scale. A revealing comparison can be made with the style of the large, directly achieved *Jaguar Devouring a Hare* (Fig. 29), shown in the Salon of 1850, with its craggier, knottier, emotion-charged modeling. Here the style lacks the nervousness, the extreme fineness of touch that mark comparable works of the 1830s, such as *Tiger Devouring a Gavial* (Fig. 22) or *Lion Crushing a Serpent* (Figs. 23 and 24). Perhaps Barye's advancing age led him to this energy-saving, mechanical process of image enlargement, or perhaps it simply reflects his enthusiasm for his increasing mastery of the technique.

Certain motifs unify the four designs, such as the vivid masks of the predators, alive with the sense of a roaring or snarling animal, and the way each feline straddles its motionless prey, as though defying some unseen rival or exulting over its success in the hunt. A relieving departure from a completely rigid conception is seen in the *Lion and Ibex* group, where the prey has its head and great horns placed directly beneath the head of the lion standing over it, whereas the other three groups all show the hindquarters of the prey below the predator's head. No doubt the lion and tiger groups were conceived as pairs, rather like the paired sphinxes lining ancient Egyptian causeways. An interesting technical detail is the brace for the body of the predator created by the mounded image of the prey, supporting it from below. This design element probably reflects Barye's caution over the brittleness of stone as a sculptural material, and the consequent fragility of the predator's legs, given the mass of stone they must support. A boldness in the largest angles and lines of the predators lends them an architectural stability and ponderousness. In mood, these designs have a quality of hieratic formality, a stately confidence, even a lordly grandeur. They are a fitting final statement for the long development of Barye's animal combats.

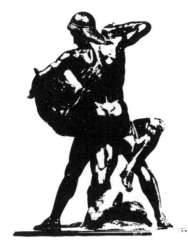

4

Thematic Variations:

The Small Sculpture, 1830 and Later

An avalanche of innovation marked the 1830s for Barye, easily the richest decade of his career. Hundreds of subtly differentiated designs came from his hand in those years, sometimes singly, at other times in clusters or constellations, often at both miniature and monumental scale. For clarity of exposition, this study offers hypothetical groupings of Barye's related designs, not in a chronological sequence, but as a means to grasp principal directions, tendencies, and motifs, many of which must have been invented almost simultaneously. Barye's elaborations suggest a composer varying certain melodic or harmonic ideas. The silhouettes and gestures of his creatures embody a kind of expressive calligraphy, the formal changes of which prefigure by half a century certain externals of Eadweard Muybridge's photographs of animals and humans in motion. Of course, Barye's calligraphic invention was worlds apart from Muybridge's mechanical recording of real movement through space. Barye's scientism underlay his mastery of the structure and appearance of his protagonists, whereas the science in Muybridge lay in a control of the photographic, image-recording process itself.

During the 1830s Barye evolved a range of subtler tendencies of style than the painterly, hieratic, and naturalistic styles of the 1820s. Extremes of style lost their compelling interest, and Barye developed a greater array of moods, compositional types, and themes within the frame of a decoratively particularized realism.

Barye's "stylistic personality" of the 1830s is rich indeed. The five hunt groups for the Duke of Orléans (*Figs. 90, 104, 125, 127, and 128*) can be seen as pinnacles of Barye's enthusiasm for Rubens and Delacroix, for the baroque and the neobaroque, and they are superb in their pyrotechnical display. Yet Barye could move from the jeweler's intricacy of the hunt groups, with their flashing decorative embellishment, to the classical planarity,

severity, economy, and restrained feeling of the reliefs of 1831, such as *Walking Leopard* (*Fig. 62*) and *Walking Panther* (*Fig. 71*). A range of moods also were articulated during this time: the agony of *Wolf Caught in a Trap* (*Fig. 61*), the vigorous exuberance of *African Elephant Running* (*Fig. 70*), the playful dreaminess of *Bear in its Trough* (*Fig. 115*), and the awesomely restrained tension of *Panther Seizing a Stag* (*Fig. 133*).

Surface and mass vary in handling, from the architectural clarity and cubicity of *Python Killing a Gnu* (*Fig. 96*) to the delicately atmospheric and painterly nuances in *Lion Devouring a Doe* (*Fig. 119*). Encyclopedic would seem an apt term for the richness and scope of Barye's work of the 1830s. These were brilliant culminations, artistic peaks unsurpassed in other phases of his career.

Toward 1840 three great tendencies coalesced in Barye's small sculpture, directions that would remain typical of Barye's later oeuvre in small scale. Two were dissimilar, perhaps even compensatory opposites: the cool, classical mode of candelabrum goddesses (*Figs. 144–47*) and the open, baroque pictorial mode of *Ocelot Carrying a Heron* (*Fig. 101*). A third, the understated tone and intricately descriptive realism of *Caucasian Warrior* (*Fig. 79*) and *Horseman in Louis XV Costume* (*Fig. 80*), stands between these extremes. These two designs were first offered in Barye's sales catalogue of 1865, and both reflect his ultimate approach to small sculpture.

GROUP 5: LOW SILHOUETTES

Low silhouettes and a certain fusion of figure and base mark the related designs in Group 5. The vertical, slablike plane of the predator is retained in several works, but it is tilted or twisted sideward in others, adding naturalistic torsion and aiding in the merging of figure and base. The dual styles in Group 4, the transitional works of 1829–30, persist in the planarity of the tigers and the rolling sphericality of the panthers. Now, however, the latter rounded forms benefit from a greater command of skeletal anatomy than was true of *Jaguar Devouring a Crocodile* (*Fig. 21*).

The motif of a predator's open jaws tearing into its prey is transformed into the snarling mouth in *Tiger Attacking a Peacock*. (The tiger's jaw is a very delicate form to reproduce, which fact probably leads to the close-mouthed but humanly intent masks of several other felines.) Moods in the big cats range from the viciously intent *Tiger Devouring a Gavial Crocodile*, the alert inquisitiveness of *Panther of India, Reduction*, to the peace of *Sleeping Jaguar*. The recumbent feline predators derive from the two series of drawings for the designs in Group 4, one made after the living animal in motion and the other after a dissected specimen. A third suite of drawings discussed in Group 4, those of the exotic gavial crocodile, is also of significance here.

To reap the full benefit of the Salon publicity accorded *Tiger Devouring a Gavial Crocodile* in 1831, and to appeal to citizens of the middle-class, Barye created small bronze versions of his monumental design in two sizes: 7 ⅞ by 20 inches (20 by 51 cm) and 4 ¼ by 10 ⅝

inches (11 by 27 cm). These he termed simply "réduction" and "réduction no. 2" in his sales catalogue of 1855 (Quai des Célestins, 10, nos. 61 and 62).

Tiger Devouring a Gavial Crocodile, Reduction (*Fig. 54*) is, when compared with the large bronze of 1831 (*Fig. 22*), only slightly different in proportion and design, although the reduction clearly is not a mechanically achieved miniature, but rather a fresh variation in a different scale.[1] One major adjustment in the smaller version is the lower placement of the crocodile's head. This, and a wider opening of the jaws, allows the delicate form of the slender lower jaw to rest upon the base for support. In the monumental design the head tilts upward so as to merge the silhouettes of the crocodile's head and hind leg. The pneumatic, subtly distended quality of the surface of the reptile is all but lost in the small version, however, which has a dryer, more graphic aspect. In keeping with the more linear handling, there is greater emphasis on the intaglio patterns of the tufts of fur at the tiger's cheeks and on the masses of incised parallel lines that create the tiger's stripes. A certain simplification occurs in the domical or lozenge-shaped forms of muscle at the side of the ribcage atop the lower back and in the flexed, upper hind leg. In the reduction one senses a greater dissimilarity in the treatment of the surfaces of the crocodile's hide and the plant-strewn base, whereas in the original a lush and subtly changing modeling in relief served to unify both surfaces. Variations in the sizes, angles, and forms of the crocodile's teeth in the original are mechanically simplified and sawlike in the smaller one. Nor is the crocodile so successful at small scale. It is more like a fabulous dragon from a medieval manuscript or a Chinese paper dragon carried in a procession than like a breathing creature with a roughly human emotional response to its plight. By contrast, the monumental crocodile is given a stance or position uncannily persuasive of its capacity to move and feel as a real creature might do.

Related drawings of predator and prey are discussed in connection with the monumental bronze in Chapter 3.

Tiger Devouring a Gazelle (*Fig. 55*) retains the general stance and silhouette of the monumental tiger in *Tiger and Gavial* (*Fig. 22*), shown in the Salon of 1831.[2] It is best compared in detail, however, with a design of similar scale, such as *Tiger Devouring a Gavial, Reduction No. 2* (Baltimore Museum of Art, Lucas Collection, L. 64.15.20; h. 4 ¼ inches; 11 cm). Both the silhouette and the narrative idea of the tiger biting into the prey held fast in its forepaws are the same in the two designs of like scale. Yet there are differences in the arrangement of the creatures' legs. For example, in the antelope group, a nearly perfect square contains the lines of the tiger's flexed foreleg and the top and back of its skull, while the forelegs of the tiger with a gavial are extended further ahead of the recumbent feline, and the cluster of forms does not lend itself to such a simple containing figure. This strict geometrical unit in *Tiger Devouring a Gazelle* is directly repeated in the rising parallel lines at the rear of the upper foreleg and at the front of the flexed thigh. The square described by the head and forelegs becomes the parallelogram of the midsection. Sustaining this series of geometric forms, the hindquarters are contained within an equilateral triangle. The antelope's hind leg and foreleg also follow a straight line along the base.

These geometric elements recall the drawing *Cow in Profile* (Walters Art Gallery, 37.2181), which is squared with a grid of rectangles proportionally similar to the rectangle containing the entire animal, a repetition of similar units in a kind of proportional system that governs the major intervals of the creature. Here Barye approached the total geometrical ordering typical of Early Renaissance architectural theory.

At the narrative level the antelope is petite in relation to the massive tiger, and thus it seems the more pathetic. Lacking the satanic overtones of the crocodile, it projects an aura of fragile innocence. Some of the proofs of this design omit the motif of the antelope's spilled entrails, a surprise in view of its fascination as a bit of romantic gore. In fact, this omission of so focal an image cannot be a mere error in the foundry. Perhaps it appealed to a more sedate audience than would prefer the gruesome version.

Tiger Attacking a Peacock (*Fig. 56*) shows the tiger as it catches the bird with a sudden pounce, having cautiously slid on its belly while stalking its prey.[3] As a design, this tiger has the lowest, flattest, and least dramatic silhouette of the entire group of related designs. The unimposing profile no doubt led Barye to overemphasize the dramatically snarling face of the tiger. This extreme not only marks a drop from the subtlety of expression found in *Tiger Devouring a Gavial* (*Fig. 22*)—the germinal design for this group of related sculptures—but a notable departure from Mme. de Staël's romantic preference for nuances of feeling.

The tiger sustains the rolling, cursive design of the predator in the monumental *Tiger Devouring a Gavial*, omitting the alternative squares and angles of the small bronze *Tiger Devouring a Gazelle* (*Fig. 55*). Despite its similar general concept, this tiger does not emulate directly any of the contour drawings made after the living animal observed in motion, except in the fragmentary motifs of the open jaws, the extended neck, the foreleg pinning the prey, and the cursive lashing tail, which do appear in the drawings. In fact, one wonders whether the implausibilities of this design led Barye to a closer emulation of the real animal, as is clear in the gavial and gazelle groups. Is this one of the earliest designs in a series that culminated in *Tiger Devouring a Gavial*, or simply the least persuasive of the later variations of the series? Without firm evidence, the question is difficult to resolve.

Key measurements indicate that this tiger is largely the same as the serpentine tiger that scrambles up the right side of the elephant in the *Tiger Hunt* (*Fig. 127*), cast in 1836 as the first group for the *surtout de table* of the young Duke of Orléans.[4] Barye retained this fragment of that design and reused it with slight modifications as the basis of this image of a feline predator seizing its prey. Several changes were made in the tiger of the *Hunt* group for this model. The fore and hind legs have been lengthened, for the legs of the *Hunt* group tiger are unrealistically short. Barye corrected this compromise of real proportions, initially necessary to unify the complex *Hunt* composition. In addition, the side of the tiger's left haunch is pressed inward toward the body. The predator's head is rotated on its axis toward the left, and a wedge of plaster has been inserted into the nape of the neck, bringing the tiger's head closer to the peacock. The base of this model is of cast plaster and it includes the integral form of the peacock, with the exception of its now-missing left wing. As for the body of the tiger, the elaborately worked surface, irregularly touched with wax and coated with shellac, makes it difficult to tell whether it is a casting or a directly built

element. The tiger's tail is rather straight and emphasizes the long line of the animal's left legs, but it lacks the vigorous impact of the serpentine line of the *Hunt* group animal. It is a recent addition, doubtless not autograph.

The coat of wax on the plaster model varies in thickness. Heavy wax appears at the shoulders and haunches of the tiger, expressive focal points in the design ultimately as significant as, say, the abdominal muscles for a classical male nude. Spontaneity and brio mark the autograph modeling of such passages. In the model's present state, however, these areas are crushed and rubbed, lacking in a final, expressive definition. Other areas of the model have a thin layer of wax, barely deep enough to record the intaglio shapes of the tiger's stripes. Incised stripe contours are also cut with a stylus directly into the plaster of the tiger's back, and the cruder, grainier quality of these stripes contrasts with the smoother, more fluid incisions in the wax for a beautiful range of textural qualities. On the monumental bronze *Lion Crushing a Serpent* of 1832 (*Figs. 23 and 24*), there is a similar contrast in the sharp, crisp look of the swirling pattern of the pelt at the side of the lion's body—a passage probably cut directly into the plaster model—as opposed to the waxy look of the lion's head and mane and the waxy surface of the base. It is typical that Barye would reiterate this finely discriminated expressive dimension in both his miniature and monumental designs of the 1830s. The peacock's projecting left wing is missing in the model, and the gap has been filled out with plaster in a rough repair to this somewhat damaged and rather freely assembled model. The qualitative difference in the repaired areas and the highly refined tiger's form is enormous.

A comparison of this model with a related bronze cast (San Francisco, California Palace of the Legion of Honor),[5] shows that the plaster model repeats the contour of the bronze only from the tip of the tail to the highest point of the middle back. From that point forward to the tiger's head, the plaster forms are set somewhat closer to the base. For this change, a wedge of plaster was inserted into the nape of the neck to give the tiger's head a further downward tilt. Whereas the deadly intimacy of the tiger's embrace of its prey is compelling in the plaster, a different effect is felt in the bronze, a more exaggerated and expansive liveliness of mood, for the bronze tiger's head is raised higher, as though to menace some unseen intruder. Thus in one stage of its refinement, changes to the tiger isolated from the *Hunt* group were made to correct glaring anatomical discrepancies. In another stage, after a bronze had been cast from the model, further changes solely related to the feeling statement or mood of the newly invented animal combat were made, reducing its extravagance of mood and rendering it more subtle in effect.

A distinctly decorative emphasis is important in the plaster model as well, with dramatic action overstated almost out of neglect. Similarly decorative, rolling surfaces and lush textures appear in Barye's related oil on canvas (San Francisco, M. H. De Young Museum),[6] where movement is nil and meaning is carried wholly at the level of lavish surfaces, predicting, say, the style of Gustave Moreau's *Dance of Salome* rather than reflecting the romantic action of Delacroix's *Lion Devouring a Rabbit*.

Sleeping Jaguar (*Fig. 57*) provides the passive extreme in this sequence of feline predators in action.[7] At the decorative level it offers an alternative to the striped tigers in the graphic,

spotted markings of the jaguar's pelt. Each spot has two concentric ellipses enclosing a third circle of radial hachure marks. Coloristic patination enriches several casts of this design, a further decorative emphasis.

A drawing, *Recumbent Feline* (Walters Art Gallery, 37.2182), apparently made after a living animal, captures the lowered head and the placement of the forepaws of the bronze. Interestingly, only those portions of the drawing have retraced contours, while the hind leg and tail areas are only vaguely shown. It is as though the animal awoke and moved away during the course of the drawing.

Closest in silhouette among the drawings after *Feline Predator Feeding* (Fig. 162) is the fully recumbent pose, with the shoulders the highest point. In the bronze, however, the hindquarters are set to the side, flat on the ground, and are not gathered and upright as in the drawing. Two other drawings of dissected feline specimens show the carcasses arranged in recumbent positions not unlike that of the bronze: one a measured drawing inscribed *lion de l'amiral Rigny*, illustrated in Ballu, and another inscribed *tigre* (Louvre, RF 8480, fol. 3v).

Panther of India, Reduction (Fig. 58) portrays a tiny, resting feline of sphinxlike regality.[8] One can almost feel the afternoon sun under which it dozes. Its head is raised, but the neck is drawn back somewhat. The left foreleg is on its side, turned with the pads inward toward the body, a persuasive symbol of the creature's total relaxation, like the line of its tail that falls easily about and behind the base. As for its position in the series of related designs, this tiny panther merges an angular organizing element of *Tiger Devouring a Gazelle* (Fig. 55), in the parallelogram of its trunk, with the arabesques and domical muscles of *Tiger Devouring a Gavial Crocodile, Reduction* (Fig. 54) and *Tiger Attacking a Peacock* (Fig. 56). Two disparate modes of organizing feline forms are mingled in an enlivening contrast for this diminutive design. A drawing of several cursive, arabesquelike poses taken by a spotted feline scratching itself (Baltimore Museum of Art, Lucas Collection, Barye Album, fol. 22r) as it rubs against the wall of its cage records this type of feline movement and form.

Two rapid contour drawings of a living recumbent feline (Walters Art Gallery, 37.2199) show a creature with its head raised and drawn back and its forepaws crossed, similar in mood and aspect to this bronze. The flexed hind leg position appears in two drawings in a series made after another feline predator feeding and viewed in motion (*Fig. 156*). In fact, the exchange of motifs and positions among various feline species becomes apparent in the relation of Barye's drawings to his bronzes in general.

Recumbent Doe with Raised Head (Fig. 59) possesses a lyrical alertness, a delicate elegance of attitude.[9] Here Barye treats a docile creature, normally the prey of his feline predators, with its own distinct identity as a protagonist. The balance of anatomical precision with expression, the handling of surfaces and modeling, and the narrative concept link it with the other designs in Group 5.

A delicate, rapidly made drawing shows an alerted doe resting beside a sleeping fawn (Walters Art Gallery, 37.2035A), with both creatures facing in opposite directions. This is precisely the concept of the related bronze *Recumbent Doe and Fawn* (Walters Art Gallery,

27.29). Barye treated both deer singly as well, as in *Recumbent Fawn* (Walters Art Gallery, 27.26).[10] To return to the drawing, the contours of the deer are treated in a rhythmical, faceted way, one tending toward the rectilinear rather than toward arabesques. In the head of the doe in both bronze and drawing, Barye enjoys the echo and play of the conical snout against the opened angle of the raised ears, and against the conical forms of the ears themselves. An animating aspect of the larger design of the doe is the play of its rectilinear shape against the cursive forms of the retracted legs.

A schematic, measured dissection drawing of a standing deer (Walters Art Gallery) has proportions much like those of the bronze doe, and it reflects the same alerted stance, with raised head and extended neck. Without doubt, this design also benefits from the cycle of dissection drawings made for *Poised Stag*, of 1829 (*Fig. 12*).

Virginia Deer Biting Its Side (*Fig. 60*) is similar to *Recumbent Doe* in the ease and natural-ness of the mood of its recumbent figure.[11] A tranquil, lyrically natural moment is depicted, as the deer nibbles gently at its side, preening itself. The spatial, gestural aspects of the form are highly expressive and three-dimensional. Viewed from above, this twisting pose reveals a vigorous, swinging pattern of both cursive and rectilinear elements, a dramatic projection into space by the antlers, rear legs, tail, and ears. It is a fully three-dimensional amplification of the potential present in the more restrained *Sleeping Jaguar* (*Fig. 57*), one rendered considerably more lively in the sculptural sense by the contrasts of the lines in space—the antlers and elevated legs—with the closed form of the deer's body, an expressive contrast not possible of course with the anatomy of the jaguar.

A drawing after a live deer (*Fig. 178*) is closely related to this design, for it shows virtually the same action, although in mirror image, but with the stag licking rather than nibbling at its side. In the drawing the body of the deer is arranged in a vertical plane, while in the bronze its body is turned on its side, flat on the earth; and it shows both the left legs extended toward the front and not folded as they are in the bronze.

GROUP 6: FROM MINIATURE TO MONUMENTAL

Group 6, a major cluster of Barye's designs of the 1830s, can be linked with the miniature relief *Walking Leopard* (*Fig. 62*), 1831, and with the monumental bronze relief for the July Column, *Lion of the Zodiac* (*Fig. 25*), 1835–40. These compositions in both miniature and monumental scale embody a planar presentation of the silhouette and an abstract baseline or plinth symbol, concepts from ancient prototypes, such as the *Walking Lion* cameo from the Caylus Collection (*Fig. 218*). The latter is a characteristic instance of Barye's susceptibil-ity to antique sources in miniature format, and of the interdependence of his works at various scales. The reliefs have boldly cubic simplifications of plane and volume, even an architectural abruptness of relief projection, probably signaling Barye's response to the plea of Gustave Planche in 1831 for a simpler style and to the still earlier admonitions of the

theorist Emeric-David for the same qualities of style in sculptural relief. A more complete break with the painterliness of *Milo of Crotona* (*Fig. 1*), the medallion relief of 1819, is difficult to imagine.

A severely planar format, occasionally relieved by a slight turn of the animal's head, unifies the designs in the round. Clarified negative shapes are described between animal and base. Action ranges through pinioned, standing, striding, and running postures. A series of works renders the giant elephants in progressively more vigorous motion, first with three feet upon the ground, then two, and finally only one. Beyond the blocky relief style, further traits are evident in this group: the arabesque contours and free movement of the *Roaring Lion* relief, the lean, taut look of *Striding Tiger*, the padded softness of *Striding Jaguar*, and the animated enormity of the elephants. Roles vary notably in these animal protagonists: a wolf is the romantically pathetic victim of a trapper; portraits of pacing wild animals are menacing and awesome; and an allegorical lion symbolizes the nobility of the fallen men of the July Revolution of 1830.

Wolf Caught in a Trap (*Fig. 61*) shows the animal cringing as it seems to howl.[12] It dances in pain, its hackles raised, its free foreleg rigidly braced as though to press away the hurt of the caught left leg. The silhouette is elegantly perfected, beautifully closed, except for the focal open jaws, a closure suggesting Sir Kenneth Clark's epithet, the "contained, cameo quality of ancient art." The inward curl of the wolf's tail implies a movement along the swelling curve of the belly, chest, and neck, which focuses in the superbly pained, howling mask. A choppy rhythm of light and shade is reflected from the richly modeled fur and muscle groups and from the irregular mound of the base, animated in a way suited to the urgent outcry of the trapped beast.

A tiny compositional drawing of a bushy-tailed wolf or fox with its cub (Louvre, RF 4661, fol. 6r) shows both creatures tearing at some fallen prey. It echoes the long, curving contours of the bronze and perhaps predicts something of its narrative intensity, despite the reversal of roles in the bronze, where the feeding predator has become the pathetic, trapped quarry of a hunter.

Walking Leopard (*Fig. 62*) is a relief of abrupt and forceful design.[13] The menacing look of the leopard's raised head and the energy of its striding motion are romatically lively. An ancient relief format from a carved cameo is transplanted to the scale typical of Barye's miniature bronzes. Yet the heraldic aspect of the cameo format, with its abstract plinth or shelf, seems to be in conflict with the naturalism of Barye's leopard. Of course the leopard is not merely naturalistic; it is freely, artfully transcribed, with a series of long whiplike arabesques. A few internal contour lines serve as accents. The fluidity of these lines suggests the more extreme flow in the drawings of a spotted feline scratching itself against a wall of its cage (Baltimore Museum of Art, Lucas Collection, Barye Album, fol. 22r). Whereas the feeling of the drawings is one of the collapse and compression of the relaxed body of the animal, that of the relief is more expansive, since the animal reaches or stretches along the plane surface of the design.

The larger contour outline is drawn with precision in the bronze, as are the negative

shapes described by the legs and tail. Also apparent is the virtually complete divorce of silhouette and setting of the figure and its three-dimensional ambience. Two major planes of relief projection are established—that of the near side of the body, and that of the inner surfaces of the farther legs. Little remains of the atmospheric nuances of painterly relief seen in the works of the 1820s.

Roaring Lion (*Fig. 63*) shows a strong, swinging silhouette line and a balanced attention to a relaxed naturalism, to boldly plastic masses, and to accents of painterly detail, as in the mane.[14] The relation of the figure to its field has a greater implication of space than has the crowded, cameolike *Walking Leopard*, especially in the area above the lion. Virtually the same stance governs *Roaring Lion* and the relief of 1831, despite the half-again larger scale of the plaster proof. The elevated head, the rapid striding movement, and even the line of the tail are the same. The perfect verticals of the near foreleg and the lower, near hind leg appear in both, as do the parallel angles of the farther legs. Whereas the leopard's muscle groups have a flattened, slablike simplification, *Roaring Lion* has distinctly domical, globular muscle groups, as in the upper foreleg, the rib area, and the upper hind leg. While only graphic stippling comprises the texture of the leopard's pelt, there is a lush surface in the lion's pelt and an exquisitely varied development of the tufted mane, which is reminiscent of the painterly relief style of the 1820s, yet bolder and more powerful. In fact, even in the somewhat stylized, rolling contours there is a subtlety of refinement quite beyond that of the leopard, although they initially suggest a close resemblance. This is surely one of the freest and most impressive of all the lion images Barye would create. Only its slightly excessive qualities of lithe slenderness and of a certain arabesque fluidity would be altered in the great *Lion of the Zodiac* relief (*Fig. 25*) and in its still more powerful reduction.

Lion of the Zodiac (*Fig. 64*), a smaller relief than the one Barye created for the July Column, has a considerably shorter, blockier lion; the torso is shorter and deeper, and the shoulder is higher.[15] It is an altogether new image and not a mechanical reduction. A great change occurs in the inward-turning, brooding, preoccupied look of the lion, almost a complete reversal of the baroque sense of a gaze projected boldly outward into the spatial realm of the spectator. The lion's head is kept more nearly parallel with the plane of the background, aiding the mood of introspection. In comparison with the monumental version, a relatively unsuccessful change is the crushed look of the cheek of the lion, an example of an excessive or inappropriate passage of flattened relief. The tufts of the mane are given a rhythmically insistent, stereotypical blade motif, unlike the lush, free grouping in the monumental lion's mane. An antique precedent for this mane stylization is seen on the well-known Roman lion in Florence (Loggia dei Lanzi). Other striking changes are the deeper and flatter forms of the head, mane, and trunk. There is a retention of the long cursive line of the back, mane, and tail, but the back arches upward more vigorously with a more robust effect. The accent of the tail's tip is reversed and points downward. This is a lion less veristic, less natural in movement and gaze. It is almost a strictly geometrical "correction" of the freer monumental lion. Straight lines are more pronounced and are simpler and more prismatic in effect, as along the lion's snout and chest and along the bottom of its trunk between the fore and

hind legs. The torso is a parallelogram, whose raking sides continue in the lines of the lion's left foreleg and its right lower hind leg and parallel the borders of the band of the zodiac on the background.

A larger bronze reduction after the monumental original, with a length of 25½ inches (64.8 cm), and cast with an integral frame at all four sides (Pivar, p. 244), apparently was offered only by Barbedienne after Barye's death, for it is listed in the Barbedienne catalogue of 1893, page 8, as "Lion de la Colonne de Juillet No. 1, 27 × 55 cm." This version does not appear in any of Barye's sales catalogues. In style, the geometricized contour, the flattening of modeling, and the stereotypical mane are similar to the smaller design of Barye's catalogues. Yet it resembles the monumental original more strongly in showing a lion with a longer, shallower torso.

Bull Pawing the Earth (*Fig. 65*), when compared with the preceding lion, might at first glance seem absurd.[16] Yet Barye at one level conceived these animals as variations upon purely formal themes. The tendency toward a verticalized, planar torso, evident in the reduction of *Lion of the Zodiac* (*Fig. 64*), is still more dominant in the slablike mass of the bull. The rear legs echo the position of those of the relief, although the choice of braced forelegs is reversed. The major line along the forehead and bridge of the nose of the bull is set at almost the same angle to the horizontal as is the line of the lion's snout and chest. The incised lines of the folds of the neck and jowls comprise a schematic inversion of the more plastic, tufted mane of the lion. An unreal heraldic quality inheres in the accents of the rather high position of the bent foreleg and in the composed curl of the tail. In terms of the place of this design in the development of the series in Group 6, the precise balance of plastic and graphic accents in the modeling of the bull provides a transition from the simplifications of *Lion of the Zodiac* relief to the knotted intricacies of *Striding Lion* (*Fig. 66*).

An elaborately finished tonal drawing of a standing bull (*Fig. 169*) is painterly in character and was perhaps inspired by a painting by Peter Potter, whose name Barye inscribed on one of his sketchbook pages. The same arrangement of the hind legs, the same verticalized, planar mass of its trunk, and a similarly loose feeling in the modeling of the hide appear in the bronze. Even the tail is carried high in both.

An antique cameo known to Barye in the Caylus Collection, *Bull Pawing the Earth* (*Fig. 204*), shows the bull in this very attitude and standing upon a symbolic plinth. The musculature of the bull's side has a rippling, free look, roughly like the meandering folds of Bayre's bull. This bull's head is lower, however, and the position of the forelegs is reversed, which lends the silhouette a more typically antique closed look, like a trapezoid resting on its longest side. Barye's bull, its braced foreleg pulled back, emphasizes the menacing look of the lowered head more strongly in a romantically appealing way.

Striding Lion (*Fig. 66*) depicts its subject in a stance nearly identical to that of the relief *Roaring Lion* (*Fig. 63*), with the single exception that the head is lower, for this lion looks straight ahead rather than upward.[17] The long line of the tail is virtually unchanged from the relief. The chest and shoulder are slightly deeper than those of *Roaring Lion*, but both share the long midsection of the monumental relief *Lion of the Zodiac* (*Fig. 25*). The

intricate handling of the whorls and tufts of the mane is similar in both the striding and roaring lion images, an accent of painterly naturalism somewhat at odds with the hieratic, striding stance of each. On the monumental lion relief Barye uses one large, pendulous tuft of mane just ahead of the ear to dominate the entire passage, whereas on all the smaller variants he prefers to play a uniformly vibrating sort of animation over the entire mane. A comparison of the several related designs makes it apparent that *Striding Lion* is far closer in style to the monumental *Lion of the Zodiac* than are the two free reductions of it; the reductions are much blockier and are conceived with different proportions. The focal motif of the tensed shoulder muscles, shared by the roaring and striding lions through their similar stances, is treated differently in each, the former with domical, knotted forms and the latter with flatter and less regularly shaped masses. The flattening points to the more planar handling of the reductions of *Lion of the Zodiac*.

An antique *Striding Lion* (*Fig. 264*) illustrated in Visconti's *Musée Pie-Clémentin* (tav. XXIX), bears a strong general resemblance to Barye's bronze, which repeats the stance of the forelegs and the motif of the tip of the arched tail touching the hind leg for support. However, the ancient lion's mask is more compressed and spherical than is Barye's boldly angular, projecting mask.

Striding Tiger (*Fig. 67*) captures the alert, searching mood of its long and lithe subject.[18] The tiger gazes intently forward. As a counter to this forward projection, the straight line of the whiskers throws the eye back along the vigorous undulations of the lower contour of its silhouette. Atop the shoulders ripple powerful plates of muscle. The paws alight gently and with tension, as though the tiger were about to break into a run. Barye does not fail to dramatize romantically this man killer. Each accent of internal line and every slight variation of texture stands out vividly, as do the taut flaps of skin between the hind leg and the side of the trunk, the long whiskers, the slightly open jaws. A dominant contrast is that of the long cursive contours of the head, neck, trunk, and looped tail with the abrupt angles of the legs, which are arranged in the hieratic, striding stance.

A drawing of the forepart of a flayed tiger, inscribed *tigre*, shows three views of the flayed foreleg and shoulder muscle groups (*Fig. 155*), a focal area in *Striding Tiger*. Only one measurement is noted, the girth of a foreleg just above the paw. However, Barye plainly invents expressive musculature, and by no means does he merely duplicate a flayed appearance on the bronze. His inventions benefit from his command of the facts and do not simply reiterate them. A second drawing inscribed *tigre*, possibly of the same specimen, shows only the head of a tiger with the jaws opened wide in frontal and lateral views (Louvre, RF 8480, fol. 7r). A few measurements are noted on this schematic drawing, such as the width and length of the mandible and the width of the mouth opening. The small bronze *Striding Tiger* (*Fig. 220*) illustrated in the Caylus Collection has a more threateningly vicious stride and mood than has Barye's bronze.

Striding Jaguar (*Fig. 68*) portrays a cat less lean and bony than the tigers and lions.[19] Its legs are thicker and its head slightly smaller in relation to its body. The skin is looser, the bones padded with a denser, softer tissue. Since its curves are more heavily rounded, even pneu-

matic, and the muscle masses are less sharply defined, a number of graphic touches enliven the design, such as the three long gouges denoting folds in the skin just behind the foreleg and the raked or combed texture applied in varying directions over most of the animal.

Indian Elephant Running (*Fig. 69*) shows its subject moving at a considerably faster pace than its walking counterpart in the Walters Art Gallery (27.99; illustrated in Pivar, p. 160), perhaps at full speed.[20] Only two of its feet touch the ground, and both trunk and tail are horizontally extended to dramatize its rapidly shifting balance. Subtleties of surface modeling are more richly achieved in this than in the walking version. A sense of the heavy skin moving, stretching, and falling loosely over the bones of the elephant is both vivid and naturalistic. Few abstract domical mounds embellish the form, and touches of linear accent are sparse and sensitively applied.

The measured contour drawing *Indian Elephant* (*Fig. 179*) emphasizes the forms of the head viewed from above, below, laterally, and in a slightly turned, three-quarter aspect. Two sets of measurements are inscribed, one in ink and the other in pencil. While both use different quantitative systems, they do preserve the major proportions and ratios of the elephant.

African Elephant Running (*Fig. 70*) depicts the most rapid movement of all the elephant designs. Its great ears are laid back, its tail and trunk in violently swaying serpentines.[21] Only one hind foot touches the ground, in a nearly antisculptural extreme of symbolized movement. Despite this vigor of action, the design nicely preserves the "contained, cameo quality of ancient art," as opposed to the more stark, interrupted silhouette of *Indian Elephant Running* (*Fig. 69*). This design is perhaps a translation of the arabesque aspect of the *Roaring Lion* relief into the realm of the giant pachyderm. The modeling of the folds of the skin about the eyes, ears, legs, and trunk is naturalistic and sensitively achieved—in final effect, poles apart from the more obtrusive sense of an invented domical treatment of musculature in *Indian Elephant Walking* (Walters Art Gallery, 27.99).

A drawing inscribed *Eléphant d'Afrique* (Louvre, RF 8480, fol. 29r) has a simple, rapidly drawn contour outline, incidentally showing the legs arranged as in Barye's bronze *Indian Elephant Walking*, which confirms the sort of interchangeability of stances and other motifs already seen in connection with his feline predators. The sketch serves simply to record certain major measurements and proportions, which, as was true of the Indian elephant drawing, are given in two systems of measurement—perhaps centimeters and *pouces et lignes*, noted in both pencil and ink. Thus Barye's several species of pachyderm reflect scientific preparation.

GROUP 7: FROM ARABESQUE TO VERISM

Two dated works are included in Group 7: the miniature *Walking Panther* relief of 1831 (*Fig. 71*) and *Listening Stag* of 1838 (*Fig. 78*). As was true of the designs in Group 6, they

have a planar format like an ancient cameo and a hieratic, striding stance. The stances of these animals are conventionalized, yet embody sensitively adjusted negative forms, often triangles, and frequently the motif of parallel or nearly parallel, braced front legs. Two late equestrian figures first listed in Barye's sales catalogue of 1865, *Caucasian Warrior* (*Fig. 79*) and *Horseman in Louis XV Costume* (*Fig. 80*), share the hieratic stance of many of the earlier creatures. A range of styles is apparent: the slablike surfaces and cursive arabesque outlines of *Walking Panther*; the arabesques of the spherical *Turkish Horse*; the sinewy verism of *Greyhound Devouring a Hare*; and the rippling, knotted muscles in *Lioness of Algeria*. Emphasis and characterization vary in these protagonists, from the romantically gruesome greyhound feeding upon its prey, to the menacing and vicious look of the lioness, to the lyrical, positivistic precision of *Half-Blood Horse*, and the romantically agitated, rearing *Turkish Horse*. Thus Group 7 is closely unified in its creatures' stances and their negative forms, although style and mood change greatly among them.

Walking Panther (*Fig. 71*) expresses a splendid tension that is felt in the long, fluid contour line of the panther's head, arched back, and tail.[22] A powerful yet free muscularity of movement and the panther's dark mood are paramount. A comparison of this design with its mirror-image mate, *Walking Leopard* of 1831 (*Fig. 62*), underscores the panther's shorter legs, the higher arch of its back, the tighter spiral of its tail, and the identical stance. A more tightly contained quality is present in the panther design, one heightened by the trimming of the edges of the abstract plinth, which thus cannot imply a landscape setting or a horizon. Although the arabesque internal lines about the rib cage and in the upper hind leg are the same in both, a great change of mood is accomplished in the image of the panther's thick, retracted neck, covered with a dense plate of muscle. The downward cast of the panther's gaze also offers a brooding, contrary mood to the searching, threatening one of the leopard.

A loose, rapidly made contour drawing, now very faint, shows a panther stalking its prey or, more probably, moving down a ramp at the zoo (Walters Art Gallery, 37.2139). It captures a stance remarkably similar to that of this relief. The high arch of the lower back and hindquarters dominates, as in the relief, and the high bulge of the shoulder, the shortened neck, and the position of the rearmost hind leg are similar. Yet the ritual striding stance of the relief is different, for this animal is crouching. One of its forelegs is raised as though stopped in motion by a camera, and its head is lowered still more, as though it were looking directly at its forepaw.

An elaborately developed ink drawing, itself an unusual choice of medium for Barye, signaling a special intent or function for the drawing, shows a walking panther (*Fig. 180*). It is clearly a reversal of *Walking Panther*, complete to the tight loop of the tail. Yet the drawing gives the animal a longer and shallower torso, suggesting a different species. It intricately develops the spotted pelt, and it denotes a landscape setting in a way that would be most appropriate for a painting.

Stalking Jaguar (*Fig. 72*) conveys a feeling of stealthy movement; the animal appears to halt and crouch at the very instant we discover it.[23] The head turns toward us, creating a

powerful counterthrust to the forward extension of its left foreleg and the long planar mass of its body. The long line of the forepaw echoes in the tail, brushing the ground between the hind paws. The view from the front of the animal shows a perfect profile of the jaguar's head, a conscious parallel of the ancient pictorial convention for human figures—a profile face set upon frontal shoulders.

This terra cotta is similar to *Walking Panther* (Fig. 71) as a mirror image and in such details as the high arch of the back, the platelike muscle masses of the shoulder, trunk, and flank, and even the long tail. The terra-cotta jaguar is greatly attenuated, whereas the relief panther is compressed, as though it were stretching upwards. Still closer to the terra cotta is the drawing *Walking Panther* (Fig. 180), in which a longer, more sinuous feline walks in the same direction as *Stalking Jaguar*. In view of its stylistic proximity to *Walking Panther* and its rigorously planar, relieflike conception with stark surfaces, *Stalking Jaguar* should be dated earlier than the terra-cotta groups of predator and prey, which move more freely in three dimensions: *Bear Overturning a Stag* (Fig. 99) and *Jaguar Overturning an Antelope* (Fig. 103).

Greyhound Devouring a Hare (Fig. 73) shows a predator totally absorbed in the act of tearing at the belly of its prey as it feeds.[24] The dog almost seems to tremble in its excitement. Its anatomical details are impressively veristic: the taut webs of skin, the stringy musculature of the hindquarters, the boniness of the spine, ribs, and haunches. The dog's planar and bony angularity contrasts forcibly with the softness of the large hare. The sprawling carcass of the hare creates a sense of spatial ambience as it repeats the implied diagonal line connecting the paws of the greyhound. The design offers a sensitively devised negative form below the dog, superbly balanced with the size of the base and the mass of the greyhound. A strange touch with respect to the meaning of the work is the dog's collar. The greyhound, by tradition, is associated with the aristocracy and with the imagery of the hunt and racing. Yet in the narrative situation of Barye's bronze, the dog does not aid or amuse man. It is merely an instinctual, feeding predator, an archetype in the romantic sense. Since the overtones of the collar as an image are those of man's capacity to control the bestial and savage in the world, perhaps its presence here is an admonition in the romantically moralizing vein not to indulge such predatory instincts. A simple alternative to such elaborately moral meanings would be that of the naturalistic moment of a dog feeding and nothing more. Yet the style or manner of its feeding as it tears at the entrails of the hare strongly implies a primal role: that of a predator devouring freshly killed prey.

A drawing of two standing greyhounds (Walters Art Gallery, 37.2030A) was probably made after a painting rather than nature, to judge from the harmony of the relationship of the dogs, their refined mood, and the stylization of their anatomy. Greyhound images known to Barye in the art of the rococo goldsmith Thomas Germain, such as his silver *Table Centerpiece*, 1729–31, offer a precedent for the generally accurate anatomy, the veristic detail, the sculptural impact, and even the psychological dramatization of his sculpture in miniature scale.[25] Several of Germain's works were in the collection of the House of Orléans and King Louis-Philippe, for whose son Barye created his *surtout de table*.

Wolf Seizing a Hare (Fig. 229), a thematically related precedent, is a Roman small bronze

fragment in the Caylus Collection (vol. 4, pl. LXX: III). The very existence of the antique type would lend an important sanction to Barye's choice of this theme, which otherwise might seem a merely extravagant romanticism.

Lioness of Algeria (*Fig. 74*) is a strangely persuasive image at the emotional level, not merely hieratic, but psychologically engaging and alive.[26] The cat looks manacingly ahead, its rigidity of stance and the terse line of its tail symbolizing well the intensity of its concentration. Geometry is clear in the organization of the proportions and the hieratic silhouette. The proportions of the rectangle of the head, from the nose to the ears, are similar to those of the rectangle containing the body and legs. The stance is artificial, almost dancelike in the elegantly planned placement of the paws. Against the larger rectilinear harmony of the design are played the meandering accents of the short internal contours and the long arc of the extended tail. One notes the expressive perfection of the gesture of the tail, the holding of the head, and even the gaze.

The suite of at least eight drawings of the dissection of a lioness of the Admiral Rigny, discussed in connection with *Lion of the Zodiac* (*Fig. 25*), has a relatively lesser significance here, since the major emphasis is placed upon a beautifully articulated mood, rather than upon the data of the physical dimensions of the animal.

Seated Basset (*Fig. 75*) captures a reflective, slightly sad mood.[27] Relieving accents countering the strictly hieratic are the slight sideward turn of the head, the extended tail, and the deep indentations of the muscle groups of the shoulders, forelegs, rib cage, and haunches, easily the richest and most plastic passages on the entire creature. In its power, this handling of canine muscle rivals that of *Lion of the Zodiac* and *Striding Tiger* (*Fig. 67*). Against the forceful muscle of the body is played a quick, rythmical texture of widely spaced, short flicks of the burin. Such graphic accents become plastically transformed into the positive, linear ridges, like wires of wax, laid about the nose, eyes, and ears to enrich the delicately realized structure of the head. The basset's thick, plated muscularity, its heavy type and handling, are an antithesis to the wiry sinews of the greyhound.

The stance of Barye's basset has an important antique source, the engraving *Seated Dog* (*Fig. 230*) in Visconti's *Monumenti gabini della villa Pinciana* (no. 43). Although the ancient sculpture represents another sort of dog with longer legs, it does show the lowered head, nearly extended forelegs, and alerted look of Barye's bronze.

African Buffalo (*Fig. 76*) applies an unreal formality to its gentle subject, from the planned, rather rigid placement of its hooves and the consequent arrangement of its legs to the extended neck and pointing head.[28] Yet a naturalistic concept emerges as well, an apparently inquisitive action, as though the animal were catching a scent on the breeze or were about to nuzzle another of its own kind. Modeling tends toward a soft, fluid handling of muscle, quite unlike the hard, chiseled look of *Standing Basset* (Walters Art Gallery, 17.72), a related design.

A similar species of buffalo is used as the hunter's lure in Barye's magnificent *Lion Hunt* group of 1837 (*Fig. 104*) for the *surtout de table* of the Duke of Orléans. There it provides an

inert, helpless barrier to the action, for the feline and human adversaries wage their mortal combat directly across its back.

A pair of tiny buffalo drawings (Walters Art Gallery, 37.2137B) is related to this bronze. The lower drawing shows several buffalo in a landscape setting, as though resting beside a stream, in both standing and recumbent postures. It is a tonal image, which strongly suggests a source in a diorama or a natural-history display. The upper drawing shows a single buffalo, viewed in strict profile, which takes a more extreme stretching or pointing stance than does the bronze. Here the meaning of the stance is of hurried movement, a straining to move rapidly, which is not conveyed in the more restrained posture of the bronze. A key to the gap between the naturalistic plausibility of the drawing as opposed to the hieratic unreality of the bronze is the change in the attitude of the raised foreleg in the drawing.

A tonal drawing in pencil of this species of African buffalo (Louvre, RF 6073, fol. 41v) stresses the textural and linear play of the bull's hide at the side of the neck, under the jaw, and at the hip joints. The placement of the hooves in the drawing has been left unclarified, as though the animal had moved during the study, or perhaps Barye had decided simply to use the hieratic stance.

A small, veristic ancient Egyptian bronze, *Bull Deity Apis* (*Fig. 246*) in the Caylus Collection (vol. 1, pl. XII: I–IV), reflects Barye's preference for planar composition, but here the bull strides with a ritual vigor unlike the mood of Barye's resting animal. Elegant images of a heifer and a bull in Visconti's *Musée Pie-Clémentin* (vol. 7, pl. XXXI) also provided sculptural precedents for this type of animal.

Barye's related, squared drawing of a cow (Walters Art Gallery, 37.2181) shows the animal in profile, standing as it appears in the bronze. The drawing is contained within a rectangle with sides in the proportional relation of two to three, height to length, exactly the ratio governing the smaller, interior rectangles with which the entire drawing is squared. This is an attempt to find in natural form a system of harmonious mathematical units or ratios, one in keeping with the suggestions of theorist Emeric-David as to the close relation of mathematics and art among the Greeks. Its exploration of a theoretical extreme is precisely the interest of the drawing, apart from its links with the bronze *Buffalo*.

Dromedary of Egypt, Harnessed (*Fig. 77*) is elegant in its veristic detail and delicate mood.[29] The dromedary is patiently watchful while resting at its tether. Evocations of far-off Egypt suggest the paintings of Barye's teacher, Baron Gros, and those of Delacroix, and no doubt the Egyptian campaign of Napoleon. Details of the elaborate bridle, saddle, and the tiny tether about the right leg are razor sharp. They are complemented with the anatomical verism of certain focal passages, such as the elaborate folds of the knobby knees or the snout and lips. Yet the stance of the dromedary is the formal, hieratic one, its unreality adding an enlivening tension.

Listening Stag (*Fig. 78*) is a dramatic, humanizing characterization.[30] The stag stands quietly, head turned to the right and forelegs together. Slight departures from the design of the related *Alerted Stag* (Walters Art Gallery, 27.90) can be recognized in the less rhetorical

stance of the parallel forelegs and the substitution for the too-elevated head position of this more naturalistic sideward turn. The alterations to the basic model are few: the left foreleg, the angle of the juncture of the neck and shoulders, and the angle of the joining of the head and neck. Otherwise the two are virtually identical. The similarities of Barye's four stag designs—including *Alerted Stag, Walking Stag,* and *Stag Standing at Rest* (Walters Art Gallery, 27.90, 27.116, and 27.93)—would unify the series for a collector, perhaps a sportsman, yet also provide notable variations of position and mood. The creation of a series of designs of the same creature shown in different stances was also true of the elephants in Group 6, as it was true of certain sequences of rabbits, panthers, tigers, and even equestrian figures.

A drawing of an alerted stag (Walters Art Gallery, 37.2046A), facing to the left, shows the animal standing on an inclined base. It has the braced and parallel front legs of *Listening Stag*, but it also has the high head with a perfectly horizontal upper contour as on *Alerted Stag, Left Foreleg Raised* (Walters Art Gallery, 27.90). It is a germinal drawing for both compositions. Similarly related to the alerted and listening stags is a drawing of a stag facing to the right (Walters Art Gallery, 37.2185B), shown with the left foreleg raised as in *Alerted Stag*, but with the head held at the more natural angle of *Listening Stag*. One hind leg is drawn to the rear, a motif common to all four bronze stags, linking this drawing to the entire series.

Caucasian Warrior, Equestrian (*Fig. 79*) has a helmeted, exotic rider wearing two pistols tucked into his cummerbund and holding a sword almost unseen, its scabbard pinned tightly against the saddle by his left leg.[31] His delicate mask betrays Mongoloid eyes and heavy lips, and he appears to look calculatingly into the distance as he pauses in his ride. The tiny alerted horse has an unusually long and full mane that touches its shoulder.

Barye's compositional drawing of a Caucasion warrior (Walters Art Gallery, 37.2327) is clearly a preparatory study for the bronze, perhaps made after a painting. The mood of this drawing is very different from the forced, agitated intensity typical of many drawings of the 1830s. Instead, it has a sketchy openness, a pervasive relaxation, a confident ease, showing Barye's taste for classical harmony, which marks his late works. Several changes from the drawing occur in the bronze. The rider's ungainly size relative to the horse is made more naturalistic and plausible. The gait of the horse changes from the gallop to a stationary position. A great plume adorns the crown of the horse's bridle in the drawing, but not in the bronze. The sculpture does reflect the helmet with its chain mail or leather cowl that falls about the rider's neck and shoulders and the wide skirtlike pantaloons of the rider in the drawing.

A second drawing, *Oriental Saddle* (Walters Art Gallery, 37.2352), gives detailed attention to the unusual patterns of its decorative embellishment. The most visible parts of the saddle evident in the bronze are the swinging curve of the lower edge of the saddle, the distinctive stirrup, and the high backrest.

Horseman in Louis XV Costume (*Fig. 80*) portrays a rider, perhaps a member of the royal guard, who carries a great curving horn over his shoulder and sits easily on his horse, as

though waiting for the royal procession to begin.[32] The horse's head is lowered, and its legs are arranged in the ancient stance seen in *Listening Stag* (*Fig. 78*). The detail is superb in the rider's costume, in the trappings of the horse, in the delicate modeling of the mane and tail, and in the structural articulation of the legs. This cast-plaster figure is inset into the base by means of plugs cast integrally with the hooves, which fit into sockets in the base. Wax is mounded over the seams. Touches of paint are visible on the rider's face. This is a fine example of the excellent craftsmanship of Barye's late miniature forms.

Half-Blood Horse (*Fig. 81*) shows the horse standing relaxed, in an almost dreamy mood.[33] A heavy, almost pneumatic roundness of the muscles of the chest and hindquarters marks Barye's image of this breed. He contrasts the massive portions of its body with the wrinkled and rather small head. Against the passages of spherical fullness and naturalistic puckering, Barye plays the sharp accents of the silhouetted tail, genitalia, pointed mane, the head itself, and the hieratic stance. A delicate drawing, *Half-Blood Horse* (Walters Art Gallery, 37.2047A), is virtually identical in type and stance to the bronze. Redrawn, hesitantly achieved contours shimmer and vibrate elegantly. It retains the stance typical of the designs in Group 7 but betrays certain differences of proportion from those of the bronze horse. A flowing, reechoing quality of contour, reminiscent of Rubens, animates the sketch.

Two fragmentary studies of a horse's head and neck (Baltimore Museum of Art, Lucas Collection, Barye Album, fol. 16r) appear on one page. Calm in mood, both are extremely close to the shape and proportions of the horse's head and snout in the bronze. In one study, the rippling tresses of the horse's mane cascade across the side of its neck. The design shows isolated, widely spaced tufts of mane, exactly the opposite of the closed, triangular form of the mane on the bronze. The second study shows the bald, muscular forms of the neck and shoulder in a way strikingly similar to this horse and to its variant, *Half-Blood Horse with Lowered Head* (Walters Art Gallery, 27.68).

Windswept mane and tail variations are shown on two pages of horse studies (*Fig. 181*). On the first page the horse's mouth is gaping, and its eye is that large, frenzied eye motif used by earlier romantic artists such as Fuseli and David. The mane has long, smoothly flowing curves, blown in the direction faced by the horse. While on the second sheet the horse's mouth is closed, its eye is more naturalistic in its modest size, and it has a more tightly curled mane with abrupt, fluttering movements dancing across the horse's neck.

Another closely related horse study (Baltimore Museum of Art, Lucas Collection, Barye Album, fol. 16v) shows a large-eyed, frantic horse as though fleeing in fear from some predator, facing into a strong wind, its long mane fluttering out behind it along the side of its smooth, strongly muscled neck. In general, the romantic agitation of these flowing manes strongly suggests the influence of George Stubbs's painting *Lion Attacking a Horse* (Liverpool, Walker Art Gallery), a reminiscence of an event the artist supposedly saw on a voyage to North Africa. Stubbs's zoological treatise, *Anatomy of the Horse* (1766), would surely have interested Barye as well. These dramatic variations also lead directly to Barye's frenzied *Turkish Horse* (*Fig. 82*). A small bronze *Standing Horse* (*Fig. 232*), which Barye recorded in the Caylus Collection, is very like this one although its head is held slightly higher, and the hooves are side by side, a stance unreal in its perfect parallelism.

Turkish Horse (*Fig. 82*) shows a prancing, spirited creature in the dashing, romantic mode of the horses of Géricault and Delacroix.[34] Long, cursive contours define the powerful body. Its chin touches its neck as though tightly reined, or as though backing away from some threat in its path. Tendencies toward spherical shoulders and flanks, evident in *Half-Blood Horse*, are the dominant note of this swirling design. Contrasting accents appear in the flat plane of the horse's cheek, the linear passage of its mane, and the straight lines of the legs.

A principal departure from *Half-Blood Horse* is the stance, one reminiscent of the equestrian statue of Marcus Aurelius in Rome but naturalistically corrected to eliminate the impossible blockage pointed out by Falconet. Only the raised foreleg of Barye's Turkish horse is drawn backward somewhat more than the antique precedent. Barye knew this ancient stance from antiquities in the Caylus Collection: a carved gemstone, *Equestrian Warrior* (vol. 1, pl. LXII: III), and a small Greek bronze, *Victorious Racehorse*, branded XPE (vol. 5, pl. LXXXV: II). This ancient stance provides an important link of the prancing *Turkish Horse* with three of Barye's rider designs, the exotic *Tartar Warrior Checking His Horse* (*Fig. 85*), the comical *Ape Riding a Gnu* (*Fig. 88*), and the mythological combat, *Lapith Combating a Centaur* (*Fig. 106*).

Delacroix's rearing charger at the right middleground of his painting *Death of Charles the Bold*, 1831 (Nancy), is close in type and mood to those of Barye. A similar, closely haltered horse is used repeatedly, almost as a leitmotiv, in Delacroix's *Battle of Taillebourg*, 1837 (Versailles), and surely is a favorite type of Barye's.

GROUP 8: FROM FORMALITY TO VIOLENT ACTION

A more complex array of themes and a taste for more intricately developed silhouettes, spatial compositions, and lavish detail embellishment are evident in the designs of Group 8. Within these new shadings of emphasis are survivals of the planar and hieratic qualities seen in the works of Group 7. The range of moods in Group 8 is very full: The naturalness and lyricism of *Amazon, Equestrienne*, the fairy-tale medievalism of *Roger Abducting Angelica on the Hippogriff*, the humor or even parody of *Orangutan Riding a Gnu*, the hieratic yet violent action of *Charles VI, Surprised in the Forest of Le Mans*, the acrobatic yet ritual aspect of the twin, leaping riders of *Bull Hunt*, and the awesome tragedy of *Greek Rider Seized by a Python*. The several horses of these compositions derive directly from the drawings that inspired the half-blood and Turkish horses. Two dated works occur in Group 8, the 1833 Salon piece, *Charles VI, Surprised*, and *Bull Hunt* of 1838, which carries the late date of the bronze pour.

Charles VI, Surprised in the Forest of Le Mans (*Fig. 83*) shows the young king called "le Bien-Aimé," the son of Charles V and Jeanne de Bourbon, who ruled France from 1380, at the age of twelve, until his death in 1422.[35] Barye depicts the episode traditionally said to mark the onset of the King's madness. In August 1392, while traveling in the forest of Le

Mans, the surprise attack of a highwayman so filled him with panic that he collapsed and had to be borne in a litter the rest of the way. Shown in armor by Barye, Charles VI was regarded as a skilled knight. Sadly, however, his was a life of pleasures punctuated by intervals of madness—a plight that surely appealed to Barye's romantic interest in the irrational, a theme elaborately developed in the art of Fuseli and William Blake.

A half-naked assailant has waylaid the riding king. The robber tumbles onto his back beneath the horse's forelegs as he clutches its reins, bringing it to a halt. In the shocked surprise that would trigger his madness, the king raises his arms as though in the moment before drawing his sword. Extreme postures and moods mark both figures, which are more forced than the now subtly expressive animal image of the design. In fact, the king actually takes a formal, ritual stance of prayerful entreaty with both arms extended upward—the ancient *orans* pose—almost like a priest celebrating the Mass. His formality is juxtaposed with the naturalistic sprawl of the assailant, who braces his leg against the chest of the horse as it rides over him. This exciting episode from earlier French history is conceived in the "style troubador," a mode often used by Delacroix in his swashbuckling history paintings.

The image of the falling assailant, clutching the reins of the mount of Charles VI, suggests the kneeling captive beneath the raised foreleg of the horse in the equestrian *Marcus Aurelius* in Rome, probably as that captive was recorded in such Renaissance variations as Leonardo's drawings for his Sforza and Trivulzio equestrians.[36] Barye's assailant is clearly a formal elaboration on this element of the ancient equestrian type, and it affords a transition between the isolated, prancing *Turkish Horse*, the equestrian designs in Group 8, and other riders of the 1830s.

A drawing of a startled horse (Louvre, RF 4661, fol. 21v), its mane and tail tossed by a strong wind, is based upon George Stubbs's *White Stallion Frightened by a Lion* (Liverpool, Walker Art Gallery). This key drawing after a stirringly romantic painting provides a formal transition between the sequence of half-blood horses and the Turkish horse and this narrative group. Barye's drawing contains many of the features found in *Charles VI, Surprised*: the same small head and its carriage, the forward-pointing ears, the strongly arched line of the neck, the nearly spherical chest and hindquarters, the half-squatting hind legs, and the braced and lifted forelegs. A more decorative drawing, of just a horse's head and neck (Baltimore Museum of Art, Lucas Collection, Barye Album, fol. 15v) shows the rhythmic intervals of the curly mane fluttering in the wind, the interrupted play of flowing tresses set against the relieving, balder segments of the horse's neck.

An armored rider stands in the stirrups of his rearing charger in Barye's drawing after a painting by Rubens (*Fig. 182*). The knight, like Barye's *Charles VI*, is dominated by a single long line from shoulder to stirrup, powerfully conveying the rider's focused energy. Barye made a pencil drawing after an equestrian relief in marble in the Louvre, *Robert Malatesta, Duke of Rimini*, of about 1482 (*Fig. 183*). The relief reflects the tradition of Florentine frescoes of *condottiere* in the Florence Cathedral: Paolo Uccello's *Sir John Hawkwood*, about 1436, and Andrea del Castagno's *Niccolò da Tolentino*, about 1456. The drawing also echoes Donatello's heroic bronze in Padua, *Gattamelata*, 1445–50. Barye's drawing centers on the stance of the rider, which he reiterated in *Charles VII, Equestrian* (*Fig. 142*), a work probably shown in the Salon of 1833.

Another drawing of an armored rider (Walters Art Gallery, 37.2223A) shows the knight's legs extended and braced in the stirrups, a posture important for this design; and the knight wears long, pointed boots like those in *Charles VI*. The saddle has a curving backrest, much like the sculpture. Of course most striking of all is the more modestly conveyed mood of surprise, as at some obstacle in his path, symbolized by the downward turn of the helmeted head and by the arm raised before the face, almost as though the rider were pulling up the reins to halt the horse. This is an exploratory, narrative drawing, and it is linked with the sculpture by mood and by implications of action. A more factual drawing, *Standing Armored Figure* (Walters Art Gallery, 37.2327), shows a suit similar to that in *Charles VI*, with chain-mail sleeves and a deep-waisted breastplate. The relative size of the knight's broadsword and saber are noted as well. A precise contour drawing of lateral and frontal views, *Legs of an Armored Knight* (Walters Art Gallery, 37.2225B), includes elaborate measurements in the mode of some of Barye's zoological drawings. One unmistakable detail, the winglike plate at the side of the knee, has been carried into the sculpture.

Roger Abducting Angelica on the Hippogriff (*Fig. 84*) shows the hero and heroine tenderly clinging to each other as their fabulous, winged hippogriff carries them across the sea.[37] The two lovers look backward, perhaps fearfully, as they brace against the wind of their rapid journey. The long, soaring lines of the hippogriff's wings, tail, legs, and neck dominate the design, creating a powerful sense of movement and even suggesting that the creature is slowly alighting. In the spirit of sixteenth-century Mannerist taste, a dichotomy is created between the quickly gliding hippogriff and the coiled but static dolphin beneath it.

Barye no doubt knew Jean-Honoré Fragonard's marvelous suite of drawings for Ariosto's *Orlando furioso* (*Mad Roland*) of 1532.[38] Canto X provides the textual source of the image. Barye created a hippogriff like Fragonard's version of the fairy-tale beast of the Middle Ages, a winged horse with the beak and talons of a hawk. Barye also contrasted the armored hero and the voluptuous nude, a motif perhaps derived from Titian by way of Rubens, who varied it many times. Barye pressed the contrast, however, by having the nude Angelica actually embrace the armored Roger.

Apparent is a fairy-tale exquisiteness of detail in the elaborate mode of the hunt groups for the *surtout de table* of the Duke of Orléans, and a glittering play of textures—in the pocked coral-reef pedestal, the crisp armor, the smooth flesh of the nude, the rippled cloth covering Roger's shield, the rush of the breaking wave, the foam of the wave's crest, the knotted sinews and the feathers of the hippogriff, and the fatty turgidity of the dolphin-headed sea serpent. This design, in fact, may have been commissioned by the elder brother of the Duke of Orléans, the Duke of Montpensier, as a counterpart of his brother's *surtout de table* by Barye.

The swirling volutes on Roger's helmet, even its form with deep ear coverings, were surely suggested by the florid helmet worn in Ingres's famous *Roger Freeing Angelica* (Louvre),[39] shown in the Salon of 1819. Barye created a winged, basilisk crown for his helmet as a formal amplification of the serpentine decoration in the prototype by Ingres, and as a miniature echo of the hippogriff. Another recent painting provided a source for Barye,

Horace Vernet's *Mazeppa*, 1826 (Avignon, Musée Calvet), in this case for the "flying gallop" of his hippogriff.[40] The same gently falling long line marks Vernet's horse and Barye's fabulous mount. Similar also are the positions of the bent right hind leg and the extended right foreleg.

Barye's drawing *Frenzied Horse* (Baltimore Museum of Art, Lucas Collection, Barye Album, fol. 16v), shows its mane tossed by the wind, its eye enormous with agitation, and it is clearly a source for the same elements of the hippogriff. Indeed, it provides a transition from the related half-blood and Turkish horses to the hippogriff. The contours of the horse's head in the drawing are altered only slightly for the hippogriff. Even the angle of the raised ears is identical. Nor does the unlikely accent of the hawk's beak depart much from the silhouette of the drawing. Perhaps the most significant change from its predecessors is the elongation of the general form, as opposed, say, to the compressed sphericality of *Turkish Horse.*

Italian Mannerist sources were important to Barye for the design of his embracing lovers. Among his several studies of recumbent female nudes after Raphael, Titian, and other sixteenth-century artists, one drawing in particular closely reflects the pose of Angelica—that of *Recumbent Venus Kissing Eros* (Louvre, RF 6073, p. 20), he seated upon her hip. Barye altered only the position of Venus' left arm embracing Eros for his Angelica, a figure also seated in a slightly more upright posture.

Two drawings on another page in the same album treat variations of the embracing couple motif. One drawing was made after a reversed engraving (Louvre, RF 6073, p. 55) of the embracing Cupid and Psyche from the *Wedding Banquet* fresco by Raphael and Guilio Romano in the Villa Farnesina at Rome. Another drawing of a seated, embracing couple on the same page is not a reversal of the original source, but a transcription of an image by Baldassare Peruzzi, *Triumph of Bacchus*, on the frieze in the Sala delle Prospettive, also in the Villa Farnesina.[41] In the first drawing from the banquet scene, the legs of the two figures are arranged along a horizontal line like that of Barye's Angelica, although not of his Roger. The second study, Bacchus embracing Ariadne while seated in their triumphal car, has a general resemblance to the bronze.

Several antiquities that Barye recorded in the Caylus Collection offer important precedents for motifs in the design. A Roman bronze chest with centaur reliefs (*Fig. 233*) treats the theme of a passionate abduction over the sea, and the centaurs share with Barye's hippogriff the antique flying-gallop convention. A Roman small bronze, *Rape of Europa* (vol. 6, pl. LXXX: I, II), offers another precedent for Barye's amorous voyagers, in which the heroine is treated as a lyric nude. The flying-gallop convention occurs in several of the Caylus Collection objects, such as the Roman marble relief of a horse and rider (*Fig. 234*), which has a long soaring line like Barye's, although reversed in direction to suggest the gentle descent of the hippogriff.

The long-bodied dolphin of the base of Barye's bronze is a symbol of the lovers' journey over the sea and a static foil to their motion. It has sources in two arcuate reliefs of marble, where such creatures frame a central group of Roman war trophies (Caylus, vol. 1, pl. LXIII), and in a splendid Roman Bronze *Dolphin* of almost serpentlike proportions (*Fig. 235*).

Tartar Warrior Checking His Horse (*Fig. 85*) shows an exotic, swashbuckling, slightly sinister rider in armor.[42] He calls up the "yellow horde" of the Genghis Khan, sweeping across the vast steppes of Asia. The Tartar reins his spirited horse brusquely to a halt, almost in operatic bravado. He wears pointed Asian shoes, heavily padded trousers, and a long outer garment of fur over a shirt of chain mail. His bow hangs across the saddle on the left, his quiver at his right side.

Both the horse and the Tartar rider are formal variations on the types discussed in Groups 7 and 8. The long line of the nearly squatting horse falls at a slightly steeper angle than that in *Charles VI*. Its long neck is now curved sharply downward, rather than being fully extended or only partly drawn back, as on the mounts in *Roger and Angelica* and *Charles VI*, respectively. The horse's raised foreleg is flexed tightly, echoing the curve of its neck and the curves of the braced arms of the rider. The warrior himself is dominated by a long straight line that runs only from shoulder to knee, and not from shoulder to foot as in *Charles VI*. This line continues in the braced forelegs of the horse, creating one arm of the large X that governs a profile view of the design. The horse's tail is raised and massive, whereas it was raised but slender in *Roger and Angelica* or blown forward between the flanks in *Charles VI*.

A partial return to the spherical, prancing *Turkish Horse* is now translated into a more planar arabesque dimension, emphatic of the superbly articulated silhouette. That spheric aspect was still present in the mount in *Charles VI*, but it was supressed in the hippogriff. Parallel straight lines set off the rolling contours of the design, as in the braced left foreleg, the line of the mane and bridle above it, the right, upper hind leg, and the rider's quiver and reins.

Barye's exotic rider on a rearing horse has several precedents in contemporary romantic paintings. Géricault's 1823 painting of a Negro rider on a rearing "Marly" horse, resembles Barye's exotic concept and prefigures the stance and dynamic spirit of his horse.[43] Delacroix's mounted Turk at the right of his *Massacre at Scio* of 1824 (Louvre), and the focal white charger in his *Death of Charles the Bold* of 1831 (Nancy), closely resemble Barye's bronze. A Delacroix watercolor, *Rearing Horse*, has hind legs almost parallel with the ground and the unusual, tightly drawn-back forelegs of Barye's piece.[44] Such flexed forelegs also appear in one of Delacroix's studies in sepia watercolor, *Giaour and the Pasha*.[45]

Certain details of the saddle and armor in *Tartar Warrior* are freely selected from Barye's notational studies discussed in connection with *Charles VI* (*Fig. 83*). For example, the same saddle with a curved, flat backrest and pommel is used in *Charles VI* as well as for the riders of the François Ier period in *Bull Hunt* (*Fig. 90*), even though roughly 125 years and very different cultural contexts separate these figures and *Tartar Warrior*.

Barye's drawing *Phidian Horse's Head* (*Fig. 184*) is clearly related to this horse. However, Barye introduces a more decorative elaboration of the modeling of the nasal ridges along the front of the skull and a somewhat shorter, wider proportion than has the original from the east pediment of the Parthenon.

Greek Rider Seized by a Python (*Fig. 86*) presents a ghastly image, in the mode of the "grotesque" as Victor Hugo would define it.[46] The serpent has seized the rider's throat,

although the rider strains to pull its jaws away, and it has locked his sword-bearing arm at his side. An enormous coil is clamped around the belly of the horse and the leg of the rider, crushing them against a tree. For Barye, the image of man as the helpless victim of a predatory creature is unusual; he prefers a glamorous knight or a successful hunter. Has Barye romantically turned inside out an allegorical convention for the triumph of good over evil? It is as though the evil Chimera now defeats an equestrian Bellerophon, reversing the emblem (*Fig. 236*) in Ripa's *Iconologie* (2:83).

The serpent as a protagonist in Barye's art has a range of interpretation, including the heraldic, the astronomical, and the naturalistic. In the 1820s his serpents were the traditional emblems of darkness and evil. They were always vanquished by creatures of a more positive meaning, such as the eagle, with its connotations of the celestial and the divine. However, in 1832 Barye's *Lion Crushing a Serpent* (*Fig. 23*) marked an expansion of its possible meanings, embracing the heraldic, dynastic, astrological, and revolutionary. Later, in the 1830s, Barye reversed his position, treating the serpent as victorious, no doubt taking courage from Victor Hugo's notion of the grotesque. The strange design of *Python Swallowing a Doe* (*Fig. 138*) is so extreme in its naturalism and so curious in its choice of moment as to be disgusting for many viewers. The moralizing interpretation of Bernardin de Saint-Pierre comes to mind: that a carnivorous animal commits a sin against the laws of its own nature in devouring its prey alive.

In the larger artistic tradition known to Barye, equestrian figures involved with serpents are rare. Typically, they are allegories of the triumph of good over evil, of the type of Raphael's *St. George Killing the Dragon*, known to Barye in the Louvre.[47] Raphael's rearing horse, its head thrown back and the serpentlike dragon beside it, no doubt were in the background of Barye's design. He actually quoted certain details of the armor in *Saint George* for the equestrian knights of his *Bull Hunt* (*Fig. 90*), the skirted helmet type, the thigh guard shaped like a miniature shield, and the butterflylike plates at the sides of the knees.

Etienne Falconet's famous equestrian bronze *Peter the Great* of 1766–82 (Leningrad) includes a Serpent of Envy in its allegory of triumph. The serpent is trodden underfoot by the horse as it ascends the rocky base, a Mountain of Virtue image. It is as though Barye inverts Falconet's baroque allegory to show the serpent as triumphant. Yet Barye's *Greek Rider Seized by a Python* hardly seems to be a dynastic or political allegory, in light of the norms of Parisian taste in the 1830s, precisely *because* it lacks or inverts traditional symbolism and thus has a wholly satanic meaning.

Does Barye's design echo certain ancient Greek tomb monuments? Elements of his competition do appear in two major examples. A rider on a rearing horse and wearing a billowing cape dominates the commemorative relief dedicated to the warrior Dexileos (Athens, Kerameikos Museum), dated 394 B.C.[48] Another heroic relief (*Fig. 237*), found at Thyrea and now in Athens, avoids such dramatic action, offering a heraldic treatment instead. The nude rider, wearing a cape, stands before his horse, a giant serpent coiling in the tree beside him. However, it is not certain that Barye knew these reliefs.

The real subject of Barye's work was not a political allegory or a tomb monument, but an episode taken from an ancient hunting narrative, retold by Diodorus of Sicily: the story of

the capture of an enormous serpent for the amusement of King Ptolemy II, who ruled in Alexandria in the third century B.C. A new French translation of Diodorus' *Bibliotheca historica* was published in Paris between 1834 and 1838.[49] The volume Barye consulted for this story, volume 2, appeared in 1834—surely the year this sculpture was made.

Diodorus tells that the hunters had met with disaster on their first attempt to capture the giant serpent, which swallowed one man head first while crushing another to death in its coils. On their second try, the hunters wove an elaborate trap from reeds. They hoped that the noise and commotion of a large group of hunters and dogs would frighten the serpent into the trap. Diodorus says:

> Against the return of the animal they had made ready archers and men with slings, and many horsemen, as well as trumpeters. . . . And, as the beast drew near, *it raised its neck into the air, higher than the horsemen* [emphasis added]. . . . With many hands they kept hitting it, and when the horsemen appeared, and the multitude of bold fighting dogs, and . . . when the trumpets blared, they got the animal terrified.[50]

Trapping the serpent, they brought it alive to Alexandria and received a handsome reward from King Ptolemy, who loved unusual creatures and honored the courage of the hunters. Barye imaginatively merged Diodorus' image of the giant snake lifting its head higher than the horsemen with that of the deaths of the two hunters in delineating his pathetic moment.

Another visual source may have complemented the story of Diodorus, since the text does not spell out the specific image of a single horseman attacked by a serpent. A watercolor painting by Henry Fuseli (*Fig. 238*), dated about 1805, shows this very idea, although with an extravagance unlike Barye's classicizing understatement. Barye altered Fuseli's notion of the serpent's prey as well. It has begun to devour the horse, and Fuseli's rider seems to be slipping free from the serpent's coils. Nonetheless, the resemblance of the two works is striking.

An early stage in the development of the concept of the sculpture is recorded in a drawing (*Fig. 185*) in a Barye sketchbook that largely dates to the period 1830–32. Here the serpent bites into the rider's side but does not yet seize him by the throat. Also, the rider's arm is raised as though he were hurling a spear or wielding a sword. That arm position, together with the low angle of the rearing horse, suggests the hunters in two ancient Roman lion-hunt sarcophagus reliefs, known to Barye in the Caylus Collection (*Figs. 239 and 240*). Furthermore, the drawing recalls Bernini's famous *Vision of Constantine* in the Vatican and its many progeny of the baroque period, such as Antoine Coysevox's *Renommée* in the Place de la Concorde, a figure holding aloft a trumpet rather than a spear to proclaim the eternal glory of the King of France.[51]

Two other drawings document Barye's visual sources. The very phrase "Greek rider" recalls the unforgettable Phidian frieze of riders from the Parthenon, among the finest of the Elgin Marbles. Barye's drawing (*Fig. 163*), recording two adjacent panels of the north frieze, shows several motifs important for *Greek Rider*. At the left of the drawing, one rider raises his right arm while guiding another horse. At the right of the drawing, a single rider sits on a horse with its head thrown back and one foreleg extended and locked. (This is not

easily legible, for both damage and a nearer horse obscure the upper portion of the rider and the afterpart of the horse.) The principal motif from the Parthenon frieze is the type of the rearing or prancing horse: its head thrown far back; its ears pointed to the rear; its forelegs lifted high above the ground; the head, neck, and body held at almost perfect ninety-degree angles. Both forelegs on Barye's sculpture continue certain long lines of the horse, in the Phidian manner. The lifted foreleg extends the almost straight line of the barrel and belly. The locked foreleg continues the axis of the neck. Barye's rider is nude, except for his cape, as are several riders on the Parthenon frieze.

One neoclassical departure from the proportions of the Phidian original is the diminished size of the hindquarters of the horse. This heightens the impact of the forepart, a portion more readily humanized, quite as the Greek horses were treated by John Flaxman in an engraving for Homer's *Iliad* (*Fig. 242*). Both Barye and Flaxman reiterate the Greek device of the echoing of inner and outer contour lines of the horse, such as the long vein running the length of the barrel, or the lines within the legs.

Another Barye drawing, *Phidian Horse's Head* (*Fig. 184*), was made after a fragment of the east pediment rather than the frieze. Barye exaggerated the size of the semicirular shape of the horse's cheek, a favorite motif he would repeat in virtually all his later horse designs. The expressive head of the horse in *Greek Rider* resembles those in *Turkish Horse*, *Tartar Warrior*, and *Charles VI*, while the bald passage of the side of the neck is closely related to the hippogriff. The essentially vertical planarity of these three related designs is altered by the sideward tilt of this caught horse. A drawing of a rearing horse (*Fig. 186*) has a similarly terror-stricken attitude and carriage of the head and a like steepness in body angle. A related drawing overleaf shows the horse walking with one braced foreleg and one lifted, also similar in the contours and planarity of its neck and head and in the motif of the backward-pointing ears.

The face of Barye's expiring rider is the dramatic focal point we would expect, and it is a sophisticated effort in eclecticism. At first glance, the archaic Greek hair and beard styliza-tion suggests a simple reference to Zeus types, or perhaps to the head of the well-known *Rampin Horseman*. Yet a comparison with the *Rampin Horseman* shows that Barye has not taken up the archaic smile or the almond eyes, but only the decorative hair and beard treatment. His rider's face displays a more animated pathos, conceived in the late archaic mode of *Dying Warrior*, about 490 B.C., from the east pediment of the Temple at Aegina (Munich, Glyptothek).[52] To this archaic basis Barye adds the Hellenistic motif of the open mouth and the pathetic gasp, perhaps derived from the *Laocoön* group in the Vatican. However, the eyes of Barye's *Greek Rider* lack the linear and three-dimensional complexity of the eyes of Laocoön. Instead, they are closer to the simplifications of an early classical style, like that of the Phidian *Head of Perikles* (Vatican).

The posture in *Greek Rider* is a variation of that in *Tartar Warrior*, with the same bent legs and the dominant long line from shoulder to knee. He is tilted backward still further, in response to the impact of the serpent at his throat. This capacity for heroic struggle is notable in several of Barye's drawings after ideal male nudes in Michelangelo's fresco *Last Judgment* (Louvre, RF 6073, p. 29) and after the muscular *Infant Hercules Killing the Serpents* in the ancient Pompeiian fresco (Louvre, RF 6073, p. 25). Yet Barye's ideal figure

type is slenderer, its gestures more open and awkward than these prototypes—an angularity in keeping with the archaic hair stylization and beard.

Technically, *Greek Rider* is a cast-plaster positive. Now in storage in the Louvre, it has never been published or discussed. It was first listed in the Louvre catalogue of 1933, almost a century after it was created. The unusual physical character of this design is worthy of clarification. Made in a piece mold taken from the clay original, this plaster proof shows "flashing" or ridges left along the separation lines of the mold. These lines are most readily visible along the center of the horse's neck, hindquarters, and tail. Originally, the rider held a sword and wore a fluttering cape, although these accessories are now largely broken away. The technical form, as a cast-plaster positive, allows us to date it with certainty to the mid-1830s. Three examples of this sort of cast-plaster model are preserved in the Louvre, and the bronze casts taken from them are dated 1836, 1837, and 1838: *Tiger Hunt*, *Lion Hunt*, and *Bull Hunt*, respectively. Such a date is both stylistically plausible and perfectly in accord with the publication between 1834 and 1838 in Paris of the literary source of its icononography, the *Bibliotheca* of Diodorus. Another means of dating the work is its almost mirror-image similarity to *Horse Attacked by a Young Lion* (*Fig. 105*), shown in the Salon of 1833. Its design was indebted to antique and Renaissance sources, and it was probably conceived as a slightly smaller mate to *Greek Rider*, even to the detail of the sideward toss of the horse's head.

The unusual appearance of the plaster model betrays two further steps in Barye's technical process. First, a layer of wax normally would be applied to the surface. Into the wax layer Barye would work an enriching linear pattern, an autograph surface texture, that would be accurately recorded in the bronze. This plaster proof has not yet received the wax layer. Second, the plaster model would be cut into a number of small, easily cast elements. Assembled, these bronze elements would create the final proof. This model was cut for casting, but was then reassembled, somewhat crudely, into a single entity. There are differences of finish along the cut taken at the horse's neck and that in the serpent just below the rider's foot. Yet sand molds apparently never were made from the separated pieces of this design, for no traces whatsoever are evident of the red French casting sand, which normally would adhere in crevices or irregularities of surface. Thus the casting process for this design came to a halt before the wax layer was added and before the sand molds were made.

Why was this design not cast in bronze? The most likely answer is that the ancient Greek look of the rider might align Barye with academic classicism, and in the 1830s Barye was seeking to establish himself more securely as a *romantique*. In fact, the only version of this theme that Barye would cast in bronze was given an exotic, North African costume from the vocabulary of Delacroix and Horace Vernet, *Python Attacking an African Horseman* (*Fig. 95*), also called an Abyssinian horseman in some catalogues.

Amazon, Equestrienne (*Fig. 87*) depicts not so much a fierce woman warrior in the antique tradition as a lady of the July Monarchy period, who rides with the classical grace and ease of a Madonna by Raphael.[53] Her face in fact is a somewhat classical mask, with a long straight nose, deep-set eyes, and tiny lips set in an "archaic" smile. Her horse alights only

upon two hooves, yet it is a massive creature, setting off the daintiness of the rider. The rider's enormous full skirt welds her and her mount into a single, bold entity. The drapery of the skirt reveals the forms and positions of the legs within, a classical touch, with the interesting exception that her feet are minimized in an unclassical, rather Mannerist way. This horse type is virtually the same as that in *Greek Rider*, with a tall neck and a distinctly planar quality of design, but it is wholly transformed in mood, from an image of terror and mortal pain to one suited to an elegant parade on a Sunday afternoon.

Both Géricault and Delacroix drew and painted such equestriennes, and Barye seems to have known their versions. Géricault's drawing, *Amazon*, also stresses the form of the full skirt, exploiting its contrast with the unreal thinness of the legs of an Arabian horse.[54] In Barye's version the giant skirt seems to weigh down the horse, adding a certain visual necessity to its crouching stance, whereas Géricault's swirls outward in the wind like the rider's veil. Géricault's rider is overly large for her mount, an error of proportional relationship predictably corrected by Barye. Barye also substitutes for the mannish top hat of the drawing a more ladylike, visored cap. An almost identical mood of nervousness and tension is felt in both horses, yet Barye's rider is more composed in mood than Géricault's rather startled equestrienne.

Delacroix created at least three versions of the theme,[55] a problematical pastel, a drawing in pencil with watercolor washes, and an ink drawing. The pastel is of major interest for its clue as to the source of the appellation *Amazon* used for these fashionably dressed equestriennes. It shows a female nude about to mount her horse, suggesting the staffage of Rubens's painting *Battle of the Amazons* (Munich).[56] Delacroix's pencil and watercolor image retains the top hat of Géricault's precedent while correcting its implausible scale relation of rider and horse. Delacroix's ink drawing stresses the woman's flowing veils and tresses, her swirling costume, and omits the body and legs of the horse altogether. Both women wear similarly stiff full skirts, but Delacroix's has a large shoulder silhouette, created by the puffy sleeves of her blouse. This differs from the contrast Barye elaborates between the massive, heavy skirt and the tight-fitting jacket with its fine detail. Barye's drawing of the isolated image of a woman's face (Louvre, RF 6073, p. 66) is cast in the mode of Raphael or Ingres, and it confirms the classical dimension of Barye's search for an ideal facial type of the sort seen in *Amazon*.

Ape Riding a Gnu (*Fig. 88*) has an amusing, whimiscal tone.[57] The ape clutches both the tail and mane of the rebellious-looking gnu, and it staunchly yet lightly refuses to be frightened or thrown off. The ape's intent concentration has so human a semblance that it can hardly be viewed as anything other than a parody of Barye's other equestrians, whether lyrical, formal, horrific, romantically noble, or swashbuckling. It is an anti-*Amazon*, a comic *Tartar Warrior*.

A similar image occurs in an engraving by Thomas Landseer in J. H. Barrow's *Characteristic Sketches of Animals . . .*, as Jacques de Caso has pointed out.[58] Of course, Barye's East Asian orangutan and the African gnu could only meet in the zoo, not in nature.[59] It is thus a zoological joke, as is his contemporary combat of an American and an Asian Indian bear, which he exhibited in the Salon of 1833 with the very lengthly title, *Lutte de deux ours, l'un*

de l'Amerique septentrionale, l'autre des Indes.[60] This title might be construed as a pedantic banner proclaiming Barye's mastery of zoology, or it might simply be a relieving bit of humor.

The stance of the gnu is close to that of the horse in *Amazon;* only the raised leg differs in that it is more tightly flexed. The balanced play of the high arched tail and the arabesque horns is like the play of the arched neck and tail of the mount in *Amazon.* The gnu's musculature repeats the balance of spherical fullness and planarity seen on the mounts in *Greek Rider* and *Amazon.* Accented textures in the pelt of the ape and on the whiskered snout of the gnu set off the rather bald surfaces of the gnu.

An ancient Roman bronze, *Seated Monkey,* studied by Barye in the Caylus Collection (*Fig. 243*) has a relaxed, humorous naturalness of tone similar to Barye's ape. Several rococo porcelain sculptures of monkeys share the whimsy of Bayre's creatures, such as J. J. Kaendler's famous *Monkey Band,* created in Meissen.[61] Other related porcelain images are *Elephant Ridden by a Monkey and Serpent,* made in Staffordshire about 1770,[62] and *Monkey with Young,* from Meissen, about 1735.[63]

Bull Attacked by a Tiger (*Fig. 89*) shows the large tiger attacking from below, biting into the flesh of the right side of the rearing bull, as though during the course of the attack the bull had tried to fend it off by overrunning it.[64] The sharp arch of the predatory tiger braced against the earth contrasts well with the relatively stiff, angular mass of the bull. The tiger's biting mask and tearing claws are focal against the side of the bull, motifs Barye had already used in the monumental *Tiger Devouring a Gavial* of 1831 (*Fig. 22*). The coil and twist of the tiger repeats the great twisting arch of the bull's shoulders and neck, as does the fragile loop of its tail. Its violently curved body and the precise form of the tiger's head and forepaws are strongly reminiscent of the tiger that clings to the hind legs of the elephant in Barye's *Tiger Hunt* group of 1836 (*Fig. 127*).

A drawing of a bull attacked from below by a predator (*Fig. 187*) is similar in mood and narrative concept and in the formal play of the curves of the predator and the neck of the bull, as well as the lines of the tail and horns. Even the extended foreleg motif appears on the bulls of both drawing and bronze. Yet the tiger bites at the head and chest rather than at the side of the bull, as though the bronze shows the action a moment later, the bull having nearly overrun its attacker.

A splendid Roman bronze bull that Barye knew in the Caylus Collection (*Fig. 244*) was surely of interest to him for its verism and for the motif of the head turned slightly toward the right, although its mood is calm and alerted.

Bull Hunt (*Fig. 90*) portrays a bull standing immobile, perhaps stunned by the mortal blow it feels in the instant before it topples.[65] Two equestrian, armored hunters charge the bull, riding side by side, their lances ready, while a third rider blocks the bull's path with his fallen horse and plunges his weapon home. The third hunter twists violently, nearly falling from his saddle. The bull's head is dramatically isolated in the silhouette of the group, projecting boldly into space from one leg of the triangular shape of the composition, as though it were already a hunter's trophy mounted on a wall. The paired riding hunters

move as though performing in an exhibition of horsemanship, not as though locked in a death struggle with a wild bull. There is an aspect of ritual formality in their parallel movements, reminiscent of the conventional parallelism typical of ancient paired riders on sarcophagus reliefs, such as those Barye knew in the Caylus Collection (*Figs. 239 and 240*).

Perhaps the interrupted rhythm of the group reflects the narrative idea of the staggering or halting of the bull as it receives the final blow. By comparison, the space in this design is not so compressed, nor do the animal protagonists crush in upon one another with the same force seen in *Lion Hunt* (*Fig. 104*). These hunters do not show the riveted attention of the lion and tiger hunters. This is a more relaxed hunt composition, given the symmetrical balance of the fallen hound—on its back, wounded by the bull, and writhing in agony—and the fallen horse placed at the opposite end of the group. The paired fallen dog and hunter neatly reiterate the paired charging equestrian knights as well. Another simple contrast is that of the vulnerably clothed, tumbling rider with the armored, swashbuckling knights, who appear at the last moment like guardian angels rescuing a soul from the devil. Detectable within Barye's rather hieratic rearing horse image is the impact of Delacroix's recent paintings centered in rearing Arabian stallions with an exaggerated curvature of the necks and flexed, lifted forelegs. Details of the armor and horse trappings are similar in Delacroix's paintings as well. The motif of the fallen horse with the rider tumbling from his saddle stems from Delacroix, and even the general mood parallels his work.

The jouster in Barye's tonal drawing, *Armored Rider, after Rubens* (*Fig. 182*), resembles the central knight in *Bull Hunt*. The long line of the figure, from stirrup to shoulders, is slightly straighter in the drawing, and the position of the lance-bearing arm is slightly higher. Yet the general relation of rider and steed is vividly similar to Barye's bronze. A hasty contour drawing, *Two Jousting Knights* (Louvre, RF 8480, fol. 11r), possibly after a painting, shows a fallen horse at the right whose forelegs and head appear in positions they might take just a moment before coming completely to rest, as in the bronze. The rider is tumbling backward, having taken a thrust, and is again shown in a moment just before that in the bronze.

A tiny contour drawing of a fallen horse (Walters Art Gallery, 37.2138) shows a still closer resemblance to the bronze in the tucked position of the head and the flexed foreleg. Bayre's measured contour drawings of pieces of armor (*Fig. 188* and Walters Art Gallery, 37.2225, and 37.2227) reflect only certain details of the costumes of these knights, and they are rather freely used. A drawing of a charging bull (*Fig. 187*) captures a carriage of the animal's head almost identical with the bronze, but Barye alters the attitude of the horns in the bronze to convey more vividly its mood of stunned surprise. The dog writhing on its back in pain, mortally wounded by the bull, is closely related to Barye's anguished *Wolf Caught in a Trap* (*Fig. 61*) in emotive concept and fluid contour. A dog on its back appears in the drawing *Stag Harried by Two Hounds* (Louvre, RF 4661, folio 7r), one facing to the left, its nearer hind leg tightly flexed, as on the bronze.

Paired equestrian hunters on rearing horses appear on two *Lion Hunt* sarcophagus reliefs that Barye knew in the Caylus Collection (*Figs. 239 and 240*), their capes billowing, their lances poised or being driven home. Even the quarry on these sarcophagi resemble Barye's preferences for his hunts. The stag, boar, bear, and lion all appear along the ground lines of

the ancient reliefs. The visual redundancy of Barye's paired riders might be inexplicable were it not for this antique precedent. A well-preserved plaster and wax model of this design is in the Louvre (RF 1725; h. 50, l. 60 cm; Louvre *Cat.*, 1956, no. 6).

GROUP 9: PROGRESSIONS, SURFACES, AND ACTION

Powerful yet intricate silhouettes of an opened, ragged kind, together with strict internal design structures of parallel lines or of crossed diagonals unify the works in Group 9 and sustain aspects of the designs in Group 8. Surface modeling moves from the flattened, rather dry quality of *Arab Horseman Killing a Lion*, to the knotted, spheric surfaces of *Lapith Combating a Centaur*, to the richly modulated, almost sketchlike freshness of *Eagle Taking a Heron*, built up of large, still-distinct pellets of wax.

Action is generally treated with a ritual unreality, as in *Arab Horseman Killing a Lion* and the mythological combats. Exceptions are the graphic voraciousness in *Tiger Overturning an Antelope*, the sweeping violence of *Lion Hunt*, and the mixture of fear and surprise in the eyes of the rider in *Arab Horseman Killing a Boar*. Mood varies from the excitement of the rearing Arabian horses, to the menacing lions and tigers, to the pathos of *Wounded Boar* and *Python Killing a Gazelle*.

Motifs recur in these works. Predators embrace and cling to their prey, as in *Tiger Attacking a Horse*, an action even translated to the plane of the mythological struggle in *Theseus Combating the Minotaur*. The curvilinear arcs of certain flat silhouettes become the curving planes pocketing three-dimensional space, as in *Eagle Taking a Heron*, a spatial dynamic further varied in the writhing, baroque movements of the pythons.

Artistic sources encompass antique, Mannerist, and French romantic works: an ancient cameo for *Arab Horseman Killing a Lion*, ancient sarcophagus reliefs of paired equestrian hunters for *Lion Hunt*, the Mannerist sculpture of Giovanni da Bologna for *Lapith Combating a Centaur*, and a merging of Géricault's drawing of grappling boxers with the *Apollo Piombino* and a Roman marble relief for *Theseus Combating the Minotaur*.

Four exquisite dated works are among this group: the early *Horse Attacked by a Lion*, shown in the Salon of 1833; two autograph, lost-wax bronzes cast by Barye himself for the *surtout de table* about 1834 or 1835, *Tiger Overturning an Antelope* and *Python Killing a Gnu*; and *Lion Hunt*, 1837, a bronze cast by Honoré Gonon for the *surtout de table*.

Arab Horseman Killing a Lion (*Fig. 91*) captures the triumphant moment of the equestrian hunter as he charges his terrified and rearing horse directly over the fallen lion.[66] The quarry has tumbled onto its side and taken the hunter's lance in its mouth. Exhausted, the lion seems almost to invite the lance, to ask for death, its paws reaching feebly, its claws only half extended, its hind leg pressing instinctively yet passively against the belly of the horse. Dominant in the silhouette are the crossed diagonals of the rising line of the elegantly rearing horse and of the hunter's planted lance. Against these straight lines play the heavy

arcs of the rider's billowing cape and the hindquarters of the horse. Lighter arcs in the horse's tail, the tuft of its mane rising between its ears, and even the flexed right foreleg of the horse serve as accents.

The antique sources of this equestrian hunter placing his lance are clearly apparent, despite an initial tendency to connect the exotic rider too exclusively perhaps with the staffage of the paintings of Delacroix or Horace Vernet. An impressive instance of Barye's attention to a miniature antique source is his use of a carved cameo in the Caylus Collection (*Fig. 203*). It shows a lion hunter on a rearing horse, confronting his quarry with his lance poised. The antique cameo is heraldic or decorative rather than persuasive in the narrative sense. Both rearing horse and crouching lion are arranged on parallel diagonals. In fact, the ancient lion is humorously posed, its forepaws and chest on the ground, its hindquarters raised in the air, its tail lifted in an impossibly buoyant arabesque. It crouches like a cat playing with a toy mouse. Yet the economy, the brevity of the design, appealed to Barye. His transformation of the cameo image shows a naturalistic plausibility of action and tone. It is as though we see the action in his bronze just a moment later than is shown on the gem, for Barye's rider has brought his horse directly over the fallen lion, and is plunging the lance home. A more realistic relation of the size of horse and rider also marks the bronze. However, the house-cat aura of the cameo lion provokes a closer scrutiny of the bronze, since Barye's passive lion seems to suggest a housecat playfully batting at a ball of yarn. Perhaps this reflects a convenient substitution of feline models, the inappropriate overtones of which were a lesson well learned, to judge from the enraged and battling lion in *Lion Hunt*, a brilliantly successful design of a slightly later date.

The very distinctive motif of the lion rolling onto its back appears in Horace Vernet's painting *Lion Hunt* of 1836 (London, Wallace Collection), a work that no doubt appealed to Barye in its crystal-clear detail and its sculpturesque immobility of presentation.[67] Indeed, the Vernet probably inspired not only this work but also the contemporary *Lion Hunt* group.

Of two Roman *Lion Hunt* sarcophagus reliefs in the Caylus Collection, Figure 239 shows the lion jumping toward the rider along an opposed diagonal line, apparently challenging him at the very moment it receives the lance in its breast. This is not too different an idea from Barye's bronze, where the lion bites at the probing lance.

Arab Horseman is not only complete in itself as a design, as perhaps the earliest and simplest approach to the themes of the ancient cameo and the Vernet painting, but it lends itself to a more complex elaboration with two riders in *Two Arabian Horsemen Killing a Lion*.

Two Arabian Horsemen Killing a Lion (*Fig. 92*) shows the two hunters charging their horses directly over the fallen, rolling lion.[68] One rider's horse has stumbled directly onto the quarry, pinning it, and its rider scrambles free of the saddle, brandishing his rifle in the air. Crossed diagonals dominate the superbly animated, ragged silhouette. The design is not so much relieflike as coinlike, with an obverse and a reverse. Opposed axial movements further enrich the composition. The dismounting rider faces and moves in a direction opposed to that of the pinned and struggling lion. The fallen and the rearing

horses move in contrary directions within the shallow spatial plane of the design. The face of the lion looks upward and that of the lancer downward, both linked by the lance itself. The perfectly balanced arrangement of the two horse's tails, raised and arched, adds a decorative accent.

A compressed, almost spaceless ambient of a Mannerist sort pervades this pyramidal design, its major figures pressed tightly against each other, almost like the jammed warriors in Giulio Romano's fresco *Battle of the Milvian Bridge* (Vatican, Sala di Costantino).[69] Against this, however, Barye plays a rhythmic hollowing of pockets into the sides of the design and of projections jutting outward. The overall effect of the projections is rich in painterly nuances of fluttering light and dark, like certain passages in the sculpture of Bernini modeled after painted forms by Correggio. Bernini's translation of painting into sculpture is seen in the marvelous drapery of *Saint Longinus* in Saint Peter's Basilica, for example.[70] This general decorative rhythm is sprinkled with accents of sharply veristic detail: the horse's trappings, the weapons, the costume tassels. Repeated arcs cascade down the fallen horseman's side of the design, a movement ending in the arcs of saddle, saddle blanket, and lion's tail.

The lion model is taken from the single lion-hunter design, but it is rotated about ninety degrees so that the implied diagonal line connecting the forepaws is the same as the rider's lance. As was true of the first version, the helpless lion bites at the tip of the probing lance. In this second version of the lion hunt the austere isolation of the protagonists is replaced with a bubbling system of small pockets and projections. The final effect is persuasive as narrative and is free of the implausibilities of the earlier, fallen lion on its back.

Barye's tiny drawing of a fallen horse (Walters Art Gallery, 37.2138) captures not only the mood of pathos and the larger contours of the horse of this bronze, but closely reflects the motifs of the tucked foreleg, the arched neck, the front of the horse's head resting on the ground, and the high hindquarters lifted by the lion trapped beneath—the descending long line from the horse's rump to its head.

Arab Horseman Killing a Boar (*Fig. 93*) depicts not so much a moment of triumph as of tense confrontation. The rider scrambles from the saddle of his fallen horse, brandishing his rifle and looking intently toward his exhausted quarry, a boar pinned beneath the fallen horse.[71] The boar still tries to threaten the alighting hunter, although dazedly. The expression of the hunter, a mixture of fear and urgency, is one of Barye's subtlest human visages of this period, compelling in the intensity of its gaze.

Opposed forces contrast boldly, yet they balance each other in the contrary movements of the boar and horse. Within this larger order is a unifying repetition of arched lines: the rider's cape, the saddle and blanket, the arcs of the horse's neck and hindquarters, and that of the long line of the boar. On the back side of the group, a desert plant becomes an expressive element, echoing the angular legs of both boar and horse and contrasting with the fluid motion of the rider's cape.

This design uses the model of the lower hunter in *Two Arabian Horsemen Killing a Lion*. The horse's tail is redone, however, into a compact line reiterating the curve of the hindquarters, as in *Charles VI* (*Fig. 83*) and *Greek Rider* (*Fig. 86*).

Wounded Boar (*Fig. 94*) portrays defiance in defeat. The majestic, trophylike head of the recumbent boar is lifted with its mouth open, at once a last gesture of challange to the hunter and a weary expression of pain.[72] A deeply embedded spear juts from its side. Despite its weakness—it is apparently unable to stand—it nonetheless seeks to threaten its adversary as it cries out. The boar's right foreleg and hind leg are lifted in unison in an involuntary response to its pain. The two left legs are extended and relaxed, as though lame. A romantically macabre, death-agony theme enlivens what otherwise might be a merely lyrical image of a resting, recumbent boar. Exhaustion and suffering are the paramount qualities. A wet, waxy texture is seen on the surface of the boar's pelt, with passages of roughly parallel, arching, incised lines to symbolize the bristles. Complementing this graphic handling is the raggedly prismatic treatment of the rocky base, an agitation that amplifies the disturbing mood of the design.

Although this boar is larger in scale and of a different pose than the quarry in *Arab Horseman Killing a Boar*, as a variation upon that smaller predecessor, it shares the focal motif of the elevated, open-mouthed boar's head. A comparison with the *Lion Devouring a Boar* group for the *surtout de table* (*Fig. 114*) and with an early drawing after it, one not by Barye's hand (Walters Art Gallery, 37.2228), shows that *Wounded Boar* is actually a mirror image of that in the animal combat for the Duke of Orléans.

Wounded Boar (*Fig. 241*), an ancient Greek vase painting in the Caylus Collection, shows a great lance piercing the boar's shoulder, the boar's mouth opened in agony, although this antique boar is standing rather than recumbent. A Barye drawing of a recumbent boar (*Fig. 152*), made after the living animal, closely resembles the bronze in the raised attitude of the head, the opened mouth suggesting a snarl, and the contrast of the extended hind leg and flexed foreleg. Another page of two studies of a recumbent boar (Walters Art Gallery, 37.2229) shows the living animal resting on its side, a position related to the hindquarters of the bronze boar. The lower of the two studies shows a side view of the boar's head with an open mouth.

Python Attacking an African Horsemen (*Fig. 95*) shows the rider reeling backward, his arms flailing under the impact of the python's strike at his throat.[73] A thick coil of the serpent crushes the horse and rider against a tree. The horse has fallen, its hindquarters are turned sideward, and its right hind leg is flexed in an involuntary response to the pressure of the python's grip. Even the rider's waist is locked in the serpent's coil.

An improbable wind lifts the horse's mane into a high ridge, to interrupt the silhouette and to relieve the excess of serpentine movement apparent in both the python and the arched neck of the fallen horse. Passages of repeated parallel lines enrich the horse's mane, its tail, the mound of earth beneath the horse, and the rider's flowing cowl and burnoose. These lines set off the finer hachure of the python's scales and the balder surfaces of the horse for a wide range of textural embellishment. The fallen rather than rearing horse sets this design apart from the larger, plaster model, *Greek Rider Seized by a Python* (*Fig. 86*), as do the open arms of this rider. In this probably earlier plaster, there is perhaps too much emphasis upon the neck and head of the rearing, frightened horse at the expense of the

sense of the python's deadly conquest. Thus the smaller, later version is more unified and more subtly articulated at the narrative level.

The drawing *Python Attacking a Horseman* (*Fig. 185*) shows a stumbling or prancing horse attempting to sidestep the ensnaring coils of the python. The horse's head is drawn downward, its chin almost against its chest, and the horse's tail is arched, as in the bronze. The python strikes at the rider's chest, however, not at his throat. The rider's free arm in the drawing resembles those of ancient riding hunters, their arms raised, about to hurl their lances, on the sarcophagus reliefs in the Caylus Collection.

A likely source for this romantically grotesque theme is the art of Henry Fuseli, who made several variations of the idea. One watercolor (*Fig. 238*) shows a giant constrictor suspended in a tree above the rider it attacks, a design concept Barye renders more compactly sculptural.

Python Killing a Gnu (*Fig. 96*) shows the snake seizing the fallen gnu at the throat.[74] The gnu's head tilts sharply backward, and its drooping tongue curves in an involuntary reflex as the python crushes it in its coils. An arch of the serpent stands in bold silhouette before the throat of the prey, contrasting with the more compact windings round its blocky body. Loops of the serpent reflect the curved horns of the gnu, and the incised pattern of the serpent's scales varies the freer cross-hatching of the gnu's pelt. The raised and tilted head of the gnu recalls those of the horses in *Greek Rider Seized by a Python* (*Fig. 86*) and *Horse Attacked by a Lion* (*Fig. 105*). This is easily one of Barye's finest designs of the 1830s.

This autograph bronze was cast by Barye himself about 1834 or 1835 for the *surtout de table* of the Duke of Orléans. A splendid crispness of detail, a waxy freshness of surface, a razor-sharp record of incisions on the wax model, and the ad hoc look of the repairs to the edges of the slightly undersize base (by means of riveted plates on all four faces), mark this exceptional cast.

A variant of this composition, cast by Barbedienne for the general market, has a long, ramplike base, which lessens the compression and impact of the struggling creatures.[75]

Several studies of a live python with prey were made for the python compositions. One pair (Walters Art Gallery, 37.2187B) shows it reaching back to swallow the prey held fast in its coils, the jaws of the predator forced open to the limit. In this bronze Barye prefers to show the prey still alive and vividly responsive. Motifs of the reserved curve and the tightly coiled loop occur in the largest study (*Fig. 189*), which shows four views of the serpent encircling and swallowing its prey. Also recorded in these studies are the general coiling movement of the serpent, its typical rhythm, and the contours of its muscular ridges and tapering dimensions.

A charcoal tracing after the Barbedienne variant of the design was made for a watercolor painting (Walters Art Gallery, 37.2021). Both painting and tracing are mirror images of the sculpture. In addition, the tracing shows the serpent wrapped about a tree trunk, in a more elaborate landscape setting reminiscent of Fuseli's watercolor, a setting echoed in *Python Attacking an African Horseman* (*Fig. 95*).

Python Killing a Gazelle (*Fig. 97*) has the python locking the immobile and helpless gazelle within a great, crushing coil, while it strikes at the throat.[76] The gazelle gasps, its mouth gaping and tongue lolling. The longer, lower silhouette of the fallen gazelle differs from the blockier, taller form in *Python Killing a Gnu*. The largest coil, wrapped about the belly of the gazelle, creates a lateral plane counter to the long axis of the group. The elegantly domical musculature of the gazelle is spatially reversed in the delicate, intaglio channels of the gazelle's head. Other contrasts with the rolling musculature of the prey are the smooth surface intaglio of the serpent's scales, the often parallel linear elements and angles of the gazelle's legs, and the fragility of the curved planes of its ears.

Two Roman bronzes in the Caylus Collection, *Ram with a Waterbag* (vol. 6, pl. XCII: V) and *Goat* (vol. 3, pl. CXXI: V), offer precedents for the double curve of the horns and their deeply striated texture on this more elegant gazelle. The Roman bronze *Ram's Head Boss* (vol. 6, pl. C: IV, V) shows a similar downward thrust of the ears. A well-preserved model of this design in plaster and wax is in the Louvre (RF 1584; h. 17, l. 40, w. 13 cm; signed A. L. BARYE; gift of Jacques Zoubaloff, 1914).

Tiger Overturning an Antelope (*Fig. 98*) shows the seated predator, which has already thrown the antelope onto its back, holding its prey still beneath its massive left forepaw as it feeds.[77] One can practically feel the tiger's fangs tearing the flesh of the antelope, so perfectly has Barye captured a dramatic instant. Seen from above, the sharp angle described by the antelope's neck and body suggests that its neck is broken. An oddly sexual touch is the way the tiger's tail brushes the antelope's genitalia. Three of the antelope's legs are drawn up in a painful cringe, and the fourth leg juts stiffly into the air, locked there by the tiger's forepaw. The antelope's extended leg interrupts an otherwise compact silhouette, sets off the powerful heads of the animals, and creates an axis about which other forms revolve, such as the long line of the fallen antelope and the globes of the tiger's back.

Both heads are superb—the satanically voracious tiger and the deathly still antelope. Great tufts of fur grow from the tiger's cheeks, and its eyes are sculpturally deep set. The antelope's fleecy neck is modeled into long, lush lines that contrast with the bony sides of its head. These animals are very large for the undersize, squarish plinth. They are dramatically compressed onto this waferlike base, a feature consistent with the other two extant, auto-graph animal combats for the *surtout de table*: *Python Killing a Gnu* (*Fig. 96*) and *Lion Devouring a Boar* (*Fig. 114*). This bronze was cast by Barye himself in a yellow bronze alloy, given a brown patina, and covered with a golden, transparent varnish. The surface of the cast is waxy and shows a play of colors, from golden yellow to a dark, almost black brown.

Typical of Barye's designs of the mid-1830s is the expressive contrast of cursive contours and straight lines meeting in perfect angles. For example, the straight accents of the antelope's lifted legs and the parallelogram described by its rear hooves and forelegs both set off the undulating back of the tiger and the curling tails of the two creatures. Two other motifs are shared with designs of this period; a tiger biting into the throat of its prey, as in *Tiger Devouring a Stag* (*Fig. 18*), and a predator that scrambles onto and embraces its prey, as in *Jaguar Devouring a Crocodile* (*Fig. 21*).

110

Bear Overturning a Stag (Fig. 99) is closely related to the preceding *Tiger Overturning an Antelope*.[78] The bear has thrown a great stag onto its back and, pinning it against a rock, has begun to feed upon the stag's right foreleg. The bear embraces its prey as it feeds. The bear's left hind paw digs into the genitalia of the stag, echoing the brush of the tiger's tail over the genitals of the antelope in the bronze.

A pyramidal silhoutte marks this design, one crowned with two focal motifs, the negative shape described by the stag's foreleg and a dorsal view of the bear's intently gnawing head. The bear's body has blocky yet spherical volumes, accented by such projections as the shoulder, pointed elbow, haunches, and hump of its back. Extended right and flexed left legs are paired in the design. A pocket of space caught between the haunches of the stag and bear adds to the sense that the bear is pushing against its prey. The stag's head and neck create near-right angles, which are repeated in the lower back and hindquarters and are reversed in the upper contour of its haunch. The fresh texture of this terra cotta nicely preserves the additive process of modeling and the traces of the fingers wiped across its surface. Energy flows from the bear's head to the stag's chest, neck, and its focal, lolling head.

Eagle Taking a Heron (Fig. 100) shows the predator perched atop a rocky crag, its wings opened and its head thrust forward as it exults over its kill.[79] A concern to articulate negative forms is so strong in this design that it almost gives the sense that positive forms have begun to dissolve, to lose substance and mass, even to disappear into space. This is particularly so in the heron lying on its back, whose wings flatten onto the rock and disappear, forms quite outweighed by the presence and impact of the very spaces given shape between the rock and the curved planes of the opened wings of the eagle. The flattening of the heron onto the rock, and the resultant abstract relation of its feathered body to that surface, predicts the flattening onto the planar masonry of the Jena Bridge of Barye's *Colossal Eagle Reliefs* of 1849 (Fig. 28).

The ultimate extension of Barye's late attitude toward negative form as the dominant element of a sculptural design is the far less successful *Kite Carrying off a Heron* (see Pivar, p. 229), a design never offered in Barye's own catalogues. It has the look of the fragile concept of an eighteenth-century porcelain master. As a new direction laden with positive prospects for the future, Barye's concern with space itself rather than solid mass would become one of the main trends of the twentieth century, beginning perhaps with certain of Picasso's cagelike wire sculptures of about 1916.[80] Later amplifications of the concept appear in the works of the Bauhaus sculptors Naum Gabo and Antoine Pevsner in the 1920s, in the art of Henry Moore in the 1930s and 1940s, and in works of Richard Lippold in the 1950s.[81] More recently still, the neon-tube structures of Chryssa embrace not only the idea of form as a line dominating three-dimensional space, but electronically produced color and light as well.[82]

Barye's page of eagle studies (Louvre, RF 6073, p. 49) shows three faint contour sketches of profile, frontal, and three-quarter views of an eagle with open wings. These have both the emotional intensity and the naturalistic acuity of the bronze eagle. The feather patterns

recorded in the several other sketches on this page are also of significance, and the general view of an eagle with open wings at the lower left is similar to this bronze. A well-preserved plaster model of this design is in the Musée du Petit Palais, Paris (inv. no. 1046).

Ocelot Carrying a Heron (*Fig. 101*) displays an intriguing interplay of shapes.[83] An ocelot bites into the neck of the heron it has seized, dragging it along the ground in its jaws; the silhouette of the piece is contained in a pyramid, with its apex at the peak of the ocelot's back. The geometrical severity of this element of the design is largely obscured by the power of the many undulating contours, and by the spatial impact of the curved plane of the heron's wing. Yet the angular mass of the silhouette is echoed in the rectilinear accents of the heron's legs and in some of the long feathers of its wings.

An intimate concern with expressive, negative forms is evident in the shaped hollows beneath the ocelot and in those beneath the heron's body and neck. The curved undersurface of the heron's wing powerfully shapes space itself. The theme of forms moving into the space of the viewer, escaping from the confines of the illusion, is felt in the play of the ocelot's lashing tail and in the heron's wing that appears to slide off the base.

The adjustment of textures is exquisitely controlled, as in the softer, tufted feathers of the heron's body, different from the harder look of the long feathers of its wing, and in the contrast of these with the soft pelt of the ocelot and with the crisply defined rock of the base. The subtlety and expressive richness of these surfaces rivals those of the superb bronze model *Lion Crushing a Serpent, Reduction No. 1* (*Fig. 109*), which suggests that both probably date toward 1845.

The drawing *Ocelot or Leopard Scratching Itself* (Baltimore Museum of Art, Lucas Collection, Barye Album, fol. 22r) shows the same peculiarly arched line of the back—hindquarters elevated, shoulder on the earth—as in the bronze. The energy of its arabesque contours is precisely in the spirit of the bronze. As was true of the drawing from this album discussed in connection with *Jaguar Devouring a Hare* (*Fig. 29*), this study dates toward 1830, confirming that both sculptures mark a return to notations made after a living animal at least fifteen years earlier.

Tiger Attacking a Horse (*Fig. 102*) is another example of a predator seizing its prey in a deadly embrace.[84] A large tiger clings upon the back and shoulder of a fallen, exhausted horse. The horse's foreleg is extended, its hoof scratching at the earth as it feebly attempts to rise, and this motif has a sinister repetition in the claws of the tiger's forepaw that tear into the horse's shoulder. Despite the violence of the narrative idea, a delicate contrast differentiates the spherical modeling of the tiger's muscles from the flatter treatment of the horse. In fact, the vertical planarity of the horse is nearly heraldic, unlike the fluid ease of the tiger.

This fallen horse is related to those in *Bull Hunt* (*Fig. 90*), *Arab Horseman Killing a Boar* (*Fig. 93*), and *Python Attacking an African Horseman* (*Fig. 95*). This horse has a rising line, amplified by a ramplike base, resembling that in *Arab Horseman*, but the flexed and extended forelegs are reversed, the horse's head is not drawn as far backward, and the tail is not as sharply arched.

Barye repeated the motif of a predator embracing its prey in a number of designs, such as *Lion Hunt* (Fig. 104), *Horse Attacked by a Lion* (Fig. 105), *Bull Attacked by a Bear* (Fig. 120), *Bear on a Tree, Devouring an Owl* (Fig.124), and *Tiger Hunt* (Fig. 127). The motif is also translated to the mythological protagonists in *Lapith Combating a Centaur* (Fig. 106) and *Theseus Combating the Minotaur* (Fig. 107). For some clinging animal predators, objects other than prey receive their embrace, such as the tree in *Ratel Robbing a Nest* (Fig. 121). Why this excellent design does not appear in Barye's sale catalogues or in the official Salon *carnets* is difficult to assess.

Jaguar Overturning an Antelope (Fig. 103) shows a jaguar as it scrambles onto its fallen prey, its claws digging deeply into the antelope's ribs and flank, pinning it on its back across a rock.[85] The jaguar looks about intently, as though in the moment before feeding, a motif that heightens our awareness that the heads of these animals are widely separated rather than closely knit, as in *Tiger Overturning an Antelope* (Fig. 98). A powerful pyramid has its apex in the shoulder of the jaguar, whose head projects dramatically outward beyond the edge of the plinth.

Flattened spherical forms create the bodies and haunches of jaguar and antelope. Angular lines in the antelope's hind legs provide contrast to these spheres and to the arabesques of both animals' tails. The rocky base duplicates the angular relationships among the antelope's shoulder, neck, and head. A clarity of mass, a tendency toward defined cubic and spheric forms, links this piece more strongly to *Python Killing a Gnu* (Fig. 96) than to the softer, more fluid *Tiger Overturning an Antelope*.

The rock below has the rhythmical texture of parallel wiping strokes of the fingertip over the clay. Antelope and base are a single mass of terra cotta, to which the jaguar, of cast terra cotta, is attached. The form of this jaguar as a cast terra-cotta replica is typical of the technical procedure used by Honoré Gonon for casting the *surtout de table* hunt groups between 1836 and 1838, a sign of their contemporaneity.

A bronze of this same crouching jaguar as an isolated form (Walters Art Gallery, 27.37) has a smoother surface quality, as though a wax model had been subjected to heat, causing its surface to flow.

Lion Hunt (Fig. 104) shows two riding hunters charging a lion, forcing their horses over the back of a buffalo lying between them and their quarry.[86] The lion stands on its hind legs, as though about to spring. Its head is turned slightly sideward and drawn back as it shies from the lance thrust by the nearest rider. The two African horsemen derive from the paired equestrian lion hunters on the Roman sarcophagus reliefs in the Caylus Collection (*Figs. 239 and 240*). Barye's riders, however, show the successive moments of charging and spearing the quarry, almost as Barye had altered the moment depicted on the ancient cameo for his *Arab Horseman Killing a Lion* (Fig. 91).

The design is heraldic in its pyramidal silhouette, its many parallel diagonals and concentric arches, and its carefully balanced opposing forces. Yet there is a strong sense of the total sweep of the action, more cohesiveness than, say, the tendency in *Tiger Hunt* (Fig. 127) to isolate elements for particular emphasis. Aiding the sense of unity is the way space is

compressed into a shallow plane, with the riders, their quarry, and the bait almost like a hand of playing cards. The stark geometry of Barye's design and its spatial compactness set it apart from those by Delacroix and Rubens. The action of the hunters gains in speed and viciousness by the agitated formal rhythms of their drapery.

The hunter closest to the lion plunges home his lance, while the second draws back as though in fear, a contrast of the human reactions of the hunters to their menacing quarry also developed in *Tiger Hunt*, where the cowering elephant driver has an active foil in the spearing hunter. Distinctly typed human reactions were regarded by romantics as signs of the universality of human behavior. The slender body of this lion and the arabesque of its upper contour closely resemble those in *Roaring Lion* (*Fig. 63*). The buffalo used as bait by the lion hunters is related to *African Buffalo* (*Fig. 76*) and *Small Bull* (CQC65, no. 207; see Pivar, p. 214). A well-preserved model of this design in plaster and wax is in the Louvre (RF 1568; h. 50, l. 60 cm; Louvre *Cat.*, 1956, no. 5).

Horse Attacked by a Lion (*Fig. 105*) shows a lion that has jumped onto the back and right side of a wildly rearing horse. Physical tension is vivid in the precariously clinging lion and in its almost automatic movement as it tears into the staggering horse.[87] The horse turns slightly toward the right in response to the weight of the lion's body clinging to that side. For a romantic, this predator is "immoral" in that it is devouring its prey alive.

A long diagonal line dominates the grid of right angles that underlies the design. A powerful, ragged silhouette is created by the planar mass of the rearing horse, with focal accents in the agonized expression of the head, the painful arch of the tail, and the desperate flailing of the forelegs. Arabesque accents in the arched mane of the lion, its tail, and that of the horse are elaborated as a theme in the gnarled, meandering roots and trunk of the tree. In the manner of a monumental bronze, the tree trunk serves to brace the belly of the rearing horse, easing the stress upon the two slender hind legs. Extended feline claws ripping into the flesh of the prey are focal details in this design, as they had been in *Tiger Devouring a Stag* of 1830 and in the monumental *Tiger Devouring a Gavial* of 1831. Barye's related dissection study, *Claw-Retracting Mechanism* (Walters Art Gallery, 37.2219), has been discussed in connection with those designs.

Barye's profile drawings of a steeply rearing horse (*Fig. 186*) take an angle virtually identical with that of this horse. It has a similar tension in the flexed hindquarters, precisely the same horizontal lower right hind leg, arched tail, and emphasis upon the motif of the open mouth. The adjoining page shows the forepart of a horse with an arching neck like the bronze. Beside it, a drawing of a rearing horse with rider captures the angles of the extended left foreleg and of the right hind leg drawn to the rear, the latter position used for the opposite hind leg of the bronze. A drawing of a frightened horse (Baltimore Museum of Art, Lucas Collection, Barye Album, fol. 16v) shows the large eye, the expanded nostrils, and the open mouth of the bronze.

Barye's *Horse Attacked by a Lion* was first exhibited in the Salon of 1833 with his monumental *Lion Crushing a Serpent*, a golden moment for the sculptor. The small sculpture comprises a summation of many artistic sources, ranging from the antique to Leo-

nardo, Rubens, Guillaume Coustou I, and Delacroix. Like the monumental design, it offers multiple levels of reference.

Of course Barye's small bronze reflects the ancient examples in the Vatican and Capitoline Museums, such as *Horse Attacked by a Lion* (*Fig. 245*). Barye may have seen these in the form of engravings or drawings. The antique prototypes were imitated as small bronzes by several seventeenth-century Italian sculptors, such as Giovanni da Bologna, Antonio Susini, and Massimiliano Soldani.[88] The ancient theme was known to the French and German porcelain masters and to French neoclassical artists and goldsmiths. Barye, however, departed from the ancient types, using a rearing horse rather than a fallen one. The rearing horse type also has antique origins, and it was a favorite motif of romantic artists.

Barye knew an ancient solid bronze, *Rearing Chariot Horse* (*Fig. 246*) in the Caylus Collection, and its dramatic intensity and long sweeping line surely must have impressed him. Two such rearing horses on a sarcophagus relief draw a triumphal car (Caylus Collection, vol. 1, pl. LXXXVI, II). A small Renaissance bronze related to Leonardo's *Trivulzio Monument* (Budapest, Museum of Fine Arts) reiterates the ancient rearing horse motif.[89] Possibly Barye knew the porcelain variations, such as *Polish Hussar* by J. J. Kaendler and Peter Reinicke made at Meissen about 1750, and *Rearing Horses* made at Hoechst about 1750 and at Langton Hall about 1760.[90]

Rubens was an important source. Barye's drawing *Armored Riders after Rubens* (*Fig. 182*) with figures mounted on rearing horses, was made after Rubens's *Tournament by the Castle Moat*.[91] Barye's drawing *Face of a Feeding Lion* (*Fig. 150*) is based on the lion in Rubens's *Lion Hunt* in Munich (Alte Pinakothek).[92] This drawing emphasizes the macabre aspect of the lion's intense concentration. A second, smaller study on the same page shows a feline predator biting into its prey while holding it fast with an extended forepaw, a motif Barye would repeat in numerous compositions. On seeing the latter study, one becomes aware that the feeding lion after Rubens has an excessively human gesture of the forepaw, more like the forearm of a man eating a bowl of soup than of an animal seizing prey. Thus it is the more plausible extended forepaw of the smaller study that Barye uses to complement the mask by Rubens in *Horse Attacked by a Lion*, while his early *Milo of Crotona* medallion, 1819, repeats the Rubensian relation of paw and mouth more exactly.

A wildly rearing horse was a favorite and oft-repeated motif of the romantic period. Among the most impressive monumental versions of the antique type to be seen in France was *Horses of Marly* by Guillaume Coustou I (1677–1746), brought to Paris by Napoleon.[93] Widely known and admired, they directly influenced paintings by David, Gros, and Géricault. Delacroix's *Death of Charles the Bold* (Nancy), for example, uses rearing chargers at the right middleground in stances like that in Barye's bronze.[94] Nonetheless, Barye's rearing horses may derive as much from *Horses of Marly* as from Delacroix.

Lapith Combating a Centaur (*Fig. 106*) shows the attacking Lapith sitting astride the centaur, his left hand pressing the centaur's head and neck sidewards, as a wrestler might do with a human opponent.[95] The Lapith's right arm and club are raised for the death blow. The focal motif of the Lapith's left hand pinning the head and neck of the centaur is

taken from Giovanni da Bologna's famous marble group in Florence, *Hercules Killing Nessus*, 1594.[96]

Barye departs from the Mannerist design with a strict planarity and a rectilinear grid, a system already intrinsic to his earlier *Greek Rider Seized by a Python* (Fig. 86), *Two Arabian Horsemen Killing a Lion* (Fig. 92), and *Horse Attacked by a Lion* (Fig. 105). There is a difference between the U-shaped, lower contour of Giovanni da Bologna's Hercules group—a line soft and unreal—and the straighter contour line in Barye's *Lapith and Centaur*. Against Barye's dominant rectilinear system is played the knotted, spherical musculature reminiscent of *Turkish Horse* (Fig. 82), yet here it is given a higher relief projection for a more exaggerated decorative effect. Furthermore, the silhouette of Barye's group is regularly broken by projecting forms, whereas Giovanni da Bologna's design is compact, with only two exceptions—in the nearly straightened right arm and in the projecting head of Hercules. An ornamental, dancelike quality is inherent in the raised arm gesture of Hercules, much like the unreal gesture of Barye's Lapith. The Lapith has the dreamy gaze of early classical Greek sculpture, such as the bronze *Charioteer of Delphi*, except for a slightly troubled look about the eyes. The Florentine Hercules is also classically dreamy, with just a shade of a darker mood. His victim, Nessus, has a satyr mask, equally as decorative and nearly as devoid of human passion. Barye's centaur mask is still more neutral in mood.

Barye's drawings after motifs in the battle frieze of the Doric temple of Apollo at Bassae (Walters Art Gallery, 37.2051) do not depict the centaur combats of that frieze, but nonetheless they strongly suggest that he knew them. *Centaur Relief* (Fig. 233) in the Caylus Collection, a decoration from a bronze chest, shows two prancing centaurs abducting beautiful ladies. The centaur at the right of the relief panel shows the motifs of the rigidly braced foreleg, the hind leg drawn backward, the violent torsion of its human torso—which is modeled with full, spherical musculature—and the raised, flowing tail. The woman riding upon the left-hand centaur wears a long, billowing, ribbonlike cape, one laden with the idea of the long sash that flows across the bronze. The drapery swag and pile of rocks prop up the belly of the centaur in the manner of ancient marble copies after bronze originals. In Barye's small bronze such a prop is not functional, especially in view of the three solidly planted hooves of the centaur. Instead, it is a bit of archaeological pedantry in the spirit of that trend in sixteenth-century art.

Echoes of the early 1830s and of Mannerist sources suggest a date between 1836 and 1840 for this design. With respect to the early date, a similarly elaborate interest in a rectilinear grid appears on a drawing for a watercolor made after Barye's *Tiger Hunt* group of 1836. The drawing is unnecessarily complex, for not only is it squared, but the diagonals of the squares are indicated as well—really a playful manipulation of rectilinear elements for their own sake. The late date, toward 1840, is possible in light of the parallel, Mannerist traits evident in the preparatory drawings for *Saint Clotilde* of about 1840.

Thesus Combating the Minotaur (Fig. 107) is based on the ancient story of the great hero's journey to Crete, where he managed to slay the Minotaur in the labyrinth, thus saving the seven youths and seven maidens of Athens who were its intended sacrificial victims. In this sculpture, a godlike Theseus stands solidly upright, his legs braced, his left hand grasping

the Minotaur's ear, his right hand holding the sword poised before its head.[97] Theseus, undaunted by the Minotaur's claws tearing into his back, is portrayed in a stance of ritual immobility that recalls images of Egyptian pharaohs hurling their lances. The serpentine fluidity and imbalance of the evil Minotaur provide a formal contrast as well as a moralizing one. The sword poised before the Minotaur's brain signifies the monster's lack of humane intellect, and it restates the moral idea of Theseus' triumph. A giantesque, herculean muscularity marks the Minotaur, heightening its awesomeness as an adversary. Barye symbolizes a potential for action in this group, rather than depicting action in progress.

An oddly sexual overtone occurs in the groin-to-groin pressure of Barye's combattants, a thematic counterpart of the tiger's tail lashing the genitalia of an antelope, or the bear's claws digging into the genitals of a stag, in his animal combats of the 1830s. Nonetheless, it is only a restrained echo of the celebrations of sexuality nearly endemic to the art of Henry Fuseli, one of whose drawings inspired Barye's design.

The face-to-face stance is unusual for this combat, since the ancient examples are normally frontal, with both protagonists facing the viewer, as in the Hellenistic example in the Villa Albani. An antique prototype of this rare stance in the Caylus Collection, the Roman relief *Hercules and Anteus* (*Fig. 247*), no doubt inspired Barye's piece. This Roman type was probably known to Pollaiuolo as well, providing him with the basis of his notable small bronze. The *Apollo Piombino*, an exciting ancient small bronze added to the Louvre holdings in 1834, provided a model for the archaic Greek hair treatment as well as the general rigidity of Barye's *Theseus*.

The stiffness of *Theseus* recalls Renaissance small bronzes of the *Victorious Hercules* by Antico (c. 1460–1528), Francesco da Sant'Agata (16th century), and Stefano Maderno (1576–1636).[98] For Mannerist sculptors in Italy, this hieratic, artificial stance offered a major alternative to the excessively fluid *figura serpentinata*. Such rigidity marks two famous works: Bandinelli's *Hercules and Cacus*, 1535, and Jacopo Sansovino's *Neptune*.[99] The neoclassical variation of this stance appears in David's *Oath of the Horatii*, 1784–85, certainly known to Barye in the Louvre. English variations of the stance were created by John Flaxman and Henry Fuseli.

Barye patterned his *Theseus* on Henry Fuseli's executioner in the drawing after the fresco by Andrea del Sarto, *Beheading of John the Baptist* (Florence, Monastero dello Scalzo). Fuseli's *Executioner with a Severed Head* shows the same braced stance of *Theseus*, and it retains the executioner's turned head and his raised arm supporting a weight.[100] Barye places a sword in the opposite, raised hand of Theseus, but he retains the half-lowered and relaxed attitude of the other arm, that grasping the ear of the Minotaur. The elaborate definition of the tensed muscles of the executioner's back—the small study at the right of Fuseli's drawing delineates even more closely the muscles of the upper back—is exactly in keeping with the treatment of Barye's *Theseus*. Barye reduces the relative size of the hips and buttocks, however, and lengthens the torso, achieving a taller, more Mannerist proportion. Barye was as susceptible to this Italian sixteenth-century prototype as he had been to that of Giovanni da Bologna's *Hercules and Nessus*, as well as to Fuseli's translation of the type into an even more hieratic and muscular mode.

Another major source of this design occurs in the Barye drawing *Grappling Boxers, after*

Géricault (*Fig. 190*), based upon images in the painter's sketchbook (*Fig. 248*). The back view of Géricault's two large boxers is the source of the composition of Barye's bronze. In fact, Géricault recorded his boxers largely in terms of neoclassical heroic stances. Thus *Theseus* stands with the same widely braced legs as the nearer of Géricault's boxers. The further boxer has been turned toward Theseus and is transformed into the Minotaur. The unlikely boulders that prop the Minotaur's bent right knee expediently fill the gap in Géricault's design. And the Minotaur's left leg hooks around the leg of Theseus, just as is true of the boxer group. Implicit in the motif of the arm of Theseus drawn back before plunging home the sword is the poised fist of Géricault's boxer about to land a blow. Barye also retains the basic X pattern of long lines seen in the Géricault drawing and plays them against the serpentine fluidity of the Minotaur.

A sheet of Barye's studies of Roman costume and swords, inscribed "Bartoli" (Louvre, RF 6073, p. 83), shows precisely the type of sword held by his *Theseus* at the lower center of the page.

GROUP 10: FIGURES AND BASES UNIFIED OR BURSTING APART

Unifying formal qualities in the designs in Group 10 are the essential axiality of the principal animal and a tension or interplay between two radically different types of silhouette—the strict, triangular one and the one of flowing arabesques. Often both types of silhouette occur within the same design when it is viewed from different vantage points. Extremes are evident as well in attitudes toward surface; textures vary remarkably, from the waxy richness of the pelts and manes of the feeding lions to the self-consciously buttered, unresolved surfaces of *Seated Lion, Sketch.*

Narrative concept and mood range widely, through the subtle psychological rapport in *Lion Crushing a Serpent*, the vigorous physical action in *Lion Crushing a Serpent, Sketch*, the total concentration in *Lion Devouring a Boar*, the playful relaxation in *Bear in Its Trough*, and the grand, almost Egyptian formality of *Seated Lion*. In roughly a half-dozen of these animal protagonists the extended forepaw is a focal motif, as in *Bull Attacked by a Bear*.

In several of the works in Group 10 the relation of figure and base undergoes considerable manipulation. The animals almost burst away from the constrained plinth of the autograph *Lion Devouring a Boar* of ca. 1830–35. The figure sinks deeply into the base of *Bear in its Trough*, predicting the spatial continuities of Degas's *Woman in a Tub*. An elaborately hollowed, pocketed base sets off the long, simple lines of *Ratel Robbing a Nest*.

Seven dated works are among the sculptures in this Group: the crisp, tiny *Lion Crushing a Serpent, Sketch* (by 1832), important for the development of the monumental design; *Bear in its Trough* (Salon of 1834), a lyrical piece, novel in the relation of the figure and base; *Lion Devouring a Boar* (1830–35), the crisp autograph bronze cast by Barye himself for the *surtout de table*; and the two closely related designs, *Lion with a Guib Antelope* (1835) and *Lion Devouring a Doe* (1837), which vary essentially in the raised and lowered lion's heads;

Seated Lion, Sketch (by 1847), unusual for its vaguely defined surfaces; and the cast-plaster *Lion's Head* (1852), a mechanical reduction of the monumental *Lion Crushing a Serpent*, created exactly twenty years earlier.

Lion and Serpent Variations

Three principal topics are discussed in connection with the many small versions Barye made of his famous monumental *Lion Crushing a Serpent*, shown in the Salon of 1832: the development of the monumental design, the freely invented small versions, and the mechanical reductions.

It is instructive to compare the principal views, those from the lion's left-front side, of two early versions of *Lion Crushing a Serpent:* the small sketch (*Fig. 108*) and a terra-cotta compositional study in the Walters Art Gallery (27.548).[101] Viewed beside the monumental bronze, the small versions manifest two different silhouette types, both of which were assimilated into the final sculpture. An essentially triangular silhouette organizes the sketch, unlike that of two great arched lines in the terra-cotta version. A triangular silhouette dominates the monumental bronze when it is viewed from the left front or right rear (cf. *Fig. 111*), whereas the flowing, arabesque contours dominate a second principal view, from the right front and left rear (see *Fig. 24*). Thus the monumental bronze embodies a dynamic, contrapuntal interplay of the two silhouette types, which had been kept distinct in the smaller, preparatory versions. Of course accents of arabesque contour serve to relieve the strict triangularity of the sketch, in the play of the downward flowing contour of the lion's neck and face against the upward curve of the tail—movements echoed in the tufts of its mane and in the rolling lines of the serpent itself. Similarly, rectilinear accents occur in the braced forelegs of the terra-cotta version to set off the preponderance of flowing curves.

The principal element retained for the monumental group from the sketch, the first version of the image to judge from Barye's own appellation, is the distance between the faces of the lion and serpent—a dramatic spatial interval that establishes the emotion-charged relation between the two. Barye apparently regarded the action of the lion—batting at the head of the serpent with its raised forepaw while holding it fast with the claws of its hind paw—as too exclusively in the realm of mere physical action. His final design restrains such action and stresses instead the psychological tension of the encounter for a great gain in dramatic effect. A second change, of an expressive kind, is the posture of the lion in the sketch when viewed from the front. The small lion leans markedly away from the serpent, creating an aura of hesitancy or fear. A distinctly positive mood, however, is conveyed by the more upright stance of the monumental lion, which definitely threatens and dominates its adversary.

The terra-cotta version shows the lion's forepaws much as they are in the monumental form, the left one braced to support the creature's weight, the right one gently pinning the serpent to earth. However, in the monumental work, Barye altered the low position of this lion's head, which nearly touches the serpent, and thus improved the legibility of the lion's face, making it the focal point of the design.

Barye offered freely invented miniature variations of his famous monumental design of 1832 in three different sizes (18 cm, 26 cm, and 36 cm high), according to the entries in his sales catalogues between 1847 and 1865. A fourth version, the smallest of them all (at 15 cm high), he termed a "sketch of the same subject." This type was the preliminary design, with the motifs of the lion slapping at the serpent with a forepaw while pinning it with a forepaw—two motifs omitted from the monumental form.

Barye exhibited a group of his small bronzes in the Section industrielle of the Exposition Universelle of 1855. The implications of the term *industrielle* would include not only the limited mass production of proofs of his designs but also mechanical reductions and enlargements after his works, made with the Collas machine or a similar device.[102] Hence, the earliest of the mechanical reductions of *Lion Crushing a Serpent* may well date prior to the 1855 exposition. The date 1852, inscribed on the plaster *Lion's Head* (*Fig. 112*), marks it a perfectly timed instance of a mechanical reduction after Barye's famous monumental bronze of 1832.

A later, state-sanctioned, posthumous effort to create copies, if not reductions or enlargements, of *Lion Crushing a Serpent* and of *Lion of the Zodiac* relief coincided with the Exposition Universelle of 1889 (*AN* F[21] 2906). This campaign of reproduction would have yielded molds and positives well suited to the making of mechanical reductions for the art market. The 1889 reissuing also coincides with the purchase of a fine Barbedienne cast of the monumental *Lion Crushing a Serpent* for Rittenhouse Square in Philadelphia. A second cast of the design made in the same period was installed on the lower register of the *Monument to Barye*, unveiled in 1894, on the Ile Saint-Louis beside the Boulevard Henri IV. The monument was sponsored by American donors and was designed by the architect Stanislas Bernier.[103]

It is likely that the undated but very late Leblanc-Barbedienne Catalogue lists only mechanical reductions of Barye's *Lion Crushing a Serpent*, in light of the corresponding dimensions of a mechanical reduction in a New York private collection[104] with no. 3 in the catalogue, and the agreement of the dimensions of the plaster *Lion's Head* (*Fig. 112*) with no. 2 in the catalogue. Even a proof in the original monumental size was available from Leblance-Barbedienne, for 5,000 francs. This means that an accurate, full-size positive was accessible in their shop, one suited to the making of reductions of any size.

A large reduction of *Lion Crushing a Serpent* was listed in the Hôtel Drouot sale catalogue of 1876 under "sculpture plâtre" as no. 493, *Lion au serpent. . . . Jardin des Tuileries. demi grandeur*. However, indications of size are vague in this catalogue, and the reference must remain imprecise.

The attitude Barye had taken toward the dissemination of his *Lion Crushing a Serpent* also motivated the creation of a number of small, modestly priced variations of the monumental *Seated Lion* of 1847 (*Fig. 27*). A small bronze version of *Seated Lion* (*Fig. 117*) appeared as design no. 99 (36 by 34 cm), in Barye's first sales catalogue of bronzes, published in the very year of the casting in bronze of this particular monumental work. Versions in four more sizes are cited in the catalogues of 1855 and later: *CQC55*, no. 48 (37 by 31 cm), no. 49 (21 by 16 cm), and no. 50 (19 by 15 cm), three sizes identical with those in *CRF55*, nos. 40, 41 and 42; *CQC65* lists a no. 48 (19 by 15 cm); and the late *CFBLB* lists

Lion assis (ésquisse) (28 by 30 cm). As representative examples, two of the several variations are discussed below (*Figs. 116 and 117*).

Lion Crushing a Serpent, Sketch (*Fig. 108*) shows a seated, snarling lion that bats at the serpent with its left forepaw while pinning the reptile to the earth beneath its left hind paw.[105] The snake is coiled, its jaws opened in challenge, as though in the moment before it would strike. Energy charges across the gap between the masks of these protagonists. The detail of the lion's claws is vividly articulated—those on the left-front and rear paws are unsheathed to hold and slash the serpent, while those on the right paw are relaxed or withdrawn. The balance of emphasis upon the dramatic psychological content of this encounter, and upon the physical action of the lion as it pins and slashes at the serpent, is rich indeed. Barye's final decision to eliminate the pinning hind paw of the lion in the monumental design must have been difficult to reach. The domical modeling, with graphic accents, in the lion's snarling face and the billowing tufts of its mane are exquisitely realized passages, among Barye's finest during this period. The strict, triangular silhouette of the principal view is set off by the arabesques of the curled tail, the lion's head and neck, its mane, and the coiled serpent.

A description of the five removable elements of this bronze model is found in Chapter 6. This cast is virtually solid bronze and is inscribed *modèle* inside the base. It is a *cire-perdue* cast, taken directly from a wax model, but it is a cast of a rather porous fabric, one that betrays the hazard involved in casting a solid form with projecting elements of greatly different diameters. Dissimilar rates of expansion and contraction—in the large mass of the lion's body as opposed to the lion's slender foreleg—created sufficient stress during the cooling of the bronze to cause the foreleg to crack completely in half. It has been crudely reattached with a pegged joint, but the original, granular fissure has not been disguised and is clearly visible.

As a design, proofs taken from this model (herein termed "variation no. 1") are easily distinguished by the absence of the rock motif at the front of the base in the hollow between the serpent and the lion's braced forepaw.[106] Another proof lacking the rock forms is in the Baltimore Museum of Art (Lucas Collection, 64.15.58), herein designated "variation no. 2." These rock forms are present on the cast plaster and wax model in Paris (Musée des arts décoratifs, inv. no. 12303).[107] Two bronze proofs with the rock motif on the base are in the Walters Art Gallery (27.87) and in the Boston Museum of Fine Arts (Res. 27.12).[108]

In Barye's drawing *Toying Lion* (*Fig. 159*), at the extreme right, are frontal and lateral views of a lion batting at something with its left forepaw.[109] Even the tail of the lion curves upward as in this small bronze. Different in the drawing, however, are the nearly vertical planes of the front and left sides of the lion's face, motifs Barye used on the monumental form instead. In the small bronze the lion's face is lower, and it is held at roughly a forty-five-degree angle to the horizontal. The bronze lion's raised forepaw is lifted nearly to the height of its eye, and its elbow touches the knee of its hind leg, whereas the drawing shows the lion's forepaw lifted only half as high and the elbow placed at some distance ahead of the knee. The frontal view in *Toying Lion* is similar to the small bronze in its sideward-leaning attitude, as though recoiling before the serpent rather than dominating it.

Lion Crushing a Serpent, Reduction No. 1 (*Fig. 109*) is a master bronze for *surmoulage* casts (see Chapter 6).[110] The lion is a separate cast, attached to the base with bronze pins, screws, and soft solder. The major part of the serpent is integrally cast with the base, except for the projecting head, which is bolted and soldered to the base.

The principal view of *Reduction No. 1*, that from the left front, is strikingly similar in its general lines and emphases to the terra-cotta study (Walters Art Gallery, 27.548). The small bronze differs from the terra cotta in the placement of the lion's head, twice as high above the surface of the base, a larger interval also used in the monumental version. Different, too, is the somewhat more vertical plane of the lion's face, another change echoed in the monumental form, as is the more plausible and powerfully modeled left shoulder of the lion. On the lion's right side, that away from the focal mask, a steely, springlike muscular tension is splendidly felt. Raw power is conveyed in the large, domical compartments of muscle, relieved with deep grooves. The bronze repeats the short snout of the terra-cotta lion's face, although the planes and modeling of the head are somewhat clearer.

One consequence of the somewhat indistinct modeling of the lion's head in *Reduction No. 1* is a diminution of its dramatic importance, with a correspondingly greater emphasis on the serpent than is true of the monumental bronze. Here the serpent is more strongly emphasized in other ways as well. Its coils are more freely piled, and its head is held high in the air, almost as though in a striking position. In the large version, however, the serpent appears to cower just beyond the slightly protective edge of the rock and to weigh the risks of striking at the lion, almost in a human mode.

A comparison of the head and mane in *Reduction No. 1* with those of the small bronze sketch (*Fig. 108*) is instructive. Barye's use of positive tufted forms in the mane and clearly defined forms in the mask in the sketch are here replaced with a more graphic handling of the mane and a less distinct structure for the mask. The main tendency of the mask in *Reduction No. 1* is toward a decoratively shimmering, almost impressionistic breaking up of the larger, simple planes, slightly confusing the final effect of this focal element.

The exuberant buoyancy of surface handling in *Reduction No. 1* is altogether different from the studiously mimetic, more soberly zoological surfaces of the monumental group. To the lion's face have been added small mounds of wax, pellets given a richer, interrupted kind of rhythm than is present in the strictly curvilinear, contour-line accents and divisions that organize the monumental mask. Nonetheless, anatomical mastery is still forceful, as in the delineation of the claws, claw sheaths, and knuckles of the focal serpent-pinning fore-paw. The base shows a sharp ridge that creates a long line to lead the eye directly from the serpent to the lion's left hind paw, a motif retained from the monumental original.

Lion Crushing a Serpent, Reduction No. 2 (*Fig. 110*),[111] another master bronze model for *surmoulage* casts, presents an interesting technical connection between this four-piece model and a *surmoulage* cast made after it (Baltimore Museum of Art, Lucas Collection, 64.15.5).[112] In the *surmoulage* cast are cold-working marks in the mane of the lion, exactly at the bronze model's separation line for the lidlike top of the lion's head. File scratches and the chattering or bouncing marks of a burin used to chase fissures in the modeling of the mane are quite clear.

In comparison with the monumental original of 1832, the much deeper rocky base of this design is decoratively elaborated, with a wrinkled surface on the signature side and a projecting crag that juts out directly below the serpent's head, a contrived echo of that projecting motif, and of the angle or plane of the lion's face. The lion's mane has a denser mass than those of *Sketch* and *Reduction No. 1*. Its hair is more wiry, and it does not fall into the same soft, bladelike tufts. On the back side a new element appears, in the long, undulant form of the snake, which leads the eye to the lion's curved haunch. This treatment of the serpent goes far beyond the subtle, abstract concern with the negative form between animal and base, which is true of the monumental original. Now the serpent is far larger, more active, and more threatening, almost to the point of excess.

Lion Crushing a Serpent, Reduction (*Fig. 111*) is the largest of the free versions.[113] The proof is signed BARYE at the top of the plinth, between the left forepaw and the serpent. No founder's marks are visible on this crisply detailed copper-alloy cast of a dark brown to black patina. The six assembled elements of the proof are (1) the base, including two-thirds of the lion's tail; (2) the lion's snout and its upper jaw and teeth; (3) the lion's body, with the stump of the tail; (4) the left paw and foreleg, to a height of about 8 cm above the base; (5) the serpent's head and a 5-cm part of its projecting neck; and (6) the right paw and foreleg, to a height of about 12 cm.

A comparison of this free variation with the monumental original reveals a greater emphasis upon the serpent. Barye exaggerated the size of its head and lifted it high above the base, a change resembling *Reduction No. 2*. Subtler alterations are also apparent: in the finer, more intricate tufts of mane behind the lion's ears; the shorter left haunch, which does not touch the elbow of the foreleg, as on the monumental design; and the flatter look of the lion's snarling mask.

Lion's Head (*Fig. 112*) is a mechanical reduction of the head of the monumental bronze of 1832.[114] The signature and date are integrally cast, not directly inscribed on the plaster. The plaster is sealed with a uniformly thin coating of wax. Token of the casting process by which this proof was made are the mold-separation lines across the forehead, just above the eyes, and along the ridge of the central cock's comb of the mane. The size of this plaster head is precisely that of the freely invented *Reduction No. 1*, since the interocular distance is the same in both, and it agrees perfectly with the size of proof no. 2 in the Leblanc-Barbedienne Catalogue. One glaring difference between the free variation and this mechanical reduction is in the measurements of the lions' open mouths: 2 cm for *Reduction No. 1* and 3.8 cm for the mechanical proof. It is almost as though Barye had intended to display the two side by side at the 1855 exposition to dramatize the distinction between the invented and mechanical reductions. Strangely enough, no bronze proof made from this type of model has come to light in an American or French collection.

Lion Devouring a Boar (*Fig. 113*) shows a seated, almost preoccupied lion feeding upon the hind leg of a boar held fast in its forepaws.[115] Immediately striking is the emphasis upon pure geometrical forms, in the stark pyramid of the lion, the nearly vertical plane of its

face, the almost parallel lines of its forelegs, and the circular plan of the base of the design. Detail in the lion's mask is superb. Even the lids of the lion's eyes are delineated, and there is a subtle play of a raked, linear texture over the domical forms of the lion's wrinkled nose and brow. Full, lush tufts of mane are regularly spaced, creating a sculptural aureole about the lion's face.

Barye's drawing *Face of a Feeding Lion*, after Rubens (*Fig. 150*), about 1819, shows a lion's mask and mane conceived wholly as a system of cursive arabesques, one almost rococo in its swirls. By contrast, the power and ruggedness of the lion's face in this small bronze testify to Barye's inventive transcendence of that early source.

Token of the importance of this theme—one considered for the *surtout de table* of the Duke of Orléans—is the existence of two further sculptural variations, numerous drawings of the boar, and even an exquisitely detailed plaster and wax model, *Boar's Head Boss* (Walters Art Gallery, 27.455), a form inspired by ancient Roman animal's head bosses.

Lion Devouring a Boar (*Fig. 114*) is the crisp autograph lost-wax bronze cast between 1830 and 1835 by Barye himself for the *surtout de table* of the Duke of Orléans.[116] Its base is shallow and platelike in the *ad hoc* mode of the autograph companion pieces *Python Killing a Gnu* (*Fig. 96*) and *Tiger Overturning an Antelope* (*Fig. 98*). This casting was not completely successful, despite the beauty and impact of its model, for its surface is filled with pinholes and tiny bubbles, and its fabric is excessively porous. The waxy finish and the exquisitely detailed, painterly lion's mask and mane suggest the quality in *Lion Devouring a Doe* of 1837 (*Fig. 119*).

As a composition, this design uses a much larger boar relative to the size of the lion than does the version in Figure 113. This boar is unquestionably alive; he suffers vividly and cries out as the irresistible lion crushes it to the earth beneath its forepaw, biting deeply into its flank.

Barye's drawing *Face of a Feeding Lion*, after Rubens (*Fig. 150*), nearly duplicates the relation of the lion's paw to its face, a distinctive motif of both bronze and drawing. A second drawing, *Standing Boar* (Louvre, RF 4661, fol. 15v), stresses the shaggy outline of the boar's head and the dense mass of bristles along the nape of its neck, like a horse's mane, a motif carried directly into the bronze. The drawing *Boar's Head* (Louvre, RF 4661, fol. 5v) shows the focal motif of the boar's half-open mouth and the tusk and its pocket indented in the flesh of the upper lip and jaw.

Lion Devouring a Boar (Louvre, OA 5746, Pivar, p. 134), a third sculptural variant, retains the motifs of the lion's forepaw pinning the boar to the ground and the lion biting into its flank. This boar, however, is smaller relative to the lion, and it is dead rather than in dramatic agony. The base is deeper and domical, in the manner of the commercial designs of the period, unlike the spare plinth of the autograph group.

Bear in Its Trough (*Fig. 115*) shows a feeding bear lolling backward, seated in its water trough and hunching over food clutched tightly between its forepaws.[117] Its mood is dreamy and preoccupied. The bear's head, shoulders, and forelegs are distinctly spherical in form, contrasting boldly with the cubical trough. The virtual disappearance of the bear's lower

back and hindquarters into the hollow of its watering trough represents an unusual spatial interaction of figure and base for Barye's designs, one that Dr. Charles Millard feels prefigures Edgar Degas's famous *Woman in a Tub* in that particular. Normally his figures are distinct from their bases. Apparently a different species from the one in *Bear Reclining on Its Back* (Walters Art Gallery, 17.76; h. 12.7 cm) is depicted here, with a shorter snout, rounder head, and shaggy, projecting fur at its cheeks.

Two drawings of a seated bear (*Fig. 191*) resemble this bronze in significant ways. One study at the center of the page shows an almost perfectly spherical back view of a bear, its head sunken onto its shoulders and its relaxed body comically, almost implausibly compressed, much like the spherical upper portion in *Bear in Its Trough*. A second drawing shows a seated bear from the front, with its hind leg flat on the ground as in the bronze.

Seated Lion, Sketch (*Fig. 116*) shows the lion gazing intently forward, its neck extended, and its head low, as though it were studying its quarry at a great distance, or noting a scent in the air.[118] It is an alert, naturalistic stance. In comparison with the natural pose of this preparatory study, the final, more formal *Seated Lion* (*Fig. 27*) looks as though it has snapped to attention.

One of the outstanding dimensions of Barye's bronze sculpture is the richness of its surface articulation. Thus the strangeness of surface quality in this bronze seems all the more curious. There is a complete avoidance of realistic surface detail and a substitution of a self-conscious frostinglike texture, perhaps imparted with a spatula to the unset plaster of the model or to a final layer of wax applied over the surface of the model. *Seated Lion, Sketch* may be an answer to those critics who spoke against the excess of minute detail on the surfaces in *Tiger Devouring a Gavial* (1831) and *Lion Crushing a Serpent* (1832). If so, it is certainly an extreme response, for not only are the details absent but also the defined surfaces they might embellish. Is this sketch to be understood as a sculptural counterpart to the bold, open style of the painted sketches (rather than finished pictures) created by Barye's contemporaries? Surely the style of *Lion Crushing a Serpent, Sketch* (*Fig. 108*), a comparable small bronze in light of its preparatory relationship to a monumental design, does not share these qualities. Accents or secondary passages in this style do appear, however, in other small bronzes, such as *Bear on a Tree, Devouring an Owl*, a free and painterly design of the late 1830s or the 1840s. Perhaps *Seated Lion, Sketch* was not offered in Barye's sales catalogues, but only in the late Leblanc-Barbedienne Catalogue, because Barye was uneasy about its extreme style and wanted to suppress its wide dissemination.

A plaster positive of *Seated Lion, Sketch*, now in the Louvre (RF not shown; h. 27, l. 33, w. 16 cm), was probably cast in a gelatin mold, to judge from the number and character of its mold-separation lines. This plaster has a notably smoother surface quality and a simpler, less embellished silhouette contour than the bronze. Nor is the peaked frostinglike texture so pronounced. This difference of surface quality does not seem to reflect the abrasion of the model, as might be caused by taking rigid piece-molds. Rather, it denotes a conscious, artful reworking of the surface with files and rasps. Certain interior elements of the plaster differ from their counterparts in the bronze, and they appear actually to have been redesigned, such as the long tufts of mane below the lion's ears, which are wider, longer, and

much flatter in the plaster version. It is tempting to think that this state of the plaster is autograph, and that the commercial small bronze reflects a stickier wax-coated surface, perhaps worked up by an artisan.

Seated Lion, Reduction (*Fig. 117*) has a sterner expression than the monumental prototype and a pronouncedly different handling of mask and mane.[119] The forelegs and paws of this lion are wider and clumsier than those of the large bronze. The lion's face departs in its proportions and modeling, not only from the large bronze, but even from the germinal anatomical drawing of the head of a lioness (*Fig. 161*). Its eyes are set farther apart, and the modeling about the eyebrows, the bridge of the nose, nostrils, and upper lip only vaguely emulates the precise, essentially spherical forms in these passages of the drawing of the dorsal view of the head of a lioness. Nor does the mane fall in a long, continuous cascade from the sides of the face onto the chest. Instead, it is cut into many separate, roughly similar short tufts. This highly decorative, somewhat conventional organizing concept is much closer to Donatello's heraldic lion, *Marzocco* (Bargello),[120] or to its ancient Roman sources, such as *Seated Lion* in Visconti's *Musée Pie-Clémentin* (vol. 7, pl. XXIX) (see *Fig. 249*), than to Barye's more personal, monumental prototype. *Egyptian Cat Deity* in the Caylus Collection (*Fig. 250*) shows the hieratic, seated posture of Barye's *Seated Lion*.

Lion with a Guib Antelope (*Fig. 118*) depicts a recumbent lion that looks forward, lifts its head slightly above the sprawled carcass of the dead antelope, and appears to roar, its mouth open and its eyes slightly narrowed.[121] The expression on the lion's face has the nearly human aspect of the lion in *Lion Crushing a Serpent*, although the different mood of the protagonist here suggests a roar of triumph above the captured prey. Tucked in close beside its body, the lion's powerfully muscular hind legs contrast with the awkward, spindly, angular legs of the antelope. The mane of the lion is sculptural, but it is organized in long, simple planes and tufts, rather than with the irregularity and free rhythms of *Lion Devouring a Doe* (*Fig. 119*). Similarly, the face of this growling lion emphasizes the major planes and volumes of the skull. A generally smooth quality of surface is evident on the flexed hind leg and the body of the lion, a tendency of design perhaps preliminary to the intricately embellished surfaces and freer handling in *Lion Devouring a Doe*. Relieving the sphinxlike axiality of the recumbent lion's body are the angle of the lion's gaze, slightly upward and toward the right, and the arabesques of its curled tail, which also moves at the right side.

Recumbent Lion (*Fig. 251*), an ancient small bronze in the Caylus Collection, has a somewhat similar pose, although the alerted head is turned more to the side than is that of Barye's bronze. An expressively curling tail matches the intensity of gaze in both. On the ancient bronze, however, the mane is close cropped and more stylized than Barye's rich, painterly development of that passage.

Lion Devouring a Doe (*Fig. 119*), in which a recumbent predator feeds intently upon the limp, broken carcass of a doe, focuses on the contrast between the snarling, relatively giant mask of the feeding lion and the frail and delicate head of the pathetic doe.[122] The lion's

tail, the secondary focal point, curls tensely upward, poised in the air, a symbol of the lion's excited concentration.

The focal motif of the feeding lion's face is, in fact, an anatomist's dorsal view, precisely as seen in the drawing *Head of a Lioness* (*Fig. 161*). The rich, spherical modeling above the lion's eyes and the intricate wrinkles about its snarling mouth are remarkably close to those of the monumental *Lion Crushing a Serpent* of 1832 (*Fig. 23*). The tufts of the lion's mane are lush and ragged. Their energy and deep relief contrasts nicely with the less plastic surfaces of the base and the lion's body. Surfaces are embellished with irregular, rhythmical passages. In contrast to the strictly axial body of the lion, the head and that of its pathetic prey are set to the right side, an asymmetrical accent Barye would repeat in such designs as *Elk Attacked by a Lynx* and *Panther Seizing a Stag* in *Group 12*.

An ancient Roman recumbent lion in the Caylus Collection (vol. 7, pl. LIX: V), a terracotta amulet with an integral plinth (*see Fig. 252*), has the same general pose and an emphasis upon a shaggy, plastically irregular mane. Of course Barye stresses the lion's complete absorption in feeding, and the pathos of its victim—narrative and psychological dimensions that are lacking in the ancient prototype.

Bull Attacked by a Bear (*Fig. 120*) shows a captured, fallen bull bellowing pathetically, its head raised in pain, as the bear bites deeply into the nape of its neck.[123] The claws of the bear rake into the embraced bull's hide, and the bear's teeth tear at the neck of its pinned prey. The heads of the protagonists are at either side of the main axis of the design: the bull looks to the left and the bear to the right. Surface textures are superbly varied in this waxy caste, particularly in the shaggy but clipped texture of the bear's fur, which plays against the sheen of the bull's hide and against the deep, graphic accents of the lines at the sides of the bull's neck and head. This is a single-piece shell, except for the attached forelegs, horns, and tail of the bull. A small break in the fabric is seen inside the bear's left rear paw.

The bull's raised head, its apparent outcry of pain or exhaustion, and the detail of the fully flexed foreleg curled beneath itself, comprise a cluster of motifs Barye would use again on the suffering prey of his autograph *Lion Devouring a Boar* (*Fig. 114*) a design also recorded in a drawing in the Walters Art Gallery (37.2228).

Ratel Robbing a Nest (*Fig. 121*) shows a ratel badger resting its right forepaw upon a gnarled tree stump.[124] It peers intently over the edge as it searches for eggs among the hollows. The long single line of its arched back dominates the silhouette, a curve relieved by the sharp accent of the creature's tail. The ratel's simple contour line sets off the intricate spatial pockets worked into the tree stump, and those between the underside of the badger and the surface of the base. An emulation of rococo porcelain forms is implicit in the elaborate tree-stump base, and in a tendency toward a painterly style of more controlled surfaces than those in *Seated Lion, Sketch* (*Fig. 116*).

A measured contour drawing of a ratel (*Fig. 192*) shows the entire animal in a profile view, not too unlike the stance of the bronze. However, Barye curiously reduced the length of the badger's snout to a more bearlike form in the bronze—unless the present cast merely reflects a damaged model.

GROUP 11: CIRCULAR BASES, VARIED SILHOUETTES, AND MOODS OF ANGUISH

Virtually all of the designs in Group 11 share a circular-base plan, giving rise to a cylindrical, conical, or spherical general mass and to various degrees of silhouette intricacy. The latter range from the powerful raggedness of *Bear on a Tree, Devouring an Owl* to the almost lacelike openness and complexity of *Elk Hunt*. The notable exception to this mode of organization is the rigidly planar and actually one-sided *Tiger Hunt* group.

Moods range delightfully among these works, through the quasi-human, exploratory grappling in *Standing Bear*; the desperate, even ultimate urgency of the equestrian hunters in *Elk Hunt*; the frozen, balletic posturing of the humans in *Tiger Hunt*; and the anguish of the pursued and fleeing quarry in *Bear Hunt*. Surface qualities vary from the painterly raggedness of *Bear on a Tree*, to the goldsmith's precision and clarity of *Elk Hunt*, to the painterly lushness of the tiger's pelt in *Tiger Hunt*.

Of the five dated designs in Group 11, three were created for the *surtout de table*: *Tiger Hunt* 1836, and *Bear Hunt* and *Elk Hunt*, both 1838. *Standing Bear* was exhibited in the Salons of 1831 or 1833 and *Two Bears Wrestling* in the Salon of 1833. Some of the finest of Barye's small bronze designs of the 1830s are found in this group.

Standing Bear (*Fig. 122*) shows the animal rearing on its hind legs in a vividly human fashion.[125] Its dour gaze is toward the front and its left forepaw is extended as an aid to its balance, which suggests a boxer's approach to his opponent. The nearly human expression of this bear recalls the amusing caricature of the sculptor Barye, given the face of a *bear*, elegantly posed before his modeling stand, tools in hand.[126] Dominant in this axial, vertical design are the vigorously undulating contours of the silhouette, almost in the manner of Rubens, and the soft, spherical modeling of the fur and flesh. The mask superbly balances the clarified, skeletal forms of the forehead and snout with the freely massed aureole of fur, which suggests the tousled mane of a lion.

Standing Bear may date as early as 1831, if it is the no. 2887, *Un ours. Équisse*, cited by Lami. It may also be either the Russian or Alpine bear shown in the Salon of 1833: no. 5238, *Ours de Russie*, and no. 5239, *Ours des Alpes*. Modern photographs show that the hind legs of actual bears in this standing position are proportionally shorter than those of Barye's bronze, suggesting that a measure of artistic license with zoological data occurs in this design.

Two Bears Wrestling (*Fig. 123*) is an animated conflict between equals.[127] The two bears roil and scramble, their jaws opened, their forepaws batting at each other. The lower of the two bears is more spherical in form, as though it were rolling away under the impact of the flailing forepaws of its opponent. A hump at the shoulder of the lower bear marks it as the American bear of the ornately zoological title of the composition as given in the Salon *carnet* for 1833: *Lutte de deux ours, l'un de l'Amérique septentrionale, l'autre des Indes*.[128] This combat of a North American and an Asian Indian bear could occur only in a zoo or a

circus, of course—a whimsical aspect of its zoological content that places it in the same class with *Ape Riding a Gnu*, a design featuring East Asian and African species.

The dramatic narrative and spatial interplay of the faces of these snarling bears—perfectly framed in the hollow below the upper bear's extended forepaw—is one of the most successful passages of this period. This composition of freely spiraling arabesques is animated yet superbly harmonious, with a ragged yet controlled silhouette. The circular outline is broken by the accents of the jutting hind leg of the lower bear and the projecting forepaw of the upper bear.

Evidently this stirring scramble is a romantically imaginative expansion upon the hint of such an idea in the drawing of two views of a seated bear (*Fig. 191*). The open jaws of these two facing bears are marvelously sinister and intense in the orchestration of the bronze. Even the spherical form of the lower bear is present in the study at the center of the page.

Bear on a Tree, Devouring an Owl (*Fig. 124*) is a balance of geometrical contrasts.[129] The owl flaps its free left wing in a vain attempt to escape from the heavy, rotund bear that clings precariously to the gnarled tree. His swollen contours contrast with the carved pockets hollowed into the opposite side of the design, and they contrast with the projecting accents of the tree branches that break the smooth silhouette of another view. The spherical masses of the bear also contrast with the sharp lines and prismatic facets of the base. This design is vigorously sculptural in the interplay of positive and negative form, and it is one of the best unified of the more complex designs of the late 1830s and early 1840s. A waxy surface quality with crisp detail is apparent over this entire proof.

Bear Hunt (*Fig. 125*) shows an armored hunter in sixteenth-century French costume charging his horse directly over the roiling mass of three tumbling bears and three hounds.[130] The action is frenzied and violent. The knight holds his broadsword aloft and prepares to slash at the enormous half-fallen bear that lunges at him and claws at his leg, as though defending another bear brought down by two hounds. The hooves of the rearing horse are just over the head of the bear brought down by hounds, and the bear seems to cringe at the sight of them. A single combat in the classical mode is suggested by the struggle of the knight and the challenging bear. A second episode is the dramatic image of the two hounds biting deeply into the belly and neck of the bear fallen on its side beneath the rearing horse. A third moment is that of the running bear alongside the knight's horse and parallel with it, harried by a biting hound and pursued by the forester wielding a sword.

The ideally youthful visage and feather-plumed hat of the swashbuckling Gothic prince crown the essentially conical mass of the design, which rises from a circular base. Below the planar form of the silhouetted, rearing horse, the arrangement of the bears and hounds becomes complex and agitated, in a rather baroque mode. Within the interwoven pattern of their solids and voids, the heads of the several animals are dramatic: The biting hounds tear at the bears, and the panting bears gasp, yet they seem to growl in anger. In fact, a sense of the din and clamor of the hunt is vividly present. The forester's humble leather costume and hunting horn set off the aristocratic feather plumes, pectoral medallion, and armor of

the riding prince, a contrast of social classes recalling Gothic paintings of about 1400, such as Gentile da Fabriano's *Adoration of the Magi* (Uffizi), with its golden-haired prince, whose spurs are being removed by a groveling groom.

As a design, *Bear Hunt* is one of the latest and most successful of the five hunt groups created for the young Duke of Orléans. Technically, the casting made by Honoré Gonon is heavy, with numerous pinholes in the breast of the horse and at the bear's side, where the hound bites at it. The patina is gray-green.

A compositional study, *Rider Brandishing a Sword* (Walters Art Gallery, 37.2175B), captures much of the energy and vitality of the bronze group. It shows the sword held high behind the rider's head, a position made physically stronger in Barye's bronze, where the sword rests upon the rider's shoulder for support. Even the sense of garments fluttering in the wind suggests the feather plume, sleeves, and skirt of the bronze rider. Three drawings of pieces of armor (*Fig. 188*) are generic to the armor of this rider in various isolated particulars.

Two measured drawings of a hunting hound (Louvre, RF 8480, fols. 27v and 28v), inscribed *chien dogue,* record Barye's study of the anatomical particulars of the mastiff type. The squarish snout, pointed ears, loose skin about the neck, and thick tail of the dogue hound are apparent in both drawing and bronze.

An ancient silver relief, *Bear-Hunter on Horseback* (*Fig. 254*), was in the Caylus Collection. Its rider, mounted on a rearing horse, plunges home the lance. Barye reversed the arms of the rider but emulated directly the bear's extended forelegs and menacing look.

Fragments of the *Bear Hunt* composition, cast in bronze, are extant in several museum collections, although none was offered in Barye's sales catalogues of bronzes: *Rider-Knight in Sixteenth-Century Costume,* h. 21¼, l. 19½ inches.; 54 by 49.7 cm (Louvre, OA 5737; see Pivar, p. 94). *Bear Fleeing Dogs,* h. 12, l. 18 inches; 30.6 by 45.8 cm (Corcoran Gallery of Art, 73.93; see Pivar, p. 103). *Forester with a Staff,* h. 12⅛ inches; 31 cm (Walters Art Gallery, 27.80; see Pivar, p. 72).

Bear Overthrown by Three Dogs (*Fig. 126*) presents a predator become prey. A snarling bear has tumbled onto its back, its legs flailing in the air, as it attempts to flee from three pursuing dogs. Clearly off-balance and perhaps still falling, the bear appears to have stumbled over the tree at the center of the base.[131] One dog tears at its ear, another leaps upon it and bites at its belly, while a third seems inadvertently pinned beneath the falling bear. All three of these motifs were known to Barye in antique prototypes. The carefully orchestrated consistency of speed and direction is impressive, almost as though Barye had corrected the apparent disjunctions of pace evident in the lower zone of *Bear Hunt* (*Fig. 125*), where the bear runs at full tilt, its forelegs extended, while the dogs appear to be almost stationary. Hence, this design well may be a later, more perfected variation.

This bear closely resembles those in *Bear Reclining on its Back* (Walters, 27.76) and *Bear in Its Trough,* Salon of 1834 (*Fig. 115*). All three designs derive from a tiny drawing of a bear on its back (Louvre, RF 4661, fol. 36v). Unlike the lyrical tone of the drawing and the two related bronzes, *Bear Overthrown by Three Dogs* treats violent action and is radically

heightened in mood and movement. Carefully related diagonal lines set off the larger complex of rolling arabesques in this intricate design, as in the axes of the bear's head and its extended forepaws, and in the forepaws of the hound pinned below the bear. A right angle governs the relation of the pinned hound's head and the head of the bear. This perfect angle is also repeated in the accented linear forms of the same hound's lower hind legs.

A fragment of the *Bear Hunt* group, its lower zone, exists as a work complete in itself, and it invites comparison. The fragment, *Bear Fleeing from Dogs* (see Pivar, p. 103), differs significantly in that its silhouette is governed by an obvious triangle, and it has a distinctly isolating or scattered quality of design, wholly unlike the smoothly interwoven flow of the forms in this freely developed later variant.

This proof is a superbly detailed master bronze, or bronze model, intended for the making of sand molds. It is fitted with removable elements held in place with pegs, such as the lower jaw of the bear and that of the hound on which its left forepaw rests, the tail of the latter dog, and the right forepaw of the dog biting at the bear's belly. Combed linear textures in the pelts of the bear and dogs are carefully controlled, if slightly balder than the corresponding surfaces in *Bear Hunt*. The foliage scattered over the base is crisp in detail and of a waxy surface quality.

Tiger Hunt (*Fig. 127*) shows three Mogul hunters crowding the tiny howdah carried by a great Indian elephant.[132] Two of the hunters parry the rush of the attacking tiger, charging up the elephant's right side, their lance and saber poised. The elephant driver cowers in fear at this sudden onslaught and instinctively draws back his elephant prod, as though to strike the rapidly ascending tiger. On the other side of the howdah, the third hunter appears to have planted his lance deep into the side of another tiger, which, although fallen and badly hurt, still clings tenaciously to the elephant's hind leg. The great elephant's hindquarters are low to the ground, a stance responding to the weight of the hunters and to the impact of the two attacking tigers. A long straight line rises at a diagonal, enhancing the impression that the elephant is pulling upward and forward against the effort of the tigers. Nodding to the frenzied tug of its driver, the elephant turns its head slightly to the right, a turning motion that further enriches the action.

As the central group of the ensemble of nine compositions created for the Duke of Orléans, this design is the tallest, for it was the pinnacle of their pyramidal arrangement, a relationship nicely preserved in the present installation of the hunts in the Walters Art Gallery. This group was conceived in a planar, relieflike mode, and its focal side is clearly that with the climbing tiger challenging two hunters and the driver. On the back of the composition, the hunter's fully extended right arm repeats other lines that jut out into space from the central mass of the design, such as the elephant's tusks and tail. Related interruptions of a smooth silhouette are the raised or poised arms and the extended legs of the men. The serpentine elephant's trunk repeats the fluid lines of both tigers. The ornate detail and silhouette represent a pinnacle of this complex style in Barye's work, one surpassed only in the *Elk Hunt* composition. Surface quality is exquisite in this bronze proof. Overall, a waxy texture is evident, and the character of detail varies from the delicately stenciled pattern of

the embroidered hem of the elephant's blanket, to the more freely developed, almost expressionistic handling of the two tigers, to the still bolder flow and tumble of the grassy base.

Two fragments of Barye's plaster original are extant: *Elephant and Rider* (Louvre, RF 1578; see Pivar, p. 65) and the somewhat altered *Climbing Tiger*, with which Barye created the composition *Tiger Attacking a Peacock* (*Fig. 56*). These fragments are cast-plaster positives, used for the making of a wax positive from which, in turn, this unique lost-wax bronze was cast. The many surface bubbles and the mold-separation lines are typical of cast-plaster forms.

The surfaces of the fragment *Elephant and Rider* (Louvre, Salle de Barye), are rather bald.[133] Absent in the plaster are the sparkling, animated, waxy surfaces of the bronze. A clue to the reason for this apparent gap is found in the passage of the embroidered hem of the elephant's blanket. There, still raised in low relief on the plaster, is a vestige of the embroidery pattern stenciled into a thin layer of wax. No doubt this plaster positive was virtually covered with a layer of wax, a layer Barye worked directly and elaborately to achieve the expressive surfaces on the bronze. From this model a mold was made and a wax positive fashioned, which was used for the lost-wax casting of the final bronze.

Another significant aspect of *Elephant and Rider*, as George Heard Hamilton has pointed out, is that it demonstrates Barye's willingness to sacrifice zoological accuracy for the sake of an artful or expressive goal.[134] The body of the elephant is about ten percent shorter than is the inaccurate body of the final bronze elephant, a change apparently made to accommodate the bulky howdah and its hunters. Thus the cast-plaster positive has been cut apart and a segment of its excessively long body removed. The rearward glance and recoiling gesture of the driver now lack any visible cause, for the tiger that once scaled this elephant's side is absent. It is curious but perhaps symptomatic of Barye's priorities at this moment that he could modify the animal image for reuse and neglect the human one. The driver rides further back and sits more vertically, his head placed at a greater distance from that of the elephant than is true of his bronze counterpart. The base of this plaster model is entirely different from that of the bronze, with the possible exception of a single, relocated clump of grass, which retains its distance behind the elephant's right foreleg but has a different relation to the left hind leg. Different on this base are the plan, surface detail, and the steeply rising angle, as though the elephant were now climbing a hill.

Extensively modified, as *Tiger Attacking a Peacock* (*Fig. 56*), the *Climbing Tiger* fragment still retains the absolutely distinctive, serpentine curve of the tiger's body, seen in a dorsal view. However, the legs of the animal have been lengthened—they appear to be unnaturally short in *Tiger Hunt*—and a wedge of plaster has been inserted into the neck of the tiger to alter the angle of its head relative to the long line of the body. Intriguing is the array of rich surface qualities in the tiger's pelt, for this cast-plaster positive faithfully records the waxy look of many passages on the original model, and it mimics several textural areas worked directly into the plaster positive as well. The two poles of possibility are contrasted with great expressive effect, a concept of surface treatment also evident on Barye's monumental *Lion Crushing a Serpent* of 1832.

As George Heard Hamilton has shown, Barye patterned the exotic howdah and elephant

trappings of the bronze upon a seventeenth-century manuscript illumination of the elephant of Emperor Akbar in Manucci's *History of India*. And this is the title he inscribed on one of the two pages of his drawings after the manuscript, *Histoire de l'Inde par Manucci* (Baltimore Museum of Art, Lucas Collection, Barye Album, fol. 20r).

The exquisite drawing *Head of an Indian Tiger-Hunter* (*Fig. 193*) recalls the semitic facial types in Baron Gros's famous *Napoleon in the Pest-House at Jaffa* (Louvre). The same coinlike perfect profile seen from a low vantage point governs the face of the focal, kneeling, plague-stricken man at the right center of Gros's painting. The conical turban of Barye's figure, however, departs from Gros's Near-Eastern type, a change to the garb of Mogul India. The slightly sad mood of this tiny drawing—its grandeur even—and the fullness of its rhythmic contours, now light, now dark, unfortunately are not carried into the hard faces of the hunters in the bronze.

Barye's zoological data were well founded in nature, as his numerous tiger studies and a drawing of an Indian elephant attest. A contour drawing with measurements, *Indian Elephant* (*Fig. 179*), shows a free three-quarter view of the entire animal and three studies of the head—the profile, dorsal, and underside views. It records such details of form as the insertion of the tusks, the shape of the jaw, the bulges of the skull, the shape of the ear, and the curves taken by the trunk. A suite of dissection studies of the tiger, evidently made from one specimen, was discussed in connection with *Tiger Devouring a Stag* of 1830 (*Fig. 18*).

Head of a Tiger, a fragment of a larger ancient bronze, was known to Barye in the Caylus Collection (*Fig. 253*). The plastic force of its cubic forms and its dramatic mood, symbolized in the half-open, snarling mouth, would surely captivate him. Another source for Barye was an elephant-and-rider relief in the Caylus Collection (see *Fig. 255*), described in the catalogue as a "Greek tomb relief." The ancient elephant driver holds his left arm fully extended, just as does Barye's frightened Mogul rider. Even the species of elephant appears to be the same—a small-eared Asian one,—although the ancient artist did not quite master the articulation of the hind legs.

An elaborately squared but rather stark contour drawing of *Tiger Hunt*, published by Ballu in 1890, is made after the sculpture specifically for a painting. A watercolor that reverses this drawing is in the Baltimore Museum of Art, Lucas Collection.[135] In the drawing the climbing tiger is given a position both higher and further forward than in the bronze. In fact, the drawing is so precisely made that it may well record the appearance of Barye's plaster model before the body of the elephant was lengthened by ten percent.

Another drawing after the *Tiger Hunt* group (Louvre, RF 4219; c. 20 by 18 inches), in black crayon on white paper, is elaborately and beautifully shaded in tones created of parallel hachure, rather than cross-hatching. It stresses parallel, unifying contour lines, achieving a form that is blocky, solid, and quite sculptural. Possibly it was made as a record of the wax positive prior to its loss in the bronze pour. Or perhaps it was intended as the basis of an etching. In any case, like the squared drawing, it was not a preparatory study, but a record of a finished design.

Elk Hunt (*Fig. 128*) shows two equestrian hunters plunging their weapons into the neck of a giant elk.[136] Their quarry rears upward, its head thrown back, its tongue lolling, and its

splendid antlers silhouetted against the sky. On the ground directly before this elk a second elk has fallen across the path, brought down by a lance lodged deep in its back. A hound has scrambled onto the fallen elk and tears viciously into the nape of its neck.

Romantic exoticism is clear in the costumes and in the Mongolian facial types of the riders. The long pigtail on the back of the shaven head of the knife-wielding rider is a motif that recalls the lyrical orientalism of the eighteenth-century porcelain masters and the costume-ball atmosphere of works like François Boucher's *Wedding of the Chinese Emperor* (Besançon). Of course the tone of violent, ultimate struggle in Barye's *Elk Hunt* is more typical of the romantic taste of his own era.

Parallels unify this design. One horse and one elk rear, while the second elk and horse have fallen. The two riders plunge their weapons into either side of the rearing stag's neck at the same moment. Opposites are juxtaposed as well: One hound is pinned beneath the fallen horse, while another is vividly free, clambering onto the back of the fallen elk. One rider is helmeted and the other has a shaven head; one carries a short knife, the other a long lance.

A sense of urgency and violent excitement are remarkably well achieved, despite the almost insurmountable constraints imposed by the convention of the round-plan base. This strict design configuration hardly lends itself to the expansive, baroque treatment the theme would seem to demand, one along the lines of Bernini's virtuoso handling of *Apollo and Daphne* or *David* (Rome, Villa Borghese).[137] Bernini's figures transcend the limits of illusion and seem to spill into the spatial ambience of the spectator. Barye's success in this exciting direction is most impressive. In fact, the persuasiveness of mood and of exotic costume, the continuity and plausibility of action, the scrupulous accuracy of anatomy, the crisp clarity of detail, the lush development of surface textures, and the nearly lacelike intricacy of silhouette mark *Elk Hunt* as a brilliant culmination of Barye's work in the 1830s. It is a touchstone for the sculptor's orchestration of complex, realistic forms into an exciting final image.

The motif of the stag's head thrown back appears in Barye's work at least as early as the large *Poised Stag* of 1829 (*Fig. 12*). One drawing in a suite of related zoological studies that features the motif (*Fig. 154*) is discussed in connection with *Poised Stag*. Two further compositional studies elaborate the motif as well, one focused exclusively upon the stag and one that includes several pursuing hounds (*Fig. 194*). Barye's small bronze *Stag Brought Down by Two Large Greyhounds* of 1832 (*Fig. 129*) also features this motif, and it is based upon the same suite of drawings.

A page of studies of an elk (*Fig. 195*), with rigid profile and frontal views, probably was made from a preserved specimen in the Muséum d'Histoire Naturelle. The distinctive head, wide palmate antlers, deep body, and spindly legs typical of elk are carefully recorded, as are measurements of the specimen.

Barye admired the excitiing imagery of narrative paintings of the hunt in the tradition of Rubens and such artists as Snyders, Oudry, Ridinger, Bachelier, Wouwerman, and Desportes. Barye's awareness of the works of all these painters is certain, since he wrote their names in his sketchbooks.

GROUP 12: PATHETIC FACES, STAGS PURSUED, AND GIANT REPTILES

The focal point of several designs in Group 12 is the pathetic head of an animal mortally wounded or caught in the grip of a predator, as in *Stag Brought Down by Two Large Greyhounds* (1832), *Fallow Deer Brought Down by Two Algerian Greyhounds*, and *Python Suffocating a Crocodile*. All three designs have an essentially pyramidal mass, and the subtly different, close variations on the imagery of stag and hounds are developed with the most delicate nuance. The motif of the serpentine, roiling movement of the hounds is contrasted with the stable, planar, even slablike forms in the several designs with deer and hounds. This flowing, curvilinear movement becomes the dominant expressive dimension of both python designs and of *Crocodile Devouring an Antelope*.

The models of four designs are waxy and crisp in detail: *Stag Brought Down by Two Large Greyhounds*, *Stag Attcked by a Lynx* (1836), and *Dead Gazelle* (1837), no doubt *cire-perdue* casts, and *Crocodile Devouring an Antelope*.

Stag Brought Down by Two Large Greyhounds (Fig. 129) presents the struggle of a fleeing ten-point stag that has slipped onto its side and fallen directly upon one of the pursuing hounds.[138] That dog's hind legs and lower body are still visible. The stag's head is drawn back in response to the pull of the hound tearing at its right ear. The upper contour of the stag's skull, a straight line, leads the eye downward, along the body of the greyhound tearing at its ear. The hound's long head and snout echo in the pointed shapes of the stag's head. Other parallels unify the design: The stag's two right legs are flexed and project into space, their lower elements set parallel in three-dimensional space, while the two left legs rest upon the sloping surface of the base. The curving lines of the hounds' tails reflect the stag's splendid antlers. The long, curving line of the antlers' main spar also echoes the arched form of the fallen stag's body and neck. The partly domical, partly wedge-shaped base amplifies the pyramidal general mass and silhouette. A delicate, superbly controlled differentiation of textures is apparent in the stag's pelt, particularly in the shaggy sides of its neck and in that of the short-haired hounds. In fact, an elegant detail refinement and a perfection of zoological mimesis mark this work, fully the equal of the miniatures of goldsmiths such as Thomas Germaine, which served as an inspiration for Barye.

Four drawings in the Louvre, three of which were discussed in connection with *Poised Stag* of 1829 (*Fig. 12*), relate to this design. The first, a contour drawing of a falling stag (Louvre, RF 4661, fol. 11r), is the initial expressive or compositional treatment of the stag itself. Barye corrected its obvious errors in anatomy by consulting a preserved specimen. The second, a page of studies of a stag's skull with inscribed measurements, (Louvre, RF 4661, fol. 12r), shows a profile view of the entire skull, with the front portion of the antlers. Two smaller studies on the page show one branch of the antler tree, and a dorsal view of the base of the antler where it is joined to the skull. In particular, the bony portion of the head of the bronze stag about the eyes, forehead,

and antler attachment reflects this zoological study. The third, a page of studies of the skeleton of a stag (*Fig. 154*), shows the articulation of the legs in profile and frontal views with extensive measurements.

The last of the four related drawings is *Stag Fleeing Four Hounds* (*Fig. 194*). Artistic sources here complement scientific ones, for the two hounds are rapidly traced sketches of Barye's more detailed drawings for *Tumbling Hounds, after Rubens* (*Fig. 196*), modeled after Ruben's *Boar Hunt* (Dresden) of about 1618–20.[139] The dog leaping across the stag's back in the Louvre drawing appears at the upper left in Figure 196. The hound directly beneath it, tumbling over the log, its belly exposed and curved tail drooping toward the left, appears just below the motif of the leaping dog in Figure 196. From this bronze Barye omits the log and the airborne stag. He prefers to rest the stag's body upon the ground, which is a less pictorial treatment but one with greater physical solidity.

Barye's reuse of one of the hounds in *Tumbling Hounds* in both drawings relates the work to several of the sculptures in Group 12. *Stag Fleeing Four Hounds* (*Fig. 194*), in fact, is a larger drawing of the same stag shown in a more complicated study, *Two Stags Pursued by Hounds* (*Fig. 197*). The position of the nearest stag in Figure 197 is virtually identical with the stags in Figure 194 and in the Louvre drawing (RF 4661, fol. 11r). Figures 194 and 197 differ significantly from the earliest one in that they reflect the mastery over proportions gained in the two drawings made after a preserved specimen (*Fig. 154* and Louvre, RF 4661, fol. 12r). A motif completely in the spirit of Rubens is the ring of three roiling hounds, swirling about the stag like a wreath, in both drawings. New in the more complex study in Figure 197 is the motif of a second, rearing stag behind the first, its head thrown so far back as to show the underside of the jaw and antlers—precisely the focal motif in *Elk Hunt* and *Fallow Deer Brought Down by Two Algerian Greyhounds*.

The compositional drawing *Single Stag Brought Down by Hounds* (*Fig. 198*) renders a distinctly later moment in the developing action. This stag, fallen on its side, takes a position almost identical with the one in the bronze *Stag of Ten Points Brought Down by Two Scotch Greyhounds* (*Fig. 130*). The drawing's motif of the hound crouching directly beneath the body of the stag is repeated in the bronze *Fallow Deer Brought Down by Three Algerian Greyhounds* (*Fig. 136*), and it is transformed into the predatory wolf in *Wounded Stag Seized at the Throat by a Wolf* (*Fig. 131*). The dog running alongside the stag's body and clutching at it with its foreleg, seen in *Fallow Deer Brought Down by Two Algerian Greyhounds* (*Fig. 135*), surprisingly is transformed into the enormous feline predator in *Panther Seizing a Stag* (*Fig. 133*).

A question arises as to the date of *Stag Brought Down by Two Large Greyhounds* (*Fig. 129*). Does the inscribed date of 1832 signify the early date of the completion of the original plaster model, that exhibited in the Salon of 1833 as no. 5234, *Cerf terrassé par deux levriers de grande race*? Although the Salon *carnet* is inconsistent, no work in bronze is indicated on page 251. Hence, all of Barye's entries seem to have been plaster. Probably the design and the cast were made in the same year, but the plaster, not the bronze, was shown in the Salon. The point is that Barye kept the early date of the original design and the later date of the bronze pour distinct in other works of this period cast by lost-wax expert Honoré Gonon, such as *Lion Crushing a Serpent*, which is signed and dated twice—as a design of

1832, but also as a cast of 1835. The distinction is also implied in the inscription on Barye's *Bull Hunt* group, for example, which says it was *cast* in 1838.

Perhaps *Stag Brought Down by Two Large Greyhounds* was cast with the financial support of the royal house of Orléans, which no doubt financed the casting of Barye's several other designs of the period: *Tiger Devouring a Gavial Crocodile* (shown as a plaster in the Salon of 1831 and inscribed as cast by Gonon in 1832); *Lion Crushing a Serpent*, 1832, inscribed as cast by Gonon in 1835); *Dead Gazelle* (shown as a plaster in the Salon of 1833 and inscribed as cast by Gonon in 1837); and the *surtout de table* ensemble of hunt groups inscribed with the date of the bronze pour—*Tiger Hunt* (1836), *Lion Hunt* (1837), and *Bull Hunt*, *Bear Hunt*, and *Elk Hunt* (1838).

Stag of Ten Points Brought Down by Two Scotch Greyhounds (Fig. 130) shows a great stag that has fallen totally exhausted after its flight from the two huge greyhounds.[140] One hound bites deeply into the stag's throat, while the other surges across its back, tearing at the stag's right ear. The greyhounds are awesome, for their long, tapering heads are nearly as large as the stag's. The stag has fallen across the leafy, acorn-filled branches of the stump of a gnarled oak tree, a touch that adds a vivid sense of momentary action and introduces a decorative realism.

The system of curved lines moving in three-dimensional space, apparent in the focal motif of the antlers, is echoed in the arabesques of the dog's tails and contrasts with the more angular lines of the legs of the stag and dogs. In a subtle way, the play of the meandering lines and volumes of the tree and its branches is adjusted to the lines and volumes of the bodies and legs of the animals. The attention to detail evident in the rocky, fissured, plant-strewn base is carried into the beautifully delineated dogs' collars, given large square buckles. This touch amplifies the narrative idea of an as yet unseen human hunter, the stag's ultimate adversary. The landscape embellishments of this base set it apart from, and perhaps compensate for, the baldness or abstract quality of the domical base of its closely related predecessor, *Stag Brought Down by Two Large Greyhounds (Fig. 129)*. In fact, in the group of 1832 there is a certain gentle conflict of styles, between the detailed realism of the stag and dogs and the unreal simplicity of the base. However, that simple surface sets off the minutely detailed realism of the animals, certainly a positive design quality. Both compositions have a notable elegance.

The uppermost hound, its forelegs drawn in tightly against its body as it leaps for the stag's ear, appears in three related drawings. One is *Tumbling Hounds, after Rubens (Fig. 196)*, and the other two are compositional drawings related to several of Barye's contemporaneous stag designs. This uppermost hound appears in an almost identical position in two of the drawings (*Figs. 194 and 197*), leaping upward from a location below and to the right of the stag. A third drawing, *Single Stag Brought Down by Hounds (Fig. 198)*, shows the ear-biting hound in a different position, much like that of its counterpart in the bronze, as crossing over the stag's back to tear at its right ear. The stag's position in the drawing is altered in that both its body and head are turned on their sides, as though the animal were totally incapable of further resistance. The bronze stag, however, still holds its head erect, as though to offer an heroic last struggle against the hounds.

The image, in *Tumbling Hounds, after Rubens* (*Fig. 196*), of a hound peering over the top of another animal's back, with its chin and forepaws resting on the quarry as though about to scramble over it, is reused for the dog that has leaped onto the right flank of the fallen stag in the compositional study *Single Stag Brought Down by Hounds* (*Fig. 198*).

Barye's bronzes *Fallow Deer Brought Down by Two Algerian Greyhounds*, *Stag of Ten Points Brought Down by Two Scotch Greyhounds*, and *Wounded Stag Seized at the Throat by a Wolf* are clearly related to Hellenistic examples (*Figs. 256 and 257*) and to another ancient type that survived in the House of the Stag at Herculaneum. Barye's fallen stag in Figure 130 repeats the general angle and the motif of the stag's head thrown far back seen on the ancient rearing stag (*Fig. 256*). The motif of dogs biting at the ear and foreleg of the quarry (*Fig. 257*) appears in three of Barye's groups, (*Figs. 129, 130, and 136*). A dog on the back of the quarry (*Figs. 256 and 257*) also appears in two Barye groups (*Figs. 130, 136*). Fallen quarry mark four of Barye's designs (*Figs. 129, 130, 134, and 135*), with the latter nearest the antique example in composition.

The waxy surfaces and crisp detail of this bronze proof lend considerable weight to the appellation *modèle*, painted inside the bronze shell. No doubt the proof was made either from a wax positive or in sand molds taken directly from the well-preserved extant model of cast plaster and wax (Walters Art Gallery, 27.460).

As for the structure of the bronze proof, the stag, the two hounds, and the landscape base are separate castings assembled into a single unit by means of threaded rods of bronze, with a filler of soft solder worked into the seams. The stag's raised right-rear leg is cast separately and attached at the precise separation line seen on the plaster model, the seam again filled with solder. The stag's outstretched left foreleg is cast integrally with the adjacent form of the ear of the hound that bites at the stag's throat. The cluster of dog's ear and stag's leg is joined to the dog's head, and solder fills the visible seam. This same hound's outstretched right foreleg is also an attached element, its seam soldered. Numerous castings made in separate molds comprise the proof.

Wounded Stag Seized at the Throat by a Wolf (*Fig. 131*) shows the wolf crouching on the ground between the forelegs of the stag, with both stag and predator facing in the same direction, as though they have just stopped running.[141] The wolf braces itself and tries to pull down the stag, not only with its fangs but also by hooking its right forepaw over the stag's rigidly braced right foreleg. The stag is dazed, almost expressing the human response of stunned disbelief.

This is a long, planar, almost relieflike design, one reluctantly translated from two dimensions into three. A quality of ritual formality is pervasive, no doubt a survival of that major tendency in Barye's art of the 1820s. The long axes of the heads of both wolf and stag are parallel in certain views. From the stag's right side can be seen the dorsal view of the wolf's head and the profile view of the stag's, a schematic mode of organization heavily laden with the conventions of zoological illustration. A long, nearly straight contour line follows the underside of the stag's body, from its extended left leg to the tip of the main spar of the right branch of its antlers. This long line is paralleled by the slightly inclined surface of the rocklike base. Against these straight lines are played the tense arches of the

stag's back, its neck, and the line of its left hind leg, belly, and right foreleg. The open, fragile straight lines of the stag's legs contrast boldly with the compact, densely swirling masses of the crouching wolf. A theme of elegant lines, moving through three-dimensional space, finds a focus in the stag's superb antlers.

The positions and angles of the stag's legs are closely related to those in the drawing *Skeleton of a Stag* (Fig. 154). An expressive change is the lower, slightly more squat position of this stag, which dramatizes the heavy pull of the predator at its throat and foreleg.

The image of the crouching wolf can be discerned in the drawing *Single Stag Brought Down by Hounds* (Fig. 198). The wolf is the nearest hound, biting at the throat of the fallen stag. In this sculpture, of course, the hound's image has been turned around and placed between the stag's forelegs. The wolf's left hind leg and forelegs are in virtually the same relationship in drawing and sculpture, and the sketch even shows the wolf's head in a dorsal view. The contour of the wolf's back is altered slightly, in the service of anatomical accuracy, but it still retains the expressive contrast of the raised haunches, low shoulders, and raised or reaching head.

The inscribed date of 1843 on this plaster cast cannot be the date of the original design, which is surely of the early 1830s. Instead, 1843 must be the late date of the casting of this particular plaster model. The relieflike format and the expressive play of rectilinear and arabesque elements in its composition are completely in the mode of Barye's style of the early 1830s.

Stag Attacked by a Lynx (Fig. 132) presents a struggle whose outcome is not yet decided.[142] The stag stands with legs braced and head lowered, turning toward the right, as it fights off the lynx. Superb realistic detail is seen, as with the paw of the lynx, which has clawed the back of the stag's head, a motif perfectly framed by the ripping paw of the lynx, which continues the long line of the stag's spine. The lynx is not without injury; one of the stag's antlers has pierced deeply into its belly, and the hind legs are drawn up in a painful cringe. Dramatically, the lynx also seems about to roll off the cliff of the landscape base. It hangs precariously but with a convincing heaviness, clinging with claws and fangs sunk into the flesh of the stag. Yet this struggle of predator and prey is caught at an instant of relative calm, rather than one of violent action. Although the stag is badly injured, it nonetheless has managed to gore the attacker, and the battle seems to be at an unpredictable moment, when either lynx or stag might emerge as victor.

The motif of the lowered stag's head, turned sideward, appears in an early, exaggerated compositional drawing, *Wounded Stag Harried by Hounds* (Walters Art Gallery, 37.2242A). This sideward turn breaks the rigid planarity of *Wounded Stag Seized at the Throat by a Wolf*, a closely related design, making it necessary for the viewer to move around the work, especially about the focal area of the lynx and the stag's head. The stance of this stag is slightly taller than that of the wolf composition, although it also reflects the drawing, *Skeleton of a Stag* (Fig. 154). The large negative form of the space between the stag's body and the surface of the base seems to need some focal point, one not provided by the texture and landscape details playing over the base. A viewer must look twice to discern that the predator is in fact a lynx and not a hound, for it has fallen onto its back with legs and tail

in the air, exactly as a hound might do. This lynx seems to be a slightly transformed hound motif, strongly reminiscent of those in the drawing *Tumbling Hounds (Fig. 196)*.

Two further compositional drawings of a stag attacked by a lynx explore different moments in the action of a stag attempting to free itself from an attacking predator. One shows the lynx clinging to the top of the stag's head, lying between its antlers and biting into the top of its snout *(Fig. 199)*. The other shows the predator upside down, apparently being thrown free by the stag, or perhaps being pierced by its antlers *(Fig. 200)*. In both drawings the lynx is much larger relative to the stag than is true of the bronze. Both drawings as well are conceived in a planar, relieflike mode, different from the more baroque feeling of the sideward twist of the bronze. The inverted, falling lynx in Figure 200 is still close in concept to the tumbling hounds in Figure 196, especially in the arrangement of the hind legs. As an autograph, lost-wax cast, definitely dated in 1836, this unique bronze provides a useful touchstone for the problems of dating and connoisseurship discussed in Chapter 6.

Panther Seizing a Stag (Fig. 133) shows a large, crouching panther as it bites deeply into the neck of an exhausted, transfixed stag.[143] The snarling face of the panther and the deep gashes made by its claws are superbly effective details. The panther appears slowly and inexorably to press the weakening but still-resisting stag closer to the ground. The giant size of the panther is imposing, its body fully as long from shoulder to haunch as that of the young stag. This marks a dramatic and perhaps compensatory change from the tiny size of the lynx in *Stag Attacked by a Lynx (Fig. 132)* a scale relationship that becomes even more extreme in *Elk Attacked by a Lynx (Fig. 134)*.

The long lines and larger volumes of the bodies of the sinking stag and climbing panther closely echo each other. The softer, more spherical forms of the panther's compressed haunches contrast with the flatter haunches and sides of the stag. The parallel lines of the three braced legs of the stag are echoed in the identical angle of the upper forelegs of the panther; and these are set off by the opposed line, placed at a right angle to them, of the panther's lower forepaws. The tense arabesque of the panther's tail echoes the jutting curves of the stag's antlers.

Barye devoted two pages of drawings to a preserved skeleton of this species of stag with its simple, four-pronged antlers. *Skeleton of a Stag (Fig. 154)* shows a profile view of the spine and legs, mainly a schema for noting measurements. This is apparent in the radical distortion of the length of the foreleg in comparison with the hind leg. Barye continued his study of the foreleg complete to the hoof, initially drawn too large for the page, in another drawing at the lower center of the page. A second related drawing, *Head of a Stag* (Louvre, RF 8480, fol. 22r), shows a dorsal and lateral view of the skull and antlers and the cervical spine, recorded in simple contours with measurements. An exquisitely detailed, perfectly preserved plaster model of this design is in the Louvre (RF 1572; h. 38.5, l. 60 cm).

Elk Attacked by a Lynx (Fig. 134) shows a giant elk of twelve points brought down by an incredibly tiny lynx.[144] The elk is in great pain, no longer able to stand, let alone to fight off its assailant. The elk has a superbly developed nubby pelt, which nicely reflects the fluid

quality of the wax model. By contrast, the forms of the lynx are bald and spherical. Boldly faceted and ragged, the rocky base sets off the fineness of the textures of both animals.

The base is massive, with a gnarled, sweeping tree trunk and tall clumps of grass. It is composed as a ramp, down which the elk slides as it is attacked. Absent is the delicate realistic detail of the base of *Stag of Ten Points Brought Down by Two Scotch Greyhounds* (*Fig. 130*). The base also lacks the baldness of the similarly sloping mound in *Stag Brought Down by Two Large Greyhounds* (*Fig. 129*). The ramplike base and certain aspects of the position of the elk suggest its relation to the group of germinal drawings discussed in connection with the compositions and zoological data of other designs in Group 12.

For this composition Barye made a drawing after a preserved specimen, with measurements, *Studies of an Elk* (*Fig. 195*). It shows a profile view of the entire animal, a profile view of the head, neck, and shoulder, and a frontal view of the antlers. The contours of the general view are cursory and serve merely as a schema for recording a fairly extensive set of measurements, intrinsic to a correct rendering of its proportions.

The compositional drawing *Stag Attacked by a Lynx* (*Fig. 199*) delineates a larger lynx, which lies along its neck between the antlers as it bites into the bridge of the stag's snout. Although the body of the stag is somewhat compressed or shortened in the drawing—which suggests that it precedes the measured study of a preserved specimen—the position of the stag's right hind leg is virtually the same as that of the bronze, and the position of the right foreleg is similar to the final form. The extended and parallel left legs of the stag seem distinctly unreal in comparison. To resolve these problems Barye at last used his earlier skeleton study (*Fig. 154*) and reversed those leg positions, enhancing plausibility.

The action is most violent of all in *Stag Attacked by a Lynx* (*Fig. 200*), with the snarling lynx literally standing on its head, as though it has been gored by the stag and is about to be thrown from its antlers. Again, the stag's nearer legs have roughly the same relation as have the right legs of the bronze elk. The line of the stag's back in the drawing has a pyramidal form with the vertex in its shoulder. Barye transposed this geometrical form to the wedge-like base of the elk composition, and he inverted it in the triangular silhouette of the elk's body. Many skeletal and contour lines of the bronze are parallel, in response to Barye's use of a geometrical order. A relieving touch of asymmetry is the elk's turning slightly to the right.

The signature on this proof is partly obliterated, suggesting it is a *surmoulage* cast made in a mold taken from a bronze model in the manner of the sequence of casts described in connection with *Lion Crushing a Serpent, Reduction No. 1* in Group 10.

Fallow Deer Brought Down by Two Algerian Greyhounds (*Fig. 135*) shows a buck of fallow deer pulled down by two giant greyhounds, one at either side.[145] The buck sinks to the ground, its head thrown back as it gasps for air. Hounds and buck move in the same direction. The analogous, nearly parallel gestures of the animals are elegantly composed. The hound on the right bites at the buck's foreleg; the hound on the left clings with both forepaws hooked over the quarry and looks directly toward the head of the exhausted buck in a way that parallels the upward gaze of the buck itself.

The links of this design with others in Group 12 are many. A hound runs along the left

side of a fleeing stag in two drawings (*Figs. 194 and 197*). Another hound bites the foreleg of the stag in the drawing *Wounded Stag Harried by Hounds* (Walters Art Gallery, 37.2242A). Rather than skidding down an inclined base, as do several of the stags in Group 12, this fallow deer appears to have clambered up the sloping surface, on which it finally collapses, a simple reversal. Its body rests directly on the base, as is true in *Elk Attacked by a Lynx*, *Stag Brought Down by Two Large Greyhounds*, and *Stag of Ten Points Brought Down by Two Scotch Greyhounds*.

A compositional drawing, *Hound Running Beside a Stag* (Louvre, RF 4661, fol. 6v), shows the two creatures essentially parallel, the stag's head held high and thrown back, much like the creatures in the bronze. The hound looks up toward the stag's head, and its forelegs are in the air, like the hound on the left in the bronze group. The hound on the left clings with both forepaws as it gazes up at its quarry. The stag runs in the ancient flying gallop position, suggesting that this drawing precedes the anatomical study used for the positions of the legs of stags in several of the designs in Group 12. At the upper left of the same page two hounds leap upward and seize the ear and throat of a rearing stag, shown with its head thrown back, in an almost explosive rising movement. Another album page (Louvre, RF 4661, fol. 5v) shows a more fragmentary compositional study, *Rearing Stag Attacked by a Hound*, again with a striking resemblance to the rising motion of this bronze.

Fallow Deer Brought Down by Three Algerian Greyhounds (Fig. 136) shows a splendid buck brought to a standstill, exhausted, by three enormous greyhounds.[146] One hound lies beneath the buck, facing the same way but twisting around to bite at its braced right foreleg. Another hound is on its back just ahead of the buck and bites at the left foreleg. The third has scrambled across the buck's shoulder from the left side in order to bite at its right ear. The Rubens-like, serpentine movements of the hounds contrast with the still-vertical, planar form of the buck and echo the arabesque shapes of the antlers. The hound clambering over the back of its quarry and the other hound fallen on its back, its belly exposed and hind legs in the air, both appear in the drawing *Tumbling Hounds, after Rubens* (Fig. 196). A hound beneath the body of a stag occurs in the study *Single Stag Brought Down by Hounds* (Fig. 198).

This is a proof of many separate pieces, and there are several irregular, bright areas at the soldered seams, as though the acid or flux were not removed completely prior to patination. Breaks in the fabric have been plugged with bronze rod, on the mid-back of the stag and on the uppermost hound. Surface detail is crisp.

Dead Gazelle (Fig. 137) is an elegantly modeled piece in which the animal lies on its side upon a flat base of an irregular, fluid shape.[147] The soft, vulnerable quality of its flesh nicely contrasts with the boniness of its slender legs, with the sharply curving lines of its horns, and even with the rather flat, abstract surface of the base. The waxy flow of the surface texture of the bronze abets the sense of softness in the gazelle's body. The gazelle's legs have fallen oddly yet compellingly, a symbol of the animal's final relaxation in death. Somewhat ambiguous is the question of whether the gazelle has met a violent end, perhaps as a

hunter's quarry or as the prey of a wild animal. No weapon or wound appears on the carcass. The gazelle remains an essentially simple, elegiac image of an elegant wild creature struck down by death. The base and animal are a single-shell casting of a waxy, richly modeled surface, no doubt a lost-wax cast. The right horn tip is broken and repaired; the left horn is attached with solder. Evidence of cold-working of the surface with burins or gravers is almost nonexistent.

Two schematic drawings of gazelles in the Louvre (RF 4661, fols. 26r and 41v) show a large profile view of the entire animal at the left center of the page, with a small dorsal view of the head and horns just to the left and below the larger drawing. Possibly this consistency of format was merely a convenience that allowed Barye to rest his right hand on the page without rubbing his drawing, or it may reflect the format of some secondary source of the image, perhaps a zoological handbook. The proportions of the gazelle on folio 14v are closer to the species shown in the bronze, especially around the shoulder and neck. However, the simpler horns and head on folio 26r seem closer to the bronze. Barye apparently combined information from both.

The original model of this design was shown in the Salon of 1833 as no. 5242, *Gazelle mort: étude* (cited in *Explication des ouvrages . . . 1ᵉʳ* Mars 1833, p. 251). However, the inscribed date of 1837 on the present bronze cast eliminates it as the *Gazelle mort, en bronze*, cited as no. 1969 in the Salon *carnet* for 1834 (*Explication des ouvrages . . . 1ᵉʳ* Mars 1834, p. 181). The inscribed date strongly suggests the existence of yet another version of this romantically pathetic image.

Python Swallowing a Doe (Fig. 138) shows the giant snake lying atop the doe, crushing and encircling its neck and shoulders as it begins to swallow the doe headfirst.[148] Impressive is the awesome accuracy of the anatomical distortions within the crushed and rubbery torso of the doe; the serpent's convolutions; the sense of strain and force within the serpent; and its relentless, inexorable ingestion. Contrasts are expressive, as with the accented angularity of the doe's tiny legs and hooves and the massive, fluid, cylindrical form of the undulating python. The serpent's tail hooks around the doe's hind hoof, a final dramatic accent, placed just beside Barye's signature.

Barye devoted four large sketchbook pages to drawings of a python with prey (*Fig. 189 and Walters Art Gallery, 37.21878*). These are vivid and chilling notations, obviously made after a live serpent observed with its kill. Closest to the concept of the bronze is the view of the serpent encircling and holding its kill with the middle coils, while its head reaches back toward the seized prey, bites it, and begins to swallow it. In the bronze Barye composed the coils of the serpent resting upon and pinning the prey in more regular curves than the scattered, less coherent ones recorded in this drawing. Two contour drawings of the python's head (37.2187B) record its distinctive shape when the jaws are forced open as wide as possible.

Serpent (Fig. 258), an ancient terra-cotta in the Caylus Collection, offers a similarly low silhouette, although its undulations are schematically regularized, and it lacks the expressive veristic nuances of Barye's python.

143

Crocodile Devouring an Antelope (Fig. 139) shows a crocodile biting into the neck of its kill, an antelope seized at the edge of a stream.[149] The crocodile pins the antelope against the streambank and, holding its prey beneath its body, menacingly begins to feed. Secondary elements counter the excess fluidity evident in Figure 138. The blockiness of the hips and lower back of the antelope complement the undulant flow of its masses. Similarly, the somewhat flattened sides and dorsal surfaces of the crocodile and the nearly mechanical rhythm of the raised compartments of its hide nicely relieve the serpentine flow of its movement. Even the piling of the crocodile on top of the antelope and the placement of the two creatures at an angle to the horizontal—as though they were seen on the sloping bank of a river—accomplish a more striking silhouette than was achieved in Figure 138, which betrays an ambiguity as to the proper vantage point. It is probably best viewed from above, as though it were a high relief. A strange subject perhaps engendered a strange composition, one mimetic of the confusion of raw nature itself. The fluid motions of this design are clearly related to those of the hunting dogs after Rubens, in other designs of Group 12. The fallen antelope of course reiterates the motif in *Dead Gazelle* (Fig. 137) and *Dead Ibex* (Walters Art Gallery, 27.159).

This base differs from the abstract plinth in *Python Swallowing a Doe* in its elaborately realistic treatment of the leaves, rushes, muddy bank, and even the pool of water into which the antelope's left hip disappears. The partial disappearance of a creature into the illusionistic dimension of its base is a special concept also evident in *Bear in Its Trough* (Fig. 115).

Python Suffocating a Crocodile (Fig. 140), shows a crocodile seized in the great coils of a python, its mouth wide open in agony as its body is bent backward and broken.[150] The python bites into the left hind leg of its prey even as it crushes the hapless crocodile to death. Persuasive is the sinuous yet powerful sense of movement captured in these sliding reptilian forms, the sense of great muscular forces pitted against each other. The high pyramidal mass of these roiling adversaries achieves a more successful silhouette than *Python Swallowing a Doe* and *Crocodile Devouring an Antelope*. The head of the crocodile, its jaws gaping in torment, effectively crowns the design.

A well-preserved plaster model, with delicate surface incisions and modeling in the serpent's scales and the crocodile's hide, is in the Louvre (RF 1585; h. 16.5, l. 39 cm).[151]

GROUP 13: FORMAL EQUESTRIANS

Two of the riders in Group 13 are majestic knights-in-armor—Gaston de Foix, Duke of Nemours (1489–1512), and Charles VII, king of France (1402–61). The third rider is the young Duke of Orléans (1810–42), son of King Louis-Philippe, for whom Barye created a portrait likeness and the splendid *surtout de table*. The young duke wears a contemporary military parade uniform. The first two miniature equestrians were made in the mid-1830s. They share an embellished, decoratively intricate realistic style in the mode of the *Tiger*

Hunt of 1836 (Fig. 127), and the two are virtually identical in scale. The third equestrian is slightly larger, has a simpler, balder stylistic treatment, and probably dates toward 1840. The horses of these three heroes share the conventional French gait or stance.

Four large pages of drawings made after the small bronze *Flayed Horse* (Walters Art Gallery), possibly a sculpture by Falconet, are basic to all of Barye's equestrian small bronzes that use the conventional gait, showing the opposite foreleg and hind leg lifted at the same moment. This small bronze was patterned after the flayed horse drawn by Edme Bouchardon in his extensive series of nearly 170 studies of the horse created for the monumental bronze *Louis XV, Equestrian* (1749–63; destroyed 1792; Paris, Place Louis XV).[152] Barye's drawing simply reverses one of Bouchardon's principal studies.[153] Falconet's small bronze statuette, about 1766, became well known in the French academies, and both Géricault and Carpeaux made drawings after it. Two of Barye's pages of drawings show eleven slightly different views of the statuette, arranged to look like a long procession of marching horses. The last two pages of Barye's studies record various major views side by side, without exploring differences of scale or an illusion of space as continuous and pictorial.

The gait in Barye's *Phidian Frieze of Riders* (Fig. 163) was taken from an ancient Greek example and differs only in that two legs on the horse's right side are lifted. Another slight variation on the gait, also known to Barye, is that where the horse lifts one hind hoof only slightly; still touching the earth, the hoof can provide physical support for the equestrian monument, as it does on the statue of Marcus Aurelius in Rome.

The pure form of the stance, as the French preferred to use it, appears in François Lemot's monumental bronze *Henri IV* on the Pont Neuf (*Fig. 228*). The statue was installed on the same bridge Barye decorated with his ninety-seven decorative masks in 1851. As a prominent, recent work, its considerable influence upon Barye is not surprising. *Gaston de Foix* (*Fig. 141*), surely was conceived as a small version of Lemot's monumental bronze, to judge from the identical pose of the riders, the identical gait of the horses, and the general resemblance of the riders' armor. Barye transferred the thigh armor of movable plates worn by Henri IV to the neck of the horse ridden by his Gaston de Foix, a whimsical touch that hardly obscures the close relationship of the two designs. Barye, however, did not emulate Lemot's long-faced horse, one derived from Verrocchio's *Colleoni Monument* in Venice.[154]

Testament to the long survival of French enthusiasm for this particular stance, and an instance of the influence of a miniature bronze equestrian upon a monumental one, are clear in Emmanuel Frémiet's famous *Joan of Arc* (1872–89) in the Place des Pyramides (*Fig. 259*). Barye's *Charles VII, Equestrian* (*Fig. 142*) no doubt inspired Frémiet's work. Token of this is Frémiet's return to the intricately decorative handling of the fifteenth-century armor of Barye's rider and the rigidly straightened legs and bolt-upright posture of both riders. However, in his characteristic fashion, Frémiet overstated virtually everything—from the overblown, almost gorillalike reaching gesture of the saint to the forced line of the saint's pose and the excess detail in the horse's shoulder muscles and leg joints. In addition to the exaggerations, an isolating emphasis upon particular details is apparent in the Frémiet design—qualities fundamentally at odds with the classical stylistic unity of Barye's equestrians.

Barye's drawings of armor for these equestrian knights are best discussed as a group, preliminary to the analyses of the separate sculptures, since they are interrelated in a fairly elaborate fashion. The armor is treated with a relaxed regard for historical accuracy, despite the existence of drawings with elaborate measurements that record Barye's close scrutiny of particular examples (*Fig. 188* and Walters Art Gallery 37.2225B). In fact, he eclectically combined details or elements of several suits of armor. He may even have designed the armor for *Gaston de Foix* freely, although retaining and revising a few motifs from the sources of the armor worn by his other knights.

One study with measurements, *Pieces of Armor* (*Fig. 188*), is an accurate preparation for the armor of *Charles VII* and for the riders in *Bull Hunt* (*Fig. 90*). It is also laden with suggestions and intimations of the apparently invented armor in *Gaston de Foix*. The frontal and dorsal views of the cuirass show a right and left half that differ in the size of a projecting ridge, which stands up like a starched lapel. Perhaps Barye actually drew from such a composite suit re-created from fragments. Yet it is more likely that the lower of the two ridges—as seen on the riders' shoulders in *Bull Hunt*—is an accurate notation, and that the higher ridge of the drawing, like that of the suit in *Gaston de Foix*, is an artful exaggeration or an invention. Another element, the shield-shaped thigh guards, are rendered literally in *Bull Hunt* and *Charles VII* but are altered into a less pointed, more rectangular shape in *Gaston de Foix*, a shape enriched with a new palmate pattern of linear ridges not seen on this drawing. The winglike forms beside elbow and knee have been made decoratively larger in *Gaston de Foix* than they were in the drawing or in *Bull Hunt* and *Charles VII*, a choice in keeping with the generally more exuberant and rhythmical decorative emphases of the armor of the bronze. Striations, like fluting on a column, appear on the sleeve and thigh of armor in another drawing, *Knight with a Broadsword* (Walters Art Gallery, 37.2327), a costume dissimilar in every other respect but this ridge motif from the armor in *Gaston de Foix*, yet surely containing the seeds of the linear pattern that embellishes the bronze. A large broadsword is depicted on this drawing, and its general type without specific details reappears as the weapon in *Charles VII*.

Another page, of a seated, armored equestrian (Walters Art Gallery, 37.2223A), shows such details as the basic helmet type depicted in *Bull Hunt*, as well as the winglike form beside the knee, the elegantly long-toed boots, the slender stirrup, and a singular saddle with a curved, planar backrest and pommel—a saddle used not only in *Bull Hunt* but also in *Tartar Warrior Checking His Horse* (*Fig. 85*). In fact, even the style of the helmet in *Tartar Warrior* may derive from that seen in the drawing and in *Bull Hunt*. Token of Barye's eclectic freedom with these motifs is the appearance of the same saddle on the mounts ridden by a warrior of Genghis Khan and by the soldiers of Francis I.

Gaston de foix, Equestrian (*Fig. 141*),[155] depicts a rider of imposing, robust forcefulness, somewhat in the spirit of Verrocchio's *Colleoni Monument*,[156] but quite different from the cool restraint of Lemot's *Henri IV* (*Fig. 228*), which depicts a slightly worried but reflective gentleman. The difference of mood is decisive, even though the pose of both François Lemot's and Barye's riders is virtually identical. A comparison with the silhouette of Lemot's *Henri IV* indicates that Barye increased the size of the rider's head, lending a

greater impact to that element of his physique by giving the figure a much larger mass of hair. Barye also treated the scarf as spatially active, as fluttering in a brisk wind. This recalls not Bernini, but Rogier van der Weyden, in such motifs as the wind-blown loin cloth of *Crucified Christ* in Philadelphia.[157] The scarf of Lemot's *Henri IV*, unlike the Barye's, falls stiffly into a carefully arranged pair of tassels at the hip. The stylized, wrinkled rhythms of the tassels echo the graphic arabesques of the horse's tail and mane, which are unreal passages conceived in the mode of the embellishments of the *Colleoni Monument*, a sort of late Gothic-baroque interlace.

The armored caparison carried by the horse in *Gaston de Foix* is exquisitely detailed. Striking are the horse's helmetlike head-shield; the movable, riveted plates protecting the top of its neck; the chain mail stretched beneath the plates; the decorative extensions of the bridle, long enough to touch the horse's chest; the heraldic crest shown in two different sizes, smaller at the shoulder and larger at its flank; the contrast of textures between the rolled bottom edge of the metal armor and the cloth fringe swaying in the wind beneath it; even the play of a panther's mask on the rump armor above the horse's tail against a quasi-human Medusa mask beneath the tail.

A marble tondo relief, *Charles IX, Equestrian*, was accessible to Barye in the Louvre.[158] This Italianizing French relief of the late sixteenth century is indebted to the ancient *Marcus Aurelius* in Rome.[159] Similar are the gait (altered for stability, with the tip of the lifted rear hoof still touching the plinth), the relatively large size of the rider, and such details as the distinctive border design of the ancient saddle blanket and the absence of stirrups. The rider's slightly bent leg and the positions of his arms—one forward, one back—appear in Barye's *Gaston de Foix*. Even the attitude of the horse's closely haltered head, the motif of its tied tail, and the billowing cape in *Charles IX* are present in the bronze, which also echoes something of its vibrant general energy.

Three ancient works in the Caylus Collection bear distinct resemblances to this bronze. A fragment of a Roman gilt bronze horse (vol. 2, pl. XCV: III) has a similarly thick, boldly arched neck and a closely haltered head. A small Roman bronze of a nude Mars as a victorious equestrian (vol. 3, pl. XLII: III) (*see fig.* 275) reiterates the stance in *Marcus Aurelius* and has a general energy like that of the Barye. A Roman bronze relief of a clothed rider (vol.3, pl. LXIX: II) shows the closely haltered head, the raised foreleg, and the rider gesticulating in a way roughly like that in *Gaston de Foix*.

It is a testament to the impact of Barye's design that this very horse would provide Emmanuel Frémiet with the basic proportions and stance for the mount in *Joan of Arc* (Fig. 259). (By contrast, Paul DuBois chose a radically different, naturalistic trotting horse for the mount in his *Equestrian Joan of Arc*, Salon of 1889, installed before Notre Dame de Rheims.)[160] On Frémiet's horse, details such as the helmetlike headpiece and the movable plates along the top of the horse's neck show a debt to Barye despite their drastic abbreviation. Frémiet altered only the position of the right hind hoof, to a slightly higher and more rearward one. The resemblances to the horse in *Gaston de Foix* complement the patterning of Frémiet's rider on Barye's miniature *Charles VII*. Frémiet combined aspects of both small equestrians to achieve the basis for his monumental one. The most personal, new aspect introduced by Frémiet is the fleshy muscularity of the horse. Doubtless, Frémiet wished to

convey the medieval symbolism of the Armor of the Faith in his figure of Saint Joan, after the example of Dürer's famous engraving *Knight, Death and the Devil*.[161]

Charles VII, Equestrian (Fig. 142) shows this king of France wearing full armor, a great broadsword, and a crown of laurel.[162] A fairy-tale quality of elegant delicacy pervades the work. Barye's base for this statuette is architecture and jewel box in one, enriched with elaborate, rather Celtic interlace patterns in low relief. The elegant, dashing steed has its mane pulled out at either side of its neck into long tresses that disappear under its trappings. The horse is not armored but wears lighter parade trappings instead. Charles VII is tall in comparison with the size of his mount. At first glance this would seem merely to reiterate the ancient convention of proportional relation, as it was evident in both *Phidian Frieze of Riders* from the Parthenon *(Fig. 163)*, and *Marcus Aurelius*. Barye, however, seeks to convey the idea that the youthful king is riding a pony rather than a horse. Charles VII, in fact, was Dauphin at the age of fourteen, was crowned king at twenty-one, and was aided in his battle against the English by Joan of Arc at the age of twenty-five. Did Barye mean to show us the Dauphin of fourteen mounted on a pony? In light of the close connection of Charles VII with Joan of Arc, perhaps it is not surprising that Frémiet studied the design so carefully in preparation for his monumental *Joan of Arc*.

A *terminus ante quem* for this design is provided by a proof in gilt bronze signed and dated 1836 (Bordeaux, Musée des Beaux-Arts, inv. no. 1022). It is inscribed *Les membres du Comité d'adm. de la Société des Amis des Arts de Bordeaux a M' T. B. G. Scott*, and *Fondu par Honoré Gonon et ses deux fils*. A note concerning this proof in the Louvre *Barye Catalogue* (1956, page 43) asserts that it was a special commission, actually patinated by the sculptor himself, and presented to the former Consul of Great Britain, Mr. Scott, who was also a founder of the Société des Amis des Arts de Bordeaux. The heirs of the consul gave the bronze to the Musée des Beaux-Arts in 1865. Less persuasively perhaps, the note also suggests that the plaster model of this design was exhibited in the Salon of 1833 under a different title, as no. 5237, *Cavalier du 15ᵉ siècle*, the title that appears in *Explication des ouvrages ... 1ᵉʳ Mars 1833*, page 251. This assertion must remain speculative, however.

A marble relief of the equestrian *Robert Malatesta, Duke of Rimini*, about 1482,[163] is the subject of one of Barye's drawings *(Fig. 183)*. The distinctive gait of Malatesta's horse places just the tip of the raised rear hoof on the ground—the same stabilizing touch given the ancient *Marcus Aurelius*. The slight backward tilt of the duke and his rigid leg supported in the stirrup are clearly repeated in Barye's *Charles VII*, as are certain details of the duke's armor. A careful notation of armor details of special interest for the sculptor is clear, such as the winglike plates inside the elbow joint and the same motif at the side of the knee. A similar breast plate is seen on the small bronze, with its distinctive, swelling curvature. Also seen on both is the thigh guard with a pointed, shieldlike form. Not evident on the drawing are such uses of chain mail as appear on the bronze. The saddle design is also accurately carried out in the sculpture, with only slight modifications. The vertical, slablike pommel is used, as are the general size and shape of the saddle blanket and the slender, linear stirrup. Even the hair stylization of the knight—a full hair mass falling over the back of the neck—is seen on both drawing and bronze, although the laurel crown appears only

on Barye's piece, no doubt as an echo of the one worn by Lemot's *Henri IV* (*Fig. 228*). The stance of Malatesta's horse is modified on the bronze only with respect to the position of the hind legs, in keeping with the choice of a walking gait. The horse's foreleg is lifted, its upper portion parallel with the ground in both drawing and bronze.

Armor similar to Malatesta's appears on the riders in *Bull Hunt* (*Fig. 90*). In fact, the rearmost rider of that group wears a variation on the shoulder armor seen in the drawing, but not seen on the bronze *Charles VII*; that is, a composite shoulder piece constructed of a single plate over the front of the shoulder and of several horizontal bands riveted together about the rear of the shoulder. The central rider in *Bull Hunt* wears shoulder armor made of a single domed plate, like that in *Charles VII*. The helmets in *Bull Hunt*, in a sixteenth-century "François premier" style, do not appear on the drawing, although an isolated, accurate study of the helmet type worn by Malatesta and the riders in *Elk Hunt* (*Fig. 128*) does appear at the lower left of the leaf—a helmet transposed from Rimini to Central Asia. These motif exchanges underscore Barye's costume-ball playfulness where one might expect to find historical accuracy.

A drawing of horse trappings (Louvre, RF 8480, fol. 20v), contains the essentials of the design of the trappings over the hindquarters of the pony in *Charles VII*. The narrow, suspenderlike straps that cross the animal's rump converge at a single point marked with a cluster of domical studs in both drawing and bronze. The wide, horizontal band that sweeps around the horse beneath its tail is decorated with evenly spaced studs in both, and it is made still wider in the bronze. Barye substitutes tassels for the curling strips of leather dangling in the drawing, and he transforms the suspended globes of the sketch to firmly attached studs—changes in the interest of structural solidity, which nonetheless retain the rhythms of the drawing. The decorative accents of the spherical studs reappear on the belt that supports the broadsword, as rivets in the armor, and as the laurel berries in the Dauphin's triumphal crown.

Duke of Orléans, Equestrian (*Fig. 143*), shows the duke as a tall, lanky figure with a relaxed, almost dreamy look.[164] The duke's face has a classicizing, ideally schematic mask, rather than a veristic one. In contrast with the calm of the rider, his horse has a focused energy, a sense of precisely controlled, measured movement. Its gait is that of the sixteenth-century marble relief *Charles IX, Equestrian*, known to Barye in the Louvre,[165] and of Lemot's monumental *Henri IV* (*Fig. 228*). The large size of the duke relative to his horse closely reflects the proportions of these two earlier designs. The cropped tail of the duke's mount is a realistic version of the longer, cropped tail of Lemot's horse.

It was of course for this same duke, the son of King Louis-Philippe, that Barye created so many of his finest works, the *surtout de table* of nine sculptural groups principal among them.

An economy of detail, rather than a decorative abundance, marks one major trend in the art of Barye toward 1840. The simple, large surfaces of the horse set off the scattered accents of detail, such as the straps and buckles of the reins and bridle; the purse and telescope case; the embroidery along the edge of the saddle blanket; the bound sword hilt; and the duke's epaulets, sash, military decorations, and embroidered hat and collar. Tex-

tures such as the leather of the duke's boots and the silk of his sash are subtly but persuasively rendered. This proof has been slightly damaged. The scabbard is bent, its lower end broken away, and the duke's neck is cracked through and held in place with a dowel.

GROUP 14: LYRIC NUDES, AND PUTTI

The designs in Group 14 embody Barye's treatment of the ideal human figure. He explored ancient classical sources and aspects of style and mood in the art of such sixteenth-century Italian masters as Raphael, Bandinelli, and Giovanni da Bologna. Following the succession of historical styles reflected in Barye's ideal human figures, the late baroque, Berninesque realism of Clodion provided inspiration for Barye's groups of *Three Putti*, created about 1850.

Candelabrum of Nine Lights (Fig. 144) was offered in Barye's first catalogue of 1847.[166] It sustains the earlier taste of the 1830s for an intricately embellished style in the aristocratic, almost fairy-tale mode of the animal hunts for the Duke of Orléans. In fact, an undocumented story often recounted in the earlier literature holds that a brother of the duke, the Duke of Montpensier, had been so impressed with the *surtout de table* Barye had created for his younger brother that he commissioned this candelabrum and *Roger and Angelica on the Hippogriff (Fig. 84)* as a mantle-top ensemble.

The base of the candelabrum has three decorative human masks, like those seen at the corners of the lids of certain Roman sarcophagi. They are placed at intervals of 120 degrees, directly beneath each of the seated goddesses. The masks provide a grotesque foil to the ideal beauty of the nude goddesses, a thematic contrast restated by the chimeras above the nudes and just below the Three Graces. The masks also support garlands of acanthus leaves suspended between them, garlands arching beneath Greek palmate motifs. At a higher level, between the *Three Graces* and the chimeras, project three branches, each of which holds three more branches; these form the nine candle supports. The candle cups are like blossoms upon stems, forms that echo rococo precedents and prefigure the arabesques of Art Nouveau in the 1890s.

The female nude enters Barye's oeuvre as a significant new theme in the candelabrum, a late complement to the heroic male nudes Barye had created as early as the *Milo of Crotona* medallion of 1819. Barye's Three Graces are not composed in the well-known arrangement of the ancient type in Siena, for all three figures face inward toward the central shaft of the design, as in the ancient Roman *Three Nymphs as Caryatids (Fig. 261)*, once in the Villa Borghese in Rome. The back view of Barye's standing nudes serves as a foil to the frontal presentation of the goddesses. Even the varied placement of the nymphs' feet on the base is like Barye's group, although he rearranges their arms into a dancer's embrace, thereby

eliminating the caryatid aspect of the Roman precedent. (Of the great number of known variations of the Three Graces motif, this Roman group is the most likely source of Barye's design.) Barye offered the tiny Three Graces group as a separate sculpture, in the form of a base for an incense burner, in his catalogue of 1855 (*CRB55*, nos. 13 and 163).

On the main, lower register of the candelabrum are the seated goddesses, facing outward: Juno with a peacock, Venus with Amor, and Minerva with a helmet, sword, and owl. The goddesses were also offered separately in the 1855 catalogue. As separate pieces, only *Venus* was altered, her transformation into a *Nereid* achieving a better in-the-round composition. *Juno* and *Minerva* were sold virtually as they are seen on the candelabrum. The three goddesses could also be purchased as a unified group, as the base for a vase rather than on the candelabrum, by 1855 (*CQC55*, no. 14).

The three goddesses considered as separate forms embody distinct changes in style, almost as a document of Barye's awareness of the key alternatives in the treatment of the ideal nude in sixteenth-century Italian art: from the classical, sensuous *Minerva* (*Fig. 145*), to the more rigid, attenuated, and stylized early Mannerist *Juno* (*Fig. 146*), to the exaggerated, *figura serpentinata*, the late Mannerist posture of *Nereid* (*Fig. 147*). Respectively, they illustrate a movement from a High Renaissance classical mode of easy, natural movement, like that of Raphael's drawing *Venus and Psyche* in the Louvre, to an early Mannerist rigidity and frontality, like Bandinelli's *Hercules and Cacus*, 1535 (Florence, Palazzo Vecchio), to a late Mannerist spiraling form, like those of the small bronzes created about 1570 for the *Studiolo* of Francesco I de'Medici (Palazzo Vecchio) by Giovanni da Bologna and the followers of Vasari.

Generic to the forms of all three goddesses regarding the relation of the seated figures to their attributes and bases are the mid-eighteenth-century rococo garden sculptures created for the Sans Souci Palace of Frederick the Great by François-Gaspard-Balthasar Adam (1710–60). Adam's cluster of a low cylindrical base, accented with a casually falling bit of drapery and an attribute, is quite like the Barye bronzes. Significantly, the Mannerist bronzes of the *Studiolo* are all standing figures with isolated attributes, a treatment much different from Adam's late baroque synthesis of a seated figure, drapery, pedestal, and attribute into one, smooth-flowing entity.

Barye's two drawings of a seated female nude (Walters Art Gallery, 37.2264A; Louvre, RF 6073, p. 51), were clearly made after a live model posed in an atelier. The model is shown in two slightly different attitudes, seated upon a precarious, temporary platform. Her seated posture is related to all three goddesses, although Barye preferred to arrange the legs of his small bronze figures in a more unified, parallel fashion than the somewhat awkward, open posture of the model, whose left leg is extended. In both studies a quality of sensuous heaviness is apparent in the model's physique, which Barye chastens considerably for his spare, stylized goddesses. Of the two, the Louvre drawing is the most similar to a particular bronze, for the model looks over her left shoulder, as does *Nereid* (*Fig. 147*). Despite the unreal, Mannerist stylization of the breasts, the bronze nonetheless realistically emulates the protruding fullness of the model's abdomen and the contours of her buttocks, thighs, and knees.

Minerva (Fig. 145) depicts the goddess of the military arts and of wisdom, with the attributes of a helmet, a sword in its scabbard, and an owl.[167] Her shield on the candelabrum version has been omitted. The owl now faces to the rear, and no longer projects outward from behind Minerva's right knee. The position of her right hand, which holds the scabbard, is brought nearer her breast, in turn changing the angle of the sword so that it rests directly before the groin rather than upon the right thigh.

Images by Raphael provided important sources for Barye's *Minerva*. A page of drawings, *Figures after Raphael's Galatea* (Walters Art Gallery, 37.2266), shows Galatea, a nymph, and a *putto* as isolated motifs, scattered on the page without regard for their place in Raphael's larger composition. The nymph holds her right hand high above her head, her scarf billowing behind her shoulders, her pose a perfect mirror image of *Minerva*. For the nymph's scarf Barye substitutes the similar catenary curve of the belt of Minerva's scabbard. The contrapposto of Galatea and the *putto* perhaps had an impact upon the exaggerated torsion of *Nereid*.

The motif of the nymph raising her hand above her head appears on an ancient cameo in the Caylus Collection (*see Fig. 262*), perhaps the very antique type studied by Raphael. The motif also is seen on a red-figure vase in the Hamilton Collection. Both appear in anthologies well known to Barye.

Raphael's drawing *Venus and Psyche*[168] is strikingly similar to *Minerva* in the particular balance of sensuousness and stylization in the ideal nude, especially in the treatment of the breasts and in the long, slightly undulant contour of Venus's right side, which becomes the left side in *Minerva*. Similar as well are the seated pose and downturned gaze. Even the hair stylization of Raphael's figure is assimilated into the form of Minerva's helmet, and it echoes in the larger intervals of the hair style of *Juno*. Barye's knowledge of the Raphael drawing in the Louvre is probable, although it can only be inferred from his other drawings after Raphael's decorations in the Farnesina: *Galatea*, *Mercury Descending*, and *Wedding Feast of Psyche and Amor* (Walters Art Gallery, 37.2266; Louvre, RF 6073, p. 67; and Louvre, RF 6073, p. 55). A well-preserved plaster model of *Minerva* is in the Louvre (RF 1590; 29 cm; Louvre *Cat.*, 1956, no. 96).

Juno (Fig. 146) shows the goddess looking downward and pointing with a scepter in her right hand, as though dictating events on earth from her place on Mount Olympus.[169] Or perhaps, at a simpler level of action, she is driving away the peacock. Conceived as a lyrical nude, she wears only a tiny tiara. The peacock is less massive here than on the candelabrum, and it faces to the rear of the form rather than crosswise from behind her knees. Its open left wing is now a foil to the projection of Juno's knees at the opposite side of the design.

Barye's delicate contour drawing after *Venus of Arles* (Louvre, RF 8480, fol. 31r) records the principal source of *Juno*, which is essentially a mirror image of the upper part of the ancient work. Barye's *Minerva* also quoted both its sources in Raphael as mirror images. The downward gaze, the linear hair stylization, the archaic frontality of the torso, the small breasts, and the contrast of one raised and one lowered arm are the same in *Juno* and *Venus of Arles*. Barye simply extended the entire lowered arm to fall beside Juno's hip, and

he rotated the raised forearm to rest on the goddess's thigh. The headband in *Venus* becomes the tiara in *Juno*. The stylized face mask in *Venus of Arles* is surely the prototype not only of *Juno* but also of *Minerva*. The archaic frontality of the ancient *Venus* is redolent of the more extreme rigidity Barye would have seen in such early Mannerist sculptures as Bandinelli's *Hercules and Cacus*, 1535 (Florence, Palazzo Vecchio).[170] His sensitivity to these overtones in *Venus of Arles* parallels the interest in progressively more Mannerist proportions in the series of three drawings after *Julia, Daughter of Augustus* (Fig. 162), another Roman sculpture he studied in the Louvre, as preparation for *Saint Clotilde* (Fig. 26).

A page containing two studies of a peacock (Walters Art Gallery, 37.2234B) shows two lateral views of the bird, the principal view for the design of *Juno*. An elegant delicacy of line and an acuity of analysis of the living subject observed in motion are impressive in these tiny drawings. They confirm Barye's ongoing fascination with the animal world, despite his commitment to a subject from the realms of ancient myth and the lyric nude. The sparkle and delicacy of these studies are wholly unlike his labored academic studies of the female nude. This peacock drawing may also be preparatory to the image of the prey in *Tiger Attacking a Peacock* (Fig. 56).

Nereid (Fig. 147) is considerably altered from the Venus figure on the candelabrum by the reversed position of the head, which now faces to the left, and by the substitution of a fabulous, long-tailed dolphin for the Amorino usually associated with the goddess of love.[171] Of course dolphins are also attributes of Venus, and possibly this twisting, awkward, rather hard-faced nude was first conceived as a Venus figure, one undoubtedly rejected by Barye as unworthy to stand as his artistic contribution to the great tradition of lyrically beautiful Venuses. Ingres, for example, would surely have condemned it as a bad job. Barye offered *Nereid* only in the catalogue of 1855, and not in the last catalogue of 1865.

Barye's drawing after a sixteenth-century Italian Mannerist nude (*Fig. 201*) records an anticlassical extreme of contrapposto and unreal, angular, and parallel limb relationships— a far cry from the grace of Raphael. The strange pose of the figure is exactly that of the small bronze *Zephyr* of 1570–75 by Elio Candido for the *Studiolo* of Francesco I de' Medici in Florence.[172] However, Candido's figure is masculine, and the stance may have been the invention of Giovanni da Bologna, as his similar *Architecture* (Vienna, Kunsthistorisches Museum)[173] suggests. No doubt the abstract beauty of the stance intrigued Barye independently of the figure's gender.

An important complement to the Mannerist influence is noted in Barye's drawing after the elegant, willowy *Diana of Gabii* (Louvre, RF 6073, p. 84). Her raised right arm and the hand holding the brooch at her shoulder are precisely those of Barye's *Nereid*. The elegant mask, particularly around the forehead, nose, and eyes, also influenced those portions of the harder, deeper face of *Nereid*. The direction of the gaze of Barye's figure is again a mirror image of the ancient prototype.

The dolphin-headed sea serpent of the base surely derives from a beautiful Roman bronze dolphin in the Caylus Collection (Vol. 7, pl. XXIX: II) (Fig. 235), which had also served as the source for the fabulous dolphin in the base of *Roger Abducting Angelica on the Hippogriff* (Fig. 84).

Three Putti Bearing a Clamshell (Fig. 148) are two slightly different paired compositions that were designed to serve as saltcellars. They well reflect the taste for academic sources typical of this period in Barye's art. The rolling, spherical quality of their plastic style and composition suggests a later date than the relative austerity of the female nudes of the candelabrum. The *putti* are far closer to the plastic vigor and exuberance of Barye's decorative masks for the Pont Neuf of about 1851 (*Figs. 31 and 32*). They bear a resemblance as well to the dense, spherical form of *Jaguar Devouring a Hare (Fig. 29)*, shown in the Salon of 1850. Perhaps the weakest element of their otherwise fine design is the inert base, which is radically unlike the character of the ragged, baroque clamshell and that of the vigorously animated *putti*. The interior surface of the clamshells is gilt.

Barye translated an ancient monumental sculpture in the Louvre into the miniature design of one of the *putti* in this bronze. His drawing *Boy with a Goose (Fig. 166)* records the boy's backward-leaning stance as he chokes the goose, which is precisely the posture of the nearest *putto* of the right group.

Two pages of variations, *Winged Putto with a Clamshell (Fig. 202)*, have the look of studies made after a goldsmith of the Empire period, such as Guillaume Biennais, one of Barye's most important early teachers. In fact, the style of these drawings—done in a sharply pointed pencil, itself unusual for Barye—is so mechanical and precise that the contours may have been intended for cutting templates of the sort a goldsmith might use for executing miniatures in precious metal. The clamshells of the drawings are all of a different, more delicately linear type than those of the bronze, which have a baroque irregularity more harmonious with the energy and style of the *putti*.

Still closer to Barye's concept of two *putti* bearing a third aloft is a terra-cotta group by Clodion, *Three Bacchic Putti*.[174] Clodion's Bacchus *putto* holds a wine goblet, which Barye transforms into the large clamshell of his design. Clodion's emotional brio, his painterly realism after the manner of Bernini, and his sensitivity to miniature scale would have great appeal for Barye.

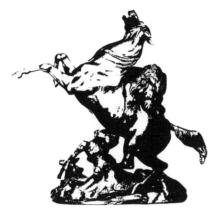

5

Art for the Middle Class:

Barye as Entrepreneur

BARYE AND COMPANY

With the decline of the monarchy of King Louis-Philippe in the late 1840s, the aristocratic patronage Barye had enjoyed came to an end. His last Orléanist commission was the monumental bronze *Seated Lion* of 1847. The telling date of 1847–48 appears on the masthead of the first printed sales catalogue of Barye's small bronzes. A note in it states that the "second series" of bronzes listed would serve nicely as decorations in business offices or sitting rooms, while those of the larger, "third series" would be best suited to salons. Thus the sculptor who once had worked for princes and the king now turned to the middle class for the patronage of his art. Where once a single exemplar for an aristocratic patron had been the norm—a mode of operation in the tradition of the master goldsmiths of the past—now quantities of small bronzes after Barye's models were to be made for the myriad middle-class interiors of Paris.

Barye apparently attempted to operate a private bronze foundry and sales outlet from about 1839 onward. This first solo venture did not succeed financially, but it did afford Barye useful experience in the Parisian art market, and it gave him courage enough to enter into a legally binding partnership for the manufacture and sale of bronzes cast after his sculptor's models. With the entrepreneur Emile Martin, the artist formed Barye and Company on 15 May 1845,[1] a legal partnership that would endure for some twelve years. their first contract was drawn for the legally conventional period of six years and was renewed for a second period in 1851. However, at the close of the second contractual term, on 16 May 1857, Barye terminated the partnership.

There were three essential articles of the partnership agreement of 1845:

Article 3: The firm will be called Barye and Company. The seat of the partnership will be in the factory established at rue de Boulogne, no. 6.

Article 4: Mr. Barye desires to be occupied exclusively with his art. Mr. Emile Martin will have only a partner's powers of signature and will be concerned only to administrate the affairs of the partnership within and about the factory.

Article 5: All of the models that have served up to this time, or those that may serve later, are placed at the disposal of the administrator of the partnership.

Four principal elements in the liquidation agreement ended the relationship in 1857:

Third Introductory Paragraph: According to the most recent inventory taken last December, the debit balance of the settlement has reached about 68,000 francs, whereas the credit assets are comprised of models, proofs, credit, and equipment.

Article 3: For the settlement of the liquidation account, Mr. Martin becomes . . . the sole and only owner of all the proofs that have been cast up to this date, the same proofs that constitute the credit settlement of the liquidation. . . .

Article 4: Mr. Martin is obliged to restore to Mr. Barye, on March 16 current, in a good state of preservation all the models by Mr. Barye, those that are stamped, the order numbers, and all the objects that aid in their manufacture, listed in the last inventory in the account of equipment.
But Mr. Barye is obliged on his part to pay in exchange to Mr. Martin on the same day, the 16th current, and in cash the sum of 35,000 francs as final payment of his debt for this liquidation.

Article 5: It is expressly agreed that, for the benefit of Mr. Martin—concerning the group of proofs that are ceded to him by the present act—Mr. Barye is forbidden to manufacture these same proofs for the period of six months from this date, March 16th current.

In view of the slight changes in the sale prices of the bronzes in the printed catalogues issued by Barye and Martin during the twelve-year life of Barye and Company, and in view of the cautious financial terms of the liquidation clause of their 1845 agreement, which states that the partnership might be terminated if its debts should reach a mere 10,000 francs, the lump sum of 35,000 francs paid by Barye in 1857 to regain free title to his models was a considerable amount.

A combination of positive circumstances enabled Barye to pay so great a sum in May 1857. Architect Hector Lefuel had awarded him three major commissions for the New Louvre Palace by then—the ensemble of four personification groups and the apotheosis pediment—for a total salary of 60,000 francs. Furthermore, Barye's art bronzes, or rather those of Barye and Company, had been awarded La Grand Médaille d'Honneur in the Exposition Universelle of 1855. As recently as October 1854, Barye had been awarded a

teaching position, the professorship of zoological drawing at the Muséum d'Histoire Naturelle, with a guaranteed annual salary of 2,000 francs. Thus Barye no doubt felt this was the proper time to end the profit-sharing agreement with Martin, who, on his part, cleverly sensed this to be a moment when Barye could afford to pay dearly to regain exclusive rights to his small bronze models. Emile Martin proceeded to charge him more than half of all that he had earned on the sculpture for the façades of the New Louvre Palace.

Emile Martin's Journal of Barye's Accounts

An original account book maintained during the period of 31 July 1850 to 30 April 1858 by Emile Martin sheds considerable light on the particularities of the firm's involvement with mass production and on the identification of its bronze founders, sales outlets, and artisans. The date of the final entries indicates that its transactions include not only seven of the twelve years of their partnership, but an additional year as well, during which Martin sold the last bronze proofs remaining in his hands under the terms of the liquidation agreement of 16 May 1857.

The original ledger was acquired in Paris from Mme Martin-Zedée, Emile Martin's daughter. It was purchased from M. C. Ross by the Walters Art Gallery in November 1949.[2] Of the ledger's 312 pages, some 243 carry Emile Martin's handwritten entries. A small label on the binding is inscribed:

[illegible] . . . personnel 32
Affaire de Barye
Journal
du
31. Juillet 1850
au
30. Avril 1858

An inscription on the front endpaper, written large in Martin's hand, reads:

Journal
Contenant les Opérations
de Barye
Commencé le 31 Juillet 1850.

Earlier biographies of Barye treat these years as a period when the sculptor was forced to consent to the reproduction of his work in order to repay his "creditor," Emile Martin.[3] In that view of the situation it was Martin who had backed Barye's unsuccessful early foundry and sales depot, and it was Martin who was intent upon recovering his losses. Possibly this was true. Yet in the absence of hard evidence, such an interpretation possesses overtones of

the legend of Barye's neglect and abuse, a theme perhaps overemphasized in the earlier literature. There is no evidence in the journal, for example, to support the notion that Barye was coerced. It seems more likely that Martin simply acted in the capacity of a skillful business manager and marketing agent, and hardly as a villainous exploiter of Barye. Furthermore, Barye's aristocratic patrons had never been lavish, and the arrangement with Martin probably had an aspect of necessity. Their partnership was clearly an effort to sell to a large audience. With respect to sheer quantity of output, one recalls the situation of one of Barye's contemporaries, Honoré Daumier (1808–79), who produced no fewer than four thousand lithographic drawings for newspapers in earning his livelihood. The increased technical facility of the Parisian bronze founders also opened the possibility of reaching larger mass or "democratic" markets, as Luc-Benoist pointed out.[4]

To turn to the specific question of the founders of Barye's designs as they are identified in Emile Martin's journal, the most frequently entered name is that of Ferdinand Barbedienne (1810–92), whose Parisian casting establishment mass-produced a great variety of high quality but inexpensive reductions of famous masterworks, created by means of both the Collas and Sauvage reduction methods, as well as bronze proofs of Barye's models.[5] At its peak, Barbedienne's factory employed about three hundred artisans and produced roughly twelve hundred bronzes a year.[6] Small wonder that the touch of Barye's own hand, autograph in the Renaissance sense, is virtually nowhere to be seen in most of the extant Barbedienne proofs.

A typical itemized entry, dated 30 September 1850, lists forty-two proofs of twenty-one different designs as those cast and sold by Barbedienne and Company, for which payment was received by Emile Martin.[7]

Barbedienne et Cie
5 Lapins sur terrasse	17.50 f
4 Lapins sur terrasse oreilles Levées	14.00
1 Cigogne seul	5.00
4 " sur tortue	40.00
1 Biche couchée	15.00
1 Panthère couchée	18.00
1 Gazelle	18.00
1 faisan	14.00
2 perrucher sur Arbre	50.00
3 Chien Epagneul	60.00
1 Cerf debout	30.00
1 Cerf jambe levée	30.00
1 Jaguar et Agouti	30.00
1 Lion et guib	60.00
1 Brule parfum	20.00
3 Paire flambeaux renaissance	60.00
2 " " à vigner	50.00
1 groupe 2 chiens et faisan	75.00
1 paire couper Enfants Levequet	130.00
4 Lapins sans terrasse	10.00
3 " Oreilles Levées	7.50

158

The entry clearly indicates the extensiveness of the work of Barbedienne's artisans in producing Barye bronzes in 1850. The Barbedienne firm is the most frequently cited of all in the journal, and it apparently produced the greatest number and variety of proofs. Emile Martin, in effect, leased the rights of reproduction to the founder and exacted a fee for his services as intermediary.

Probably the cost charged by Barbedienne for the fabrication of certain proofs is represented in the difference between the higher prices stated in Barye's printed catalogues of 1847–48 and 1855 and the price paid in Emile Martin's journal in 1850. A typical sampling:

Proof Title	Barye Catalogue, 1847–48	Martin's Journal	Barye Catalogue, 1855
Lapin sur terrasse	6.00f	3.50f	6.00f
Cigogne	8.00	5.00	8.00
Panthère couchée	20.00	18.00	20.00

The price difference is not a fixed percentage; it varies and becomes larger where the design of a particular work demands a more lengthy or more delicate process of fabrication and finishing. An easily cast *Panthère couchée*, for example, incurs only a 10-percent finishing charge, whereas the more delicate *Cigogne*, with its fragile, spindly legs and tiny size, calls for a 37.5-percent charge. The equally tiny *Lapin sur terrasse* requires a 41-percent charge. Thus the fee exacted by Barbedienne for the casting and finishing of a particular work might range from 10 to 41 percent, as the production cost demanded.[8]

Striking evidence of the use of various founders by Barye and Company is provided by an entry for 31 May 1851, where no fewer than five different casters are listed as paid for the execution of proofs of the same decorative work, a pair of matching but slightly different groups of *Three Putti Bearing a Clamshell* (Fig. 148), matching saltcellars patterned after a small sculpture by Clodion:

Bronzes			31 Mai 1851	
3 paye Lévèque				
1 paire Enfants	Barbedienne		30	20.00 f
1 "	Raingo		3 Dbre	20.00 f
1 groupe "	Barbedienne		15 fevrier	10.00
1 paire "	Lévèque		13 Mars	20.00
1 "	Roussel		13 "	20.00
2 "	"		3 Mai	40.00
				130 f

That Barbedienne was paid 10 francs for a single "groupe" and the other casters were paid 20 francs per "paire" corroborates the fact that the two matching compositions differ slightly in design and were taken from separate models. The work is more clearly described in an entry for 30 June 1851, as "1 paire Coupes Enfants coquilles dorées."

Of the many named bronze casters and artisans Barye and Company dealt with, most

can be documented further in sources other than Emile Martin's journal. A list of these firms and individuals demonstrates the extensiveness of the mass production in Barye's operations. Since most of the names are mentioned repeatedly in the journal, only the first citation of each is mentioned here, unless later ones render identification more certain. The following bronze casters and sculptors are cited in Emile Martin's journal:

1. Barbedienne et Cie, page 4, 30 September 1850.[9]
2. Bastide, fondeur, page 2, 31 August 1850.
3. Bastide et Trevon, page 14, 31 January 1850.
4. Boyeve, page 40, 30 September 1851, paid for the reproduction of several of Barye's sculptor's models, from which molds would be taken:
 > 1 modèle terrasse sur cire petit famille de cerf
 > 1 terrasse moufflon modèle
 > 1 terrasse chien à l'oise modèle
 > 1 petit gazelle cire.
5. Bressan, fondeur, page 154, 30 November 1855.[10]
6. Eck & Durand, page 2, 31 August 1850.[11] (On 31 August 1851, page 36, the firm is paid for an expense of 23 July called "5 terrasses per petites animaux.")
7. Fauconnier, page 36, 31 July 1851.[12] (On 31 August 1851, page 37, an entry cites "4 bas reliefs Fauconnier.")
8. Gayrard, page 10, 30 November 1850.[13] (On 30 June 1851, page 32, he is paid for "Ochar de modèles et épreuves.")
9. Gervais, sculpteur, page 129, 31 December 1854.[14]
10. Grandvarler, page 41, 30 September 1851, paid for
 > 1 modèle de la famille de Cerfs
 > 1 modèle Moufflon
 > 1 modèle d'un chien a l'oise.
11. Grigault, Alfred, page 44, 31 October 1851, paid for "1 modèle du Chien a l'oise."
12. Lecompte, page 44, 31 October 1851, paid for "1 modèle de petit cerf" and "1 modèle de gazelle." On page 37, 31 May 1852, he is paid for "1 modèle tête de mascaron."
13. Lévèque, page 5, 30 September 1850.[15] (See also page 24, 31 March 1851.)
14. Liènard, sculpteur, page 130, 31 December 1854.[16]
15. Pressange, fondeur, page 229, 30 September 1857.[17]
16. Richard, fondeur, page 21, 31 March 1851.[18]

Bronze casters and sculptors were paid for a variety of tasks ranging from the sophisticated one of the reproduction of a sculptor's models, occasionally even in wax, to the more usual casting of bronze proofs, and the still less demanding labor of the casting of bases. Although the word *modèle* is ambiguous and might accurately describe a sculptor's model or a bronze proof, one assumes the distinction made between *modèles* and *épreuves* in an entry dated 30 June 1851 to be a meaningful record of the distinction in usage maintained in Barye's circle. Thus it is fairly certain that even sculptor's models of Barye's designs were reproduced by paid artisans and probably were not always touched by Barye himself, a further insight into the complexities of the problem of autograph.

Thirty-two artisans and suppliers are also cited in Emile Martin's journal:

1. Bailly, page 124, 30 September 1854, paid "sur le animaux bas reliefs Monter par Eck et Dur."[19]

2. Barbedienne is paid "sur la dorure des Flambeaux . . . ," page 24, 31 March 1851. On 31 August 1851, page 37, he is paid to "Réparé 1 Cigogne et tortue [and to] Reciselé 1 paire flambeaux renaissance de l'argent."

3. Barré, note de monture, page 85, 28 February 1853.[20]

4. Bernard, monteur, page 214, 31 March 1857.[21]

5. Bertolin, Société Marbrière, page 233, 30 September 1857.

6. Boulonnois, page 123, 30 September 1854, paid for "Monture et Bronzage."[22]

7. Boyer, page 124, 30 September 1854, paid for "Galvanisation de 4 Bas reliefs."[23]

8. Chasseur, ciseleur, page 225, 31 July 1857. On page 239, 30 November 1857, he is paid for "dorure."

9. Chauvin, emailleur, page 241, 31 December 1857.[24]

10. Cheret, Jules, ciseleur, page 1, 31 July 1850.

11. Claude, marbrier, page 15, 31 January 1851.[25]

12. Couve, bronzeur, page 143, 31 August 1855.

13. Dethy, marbrier, page 34.

14. Detouche, ciseleur, page 191, 31 October 1856.[26]

15. Dotin, émailleur, page 219, 30 April 1857 (also spelled Dottin on page 241, 31 December 1857.)

16. Decreux, ciseleur, page 208, 31 January 1857.

17. Duménil, tourneur, page 146, 31 August 1855.[27]

18. Dupin, papetier, page 190, 30 September 1856.

19. Eck & Durand, page 124, 30 September 1854 (a firm mentioned in a payment to Bailly "sur le animaux bas reliefs Monter par Eck & Dur.")

20. Faure, page 220, 30 April 1857, is paid for "Emaillage a froid reparation de 30 pieces."[28]

21. Gaday, monture, page 240, 31 December 1857.

22. Gallimard, page 120, 31 July 1854, is paid for "monture de le Bas reliefs."

23. Gauthier, bijoutier, page 214, 31 March 1857.[29] (Also cited as Gauthier, emballeur, page 154, 30 November 1855.)

24. Gautier, galvaniseur, page 199, 31 December 1856.[30]

25. Ghislain, marbrier, page 102, 31 December 1853.

26. Hardeler, page 105, 31 January 1854, is paid for "Monture de bas reliefs."

27. Lecompte, ciseleur, page 1, 31 July 1850. (He is also paid for "dorure et bronze de 2 groupes Enfants Lévèque," page 24, 31 March 1851.)

28. Leroy, ciseleur, page 195, 30 November 1856.[31]

29. Picard, doreur, page 185, 1 July 1856.[32]

30. Rochet, note de ciseleur, page 85, 28 February 1853.[33]

31. Sullen, note de ciseleur, page 85, 28 February 1853.

32. Voisin, tourneur, page 1, 31 July 1850.

These entries show that artisans were paid for an array of services in the production and repair of Barye's sculpture: for mounting works in the round, framing reliefs, chasing proofs, lathe-turning bases, gilding, plating by means of electrolysis, and for enameling proofs. Suppliers were paid for drawing paper, packing material, marble, and bronze. Barye even seems to have employed one of his sons as an assistant, the sculptor Alfred, since a payment of 4.00 francs is recorded to one "Barye," page 183, 1 July 1856, and a "Barye fils" is cited on page 186, for 31 July 1856.[34]

A sign of the elusiveness and complexity of the problems of autograph and of proof authenticity is the still unanswerable question of the value placed upon numbered proofs by Barye, or by his partners and subordinates. The practice of numbering successive casts of a given design appears to have originated in the operations of Barye and Company. Yet it is apparent that numbered proofs as such were not recorded in Emile Martin's journal, with one intriguing exception. The single entry in the entire eight-year span of the journal that records proof numbers does so for a dealer not from Paris but from Nancy. Possibly this record of numbered casts was necessary because of the dealer's (and his customers') distance from Barye himself, who might easily have authenticated a questionable proof for a Parisian client, just as Corot occasionally did with his often-copied paintings. The following entry of 31 October 1850, lists numbered proofs:

Daubrée de Nancy		
1 Cerf qui marche	41e Epreuve	35.00 f
1 Chien et lapin	14e	36.00
1 Epagneul	15e	18.00
1 Panthère	27e	18.00
1 Faon couchée	39e	12.00
1 Lapin oreilles couchées	87e	3.50
1 " Droites	78e	3.50
1 " couchées	95e	2.50
1 " Droites	49e	2.50
1 Tortue sur plinthe	1er Epreuve	4.00
1 Bougeoir	18e	5.00
2 pairer flambeaux renaissance	91e et 92e	36.00
1 cheval turc	7e	85.00
		261 f

This unique entry is followed by a typical list of twenty-four unnumbered bronzes cast by Barbedienne. The documentation is simply not yet extensive enough to explain when and why Barye or his casters numbered proofs and when they ceased to do so. Forgery of such numbers of course is a simple matter, as is that of Barye's typical block-letter signature. Perhaps the ease of forgery is in part responsible for even Barye's apparently relaxed attitude toward the problem. The absence of proof numbers also would serve to minimize any stigma that might inhere in the notion of large editions of a given design.

The unusually high proof numbers of the candelabra sold to Daubrée of Nancy in 1850, the ninety-first and ninety-second casts, provide accurate evidence as to the quantities of proofs—at least those of certain inherently popular forms created in Barye's limited mass-production operations. They also suggest that Barye's functional decorative objects enjoyed greater popularity than has heretofore been suspected. His tiny, inexpensive rabbits were predictably successful. Prices placed upon proofs and models remained at the same level throughout the eight-year period recorded; no dramatic increase or reduction occurred.

Bad debts, "mauvaises créances," are cited in the journal. Among those names appear some fairly eminent men, such as Jules Dupré, possibly the Barbizon painter (1812–89), and Alexandre Dumas, perhaps the popular novelist (1824–95). Dumas's debt is later

mentioned as one of several involved in litigation, the "créances litigieuses," on page 184, for 1 July 1856.

In sum, Emile Martin's journal of Barye's accounts documents his involvement with the mass production of proofs of his models and even that of the models themselves. He dealt at various times with some sixteen different bronze casters and thirty-two artisans. In one entry five bronze founders were paid for proofs of the same composition. The employment of Barye's son was noted in 1856. The significance of the high proof numbers of the candelabra is twofold: They yield an accurate notion of the quantities of the more popular forms actually produced by Barye and Company, and they demonstrate the unsuspected popularity of his functional objects.

CATALOGUES OF SCULPTURE PUBLISHED BY BARYE

Between 1847 and 1855 Barye and Company issued some five printed sales catalogues of bronze proofs made after Barye's designs.[35] The number of these catalogues and the steadily expanding lists of designs they offered provide fairly certain evidence of the increasing success of the business. An entry in Emile Martin's journal for 31 December 1851, in fact, indicates a profit for the period 1849–51 of some 3,919 francs. Without an active market, such catalogues would have constituted an unlikely extravagance. The mastheads of the catalogues and the number of designs they list are:

1. *Catalogue des bronzes de Barye*/ rue de Boulogne, no. 6 (Chaussée d'Antin), Paris/ Années 1847–1848.—1er Septembre 1847. (107 works.) (Abbreviated *CRB47*). The address was Barye's at the time of the initial partnership contract of 15 May 1845.

2. *Bronzes de Barye*/ En vente dans ses magasins/ rue Saint-Anastase, 10, a Paris (Marais). (113 works.) (Abbreviated *CRSA*.)

3. *Catalogue des bronzes de Barye*/ 12, rue Chaptal (Chaussée d'Antin), Paris. (113 works.) (Abbreviated *CRC*.) The address was Emile Martin's at the time of the liquidation of the partnership, on 16 May 1857.[36] The nearby address of 11 rue Chaptal was given for Martin at the signing of the initial partnership contract in 1845.[37]

4. *Catalogue des bronzes de Barye*/ Statuaire, Exposition universelle de 1855, Médaille d'Honneur/ rue des Fossés-Saint-Victor, 13, Paris. (152 works.) (Abbreviated *CRF55*.) The address was Barye's at the time of the liquidation of the partnership in 1857.[38]

5. *Catalogue des bronzes de Barye*/ Statuaire, Exposition universelle 1855, La grande Médaille d'Honneur/ quai des Célestins, 10, Paris. (197 works. Abbreviated *CQC55*.)

6. *Catalogue des bronzes de A. L. Barye*/ Statuaire, Exposition universelle de 1865, La grande Médaille d'Honneur, quai des Célestins, 4, à Paris. (230 works. Abbreviated *CQC65*)

As primary texts, the catalogues are most useful for authentication, since they assign to each work an order number, a title, a price, and rough dimensions. Measurements are rounded off to the nearest centimeter, but they are inconsistently taken, sometimes including the plinth, sometimes without. This sort of discrepancy, inherent in the makeup of the catalogues themselves, was further complicated by the typographical errors introduced by the less than accurate printer of Roger Ballu's important monograph on Barye (1890)—the first and only study to print the texts of all the known catalogues of Barye bronzes. Ballu's careless printer not only scrambled the measurements of several of the designs, creating difficulties for those who would use this information, but he even lost the entire masthead of Barye's last printed catalogue, of 1865.[39] The last catalogue was produced by the artist long after the liquidation of Barye and Company, when he had reattained free title to the use of his earlier models and had created a number of wholly new designs as well.[40] Thus the errors of Ballu's printer led to the false conclusion that the late offerings of the 1865 list had been available ten years earlier, whereas the two lists, actually separated by a decade, were accidentally melded into one and were given the earlier date. The recent publication by Stuart Pivar of an accurate facsimile of the 1865 catalogue resolves the problem.

The richness and carefully honed balance of the spectrum of offerings in Barye and Company's first catalogue of 1847 testifies to the years of experience the sculptor had gained in the operation of his personal foundry and sales outlet, from about 1839 until 1845, and to the deliberate thought he gave to his foray into the Parisian art market. The 1847 list opens with the tiniest and least expensive designs, the tortoise and rabbit, at five and six francs, respectively. Families of related designs would tempt the buyer. For the sportsmen, spaniels, pointers, and bassets were offered, not only singly, but often with the hunter's quarry, such as pheasants and stags. Exotic scenes were available, such as *Elephant with an Indian Rider, Killing a Tiger* and *Two Arabian Horsemen Killing a Lion* (nos. 68 and 76). Buyers with a taste for exotic animals would enjoy the five jaguar designs and the several groups with lions and tigers. Romantically stirring combats of predator and prey were numerous: *Ocelot Carrying a Heron, Tiger Attacking a Bull,* and *Wolf Seizing a Wounded Stag at the Throat* (nos. 59, 62, and 65). For the academics tried and true mythological themes could be purchased, such as *Three Graces* and *Theseus Combating the Minotaur* (nos. 64 and 77). Equestrian statuettes were offered in a variety of modes: the romantically medieval *King Charles VII* and *Roger Abducting Angelica on the Hippogriff* (nos. 71 and 78); the forbidding and exotic *Chinese Rider,* (no. 75); the contemporary *Duke of Orléans* and the lyrical *Amazon Equestrienne* (nos. 73 and 104); the comic, even antiheroic *Orangutan Riding a Gnu* (no. 54); and the ghastly and chilling *Abyssinian Rider Surprised by a Serpent* (no. 74). Barye's famous monumental designs were available in small scale. *Seated Lion of the Tuileries Garden* (no. 66) and even a sketch of it (no. 36), as well as versions of *Tiger Devouring a Gavial Crocodile* in two sizes (nos. 47 and 67). Numerous candelabra, an inkwell, an ornamental cup, and an incense burner would interest buyers in search of "useful" bronzes. Obviously this array of forms, themes, and protagonists embodied a point of view wholly professional and highly refined. It might be said that no stone was left unturned in Barye's attempt to appeal to middle-class taste. Interestingly, only this first catalogue of 1847 states that each bronze carries a proof

number.[41] The negative ramifications of that policy no doubt dictated the omission of the statement in successive catalogues.

The humble and whimsical note of the first entries of the 1847 catalogue[42] was interestingly altered in 1855 by the substitution of *General Bonaparte*, hero of the Napoleonic legend, for the tortoise earlier dignified as Number 1. The later catalogue offers special variations on certain forms and themes, such as alternative quarry for a given hunt image: *Arab Rider Killing a Lion*, or a *Boar* (nos. 8 and 9); and *Two Dogs Pointing a Pheasant*, or a *Partridge* (nos. 30 and 31). The figure of the bear is treated as standing, seated, and in a group (nos. 22–24). Mirror-image and paired compositions are available, as with the standing and seated bassets (nos. 32–35); and the standing bassets are offered in a second, smaller scale (nos. 36 and 37). Lovers of the big cats would enjoy the nine tiger designs and ten jaguar compositions (nos. 54–63 and 72–81, respectively). The monumental *Seated Lion* appears in three reduced sizes (nos. 48–50). Species portraits of single animals are typically grouped, and their essentially lyrical tone and positivistic bias would be set off by the inclusion of an animal combat or two, featuring the same protagonist in some dramatically extreme situation, as with the twenty-one designs of elk, stags, does, and fawns set off by two animal combat designs (nos. 105–124). Birds of prey are grouped and contrasted with more decorative birds, as with the eagles, pheasants, storks, and parakeets (nos. 131–41). And Barye's most famous monumental design, *Lion Crushing a Serpent*, is available in two different reductions as well as a sketch (nos. 44–46).

The variations of the 1855 catalogue are so elaborate as to seem overrefined, suggesting a seeking after marketable alterations for commercial rather than artistic reasons. Yet it is completely characteristic of Barye as an artist that he would take delight in, would regard as a challenge to his creativity, such variations in a design as those that differentiate the half-blood horse with raised head from its counterpart with a lowered head. To regard these fine variations as mere commercialism would be to misconstrue Barye's notion of the nature of his art.

6
Alchemy:
Barye's Technical Artistic Practice

Fascinating are the transmutations of artistic raw material into the pure gold of Barye's final forms—from tiny wisps of ideas, the dart of a line on paper, the swelling of a wax model, to the final concretization in bronze or stone. These half-mysterious processes of image formulation and execution are richly documented in the primary material of Barye's drawings, sculptor's models, and bronze proofs.

DRAWINGS

Few of Barye's drawings appear to have been made as expressive final forms in themselves. Most play a role in the development of a sculpture, either as studies of a form in nature or as studies of an artistic precedent. Specific functions within the broad spectrum of possibilities can be illustrated briefly.

Partial aspects of an artistic precedent are recorded in such typical drawings as *Milo of Crotona, after Puget* (Fig. 149) and *Phidian Frieze of Riders* (Fig. 163), and both have a demonstrable impact upon Barye's sculpture. Anatomical form and measurements are noted in a host of drawings, such as *Skeleton of a Stag* (Fig. 154) and *Forepart of a Flayed Tiger* (Fig. 155), which document Barye's study of osteology and the musculature of his typical protagonists. Contour outline is clarified in drawings such as *Mannerist Female Nude* (Fig. 201) and *Grappling Boxers, after Géricault* (Fig. 190), of significance for Barye's

167

seated goddesses and his *Theseus Combating the Minotaur*. Surface texture is noted with great precision of nuance in studies such as *Recumbent Boar* (Walters Art Gallery, 37.2338), which is related to the exquisite textural development in the bronze *Hercules with the Erymanthean Boar* (*Fig. 3*). Compositional development is the obvious point of some series of animal drawings, such as those of a falling stag in which the animal shown in exactly the same pose, first as a skeletal drawing (*Fig. 154*), then as a normal creature, and finally incorporated in a narrative situation (*Fig. 197*)—a series basic to the bronze, *Fallow Deer Brought Down by Two Algerian Greyhounds* (*Fig. 135*). Correct proportional enlargement is the rationale for squared drawings, such as *Family of Deer* (Louvre, RF 4661, fol. 23r), linked with the bronze *Stag, Doe, and Nursing Fawn* (*Fig. 7*). Mood is expressively articulated in a drawing such as *Two Stags Pursued by Hounds* (*Fig. 197*), related to *Elk Hunt* (*Fig. 128*), among other designs, which echoes its florid intricacy of rhythm and its flashing movement.

The translation of a sculptural image for a painting is apparent in *Panther Attacking a Civet Cat* (Walters Art Gallery, 37.2071), a squared drawing made after the bronze (*Fig. 20*), a study whose elaborate pattern of tone and shadow would be of value principally for a painting. Studies after nature specifically for paintings are also extant, such as *Recumbent Tiger on a Ledge* (Louvre, RF 4214), where the intricate pattern of stripes on the tiger's face obscures the sculptural masses of the head. An image in nature ultimately to be rendered as sculpture in both miniature and monumental scale is recorded on an occasional drawing, such as *Seated Lion* (Walters Art Gallery, 37.2248),[1] intimately connected with the monumental *Lion Crushing a Serpent* (*Fig. 23*) and the small bronze *Lion Crushing a Serpent, Sketch* (*Fig. 108*). Only a representative example of each function is cited here, since the many drawings related to specific works of sculpture are discussed in that context. Needless to say, numerous drawings manifest several functions at once.

SCULPTOR'S MODELS

Models for Barye's sculptural designs are abundant in French and American collections. A better comprehension of the significance of the models in regard to Barye's technical method is now possible in light of discoveries made in connection with the exhibition at the Fogg Art Museum, "Metamorphoses in Nineteenth-Century Sculpture," in 1975, and the recent purchase by the Detroit Institute of Arts of an autograph bronze from Barye's *surtout de table* and three related terra cottas.[2] Another important source of documentation is the *Catalogue des oeuvres de feu Barye*, from the posthumous sale of Barye's studio effects held at the Hôtel Drouot in February 1876.

Models for Monumental Bronzes

The designs for Barye's unique monumental bronzes no doubt were first created in clay, directly applied over a supporting armature contained within the form.[3] Low cost and rapid workability make clay the likely choice for an initial form at monumental scale. From the clay model a plaster piece mold would be taken, or perhaps a gelatin mold. The piece mold, in turn, would be used to make either a more durable positive of cast plaster or a wax positive. In this way, the plaster piece mold or gelatin mold could be reused, say, for casting a number of wax positives. Such multiples would eliminate the danger of the loss of a unique sculptor's model in a bad bronze pour, since replacements were ready at hand. Even though these monumental wax positives were cast reproductions of an original, essentially temporary model of clay, and therefore an indirect type of model, Barye obviously reworked their surfaces extensively, if not totally. He did this to restore an autograph touch to them before allowing them to be covered with the investment or mold fabric for their final casting by the lost-wax process. The fine texture of a wax model and of the investment material used for lost-wax matrices yielded castings of the most exquisite detail and surface. A monumental wax positive, cast in a piece mold or gelatin mold, was used for the fine lost-wax casts of *Tiger Devouring a Gavial Crocodile*, Salon of 1831 (*Fig. 22*), and *Lion Crushing a Serpent* of 1832 (*Fig. 23*). A full-size plaster positive of *Lion Crushing a Serpent* was sent to the Musée de Lisieux in 1834, according to Lami.[4]

A plaster positive of Barye's later *Lion of the Zodiac* relief for the July Column, 1835–40, apparently was offered for sale in the 1876 Hôtel Drouot Sale catalogue as no. 518, *Lion de la colonne de Juillet, premier projet, Esquisse plâtre*. Yet the phrase *premier projet* may imply small scale; hence this plaster may have been one of the several small variations of the monumental design, rather than a full-size plaster positive. The reference is not conclusive.

The surface of Barye's monumental bronze *Seated Lion* of 1847 (*Fig. 27*) is so badly eroded by the corrosive atmosphere of its outdoor location that it is difficult to discern the bronze-casting process used. A full-size cast-plaster positive of the design is in storage in the Louvre,[5] probably the model also used for the strange mechanical reversal of Barye's original, now paired with it before the quai portal of the Louvre. The reversed copy deliberately reproduces even Barye's signature in reverse.

A three-dimensional model does not survive for Barye's destroyed bronze relief *Napoleon III as an Equestrian Roman Emperor*, about 1861, once installed on the Riding Academy façade of the New Louvre, although it is documented that an initial model in clay was followed by a cast-plaster positive.[6]

A magnificently well preserved cast-plaster positive of *Napoleon I as an Equestrian Roman Emperor (Fig. 50)* for Ajaccio, is displayed in the Salle de Barye of the Louvre (RF 1562). It is the contractually required model, at one-third scale (h. 1.35 m), which was mechanically enlarged for the final bronze by means of a Collas machine or a similar device.[7] The plaster positive has been cut into a number of simple (and thus readily reproduced) separate elements to facilitate enlargement to full size. Divisions are quite legible, as at the base of the horse's neck, along its lips, and on the rider's leg and arm. This

model was offered in the 1876 Hôtel Drouot sale as no. 481, *Napoléon I^er. Statue équestre, pour la ville d'Ajaccio. Demi-grandeur d'exécution.*

Models for Monumental Stone Sculpture

An entry in the 1876 Hôtel Drouot sale catalogue strongly suggests that a cast-plaster positive, perhaps the presentation model at reduced scale, served in the creation of the marble *Saint Clotilde*, of 1840–43 (*Fig. 26*) for the Church of the Madeleine in Paris. The entry, no. 495, reads, *Sainte Clotilde, exécutée en marbre, église de la Madeleine. Demi-grandeur.* Again, a mechanical device such as the Collas machine aided in accomplishing the final enlargement in stone, some three meters in height.[8]

Apparently, models for the eight *Colossal Eagle Reliefs* for piers of the Jena Bridge (*Fig. 28*), and for the ninety-seven decorative masks for the Pont Neuf cornice (*Figs. 31 and 32*) are no longer extant. The look of the images in both commissions suggests a use of clay models, followed by cast-plaster positives, for the final enlargement in stone.

Cast-plaster positives taken from Barye's first clay sketches in small scale (h. c. 26 cm) for the four personification groups for the Cour du Carrousel of the Louvre, *Strength, Order, War,* and *Peace* (*Figs. 34, 36, 38, and 40*), are in storage in the Louvre (RF 1579–82). These sketches were offered for sale in the 1876 Hôtel Drouot catalogue as nos. 502–5 under the category "Esquisses Plâtres." Cast-plaster positives, no doubt the contractually required presentation models of the four groups (h. 1 m), were also offered for sale in 1876, as nos. 483–86, and they were described as "Demi-grandeur." The presentation model of *Peace* is displayed in the Salle de Barye in the Louvre (RF 1557).

A plaster positive, apparently an intact presentation model of the entire pedimental relief for the façade of the Sully Pavilion of the New Louvre (*Fig. 42*), ultimately carved in stone in 1857, was offered for sale in the 1876 Hôtel Drouot catalogue as no. 487, "*Napoleon dominant l'Histoire et les Arts, exécuté en pierre, cour du Louvre. Demi-grandeur. Fronton plâtre.* The focal element of the pediment model, *Portrait Bust of Napoleon I*, in plaster, is reproduced in Pivar (p. 95).

Cast-plaster positives of the small, original sketches in clay of the pair of River Gods (*Figs. 45 and 47*), intended for the Riding Academy façade of the New Louvre, are in storage in the Louvre (RF 2006 and 2007). Nail heads are visible at terminal points of one of the figures—at the shoulders, wrists, knees, and elbows. These would be of aid in the rapid enlargement of the design to the scale of the contractually required presentation model, a technical practice not yet apparent on the initial sketches of the personifications. The pair of large presentation models are on display in the Salle de Barye in the Louvre (RF 1560 and 1561), and they were offered in the 1876 Hôtel Drouot catalogue as nos. 488 and 489, *Jeune homme rep. un fleuve . . . demi-grandeur.*

Cast-plaster presentation models of Barye's four late animal combat groups, about 1869, for the Palais de Longchamp at Marseilles—*Lion and Boar, Lion and Ibex, Tiger and Doe,* and *Tiger and Gazelle*—are illustrated in Pivar (pp. 137–40). Neither the scale nor the location of the plaster models are indicated, however.

Models for Small Bronzes

Two types of model were most frequently employed by Barye for the sand-cast editions of his small bronzes: a model of cast-plaster touched with wax, and a bronze proof of exceptionally fine detail. A plaster model is light, strong, and easily repaired, and the detail recorded in its outer layer of wax could be quickly retouched to restore its freshness after the erosive effects of the taking of a sand mold. A plaster and wax model might be used for the casting of a master bronze, such as *Lion Crushing a Serpent, Reduction No. 1 (Fig. 109)*, a master bronze used in turn as the model for a *surmoulage* edition of the design. Plaster positives of Barye's designs for small bronzes survive in some quantity; the richest collections are those of the Musée du Petit Palais and the Louvre.

From a master bronze, as many as a dozen or more sand molds might be taken without damage to the bronze itself. Such bronze models were not only cast as single-piece shells. If the form was complex or possessed undercuts that were difficult to reproduce in the sand-mold process, the bronze model could have a segmented or keyed configuration, which might be dismantled into easily cast component elements. Examples of the latter type are *Lion Crushing a Serpent, Reduction No. 2 (Fig. 110)*, of four elements, and *Lion Crushing a Serpent, Sketch (Fig. 108)*, of five elements.

These conclusions as to the norms of Barye's technical practice were verified during the course of research at the Fogg Art Museum, for the exhibition "Metamorphoses in Nineteenth-Century Sculpture." During a discussion at that time, Arthur Beale found traces of fresh, unscorched red French sand—a sure sign that the model in question had been used for the taking of a sand mold—on the underside of a model of plaster and wax, *Tiger Attacking a Peacock (Fig. 56)*, which I had just characterized as typical of Barye's models for bronzes. The presence of the sand confirmed for Beale the accuracy of my view, which was based upon methods of connoisseurship rather than documentation.[9] Furthermore, Beale's precise measurements of each cast in a group of nine, of another design, again confirmed my opinion based in connoisseurship—that one particular proof was indeed a master bronze, reproduced by the other eight in the series, *Lion Crushing a Serpent, Reduction No. 1 (Fig. 108)*. Beale found that the latter proof also had traces of fresh French sand on the interior of the shell, corroborative evidence that it, too, had served for the making of sand molds. He says of his method of documentation:

> At first, careful four-point measurements were made on each of the nine bronze examples. . . . All the casts were very close in size (less than one millimeter difference in 35.5 centimeters) except for one from the collection of the Walters Art Gallery, which was about one percent larger than the other casts. We had found a master bronze model and could accurately relegate these other casts to the classification of *surmoulages* (casts that use other casts as models).[10]

The smaller size of the eight *surmoulage* proofs is the result of the shrinkage of the bronze upon cooling, normally about one and one-half percent. My criteria for assessing this particular proof as a master bronze were several: the exceptionally crisp, waxy quality of the cast; the richly worked conception of surface handling; a free, flicking, sparkling sort of

accenting; a conscious avoidance of regularity in the intervals and of parallelism in the hachure of the lion's pelt; and the presence of the infrequently seen stamped mark, a VP under a crown.[11]

The intimate connection of the two types of model, those of plaster and those of bronze, is well documented in the 1876 Hôtel Drouot sale catalogue. One group of proofs is described as bronzes cast from plaster models, nos. 428–43, "bronzes fondu sur le plâtre ayant servi de modèle." Another group apparently consists of paired plaster models and master bronzes, with the bronzes not yet reproduced in a series of *surmoulages*. The plaster model, "modèle en plâtre," is followed by the unissued bronze, "bronze inédit," as for nos. 448 and 449, *Tigre dévorant une antilope*. Bronze models, "modèles en bronze," are listed as nos. 577–730, and most of the individual entries of the group are accompanied by the phrase, "Modèle en bronze avec son plâtre," a bronze model with its plaster. A group of bronzes, evidently *surmoulage* casts, are termed proofs, "épreuves," nos. 232–427. Each such title is followed by the number of proofs available, as for no. 273, "*Loup pris au piège. Trois épreuves*," that is, *Wolf Caught in a Trap*, three proofs. The idea of *surmoulage* editions of Barye's designs surely was implicit in the very masthead of the 1876 sale catalogue, which points out that models are sold with reproduction rights, "modèles avec droit de reproduction."

Two exceptional types of directly built models are also noted in the categories of objects offered in the 1876 sale: those in wax and those in terra cotta, "ésquisses cire," nos. 524–53, and "ésquisses terre cuite," nos. 554–75. Among the wax models listed are a number of rare designs, perhaps never cast in bronze during Barye's lifetime, such as no. 524, *Cheval anglais, English Horse*; no. 533, *Renommée. Figure équestre, Fame on Horseback*; no. 543, *Caracal couché sur une branche d'arbre, Lynx Resting on a Tree Branch*; and no. 550, *Girafe*, the very one on display in the Salle de Barye (RF 238). Equally unusual titles, probably never cast by Barye, occur among the terra-cotta sketches, such as no. 554, *Cheval surpris par un jaguar, Horse Attacked by a Jaguar*; and no. 555, *Taureau terrassé par un lion, Bull Brought Down by a Lion*, now on display in the Salle de Barye (RF 2593).

Barye's technique of using a plaster positive as the model for the casting of a wax positive, in turn to be used for a lost-wax bronze proof, is documented in the 1876 Hôtel Drouot sale catalogue. Entry no. 497, *Charles VI Frightened in the Forest of Mans* (Fig. 62), is described as a work "fondu à cire perdue pour S.A. la princesse Marie d'Orléans. Plâtre doré." This is the very process by which the lost-wax casts of several of Barye's hunt groups for the *surtout de table* were achieved.

BRONZE PROOFS

The documentary evidence of Barye's involvement with numerous artisans and several founders, recorded in Emile Martin's journal, is borne out by the visual evidence of the varied qualities of the extant bronze proofs, with regard to alloy, patina, and the techniques

of casting and of proof fabrication. Several distinct approaches to the casting process itself are apparent: the occasional use of the costly lost-wax technique, the casting of separate components of proofs to be assembled into a single entity, and the casting of contiguous, single-piece shells.

Generally accepted criteria for a good bronze casting are that it record surface detail with crispness, that it have no bubbles, ruptures, or tears in the fabric, that the alloy be of fine grain, and that the walls of the casting be of uniform thickness, heavy enough for proper strength but not needlessly massive.

The alloy of bronze for a particular proof is occasionaly cited in Emile Martin's journal as yellow bronze, implying that some range of choice was exercised in this regard. A yellow alloy of bronze would contain relatively less copper and more tin and antimony. Perhaps nonartistic criteria were operative in the matter of alloy selection, such as price or availability. Yet visual, artistic values may also have figured in the choice. A high percentage of tin and antimony enables the bronze to mimic precisely the smallest surface details; it also produces a hard, rather brittle casting. A greater percentage of copper and lead allows a richer and darker range of surface coloration and patinas, and it yields a softer, more easily chased proof. A yellow bronze alloy could relate well coloristically to the use of gilt on the base or shell of the sculpture.

The *Surtout de Table* for the Duke of Orléans

Central in any consideration of Barye's art of the 1830s is the splendid table decoration ensemble commissioned by the young Duke of Orléans about 1834. To review briefly, the *surtout de table* was comprised of nine sculptural groups, the themes of which would exploit Barye's flair for the exotic, for adventure, and for an exquisitely detailed, realistic style. No doubt both artist and patron were impressed with the table ensembles created by the French master goldsmiths of the rococo era, several of which were in the Orléans family collection. Much in the spirit of that rococo decorative tradition, five different hunting scenes comprised the heart of the ensemble: *Bull Hunt* (Fig. 90), *Lion Hunt* (Fig. 104), *Bear Hunt* (Fig. 125), *Tiger Hunt* (Fig. 127), and *Elk Hunt* (Fig. 128). *Tiger Hunt*, the tallest of these and the first to be cast, was placed at the geometric center of their cruciform arrangement upon the table. The other four hunts were arrayed around it, on the arms of the cross-plan. The two longest hunt compositions, *Bull Hunt* and *Lion Hunt*, were placed on the long axis of the table.

Outside the central zone of the hunt episodes, at the terminals of the crossed axes, were four smaller and simpler animal combats, only three of which are extant: *Python Killing a Gnu* (Fig. 96), *Tiger overturning an Antelope* (Fig. 98), *Lion Devouring a Boar* (Fig. 114), and *Eagle and Elk* (lost). One of Barye's finest efforts of the 1830s, this ensemble is worthy to stand in the tradition of the master goldsmiths (in fact, at first the *surtout* was to be cast in silver rather than bronze), and it embodies one of the most sophisticated romantic points of view to be found in French sculpture at the time.

Barye himself cast only the four smaller groups of predator and prey, enlisting the

technical expertise and facilities of the professional founder Honoré Gonon & Sons for the casting of the five larger and more complex hunt groups. Gonon worked closely with Barye in these years, for he cast by the lost-wax process Barye's monumental *Tiger Devouring a Gavial* (Fig. 22) and *Lion Crushing a Serpent* (Fig. 23), and the small bronze *Stag Brought Down by Two Large Greyhounds* (Fig. 129).

Gonon took a set of molds from Barye's models for the hunt groups to make cast-plaster positives, from which cast-wax positives used for the lost-wax bronze pour were made. This technique ensured that the original sculptor's model could be reproduced, even in the event of a bad pour. Traditional criteria of quality are brought into question by this use of indirectly fashioned wax models for the casting of the hunts. Are these hunts inferior to the lost-wax casts for which no plaster positives were retained? Probably not, although a purist might disagree. In any case, they comprise a distinct group of casts within those particular technical limits. Complete cast-plaster positives of *Lion Hunt* and *Bull Hunt* are in the reserve section in the Louvre. They are recorded in the 1922 Louvre catalogue as nos. 926 and 927, and in the Louvre's 1956–57 Barye exhibition catalogue as nos. 5 and 6. A fragment of *Tiger Hunt*, a slightly altered cast-plaster elephant, is displayed in the Salle de Barye as *Elephant and Indian Rider* (RF 1578). Another fragment of the cast-plaster model of *Tiger Hunt* is the partially reworked tiger in *Tiger Attacking a Peacock* (Fig. 56).

Interestingly, however, no multiples or fragments of the three extant animal combats for the *surtout de table* have come to light. They are unique, and their models were either lost in a lost-wax pour, or they were destroyed if they had been made of plaster. Given the extensive role of professional artisans in casting the hunts, the presence of Barye's autograph touch in the three animal combats becomes apparent. Their unique value for problems of Barye connoisseurship is clear. A detailed discussion of the most recently discovered of the three will serve as a representative of the entire group, since all three are similar in quality.

Tiger Overturning an Antelope (Fig. 98) is an autograph bronze for the *surtout de table*, designed and executed about 1834–35. The dimensions are: h. 9 ¼, l. 11, w. 9 inches. The plinth measures 9 ⅛ by 7 ¾ inches, and the animals project beyond the plinth at all four sides.

The ad hoc character of the facing of two trimmed edges of the integrally cast plinth, with vertical plates of bronze, roughly ⅛ inch thick, crudely riveted and soldered to the fabric, is an unmistakable sign of the autograph nature of this cast, as it is of the exact contemporaneity of the three related animal combats for the *surtout de table*, which share this technique. It is an almost ostentatiously primitive mode of construction, one never to be seen again in Barye's oeuvre.

This is a heavy proof of a yellow bronze alloy, given a brown patina, and covered with a golden, transparent varnish. Some coloristic play enriches the cast, with changes from a golden yellow to a dark, almost black hue of brown. The surface of the cast is waxy. Integrally cast hachure patterns are crisp, especially in the heads of the animals and in the body of the antelope. Curiously, the tiger's stripes are omitted, a motif to be strongly emphasized in *Tiger Hunt*, cast in 1836. Dry-working of the surface with gravers or burins is minimal, and it appears only over some minor flaw in the casting, as on the tiger's jaw and

across the badly rubbed forms of its shoulder and mid-back, where a matte color of a notably different hue is present as well.

Many pinholes appear over virtually the entire surface of the tiger's body, flanks, and forelegs. These indicate technical difficulties in the pour, such as gas entrapment and temperature levels too low for a uniformly fluid movement of the bronze within the matrix. Steam or gas entrapment doubtless prevented the form of the tiger's lower jaw (at the right side) from filling completely with bronze. The surface of the lower jaw is granular and lacking in the waxy sheen of the areas immediately around it. The jaw is deeply pocked, as though by large bubbles. Cold-working marks of the burin are evident over this passage, but they are kept very fine so as not to compete with the superb, integrally cast detail of the nearby areas. The flaw has been disguised and gives the impression that the thick pelt of the antelope's throat bushes outward over the bonier form of the tiger's jaw, a naturalistically plausible general effect. Related to the problem of the entrapped gases are the pinhole gap inside the tiger's right ear and the bubble in its left forepaw, between the third and fourth toes.

Barye unwisely cast the antelope's legs in one piece with the larger shell, a risky decision in view of the greatly differing rates of expansion and contraction in the large mass of the bronze as opposed to the very light legs. Predictably, fracture marks appear on the extended left foreleg below the knee. The tip of the antelope's right rear leg did not fill with bronze, and a large patch was fitted into the gap, measuring roughly 1 ¼ by ¼ by ¼ inches.

Many traces of the core material remain inside the bronze shell, as do trapped fragments of the bronze wire used as an internal armature within the sand core of the mold. Visible also are the bronze pins that held the sand core in place within the matrix, pins that merged with the fluid bronze of the shell during the pour. Sand traces just below the antelope's head are still bright red, indicating an area that remained relatively cool during the pour. Conversely, sand traces inside the antelope's left haunch have been burnt black by extreme heat, the more usual effect. This difference of heat reception at several points in the matrix may itself be a sign of technical difficulty, since it is obviously ideal to keep the bronze at a uniformly high temperature throughout the matrix for a maximum of fluidity and for the most accurate mimicry of the detail recorded in the mold.

Two vertical edges of the plinth were cast successfully, while the other two were finished with vertical facings of bronze sheet, each strip held to the bronze shell with four bronze rivets. One such sheet is also laminated, to gain thickness at the corner below the antelope's hind leg and tail. This facing strip is movable, perhaps because the rivets have loosened with time, or perhaps because they were not hammered tightly into place. On the underside of the base, at the corner beneath the antelope's head, several details are of interest. One of the integrally cast edges of the plinth was free enough of casting flaws to be retained largely as it was. At the corner, however, Barye added a scrap of bronze sheet, attached in the horizontal plane with two rivets, to fill a large gap. Also visible at this corner is the riveted, vertical facing strip of the adjacent edge.

In light of the obvious problems inherent in Barye's own craft of bronze casting at this time, it seems reasonable that the sculptor would seek out Honoré Gonon's professional assistance for the casting of his larger and more complex hunt groups. This implies that the

three extant animal combat groups were cast prior to the hunts, in an exploratory spirit, about 1834 or 1835. Corroborating this view is the date of 1836 for *Tiger Hunt*, the earliest hunt to be cast by Gonon.

It should be reemphasized that these five dazzling hunts are also autograph in a real sense, although they have been achieved with indirectly fashioned cast-wax models. Barye surely worked the surfaces of those models, imbuing them with his touch, before the mold investment was applied. The molds taken from Barye's original, directly built models by Gonon were retained and apparently were used later to create the sort of cast-plaster positives now in reserve in the Louvre. Yet another sign of Gonon's caution is the unusual heaviness of these casts, for their massive walls were so designed to assure an absolute maximum of free movement and fluidity for the molten bronze within the matrix. The hunts of the tiger, lion, and bull have inscriptions stating that they were cast in a single pour and were not retouched: "bronze d'un seul jet sans ciselure." The hunts of tiger, lion, bull, and bear are inscribed with the name of Gonon's foundry, "Hôtel d'Angivilliers."

Unique Bronzes

Unique casts of three different designs of the 1830s are extant. Two of them have inscriptions stating that they were cast by Honoré Gonon and Sons, and they are similar in quality of surface and heaviness of fabric to the five hunt groups for the *surtout de table: Stag Brought Down by Two Large Greyhounds* (*Fig. 129* is inscribed FONDU D'UN JET SANS CISELURE PAR HONORE GONON ET SES DEUX FILS; *Dead Gazelle* (*Fig. 137*) is inscribed FONDU PAR HONORE GONON ET SES DEUX FILS, EPO 141.

The third unique bronze is very heavy and surely reflects Barye's craftsmanship as a founder shortly after his casting of the four animal combats for the *surtout de table. Stag Attacked by a Lynx* (*Fig. 132*), an autograph bronze, is signed and dated in block capital letters raised in relief along the sides of the base: on the right side, A L BARYE 1836; on the left side, CERF ATTAQUE PAR UN LYNX. An unusual founder's monogram is inscribed at each end of the base ⊕ . This is a heavy, almost solid bronze proof, cast by the lost-wax method. Both of the stag's left legs have cracked through, a sign of the same technical problem that beset the contemporaneous *Tiger Overturning an Antelope* (*Fig. 98*); namely, that the extreme differences in the rates of expansion and contraction between the heavy mass of the stag's body and its delicate legs caused the legs to fracture as the bronze cooled. The cracks have been repaired, and cold-working with files is evident on both breaks, giving them a different surface quality than the crispness of integrally cast detail over most of the proof. Thin places in the fabric and pinholes occur along the right side of the stag's neck and head. The left antler is cracked and repaired. Ridges left along the piece-mold junctures have also been removed by cold-finishing about the hindquarters and tail. A lushness of integrally cast surface detail crisply reflects the wax original, especially in the incised patterns of the pelts and in the freer texture of the base. It is even possible to discern the three different widths of stylus Barye used to make the incisions on the furry pelt in working up the wax original.

Master Bronze Models

Bronze casts used as models for *surmoulage* editions of Barye's designs comprise another distinct group of unique bronzes. Only a few of the master bronzes are identifiable with certainty. Among the known examples, one is unique in that it is a single-piece shell, *Lion Crushing a Serpent, Reduction No. 1 (Fig. 109)*. Furthermore, it is of importance for its record of the qualities of modeling and surface typical of Barye's small bronze style of the late 1840s. Thus it significantly complements the autograph bronzes of the 1830s. This particular proof was identified as the master for a *surmoulage* edition, not only by methods of connoisseurship but also with the corroborating evidence of the traces of unburnt French sand remaining in the interior of the bronze shell from the process of mold making, and by the fact that this bronze measured about one percent larger than each of the eight other casts made in molds taken from this very master bronze.

The remaining, positively identifiable master bronzes are not finished sculptures complete in their own right. They were designed with removable segments specifically to facilitate the making of sand molds, and they were intended primarily to be durable models for editions of the designs. *Lion Crushing a Serpent, Reduction No. 2 (Fig. 110)*, is constructed of four removable elements. On the focal side, beneath the lion's face, it is cold-stamped with the mark VP under a crown. A letter S, tilted toward the left at a forty-five-degree angle, possibly the mark of a particular artisan, is stamped at the right rear of the base. Several pieces of this model are held in place by sliding pins and by integrally cast "keying" ridges and sockets.[12]

The lowest piece is comprised of the plinth with its integral molding. A keying notch has been cut into its left side, which matches a similar notch in the next higher section of the model, assuring that both will be assembled facing the proper direction. The second element is the rocky base, with an integrally cast serpent, as well as the end portion of the lion's tail. The tail includes a reserved ridge of metal around the end to be butt-jointed, which would be peened over a soldered seam. Two pins are mounted at the extreme ends of this section of the model, which mate with holes in the plinth below. Four holes are bored in the top surface of the rocky base for the attachment of the pegs integrally cast with the lion's paws. The third segment is the lion's body with the stump of its tail. On the uppermost, machined surface of this element are three integrally cast teats joined by low ridges of metal, like tiny walls connecting the three corner towers of a fort. These mate with sockets cast in the underside of the last, lidlike element of the model, the top of the lion's head. On this fourth part, interestingly, the keying system was supplanted with a second, perhaps more stable system of three long pegs of bronze rod soldered to the underside of the lid. These fit into tubular sockets soldered onto the walls of the lion's body. Traces of both fresh and fired French sand are visible in the interior, evidence of both the use of this model for the making of sand molds and for casting the model itself.

Lion Crushing a Serpent, Sketch (Fig. 108) is a nearly solid bronze model of crisp detail directly cast from a wax positive.[13] It has been cut into five removable elements to facilitate the making of sand molds: the lion's body; the lion's right foreleg and paw; the lion's tail; the serpent's head; and the plinth. An unusual inscription, O BARYE 12 in letters 3 millimeters

high, is cold-stamped beside the lion's left haunch. Do the numerical prefix and suffix signify an artisan or founder, or do they identify this proof as the master for a particular *surmoulage* edition of the design? A documented answer is not possible. Interestingly, a second, minor variation of this design can be observed in a plaster positive in the Musée des Arts Décoratifs,[14] which has additional small rocks at the front of the base, between the lion's paw and the serpent, unlike the bald surface of that area of the model in Figure 108. Did Barye add these rocks out of artistic, compositional necessity, or did he do it to make each of the two series distinctive? Again, a documented answer is not possible.

A fourth master bronze represents a fascinating extreme of intricacy in that it has no fewer than twelve separate pieces. *Tiger Devouring a Stag* (*Fig. 19*) shows traces of fresh French sand in the interior of the shell, confirming its use as a model for sand molds. Reserved ridges of bronze are visible along most of the joints and seams, which were intended to be chased over a soldered joint so as to conceal it and to allow a uniformity of patina. Listed briefly, the separate elements are: (1) The plinth with its integral molding—unit includes the integrally cast body of the stag, its right forehoof, and the tiger's right forepaw with its dramatically exposed claws. The initial form of this base was smaller than its present state, perhaps the result of a flawed casting, for the entire back end was added to the plinth, a large, arcuate segment, which shows the signature, BARYE. Soft solder was worked over the underside of the juncture, and passages of cold chisel work were used to thin an excessively heavy area of fabric. (2) The stag's right foreleg, attached with a threaded pin. (3) The stag's left, lower hind leg and hoof. (4) The stag's right foreleg. (5) The stag's head and ears. (6) The stag's lower jaw, attached to its head with a threaded pin. (7) and (8) The left and right antlers. (9) The stag's neck, with the integral, biting tiger's head. (10) The tiger's body. (11) The tiger's tail. The total reaches twelve if the two segments of the plinth are counted separately. The intricacy of this model reveals how near Barye's technical procedures were to those of the goldsmiths. Only an artist or artisan fascinated with the miniature would devise such a form.

Unfortunately, the certain identification of master bronzes is difficult in the case of designs where the evidence is not obvious. For example, to measure all of the extant casts of a given design to find the exemplar that is largest by one percent is virtually impossible in light of the wide dispersion of the bronzes. In addition, Barye's last sales catalogue of 1865 lists roughly two hundred distinct designs, exclusive of the decorative objects. And the appellations in the 1876 Hôtel Drouot sale catalogue, which seem so enlightening, are not wholly accurate. Stamped founder's or artisan's marks on the bronze proof are of some help, but given today's technological capacities, they are all too easily forged. The mark VP under a crown, for example, appears on casts of various quality and thus, of itself, is not a sign of a bronze model. The VP mark is seen on the rather mediocre cast from a rubbed model of *Jaguar Devouring an Agouti* (Walters Art Gallery, 27.85), surely not a master bronze, and it appears on the excellent artisan proof *An Arab Horseman Killing a Lion* (*Fig. 91*), also not a master bronze. In sum, the identification of an autograph or master bronze is a task of connoisseurship of the first order. An entire constellation of relevant variables must be evaluated for this judgment, in light of the experience gained through a direct study of the largest possible number of Barye bronzes.

Assembled Proofs

The most typical sort of proof of the more complex designs is one cast in several small components and mechanically assembled into the final form. A certain range of technical practice is seen in a selection of examples. In one splendid proof of *Bear Overthrown by Three Dogs* (*Fig. 126*), possibly a bronze model, the several animals and the base are fixed together temporarily with bolts and soft solder. It is unfinished at many junctures. Certain points of attachment, like those of the dog's paws, are cast with integral, polygonal haloes of metal, which fit precisely into sockets cast for them in the base. The haloes are cast with a small ridge of metal raised around the periphery. The ridge would be peened over the soldered seam to disguise it for a more uniform patination. Several elements of the animals' forms are separately cast, with tubular projections designed to fit into cylindrical sleeves on the main casting. Pins are driven through these "Roman" joints to fix the appendage before soldering and before chasing the reserved ridge of bronze over the soldered seam to disguise it. Elements fixed with pinned sleeve joints are the bear's lower jaw and the jaw and tail of the lowermost dog. Surface detail on this proof is generally crisp, and the only finishing still required is to disguise the sleeve joints.

Another complex design, assembled of many pieces, is *Fallow Deer Brought Down by Three Algerian Greyhounds* (*Fig. 136*). Surface detail is crisp, but the bronze proof shows many irregular, bright areas around the soldered joints, as though the acid or soldering flux were not thoroughly cleaned away before patination was applied. Several breaks in the bronze fabric have been repaired with plugs of bronze rod, as on the middle of the deer's back and the back of the uppermost hound. In a word, professional finish is lacking in this proof.

A definitely dated, early cast, assembled of several pieces, is *Poised Stag* of 1829 (*Fig. 12*). The animal, antlers, and base are separate castings. Solder attaches the antlers. A mold-separation line along the stag's left shoulder is crudely filed, since a long, flat spot is evident. Three ruptures in the bronze fabric have been repaired with small round plugs of bronze along the left side of the rib cage. Two gates were sawed into the bronze shell to allow removal of core material, then soldered into place again. One is at the left hind leg, and the other is at the front right side of the throat.

A kind of groping toward technical proficiency is still evident in the early proof of *Standing Bear*, Salon of 1831 (*Fig. 122*). It is a heavy shell, and the separately cast figure and base were assembled with bronze screws and pegs and brazed. By comparison, another light, single-piece shell of this design (Walter Art Gallery, 27.137) is no doubt the work of a professional artisan.

A certain crude, technical experimentation is apparent in *Two Bears Wrestling*, Salon of 1833 (*Fig. 123*). The silver leaf applied to the bronze has peeled away in several areas, and on the undersides of several projecting forms it runs in streams as though melted. The proof itself is a piece-mold casting, with visible mold-separation lines in several places. The upper half of the uppermost bear is joined to the lower half at a clearly visible horizontal seam; this is a bolted and soldered attachment. The fabric is porous and the texture sandy. Extensive chasing and filing is evident around the faces of the bears.

At the opposite end of the spectrum are several proofs of high quality, almost that of an autograph or master bronze. *Bull Attacked by a Bear* (*Fig. 120*) is stamped BARYE 1, and it has crisp detail, despite an overall granular texture. It is a single-piece shell, except for the attached bull's forelegs, horns, and tail. A waxy texture is seen over the entire bear, but it is present only in accented passages on the bull, as in the pelt along its forehead. A small gap occurs inside the bear's left hind paw. *Rearing Bull* (Walters Art Gallery, 27.38) is also stamped BARYE 1. It is a yellow bronze proof of extremely crisp detail. Some file work has reshaped the tail, ears, horns, and back, along the major mold-separation line that follows the spine. *Virginia Deer Biting Its Side* of 1837 (*Fig. 60*) is stamped BARYE 8 in letters .05 centimeters high. It is a waxy, crisp proof, with file marks apparent around the attachment of the antlers. *Python Suffocating a Crocodile* (*Fig. 140*) is signed A.L. BARYE, and it has crisp surface detail in the serpent's scales and crocodile's hide. The several pieces of the proof are fastened both with solder and with bronze rods peened at the ends, rather than with screws. One of the latest of this group of casts, *Python Swallowing a Doe* of 1840 (*Fig. 138*), is stamped BARYE 2, and it shows a second, partially registered signature stamp, BAR. It is a superbly detailed, crisp proof. The serpent and doe are attached to the base with bronze pegs and solder. Unfilled gaps are seen between figure and base. The soldered appendages include the doe's left ear and right hind knee and hoof.

Another group of fine artisan casts are of approximately similar quality. *Eagle Taking a Heron* (*Fig. 100*) is a proof of several assembled elements with soldered seams. File marks are visible along them and around the eagle's face. *Elephant and Indian Rider Killing a Tiger* (Walters Art Gallery, 27.149) is assembled both with screws and solder. *Elk Attacked by a Lynx* of 1838 (*Fig. 134*), shown as a plaster model in the Salon of 1834, is a proof assembled of several pieces. The joint between the elk and lynx is incompletely soldered and chased. Chasing at other joints and along the mold-separation ridges is hasty, as at the elk's right flank. *Horse Attacked by a Lion*, Salon of 1834 (*Fig. 105*) is assembled of separate castings for the horse and base. A section of the horse's belly has been sawed out, both as a hatch for the removal of core material and to facilitate bolting the horse to a tree trunk of the base. The hatch is soldered in place. *Crocodile Devouring an Antelope* (*Fig. 139*) is assembled of several pieces with solder and screws. Soldered seams on the crocodile's leg are now quite apparent as black lines visible through the patination. A mythological image, *Lapith Combating a Centaur* (*Fig. 106*), is a yellow bronze proof assembled of several pieces. Seams have opened at the two rear hooves and within the swag of drapery between the centaur's horse-belly and the rock.

Single-piece Shells

Single-piece sand-cast shells occur frequently in the extant Barye bronzes, particularly among the simpler designs. Most often they are of light weight and represent professional artisan craftsmanship, and not the technical hesitancy of Barye himself. Barye was mainly an innovator of imagery, and he was less patient with image reproduction than were his artisans or those of Barbedienne's enormous plant. In this connection, the combination of

light weight and the use of a reddish or distinctly coppery alloy of bronze are fairly sure signs of a late, artisan cast. A *light* cast is a *late* cast, particularly with respect to the designs of the 1830s. Two early examples of this type of proof are *Wounded Boar (Fig. 94)*, a cast of crisp surface detail in a yellow bronze alloy, and *Lion Devouring a Doe* of 1837 (*Fig. 119*), which is stamped BARYE at both sides of the lion. Waxy surface qualities are apparent in the lion's head and mane and in the forms of the doe, while more resistant textures like those of carved plaster appear on the lion's torso and hindquarters. The tufts of the lion's mane are cut boldly into the wax, and the vigor of their deep relief contrasts with the less plastic surfaces of the base and the lion's body.

Notes

CHAPTER I

1. Théophile Gautier, *Les Beaux-Arts en Europe* (1855–56), 2:180–81, cited in Hubert, "Barye et la critique," p. 227.

2. The following account is taken from the several major studies of Barye: Charles DeKay, *Barye, Life and Works* (New York, 1889); Roger Ballu, *L'Oeuvre de Barye* (Paris, 1890); Stanislas Lami, "Barye," *Dictionnaire des sculpteurs de l'école française* (Paris, 1914), 1: 69–85; Charles Saunier, *Barye* (Paris, 1925); and Charles Otto Zieseniss, *Les Aquarelles de Barye* (Paris, 1956).

3. Bosio's sculpture is displayed near Barye's *Lion Crushing a Serpent* in the Salle de Barye.

4. "Monsieur Barry, passage Sainte-Marie (16 Octobre 1828). Le lion est mort—Au galop—Le temps qu'il fait doit nous activer—Je vous y attends. Mille amitiés," cited in Zieseniss, *Aquarelles*, p. 36 n. 2, from Joubin, *Correspondence*, 1: 225. Joubin points out that the museum archives record the death of an African lion on 16 October 1828, the date Joubin assigned to Delacroix's letter.

5. Cited in Hubert, "Barye et la critique," p. 224.

6. Benge, "Lion Crushing a Serpent," p. 33.

7. "Quelle vigeur et quelle vérité! Ce lion rugit, ce serpent siffle. Quelle rage dans ce mufle grincé, dans ce regard oblique, dans ce dos qui ce hérisse! Quelle puissance dans cette patte posée sur la proie!. . . . Où M. Barye a-t-il donc trouvé à faire poser de pareils modèles? Est-que son atelier est un désert de l'Afrique ou une forêt de l'Hindoustan?" Alfred de Musset, "Salon de 1836," *Revue des Deux Mondes*, 2 (1836), p. 172.

8. "M. Barye par un heureux privilège, a respecté tout à la fois les droits de l'imagination, et les droits de la science; . . . l'exactitude se concilier avec l'invention." Quoted in "Peintres et sculpteurs modernes de la France," *Revue des Deux Mondes*, vol. 3 (1851), pp. 60–61.

9. Lami, "Barye," p. 71.

10. Saunier, *Barye*, pp. 30–31.

11. The original letters of contract are published in Pivar, *Barye Bronzes*, pp. 274–76.

12. "Le lion de 1847 a subi les outrages de la ciselure . . . tandis que ils ont été effacés par la ciselure. Cette apparence d'omission . . . est plus sensible dans les membres postérieurs que dans les membres antérieurs. . . . Si Honoré Gonon eût fondu le second comme il avait fondu le premier. . . ." Planche, "Sculpteurs modernes" (1851), p. 51.

13. Pivar, *Barye Bronzes*, pp. 137–40.

14. Peter Fusco, "Jean-Jacques Feuchère," in *Romantics to Rodin*, pp. 266–68.

15. See the view of Chandler Rathfon Post, *A History of European and American Sculpture from the Early Christian Period to the Present Day*, 2 vols. (Cambridge, Mass., 1921), 2:127–30.

16. I am indebted to the late Professor H. W. Janson for this observation.

17. *Catalogue des Bronzes de Barye*, rue de Boulogne, no. 6 (Chaussée d'Antin), Paris, Années 1847–48, n. 1.

18. "Mais que savons-nous si elles ne transgressent pas leur lois naturelles?" J. H. Bernardin de Saint-Pierre, "Etude Sixième, Reponses aux objections contre la Providence, tirées des désordres du règne animal," *Oeuvres complètes*, pp. 263–64.

19. Paraphrased in René Wellek, *A History of Modern Criticism, 1750–1950*, Vol. 2, *The Romantic Age* (New Haven, Conn., 1955), p. 220.

20. Mme de Staël in *De l'Allemagne*, p. 146, says that "pour manifester cette existence tout intérieur, il faut qu'une grande variété dans les faits présente sous toutes les formes les nuances infinies de ce qui se passe dans l'âme. Si de nos jours les beaux-arts étaient astreints à la simplicité des anciens, nous n'atteindrions pas à la force primitive qui les distingue, et nous perdrions les émotions intimes et multipliées dont notre âme est susceptible."

21. Victor Hugo, "Preface" [to *Cromwell*] (October 1827), in *Cromwell, Hernani, Oeuvres complètes*, vol. 1 (Paris, 1912), pp. 7–51.

22. Two of Falconet's principal works surely were known to Barye through his academic training and his interest in the equestrian monument: *Observations sur la statue de Marc-Aurèle, et sur d'autres objets relatifs aux beaux-arts: A Monsieur Diderot* (Amsterdam, 1771) and the six-volume tract, *Oeuvres d'Etienne Falconet statuaire; Contenant plusieurs écrits relatifs aux beaux-arts…* (Lausanne, 1781).

23. Toussaint-Bernard Emeric-David, an academic theorist and critic, was an avid writer on sculpture. His prize-winning essay surely was known to Barye: *Recherches sur l'art statuaire, considéré chez les anciens et chez les modernes ou Memoire sur cette question proposée par l'Institute National de France: Quelles ont été les causes de la perfection de la sculpture antique, et quels seroient les moyens d'y atteindre?* (Paris, 1801, 1805).

24. Antoine-Chrysostome Quatremère de Quincy published a detailed program of reform for the French Royal Academy of Art, which was well-known among artists; *Considérations sur les arts du dessin en France, suivies d'un plan d'Académie, ou d'Ecole publique, et d'un système d'encouragement* (Paris, 1791). He discussed the Elgin Marbles in *Lettres écrits de Londres à Rome, et adressées à M. Canova sur les marbres d'Elgin, ou les sculptures du temple de Minerve à Athènes* (Rome, 1818).

25. Since Barye's drawings reflect the engravings of John Flaxman, his awareness of Flaxman's writing is likely: *Lectures on Sculpture as Delivered Before the President and Members of the Royal Academy, by John Flaxman, Esq. R.A.*, 2d ed. (London, 1838).

26. Quatremère de Quincy, *Considérations*, pp. 131–33.

27. Flaxman, *Lectures on Sculpture*, pp. 158–59: Leonardo da Vinci … [created] in the Contest for the Standard … the first great example of complicated grouping since the arts flourished in ancient Greece…. We are sure the several hunts of the lions, hippopotamus, and crocodile, were painted by Rubens in emulation, if not imitation, of Leonardo's Battle … and such is their merit, that in them you see the men strike, the horses kick, the wild animals roaring, turn and rend their hunters, with a grandeur of lines equal to the vivacity of action and passion. In comparing these with similar subjects in ancient basso-rilievos, particularly with those on the arch of Constantine, in which Trajan hunts the lion and boar, modern genius shines with uncommon brilliancy, and Trajan with his followers, and the animals they attack are tame, insipid, and unnatural.

28. See Jane Horswell's well-illustrated *Bronze Sculpture of Les Animaliers* (London, 1971).

29. Ibid., pp. 83, 145, 195, and 223.

30. *Romantics to Rodin*, p. 267 and cover.

31. See *Sur les traces de Jean-Baptiste Carpeaux*, Figs. 49–86; and Annie Braunwald and Anne Middleton Wagner, "Jean-Baptiste Carpeaux: Ugolin et ses Enfants," in *Metamorphoses*, pp. 109–23.

32. *Sur les traces de Carpeaux*, Fig. 372.

33. Rudolf Wittkower, *Art and Architecture in Italy, 1600–1750*, 3d ed. (Baltimore, 1973), Figs. 153 and 154.

34. *Sur les traces de Carpeaux*, Figs. 284–326; and Braunwald and Wagner, in *Metamorphoses* pp. 124–43.

35. *Sur les traces de Carpeaux*, Figs. 245–83.

36. Ibid., Figs. 330–43.

37. Albert Elsen, *Rodin* (New York, 1963), p. 205.

38. Albert Elsen, ed., *The Sculpture of Henri Matisse* (New York, 1972), pp. 16–21 and Figs. 16–21.

CHAPTER 2

1. Luc-Benoist, *La Sculpture romantique*, p. 146, n. 1.

2. Pivar, *Barye Bronzes*, p. 240.

3. M. C. Ross, "A Barye Proof in the Walters Art Gallery," *Numismatics Review* (January 1947), p. 16, pl. V; and *Romantics to Rodin*, pp. 124–26 and fig. 14.

4. Blunt, *Art and Architecture in France*, pl. 179a.

5. See Elena Bassi, *Canova* (Rome, 1943).

6. See Louvre, *Cat.*, 1922, no. 932; and 1956, no. 109. Gift of Jacques Zoubaloff, 1919.

7. See Louvre, *Cat.*, 1956, no. 103; and *Romantics to Rodin*, p. 126, fig. 15.

8. See Pivar, *Barye Bronzes*, p. 217.

9. Escholier, *Delacroix*, 3:79.

10. See Louvre, *Cat.*, 1956, no. 102; and Benge, "Barye, Flaxman, and Phidias," pp. 99–105.

11. *The Iliad of Homer Engraved from the Compositions of John A. Flaxman R. A. Sculptor* (London, 1805). *Iliade d'Homere gravée par Thomas Piroli d'après les desseins composées par Jean Flaxman sculpteur à Rome* (Rome, 1845).

12. *The Iliads of Homer, Prince of Poets . . . translated . . . by George Chapman*, vol. 1, 3d ed. (London, 1888).

13. Theodore Reff, "Edgar Degas' Little Ballet Dancer of Fourteen Years," *Arts* 51 (September 1976): 66–69.

14. Exhibited in "Barye Sculpture and Drawings," American Federation of Arts, 1959–60. See *CRB47*, no. 8.

15. *French Master Goldsmiths*, pp. 118–19.

16. See Philadelphia Museum of Art, *Bulletin* (1961), p. 69, no. 58.

17. Joubin, *Correspondance*, 1:225 and n. 2.

18. See *CRB47*, no. 21; and Philadelphia Museum of Art, *Bulletin* (1961), p. 69, no. 47.

19. *French Master Goldsmiths*, pp. 120–21, 239.

20. John Rupert Martin, "The Baroque from the Point of View of the Art Historian," *Journal of Aesthetics and Art Criticism* (1955), pp. 164–71.

21. Louvre, *Cat.*, 1956, p. 43, no. 108.

22. See Philadelphia Museum of Art, *Bulletin* (1961), p. 69, no. 55.

23. *NYBMA89*, p. 22, no. 99.

24. Ibid., no. 100.

25. Ibid., no. 93; and *CQC65*, no. 199.

26. See Cushion, *Animals*, fig. 18a.

27. See Pivar, *Barye Bronzes*, p. 226.

28. This proof is also signed SOYER. A. Soyer, a Parisian sculptor and bronze caster, was a partner of the founder Inge. He studied in Rome about 1827 as the prizewinner of the French Academy. Soyer died after 1844. See Thieme-Becker, 31:315.

29. Louvre, *Cat.*, 1956, pp. 46, nos. 121–23.

30. *NYBMA89*, p. 17, no. 31; and *CQC55*, no. 59.

31. *NYBMA89*, p. 17, no. 25; and *CQC55*, no. 71.

32. *NYBMA89*, no. 30; and *CRB47*, no. 30.

CHAPTER 3

1. Exhibited in the Salon of 1831 as no. 2177, *Un tigre ayant supris un jeune crocodile le dévore*, *Explication des ouvrages . . . 1831*, p. 169; Louvre, *Cat.*, 1956, no. 3. See Hamilton, "Origin," pp. 250–53; and Hubert, "Barye at la critique," pp. 223–30.

2. "Il y a de la rage dans le tigre qui dévore, et de la souffrance dans le crocodile qui se tord sous des dents. Je reprocherai à M. Barye d'étouffer la vie de ses animaux sous une multitude de détails reproduits trop petitement. J'aimerais mieux cent fois que les détails fussent moins nombreux. . . . La complication de . . . l'éxecution donne à l'oeuvre un caractère inévitable de sécheresse et de dureté," *Salon de 1831* (Paris, 1831), p. 105.

3. "The farther I went along [in the natural-history collection of the Jardin des Plantes], the more this feeling increased: it seemed to me that my being was rising above the commonplaces, the small ideas, the small anxieties of the moment." Delacroix marveled at the "hideous dragons, the lizards, the crocodiles, the alligators, the monstrous gavials with their jaws tapering suddenly and ending at the nose with a curious protuberance," *Journal*, 19 January 1847, cited in Elizabeth Holt, *From the Classicists to the Impressionists* (Garden City, N.Y.; 1966), p. 157.

4. Cited in Hubert, "Barye et la critique."

5. Hamilton, "Origin," p. 253 and nn. 9 and 10.

САЙ

NOTES

6. Exhibited in the Salon of 1833 as no. 2458, "*Un lion; modèle en plâtre,*" cited in *Explication des ouvrages... 1833*, p. 180; Salon of 1836, no. 1864, "*Lion en bronze.* (M.d.R.) les commandes ordonnées par le Roi," cited in *Explication des ouvrages... 1836*, p. 198. See Louvre, *Cat.*, 1922, p. 7, no. 907; Ibid., 1956, no. 1; *CQC55*, no. 43; *CQC65*, no. 40; and *CFBLB*, no. 9. A fine bronze cast by Barbedienne, dated about 1889–91, is in Rittenhouse Square, Philadelphia.

7. Loys Delteil and N. A. Hazard, *Honoré Daumier: Le Peintre-graveur illustré*, vols. 21–29 (Paris, 1925–26).

8. An example of this relationship of the Lion of Leo and the Serpent of Hydra appears in Albrecht Dürer's woodcuts of star charts, c. 1515, for Johann Stabius. See *The Complete Woodcuts of Albrecht Dürer*, Willi Kurth, ed. (New York, 1963), figs. 295 and 296.

9. See Note 4.

10. See Note 4, Chapter 1.

11. *Metamorphoses*, p. 92, fig. 11.

12. "Servir-vous assez bon pour vouloir bien m'envoyer un billet qui m'autorise à faire voir à une famille américaine qui est sur le point de quitter Paris pour ... retourner aux Etats-unis, le modèle de l'Eléphant qui est sur l'emplacement de la Bastille, que les gardiens n'ont plus la permission de laisser voir et que mes amis ont une extrême curiosité de visiter," *AN* F¹³ 1244. See Alavoine's watercolor *Elephant Fountain* (Paris, Musée Carnavalet) in Robert Rosenblum's *Transformations in Late Eighteenth-Century Art* (Princeton, N.J., 1967), fig. 151.

13. "M. Le Comte de Hauterine visite le modèle de l'éléphant," *AN* F¹³ 1244.

14. "M. Bruner, fils, propose de mettre du gaz dans la Tronque de l'éléphant," *AN* F¹³ 1244.

15. "Monsieur le Directeur: D'après ce que vous m'avez d'arreter les degredations du grand modèle de l'éléphant, je me suis occupé de rechercher les moyens les plus economiques de parvenir à ce resultat, et j'ai reconnu qu'au moyen d'une housse en toile impermeable couleur de bronze on cacherait les progres pendant plusieurs années, ce qui donnerait le temps de prendre une détermination sur l'usage qu'il conviendra d'en faire," *AN* F¹³ 1244. "M. Denis propose de construire l'Eléphant en mortier-beton," *AN* F¹³ 1244.

16. Bonnamy fils describes the "urodonte" as "le gros tapir de Sibérie ou de Botany Baie a deffence [tusked?]," *AN* F¹³ 1244.

17. Seymour, *Verrocchio*, figs. 98–102.

18. Pietro Toesca, *Il Trecento: Storia dell'arte Italiana*, vol. 2 (Turin, 1964), tav. VII, facing p. 304.

19. *Metamorphoses*, p. 92, fig. 11.

20. See *CQC65*, no. 44; and *CFBLB*, no. 17; the plaster model appears in Janneau, *Donation Zoubaloff*, p. 12. A fine Barbedienne cast is in Mount Vernon Place, Baltimore.

21. Emeric-David's best-known work was his prize-winning essay for the set question of an academy competition of 1800: *Recherches sur l'art statuaire, considéré chez les anciens et les modernes* (Paris, 1801, 1805).

22. Planche, "Sculpteurs modernes" (1851), p. 51.

23. Janneau, *Donation Zoubaloff*.

24. A cast of this work was commissioned by the Minister of the Interior on 8 October 1851 for 4,000 francs. Final payment for the bronze was made on 22 July 1852. The plaster model was shown at the Salon of 1850 as no. 3172, "*Jaguar et lièvre; groupe; plâtre,*" *Explication des ouvrages... 1850*, Sculpture, p. 257. The bronze proof was exhibited in the Salon of 1852 as no. 1295, "*Un jaguar dévorant un lièvre; bronze,*" *Explication des ouvrages... 1852*, Sculpture, p. 204. The bronze was exhibited a second time, in the Exposition Universelle of 1855, as no. 4245, "*Jaguar dévorant un lièvre*; bronze. M. de l'Empereur. (Salon de 1852)," *Explication des ouvrages... 1855*, Sculpture, p. 459. Exhibited in "Barye Sculpture & Drawings," American Federation of Arts, 1959–60. See *CQC55*, no. 78. For the plaster model, see Janneau, *Donation Zoubaloff*, pl. XVI.

25. "Avec quelle volupté feline la bête féroce étreinte dans ses pattes puissantes le pauvre lièvre de grâce! Son dos s'arque, ses babines se froncent, des frissons de plaisir courent sur son poil comme des ondulations de moire; ses muscles tressaillent, tout son être trahit l'orgasme de la cruauté qui va se satisfaire.... M. Barye ne traite pas les bêtes au point de vue purement zoologique ... il agrandit, il simplifie, il idéalise les animaux et leur donne du style; il a une façon fière, énergique et rude, qui en fait comme le Michel-Ange de la ménagerie." Cited in Hubert, "Barye et la critique," p. 227.

26. A bronze cast of the design was commissioned by the Minister of the Interior on 30 January 1849 for the sum of 10,000 francs; final payment was made to Barye on 1 June 1852. Exhibited in the Salon of 1850 as no. 3171, "*Un centaure et un Lapithe*; groupe, plâtre (M.I.)," *Explication des ouvrages... 1850*, Sculpture, p. 257. See *CQC55*, no. 19; and *CFBLB*, p. 1. This bronze was purchased of Barye in Paris in 1873 by William Walters, acting for William Corcoran, who had ordered a copy of "every work available" for his very rich collection of Barye.

27. Pope-Hennessey, *High Renaissance and Baroque Sculpture*, pl. 91.

186

28. Cited in Saunier, *Barye*, p. 34.

29. See Pivar, *Barye Bronzes*, facing p. 20.

30. A document in the Archives Nationales de France records the commission for ninety-seven large masks for the cornice of the Pont Neuf.

31. Perhaps in Paris, Hôtel Drouot, *Catalogue des oeuvres de feu Barye*, 1876, as no. 501, "Esquisses plâtre. Napoleon I^{er} en costume heroique."

32. See Duclaux, *Bouchardon*, pl. XXV.

33. Personifications of *Strength* and *Order*, for the Denon Pavilion façade, in the Cour du Carrousel, figs. 34–37, were commissioned on 18 December 1854 (*AN* F^{21} 1746) and installed by 13 January 1856 (*AN* F^{21} 1750). Personifications of *War* and *Peace*, for the Richelieu Pavilion façade, at the opposite side of the Cour du Carrousel, figs. 38–42, were commissioned a few weeks later, on 17 January 1855 (*AN* F^{21} 1747), but they also were installed by 13 January 1856 (*AN* F^{21} 1750). The contracts specified that Barye would receive 5,000 francs for each related pair of models at one-third scale and 15,000 francs for each pair of full-size stone groups.

34. Barbedienne's sale catalogue of 1893, *Catalogue des Oeuvres de A.-L. Barye*, offered bronze casts of the four personification groups in three sizes: "Grandeur originale, H. 1,00 m; La Réduction No. 1, H. 0,50 cm; La Réduction No. 2, H. 0,36 cm." For sketches, see Paris, *Cat.*, 1875, nos. 39–43; Paris, *Cat.*, 1889, nos. 580–83; Louvre, Barye *Cat.*, no. 87; *Catalogue des oeuvres de feu Barye*, 1876, nos. 502–5, acquired by Jacquemart. For models, see Paris, *Cat.*, 1875, nos. 573–76; Louvre, Barye *Cat.*, 1956, no. 88; *Catalogue des oeuvres de feu Barye*, 1876, nos. 483–86; Louvre, *Catalogue des sculptures*, 1922, nos. 913–16. The sketches have never been illustrated.

35. See Frances H. Dowley, "A Neo-Classic Hercules," *Art Quarterly* (Spring 1952), pp. 73–76.

36. This pavillion is termed the "Pavillion de l'Horloge," in reference to the clock tower designed by Lemercier in 1624 that faces the Old Court of the Louvre Palace. It is the façade directly opposite to that by Lefuel of the 1850s. A document in the Archives Nationales de France, F^{21} 1750, refers to Barye's pediment in yet another way, as the "fronton du Pavillion du Vieux Louvre côte de la place Napoléon" (a pavillion of the Old Louvre, facing the new Place Napoleon III).

37. The Plaster portrait bust is illustrated in Pivar, *Barye Bronzes*, p. 95. See Aulanier, *Histoire*, 4:19; and Louis Hautecoeur, *Histoire du Louvre, Le Château, Le Palais, Le Musée: des origines à nos jours, 1200–1928* (Paris, n.d.), p. 105.

38. See Napoleon III, Emperor of the French, *Napoleonic Ideas* (*Des Idées Napoléoniennes, July 1839*),

Brison D. Gooch, ed. (New York, Evanston, London, 1967). Gooch characterizes this essay as "second only to the declarations of Napoleon at St. Helena as basic ideology for the Legend," p. 7.

39. For the program of the dedications of the several pavilions of the New Louvre, see Aulanier, *Histoire*, 4: 22–23. The themes of the pediments on the Denon and Richelieu pavilions are published in Anne Pingeot, "Role de la sculpture dans l'architecture, à propos de l'Opéra de Paris," *Revue suisse d'art et archeologie* 38 (1981): 119.

40. "Le buste de Napoleon premier posé sur un cype entouré et couronné par les deux figures allégoriques de l'histoire et des beaux-arts, les extremités des Tympan sont occupées par les attributs de chacun de ces figures."

41. Ripa, *Iconologie*, 1:88.

42. See Benge, "Barye's Apotheosis Pediment," p. 624, fig. 19.

43. See Benge, "Drawings for Barye's Apotheosis Pediment," p. 166, fig. 6.

44. Peter Murray, *Architecture of the Renaissance* (New York, 1971), figs. 455, 456, and 461.

45. An observation made by Eitner in *Géricault*, p. 15.

46. See L'Union centrale des arts décoratifs, *Recueil des dessins d'orfèverie du premier empire par Percier et Biennais* (Paris, n.d.).

47. Ibid., pl. 47.

48. See Benge, "Apotheosis Pediment," p. 616, fig. 7.

49. Ibid., p. 617, fig. 9.

50. See Benge, "Drawings for Barye's Apotheosis Pediment," p. 168, fig. 11.

51. Terisio Pignatti, *Giorgione* (London, 1971), p. 108; and Harold E. Wethey, *The Paintings of Titian*, vol. 3 (London), 1970), pls. 57 and 58.

52. Duclaux, *Bouchardon*, pls. XXII, XXIII, and XXV.

53. Illustrated in Pivar, *Barye Bronzes*, p. 220.

54. See *Les Merveilles du Louvre*, 2: 72.

55. *River God* sketches: plaster casts after clay originals, left and right figures, signed BARYE; h. 21 cm; 1861 ff.; Louvre, RF 2006 and 2007; Barye Sales *Cat.*, 1876, nos. 506 and 507; purchased Jacquemart; Barbedienne Collection; gift of Jacques Zoubaloff, 1929. *River God* models: plaster originals for mechanical enlargement, left and right figures, signed BARYE; h. 60 cm; 1861 ff.; Barye Sales *Cat.*, 1876, nos. 488 and 489; formerly Barbedienne Collection; gift of Jacques Zoubaloff, 1912; Louvre, RF 1560 and 1561. Sketches: Barye *Cat.*, 1875, nos. 44 and 45; Barye Sales *Cat.*, 1876, nos. 44 and 45; Paris, *Cat.*, 1889, nos. 584 and 584 bis. Models: Barye Sales *Cat.*, 1876,

nos. 8 and 9; Paris, *Cat.*, 1889, nos. 578 and 579. Bibl: Louvre, *Cat.*, 1956, nos. 89 and 90, sketches and models, respectively.

56. See *Sur les Traces de Carpeaux*, nos. 246, 250, 251, 258, and 281.

57. See Dezarrois, "Un projet mysterieusement abandonné."

58. Illustrated in Pivar, *Barye Bronzes*, p. 51.

59. See Dezarrois, "Un projet mysterieusement abandonné"; Paris, Hôtel Drouot, *Cat. des oeuvres de feu Barye*, 1876, no. 481; and Louvre, *Cat.*, 1956, no. 91.

60. The plaster model of Barye's unusual, seemingly archaic *Winged Victory* is in the Louvre: RF 1593; h. 21 cm; Louvre, *Cat.*, 1956, no. 92.

61. See Charles Seymour, Jr., *The Sculpture of Verrocchio* (London, 1971), p. 183.

62. See *Ossian und die Kunst um 1800*, exhibition catalogue, Hamburger Kunsthalle (Munich, 1974), pp. 108–11; see also Rosenblum, *Transformations*, fig. 96.

63. See *Sur les traces de Carpeaux*, no. 372.

64. For plaster model of the relief tondo, *Emile Diaz*, see: Louvre, *Cat.*, 1956, no. 110; Vitry, *Salle Barye*, 1931, p. 65; Louvre, *Cat. des sculptures*, 1922, no. 924; Janneau, *Donation Zoubaloff*, p. 15. Bronze proof: see Pivar, *Barye Bronzes*, p. 243. For *Young Man in a Beret*, see Pivar, *Barye Bronzes*, p. 240.

65. See Pivar, *Barye Bronzes*, p. 106.

66. See Pivar, *Barye Bronzes*, pp. 137–40.

Chapter 4

1. *NYBMA89*, p. 17, no. 29; *CRB47*, no. 67; and *CQC55*, no. 61; see also Hamilton, "Origin."

2. *NYBMA*, p. 17, no. 28; *CRB47*, no. 48; and *CQC55*, no. 63.

3. Paris, Hôtel Drouot, *Cat. des oeuvres de feu Barye*, 1876, no. 548, "*Tigre saisissant un paon*. Plâtre retouché à la cire"; and *CFBLB*, 14. For the bronze proof see London, Sladmore Gallery *Cat.*, p. 41.

4. *Metamorphoses*, pp. 84–87 and figs. 4, 4a, 5, and 6.

5. Ibid., fig. 6.

6. London, Sladmore Gallery *Cat.*, p. 41.

7. *NYBMA89*, p. 18, no. 47; Louvre, *Cat.*, 1956, no. 34; and *CRB47*, no. 94.

8. *NYBMA89*, no. 27; *CRB47*, no. 11; and *CQC55*, no. 70.

9. *NYBMA89*, p. 20, no. 68; *CRB47*, no. 10; *CQC55*, no. 118.

10. See Pivar, *Barye Bronzes*, pp. 168 and 174.

11. *NYBMA89*, p. 19, no. 63; *CRB47*, no. 57; and *CQC55*, no. 124.

12. *CQC65*, no. 193.

13. Exhibited in "Barye Sculpture and Drawings," American Federation of Arts, 1959–60. See *CRB47*, no. 31; and *CQC65*, nos. 149 and 153.

14. *NYBMA89*, p. 23, no. 114.

15. *NYBMA89*, p. 18, no. 42; and *CQC55*, no. 151.

16. *NYBMA89*, p. 21; and *CRB47*, no. 61.

17. *NYBMA89*, p. 18, no. 44; and *CRB47*, no. 45.

18. *NYBMA89*, p. 18, no. 45; Louvre, *Cat.*, 1956, no. 32; London, Sladmore Gallery *Cat.*, no. 36; and *CRB47*, no. 49.

19. *NYBMA89*, p. 19, no. 50; Louvre, *Cat.*, 1956, no. 35; and *CRB47*, no. 28.

20. Perhaps exhibited in the Salon of 1833 as no. 3241. See *NYBMA89*, p. 16 no. 21; *CQC55*, nos. 92 and 93; and *CQC65*, no. 212.

21. *NYBMA89*, p. 16, no. 22; and *CQC65*, nos. 91 and 211.

22. See *CRB47*, no. 32.

23. Paris, Hôtel Drouot, *Cat. des oeuvres de feu Barye*, p. 39, no. 559.

24. Exhibited in "Barye Sculpture and Drawings," American Federation of Arts, 1959–60. See *NYBMA89*, p. 19, no. 62; and *CQC65*, no. 191.

25. *French Master Goldsmiths*, pp. 116–17.

26. *NYBMA89*, p. 18, no. 46; and *CQC55*, nos. 51 and 52.

27. *NYBMA89*, p. 20, no. 78; and *CRB47*, nos. 39 and 40.

28. Baltimore Museum of Art, *Cat.*, 1965, p. 71, no. 353; and *CQC65*, no. 204.

29. *NYBMA89*, p. 20, no. 76; and *CQC65*, no. 228.

30. See *CRB47*, no. 20; and *CQC55*, no. 114.

31. See *CQC65*, no. 185.

32. Louvre, *Cat.*, 1956, no. 117; *CQC65*, no. 184; Corcoran, *Illustrated Handbook*, p. 118, no. 760; Vitry, "Une nouvelle donation," p. 17; Louvre, *Cat. des sculptures*, 1922, no. 931; Janneau, *Donation Zoubaloff*, p. 16.

33. *NYBMA89*, p. 22, no. 105; and *CRB47*, no. 22 and 23.

34. *NYBMA89*, p. 22, no. 102; *CRB47*, no. 52; and *CQC55*, nos. 101 and 102.

35. Exhibited in the Salon of 1833 as no. 5236; *Explication des ouvrages . . . 1833. Supplément, sculpture*, p. 251. See Louvre, *Cat. des sculptures*, 1922, p. 8, no. 925; Louvre, *Cat.*, 1956, p. 44, no. 112.

36. Sir Kenneth Clark and Carlo Pedretti, *Drawings of Leonarda da Vinci at Windsor Castle*, 2d ed., vol. 2 (London, 1969), 12358 recto (Sforza), 12354–55 (Trivulzio).

37. Exhibited at Smith College, 1946; Dayton Art Institute, "Flight: Fantasy, Faith, Fact," *Cat.*, 1953–54, no. 114. See *Romantics to Rodin*, p. 136; *NYBMA89*, p. 15, no. 5; *CRB47*, no. 78; and R. B. K. McLanathan, "Ariosto and Tasso," *Art News* (1946), p. 36.

38. Elizabeth Mongan, Philip Hofer, and Jean Seznec, *Fragonard Drawings for Ariosto* (New York, 1945).

39. *Ingres in Italia*, no. 78.

40. Trapp, *Delacroix*, p. 77.

41. Freedberg, *Painting of the High Renaissance*, vol. 2, fig. 482.

42. See *CRB47*, no. 75; and *CQC55*, no. 6.

43. Klaus Berger, *Géricault and His Work* (Lawrence, Kansas, 1955), p. 83.

44. Escholier, *Delacroix*, 1:137.

45. Ibid., p. 181.

46. Louvre, *Cat. des sculptures, supplément*, 1933, p. 56, no. 1643.

47. I am grateful to Dr. Dewey Mosby for this suggestion.

48. Gisela M. A. Richter, *A Handbook of Greek Art*, 2d ed. (London, 1960), fig. 216.

49. See *Bibliothèque historique de Diodore de Sicile*.

50. This English translation is in *Diodorus of Sicily in Twelve Volumes*, vol. 2, pt. 37, p. 191. For the complete story, see pts. 36 and 37. The Second Ptolemy is identified as Ptolemy Philadelphus, who ruled from 285 to 246 B.C. The French text is in Miot, *Bibliothèque historique*, Tome second, Livre troisième (1834), vol. 37, pp. 62–63.

51. Rudolf Wittkower, "Bernini's Equestrian Louis XIV: The Vicissitudes of a Dynastic Monument," in *Studies in the Italian Baroque* (London, 1975), fig. 129; see also fig. 139, Losenko's drawing of Falconet's *Peter the Great Equestrian*.

52. H. W. Janson, *History of Art*, 2d ed. (Englewood Cliffs, N.J., 1977), fig. 144.

53. Exhibited in "Barye Sculpture and Drawings," American Federation of Arts, 1959–60; Marion Koogler McNay Art Institute, *Cat.*, 1965, no. 29. See *NYBMA89*, p. 16, no. 18; and *CRB47*, no. 104.

54. Berger, *Géricault*, p. 30 and pl. 36.

55. Escholier, *Delacroix*, 2: facing p. 128 (pastel); 2:210 (pencil and watercolor); and 3: unpaginated (ink).

56. Stevenson, *Rubens*, pl. 144.

57. *NYBMA89*, p. 61, no. 60 or 61; *CRB47*, no. 54; *CQC55*, no. 21.

58. See de Caso, "The Origin of Barye's 'Ape Riding a Gnu.' "

59. I am grateful to the late Professor H. W. Janson for this observation.

60. *Explication des ouvrages . . . 1833. Supplément, sculpture*, p. 251.

61. Cushion, *Animals*, figs. 10 and 11.

62. Ibid., fig. 27a.

63. George Savage, *Eighteenth-Century German Porcelain* (New York, 1958), pl. 37c.

64. See *CRB47*, no. 62.

65. See *NYBMA89*, p. 15, no. 3; and Paris, Hôtel des ventes mobilières, *Cat.*, 1853, no. 3 or 4.

66. *NYBMA89*, no. 12; and *CQC55*, no. 8.

67. Trapp, *Delacroix*, p. 211.

68. *NYBMA89*, no. 12; and *CQC55*, no. 8.

69. Freedberg, *Painting of the High Renaissance*, vol. 2, p. 696.

70. Wittkower, *Bernini*, pl. 41.

71. *NYBMA89*, p. 22, no. 106; and *CQC55*, no. 9.

72. Exhibited in "Barye Sculpture and Drawings," American Federation of Arts, 1959–60. See *NYBMA89*, p. 22, no. 106; and *CQC55*, nos. 221 and 222.

73. Baltimore Museum of Art, Lucas Collection, *Cat.*, 1965, no. 398; *CRB47*, no. 74; and *CQC55*, no. 10.

74. Paris, Hôtel des ventes mobilières, *Cat.*, 1853, no. 2.

75. *Metamorphoses*, p. 84, fig. 3.

76. *NYBMA89*, p. 21, no. 87; *CRB47*, no. 102; and *CQC55*, no. 149.

77. See Benge, "A Barye Bronze"; and *Romantics to Rodin*, pp. 129–31, fig. 18.

78. Paris, Hôtel Drouot, *Cat. des oeuvres de feu Barye*, p. 39, no. 557; and Benge, "A Barye Bronze."

79. *NYBMA89*, no. 108; Louvre, *Cat.*, 1956, no. 26; and *CQC55*, no. 131.

80. Sir Herbert Read, *A Concise History of Modern Sculpture* (London, 1971), fig. 66.

81. Ibid., figs. 110, 111, 113, 114, 170, and 286.

82. Jack Burnham, *Beyond Modern Sculpture* (London, 1968), fig. 113.

83. Louvre, *Cat.*, 1956, no. 18, OA 5770; and *CRB47*, no. 59.

84. See Pivar, *Barye Bronzes*, p. 207.

85. Paris, Hôtel Drouot, *Cat. des oeuvres de feu Barye*, p. 39, no. 556; and Benge, "A Barye Bronze."

86. Paris, Hôtel des ventes mobilières, *Cat.*, 1853, no. 3 or 4; Philippe Verdier, "Delacroix's Grandes Machines: 2," *Connoisseur* 157 (1964), p. 9; the plaster model is illustrated in Janneau, *Donation Zoubaloff*, pl. XVIII.

87. Exhibited in the Salon of 1833 as no. 5235, *Cheval renversé par un lion*, cited in *Explication des ouvrages . . . 1833*, p. 251. See also Baltimore Museum of Art, *Cat.*, 1965, no. 366; *NYBMA89*, p. 22, no. 101; and *CRB47*, no. 100.

88. Weihrauch, *Europäische Bronze-statuetten*, figs. 264 and 507.

89. Ibid., fig. 38.

90. Savage, *German Porcelain*, pl. 59a; and Cushion, *Animals*, figs. 15 and 23a.

91. Stevenson, *Rubens*, pl. 74.

92. Ibid., pl. 88.

93. Kalnein and Levey, *Art and Architecture*, pls. 38 and 39.

94. Trapp, *Delacroix*, p. 180.

95. *NYBMA89*, p. 16, no. 10; *CQC55*, nos. 20 and 193; and *CQC65*, no. 18.

96. Pope-Hennessey, *High Renaissance and Baroque Sculpture*, pl. 91.

97. *NYBMA89*, no. 9; "David to Courbet," Detroit Institute of Arts, *Cat.*, 1950, no. 125; and Benge, "Barye's Use of some Géricault Drawings," pp. 13–27. See also *CRB47*, no. 77.

98. Weihrauch, *Europäische Bronze-statuetten*, figs. 136, 149, and 299.

99. Pope-Hennessey, *High Renaissance and Baroque Sculpture*, pls. 64 and 113.

100. *Johann-Heinrich Füssli*, p. 133, fig. 54.

101. *Lion Crushing a Serpent*, terra cotta, h. 8⅝, l. 12⅜ inches; 22 by 31.5 cm; formerly collections of Pierre Bertrand, Paris, and André Theuriet; Walters Art Gallery 27.548. See *Walters Art Gallery Bulletin* 8, no. 5 (1956).

102. See the illustration of a Collas machine in *Metamorphoses*, p. 47, fig. 30.

103. See Pivar, *Barye Bronzes*, facing p. 20.

104. *Metamorphoses*, p. 103, fig. 28.

105. *NYBMA89*, p. 18, no. 39; *Walters Art Gallery Bulletin* 8, no. 5 (February 1956); *Metamorphoses*, p. 94, no. 14; *CQC55*, no. 46; *CQC65*, no. 43; and *CFBLB*, p. 9, no. 3.

106. *Metamorphoses*, p. 93 and figs. 15 and 16.

107. Ibid., p. 95, fig. 16.

108. Ibid., p. 96, fig. 17.

109. Ibid., p. 92, fig. 10.

110. *NYBMA89*, no. 36; *Walters Art Gallery Bulle-tin* 8, no. 5 (February 1956); and *Metamorphoses*, no. 18. See also *CRB47*, no. 66; *CRSA*, no. 66; *CQC55*, no. 44; *CQC65*, no. 41; and *CFBLB*, p. 9, no. 2.

111. *Metamorphoses*, no. 21, pp. 100–1 and figs. 21 and 21a; see also *CQC55*, no. 45, and *CQC65*, no. 42.

112. *Metamorphoses*, p. 98, figs. 22 and 22a.

113. Exhibited in San Antonio, Texas, at Marion Koogler McNay Art Institute, 1965. See Baltimore Museum of Art, Epstein Collection, *Cat.*, 1939, p. 29; *Metamorphoses*, p. 101 and fig. 24; and *CRF55*, no. 36.

114. *Metamorphoses*, p. 102 and fig. 25.

115. See *CQC65*, no. 215.

116. Paris, Hôtel des ventes mobilières, *Cat.*, 1853, no. 2, purchased by M. Bejot.

117. Exhibited in the Salon of 1834 as no. 1970, "*Ours dans son auge, en bronze. (Appartiennent à S. A. R. le duc d'Orléans)*," in *Explication des ouvrages . . . 1834*, p. 181. See also *NYBMA89*, p. 19, no. 55.

118. See *CFBLB*, no. 13.

119. *NYBMA89*, p. 17, no. 33; and *CRB47*, no. 99.

120. Janson, *Donatello*, pls. 18a and 18b.

121. See *CQC55*, no. 42.

122. *NYBMA89*, p. 18, no. 40; *CRB47*, no. 44; and *Walters Art Gallery Bulletin* 9, no. 6 (March 1957).

123. *NYBMA89*, p. 19, no. 54; and *CRB47*, no. 63.

124. See *CQC65*, no. 189; and *Corcoran Gallery Handbook*, p. 119, no. 769.

125. Perhaps exhibited in the Salon of 1831 as no. 2887, and in the Salon of 1833 as nos. 5238 and 5239. See *NYBMA89*, p. 19, no. 57; and *Explication des ouvrages . . . 1833*, p. 251.

126. See DeKay, *Barye*, p. 42.

127. Exhibited in the Salon of 1833 as no. 5240, and in "Barye Sculpture and Drawings," American Federation of Arts, 1959–60. See also *NYBMA89*, p. 19, no. 56; *Explication des ouvrages . . . 1833*, p. 251; and *CRB47*, no. 55.

128. *Explication des ouvrages . . . 1833. Supplément, sculpture*, p. 251.

129. Exhibited in "4,000 Years of Modern Art," Walters Art Gallery, 1956–57, *Cat.*, no. 34. See also *CQC65*, no. 214.

130. *NYBMA89*, p. 15, no. 2; Paris, Hôtel des ventes mobilières, *Cat.*, 1853, no. 1; and Paris, San Donato, *Sale Cat.*, Paris, 1870, no. 1535.

131. *NYBMA89*, p. 19, no. 53; and *CQC65*, no. 187.

132. Paris, Hôtel des ventes mobilières, *Cat.*, 1853, no. 1; and Hamilton, "Origin."

133. See Pivar, *Barye Bronzes*, p. 65.

134. See Hamilton, "Origin," p. 254, fig. 8, and n. 20.

135. Both drawing and watercolor are illustrated in ibid., figs. 6 and 7.

136. *NYBMA89*, p. 15, no. 1; Paris, Hôtel des ventes mobilières, *Cat.*, 1853, no. 1; and Paris, San Donato *Sale Cat.*, 1870, no. 1534.

137. Wittkower, *Bernini*, pls. 13 and 14.

138. Exhibited in the Salon of 1833 as no. 5234. See also *Explication des ouvrages . . . 1833. Supplément, sculpture*, p. 251.

139. Stevenson, *Rubens*, pl. 84.

140. See *CRB47*, no. 70; and *CQC55*, no. 110.

141. Louvre, *Cat.*, 1956, no. 19; Louvre, *Cat. des sculptures*, 1922, p. 10, no. 942; and *CRB47*, no. 65.

142. *Metamorphoses*, p. 35 and figs. 11a and 11b.

143. See *CQC55*, no. 64; and *CQC65*, no. 62.

144. Exhibited in the Salon of 1834 as no. 1975, "*Etude d'un cerf et d'un lynx; groupe en plâtre.*" See *Explication des ouvrages . . . 1834*, p. 182; and *CRB47*, no. 58.

145. See Benge, "Géricault Drawings."

146. See *L'Art vivant* 8 (December 1932): 592.

147. Exhibited in the Salon of 1833 as no. 5242.

148. *NYBMA89*, p. 21, no. 89; *CRB47*, no. 56; and *CQC55*, no. 148.

149. See *CRB47*, no. 101; and *CQC55*, no. 147.

150. Exhibited in "Barye Sculpture and Drawings," American Federation of Arts, 1959–60. See *NYBMA89*, p. 21, no. 88; *CRB47*, no. 103; and *CQC55*, no. 150.

151. Barye Sales *Cat.*, 1876, no. 618, acquired by Jacquemart; gift of Zoubaloff, 1914; Louvre, *Cat.*, no. 22.

152. Duclaux, *Bouchardon*, nos. 44–54.

153. Ibid., pl. XIV.

154. Seymour, *Verrocchio*, pp. 98–102, 183.

155. *NYBMA89*, p. 16, no. 14; and *CQC55*, no. 4.

156. See note 154.

157. Charles D. Cuttler, *Northern Painting* (New York, 1968), fig. 143.

158. *Les Merveilles du Louvre*, 2:72.

159. *Horses of San Marco*, p. 33, fig. 49.

160. *Romantics to Rodin*, p. 246.

161. Cuttler, *Northern Painting*, fig. 453.

162. *NYBMA89*, p. 16, no. 16; *CRB47*, no. 71; and *CQC65*, no. 180.

163. *Les Merveilles du Louvre*, 1:338.

164. Exhibited in "Barye Sculpture and Drawings," American Federation of Arts, 1959–60. See *NYBMA89*, p. 16, no. 17; and San Antonio, Texas, Marion Koogler McNay Art Institute, *Cat.*, no. 18. *CRB47*, no. 73.

165. *Les Merveilles du Louvre*, 2:72.

166. *NYBMA89*, p. 15, no. 6; and *CRB47*, no. 105.

167. *NYBMA89*, p. 21, no. 91; and *CQC55*, no. 15.

168. Freedberg, *High Renaissance Painting*, vol. 2, fig. 402.

169. *NYBMA89*, p. 21, no. 90; San Antonio, Texas, Marion Koogler McNay Art Institute, *Cat.*, no. 22; and *CQC55*, no. 16.

170. Pope-Hennessey, *High Renaissance and Baroque Sculpture*, pl. 64.

171. See *CQC55*, no. 17.

172. Vitzthum, *Lo Studiolo*, p. 63.

173. Pope-Hennessey, *High Renaissance and Baroque Sculpture*, fig. 130. The same bronze is called *Astronomy*, a name more accurately reflective of its attributes, in Charles Avery, *Florentine Renaissance Sculpture* (New York, 1970), fig. 183.

174. H. Thirion, *Les Adam et Clodion* (Paris, 1885), p. 209.

Chapter 5

1. The letter of contract is published in Pivar, *Barye Bronzes*, between pp. 20 and 21, the liquidation agreement on pp. 274–76.

2. I wish to thank the Walters Art Gallery for allowing me access to this invaluable manuscript.

3. Zieseniss, in *Les Aquarelles*, speaks of Emile Martin as "le créancier . . . qui installe un magasin de vente, 12, rue Chaptal," and as the man to whom Barye had given over "la vente de ses modèles," pp. 23, 13.

4. Luc-Benoist, *La Sculpture romantique* pp. 31, 32.

5. Ibid., p. 32.

6. Thieme-Becker, *Künstlerlexikon*, 2: 467. A. de Champeaux, *Dictionnaire*, 1: 59–66, gives an extensive list of the works produced by Ferdinand Barbedienne, director of the great Parisian bronze-casting house. The bronzes range from reproductions of numerous masterpieces of antiquity, the Renaissance, the seventeenth through nineteenth centuries, to Barye, and it even includes useful decorative objects, such as candlesticks. Apart from the several early catalogues of Barbedienne's entire output, two late ones are dedicated to Barye's works: one is undated, *F. Barbedienne*

editeur, Oeuvres de A. L. Barye, Paris (copy in the Metropolitan Museum of Art Library); the second, *Oeuvres de A. L. Barye, Bronzes d'Art, F. Barbedienne,* 30 boulevard Poissonnière, Paris (1893), is reproduced in Pivar, *Barye Bronzes,* pp. 277–81.

7. A ledger-page facsimile is reproduced in Benge, *Sculpture,* fig. 507. Orthography in the account book is as flexible as the haste of the writer would dictate, and Emile Martin's entries are herein recorded without alteration.

8. The lower prices of 1850 may simply reflect a general drop in the valuation of Barye's work. Yet such an explanation does not convincingly account for the wide variation in the price decreases assigned to particular designs. Varying degrees of production difficulty remain the most plausible basis for the differing costs.

9. See Note 6.

10. One Bresson exhibits 99 bronzes in a public sale on 5–7 December 1836, cited in Lugt, *Répertoire,* vol. 1, entry 14513.

11. Charles Eck and Pierre Amedée Durand (1789–1873), a sculptor and a medallist, were business partners in mid-nineteenth-century Paris. Durand is cited in Thieme-Becker, 10: 198–99.

12. Possibly an heir or descendant of Barye's teacher and employer of the 1820s, Jacques-Henri Fauconnier (1776–1839), cited in Thieme-Becker, 10: 295.

13. Possibly Raymond Gayrard (1777–1858), who published *Médailler général de la monarchie française, ou Collection complète des portraits des rois de France* (Paris, 1822); cited in Thieme-Becker, 13: 306, and Lami, *Dictionnaire,* 3: 28–39. Or the citation may refer to his son, Joseph-Raymond-Paul Gayrard (1807–55); cited in Lami, *Dictionnaire,* 3: 39–41, and Thieme-Becker, 13: 305–6.

14. Probably Eugène Gervais, who exhibited from 1846 to 1880 in the Paris Salons, showing graphics, watercolors, gouaches, engravings, and etchings; cited in Thieme-Becker, 13: 490.

15. Probably the manufacturing jeweler Louis-Auguste-Edmond Lévêque (1814–75); cited in Lami, *Dictionnaire,* 3: 344–47, and Thieme-Becker, 23: 154.

16. Paul Liènard (d. 1900), a sculptor who exhibited in the Salons of 1864, 1866, and 1890; cited in Lami, 3: 351–52, and Thieme-Becker, 23: 209.

17. Possibly the founder identified by the mark VP under a crown, which appears on several bronze models for *surmoulage* editions (*see Figs. 109 and 110*).

18. See Barye's portrait medallion of Richard (*Fig. 11*). Felix Richard (d. 1888) exhibited in the Salons of 1872, 1880, and 1881; cited in Lami, 4: 142–43.

19. Charles-Elie (or Eloy) Bailly (1830–95); cited in Lami, 1: 38–40, and Thieme-Becker, 2: 372.

20. Several possibilities exist. Jean-Baptiste Barré (1803–77); cited in Lami, 1: 44–45. Jean-Jacques Barré, *ciseleur,* named "graveur général des monnaies" in 1842. A son of Jean-Jacques, Jean-Auguste Barré (1811–96), succeeded to the post of his father in 1855; cited in Lami, 1: 45–46, and Thieme-Becker, 2: 528.

21. Several possibilities exist. Antoine-Louis Bernard (b. 1821), a student of Dürer and Klagmann, exhibited a bronze entitled *Napolitain jouant avec une écrevisse* in the Salon of 1848 and exhibited in the Salons of 1859 and 1865; cited in Lami, 1: 105–7; Thieme-Becker 3: 429; and de Champeaux, *Dictionnaire,* 1: 107. Victor Bernard (1817–92?); cited in Thieme-Becker, 3: 433–34.

22. A sale of 190 "modèles en bronze" some twenty-five years later, in November 1879, held at the Maison Boulonnois in Paris; cited in Lugt, *Répertoire,* vol. 3, entry 39625.

23. Possibly Jean-Baptiste Boyer (b. 1783); cited in Lami, 1: 183, and Thieme-Becker, 4: 491.

24. Possibly Charles Chauvin (1820–89), a landscape and decorative painter; cited in Thieme-Becker, 6: 442.

25. Several possibilities exist. Auguste-Alfred Claude, a sculptor who exhibited a bronze medallion of "Portrait de M. F. B." in the Salon of 1876; cited in de Champeaux, 1: 301. Victor Claude (1811–53), a painter cited in Lugt, *Répertoire,* vol. 1, entry 21314, and Thieme-Becker, 7: 59.

26. Possibly Laurent-Didier Detouche (1815–82), a painter of religious pictures, history, genre, and portraits; cited in Thieme-Becker, 9: 164.

27. Probably Paul-Chretien-Romain-Constant Duménil (b. 1779), a painter, draftsman, and illustrator of natural-history texts; cited in Thieme-Becker, 10: 117.

28. Several possibilities exist. Eugène Faure (1822–79), a painter who first studied sculpture with David d'Angers and François Rude; Louis Faure (1785–79), a painter and lithographer; Mme Octavie Faure (b. 1809 or 1810), a painter; Amedée (Victor A.) Faure (1801–78), a painter and lithographer; André-Baptiste Faure (b. 1806), a painter; all cited in Thieme-Becker, 11: 300. Lugt, *Répertoire,* vol. 2, cites exhibitions of Faure in entries 11602, 18129, 18227, 18247, and 18288.

29. Possibly Charles Gauthier (1831–91); cited in Lami, 3: 21–25, and Thieme-Becker, 13: 284–85.

30. Possibly Jacques-Louis Gautier (b. 1831); cited in Lami, 3: 25–27, and Thieme-Becker, 13: 286.

31. Several possibilities exist: Adolphe Leroy (1810–88), a landscape and portrait painter; Alphonse Leroy (1821–87), a copper engraver and illustrator; Augustine Leroy (1834–59), who exhibited watercolors and miniatures; Etienne Leroy (1828–87), a genre and portrait painter; all cited in Thieme-Becker, 23: 116.

32. Possibly Louis-François Picard (1820–66), a genre painter; cited in Thieme-Becker, 26: 575.

33. Several possibilities exist: Jean-Marie Rochet, a *ciseleur*, or his son, Louis Rochet (1813–78), or a Charles Rochet (1819–1900); all cited in Lami, 4: 157–61.

34. Probably Alfred Barye, who exhibited from 1864 to 1882; cited in Lami, 1: 85.

35. See Ballu, *Barye*, pp. 161–83.

36. See document in Pivar, *Barye Bronzes*, p. 274.

37. Ibid., between pp. 20 and 21.

38. Ibid., p. 274.

39. This should appear in the center of page 178, above "Figures," as in Pivar, p. 263: "*Catalogue des Bronzes de A. L. Barye, Statuaire*, quai des Célestins, 4, a Paris, Exposition Universelle de 1865, La Grande Médaille d'Honneur."

40. See "Nouveaux modèles," nos. 184–230.

41. Ballu, *Barye*, p. 163, "NOTA.—1. Chaque bronze porte, d'une façon apparente, le numéro de l'épreuve et le poinçon de l'auteur."

42. "1. Une tortue; 2. La même avec plinthe; 3. Un lapin, les oreilles couchées," etc.

CHAPTER 6

1. *Metamorphoses*, p. 92, fig. 10

2. I wish to thank Mrs. Jeanne L. Wasserman, honorary curator of sculpture, Mr. Arthur Beale, director of the Center for Conservation and Technical Studies, and Dr. Seymour Slive, director of the Fogg Art Museum for their kind invitation to participate in technical investigations and to contribute to the catalogue of the exhibition. I also wish to thank René Gaborit, conservateur en chef, and Victor Beyer, former conservateur en chef, Departement des sculptures, Musée du Louvre, for their generous permission to study Barye's works in reserve, and to study and exhibit at the Fogg Art Museum for the first time the unique plaster model of Barye's *Lion's Head* (*Fig. 112*); see *Metamorphoses*, p. 102, fig. 25. I am grateful to Dr. Dewey Mosby, former curator of European art, Detroit Institute of Arts, for his kind invitation to study the newly acquired autograph bronze and terra cottas, in 1977, work culminating in the essay, "A Barye Bronze and Three Related Terra Cottas."

3. The letter of contract for Barye's late commission for the monumental bronze relief *Napoleon III, as an Equestrian Roman Emperor* (*Figs. 43* and 44), in AN F^{21} 1749, dated 30 December 1861, speci-

fies a clay sketch, a piece mold after the clay model, and a plaster proof: "l'ésquisse en terre, le moulage, une épreuve en plâtre anglais." The scale of this monumental relief is described as one and one-half times life size: "grandeur nature et demie."

4. Lami, "Barye," p. 74.

5. Janneau, *Donation Zoubaloff*.

6. See Note 3.

7. See Arthur Beale's well-documented essay. "A Technical View of Nineteenth-Century Sculpture," in *Metamorphoses*, pp. 28–55, especially pp. 46–48 and the illustrations of the enlarging process.

8. Ballu, *Barye*, p. 135, indicates a height of three meters.

9. See Benge, "Antoine-Louis Barye, 1796–1875," in *Metamorphoses*, especially pp. 85–87, figs. 4, 4a, 5, and 6.

10. Beale, "A Technical View," p. 53.

11. Possibly the mark of one "Pressange, fondeur," cited in Emile Martin's journal.

12. See the "exploded" view in *Metamorphoses*, p. 97, fig. 21a.

13. *Metamorphoses*, p. 94, figs. 14, 14a, 14b.

14. Termed "Variation No. 2," in *Metamorphoses*, pp. 93–98, figs. 15–17, and 17a.

Bibliography

MANUSCRIPTS

Baltimore, Walters Art Gallery: Emile Martin. *Journal Contenant les opérations de Barye*, 31 Juillet 1850 à 30 Juin 1858.

Paris, Archives Nationales de France, Documents: F^{13} 768, 1243, 1244; F^{17} 3578, 22731; F^{21} 14, 63, 194, 586, 1449, 1746, 1747, 1749, and 1750. (Cited by Lami but not available: F^{21} 5^e serie, 14; F^{21} 6^e serie, 63; F^{21} 577; O^4 1607; O^4 2304; and O^4 2353.)

BOOKS

Alexandre, Arsène. *Antoine-Louis Barye*. Paris, 1889.

The Antiquities of Athens and Other Monuments of Greece as Measured and Delineated by James Stuart... and Nicholas Revett, Painters and Architects, 3d. ed. London, 1858.

Aulanier, Christiane. *Histoire du Palais et du Musée du Louvre: Le Nouveau Louvre de Napoléon III*. Paris, 1946.

Babelon, Jean. *Choix de bronzes de la collection Caylus, donnée au Roi en 1762*. Paris and Brussels, 1928.

Ballu, Roger. *L'Oeuvre de Barye*. Paris, 1890.

Bartoli, Pietro Santi. *Admiranda romanorum antiquitatum ac veteris sculpturae vestigia anaglyphico opere elaborata ex marmoreis exemplaribus quae romae adhuc extant in Capitolio aedibus hortisque virorum principum ad antiquam elegantiam a Petro Sancti Bartolo*. Rome, 1693.

————. *Le antiche Lucerne sepolchrali figurate*. Rome, 1729.

————. *Gli antichi sepolchri ovvero mausolei Romani ed Etruschi*. Rome, 1768.

Benge, Glenn F. "The Sculpture of Antoine-

Louis Barye in the American Collections, with a Catalogue Raisonné." 2 vols. Ph.D. dissertation, University of Iowa, Iowa City. 1969.

Berger, Klaus. *Géricault Drawings and Watercolors*. New York, 1946.

Bernardin de Saint-Pierre, Jacques Henri. *Oeuvres Complètes*. Paris, 1834.

Bibliothèque de l'Union Centrale des Arts Décoratifs. *Recueil de Dessins d'Orfèvrerie du premier empire par Biennais orfèvre de Napoléon I^{er} et de la couronne*. Paris, n.d.

Bibliothèque historique de Diodore de Sicile, traduite du Grec par A. F. Miot, ancien conseiller d'état, Membre de l'institut. 7 vols. Paris, 1834–38.

Blanc, Charles. *Les Artistes de mon temps*. Paris, 1876.

Blunt, Sir Anthony. *Art and Architecture in France, 1500–1700*, 2d ed. Baltimore, 1970.

[Carpeaux]. *Sur les traces de Jean-Baptiste Carpeaux. Exposition au Grand Palais, Paris*, March 11–May 5, 1975. Paris, 1975.

Caylus, Anne Claude Phillipe, Comte de. *Recueil d'antiquités égyptiennes, étrusques, grecques, romains, et gauloises*, 7 vols. Paris, 1752–67, 1773.

—————. *Recueil de trois cents têtes et sujets de composition gravés par M. le comte de Caylus d'après les pierres gravèes antiques au Cabinet du Roi*. Paris, 1775.

de Champeaux, A. "Barye," *Dictionnaire des fondeurs, ciseleurs, modeleurs en bronze, et doreurs, depuis le moyen-âge jusqu'à l'époque actuelle*, vol. 1. Paris and London, 1886. Pp. 59–66.

Claretie, Jules. *L'Art et les artistes français*. Paris, n.d.

—————. *Peintres et sculpteurs contemporains, 1^{er} serie, 6^e livraison*. Paris, 1882.

Clement, Charles. *Artistes anciens et modernes*. Paris, 1876.

Corcoran Gallery of Art. *Illustrated Handbook of Paintings, Sculpture, and Other Art Objects (Exclusive of the W. A. Clark Collection)*. Washington, D.C., 1939.

Cushion, John P. *Animals in Pottery and Porcelain*. New York, 1966.

Cuvier, Georges, Baron de. *Discours sur le revolutions de la surface du globe, et sur les changements qu'elles ont produit dans le règne animal*. Paris, 1826.

—————. *Recherches sur les ossements fossiles de quadrupèdes*. Paris, 1825.

—————. *Le règne animal distribue d'après son organization pour servir de base à l'histoire naturelle des animaux et d'introduction à l'anatomie comparée*, 3 vols. Paris, 1836–49.

DeKay, Charles, *Barye: Life and Works*. New York, 1889.

Delaborde, Henri. *Discours prononcé aux funerailles de Barye, 28 Juin 1875*. Paris, 1875.

—————, and J. J. Guillaume. *Discours prononcés à l'inauguration du monument élevé à la memoire de Barye, à Paris, sur le terreplein du pont de Sully, le lundi 18 Juin, 1894*. Paris, 1894.

Delacroix, Eugene. *Journal*. Translated by Walter Pach. New York, 1961.

Delécluze, E. J. *Exposition des artistes vivantes 1850*. Paris, 1851.

Delteil, Loys. *Barye. Le Peintre-graveur illustré*, vol. 6. Paris, 1910.

Diodorus of Sicily in Twelve Volumes. Translated by C. H. Oldfather. Cambridge, Mass. and London, 1967.

Duclaux, Lise. *La Statue équestre de Louis XV. Dessins de Bouchardon, sculpteur du Roi*. Cabinet des Dessins, Musée du Louvre. 13 January—30 April 1973. Paris, 1973.

Eitner, Lorenz. *Géricault. An Album of Drawings in the Art Institute of Chicago*. Chicago. 1960.

Emeric-David, Toussaint Bernard. *Discours sur la vie et les ouvrages de Pierre Puget, couronnée par l'Académie de Marseilles, le 12 Avril 1807*.

—————. *Essai sur le classement chronologique des sculpteurs grecs les plus célèbres, ou Fragment d'un discours sur la sculpture ancienne*. Paris, 1807; 2d ed., 1831.

—————. *Examen des inculpations dirigées contre Phidias, fragment d'un memoire sur le classement chronologique des sculpteurs*

grecs, lu dans la séance publique de l'Académie des inscriptions et belles-lettres de l'Institut royal de France, le 25 juillet 1817. Paris, 1817.

———. *Quelques remarques sur un ouvrage de M. le comte Cicognara intitulé: "Storia della scultura . . ." ou Essai sur la sculpture française.* Paris, 1819.

———. *Sur les progrès de la sculpture française depuis le commencement du règne de Louis XVI jusqu'aujourd'hui.* Paris, n.d.

Escholier, Raymond. *Delacroix, peintre, graveur, écrivain,* 3 vols. Paris, 1926–29.

Flaxman, John. *Lectures on Sculpture as Delivered Before the President and Members of the Royal Academy, by John Flaxman, Esq., R.A.,* 2d ed. London, 1838.

———. *Compositions from the Works, Days, and Theogony of Hesiod. Designed by John Flaxman, R. A. P. S. Engraved by William Blake.* London, 1817.

———. *The Iliad of Homer. Engraved from the Compositions of John Flaxman, R. A. Sculptor.* London, 1805.

———. *The Odyssey of Homer. Engraved from the Compositions of John Flaxman, R. A. Sculptor.* London, 1805.

Freedberg, S. J. *Painting of the High Renaissance in Rome and Florence,* 2 vols. Cambridge, Mass., 1961.

French Master Goldsmiths and Silversmiths from the Seventeenth to the Nineteenth Century. Preface by Jacques Helft and essays by Jean Babelon, Yves Bottineau, and Olivier Lefuel. New York, 1966.

Johann Heinrich Füssli. Hamburger Kunsthalle, 4 December 1974—19 January 1975. Essays by Werner Hoffmann, Gert Schiff, and Georg Syamken. Hamburg, 1974.

Gautier, Théophile. *Les Beaux-Arts en Europe.* Paris, 1844, 1856.

Gigoux, J. *Causeries sur les artistes de mon temps.* Paris, 1885.

Gonse, Louis. *Les chefs-d'oeuvre des Musées de France. Sculpture et objets d'art.* Paris, 1904.

Gronkowski, C. *Palais des Beaux-Arts de la ville de Paris. Catalogue sommaire des collections municipales.* Paris, 1927.

d'Hancarville, Pierre-François Hugues. *Antiquités étrusques, grecques, romains, tirées du Cabinet de M. Hamilton envoyé extraordinaire de S.M. Britanique en Cours de Naples,* 4 vols. Naples, 1766–67.

———. *Antiquites étrusques, grecques et romaines, gravées par F. A. David, avec leurs explications par d'Hancarville . . . ,* 5 vols. Paris, 1785–88.

Hawley, Henry. *Neo-classicism, Style and Motif.* Cleveland, Ohio, 1964.

The Horses of San Marco, exhibition catalogue. Translated by John and Valerie Wilton-Ely. New York: Metropolitan Museum of Art, 1979.

Horswell, Jane. *Bronze Sculpture of 'Les Animaliers.'* London, 1971.

Ingres in Italia (1806–1824, 1835–1841), Mostra all'Accademia di Francia, Villa Medici, 26 February—28 April 1968. Rome, 1968.

Janneau, Guillaume. *La Donation Jacques Zoubaloff aux Musées de France.* Paris, n.d.

Janson, H. W. *The Sculpture of Donatello,* 2d ed. Princeton, New Jersey, 1963.

Joubin, A. *Correspondance générale d'Eugène Delacroix,* 3 vols. Paris, 1936–38.

Jouin, Henri. *David d'Angers, sa vie, son oeuvre, ses écrits et ses contemporains,* 2 vols. Paris, n.d.

Kalnein, Wend Graf, and Michael Levey. *Art and Architecture of the Eighteenth Century in France.* Baltimore, 1972.

Lami, Stanislas. "Barye," *Dictionnaire des sculpteurs de l'école française au dix-neuvieme siècle,* vol. 1. Paris, 1914.

Lengyel, Alfonz. *Life and Art of Antoine-Louis Barye.* Dubuque, Iowa, n.d.

Lenormant, Charles. *Les Artistes contemporaines, Salons de 1831 et 1833.* Paris, 1833.

Luc-Benoist. *La Sculpture française.* Paris, 1945.

———. *La Sculpture romantique.* Paris, 1928.

Lugt, Frits. *Répertoire des catalogues de ventes publiques, intéressant d'art ou de la curiosité.* The Hague, 1938.

Les Merveilles du Louvre, 2 vols. Preface by Jean Charbonneaux. Paris, 1958.

Metamorphoses in Nineteenth-Century Sculp-

ture. Jeanne L. Wasserman, ed. Fogg Art Museum, Cambridge, Mass., 1975.

Musée du Louvre. Département des antiquités Grecques et Romaines. Catalogue sommaire des marbres antiques. Paris, 1896.

Paris, Bibliothèque Nationale. *Le Romantisme. Catalogue de l'exposition,* 22 January—10 March 1930. Paris, 1930.

Paris, Musée des arts décoratifs. *Guide illustré.* Paris, 1934.

Paris, Musée de sculpture comparée. *Catalogue général du musée de sculpture comparée au Palais du Trocadero (moulages) par Camille Eulart et Jules Roussel.* Paris, 1910.

Patte, P. *Monuments ériges en France à la gloire du Roi Louis XV.* Paris, 1765.

Philadelphia Museum of Art. *Catalogue of the W. P. Wilstach Collection.* Philadelphia, 1922.

Pivar, Stuart. *The Barye Bronzes: A Catalogue Raisonné.* London, 1974.

Quatremère de Quincy, Antoine Chrysostome. *Canova et ses oeuvres: ou Mémoires historiques sur la vie et les travaux de ce célèbre artiste.* Paris, 1836.

———. *Essai sur l'idéal.* In *Applications pratiques aux oeuvres de l'imitation propre des arts du dessin.* Paris, 1837.

Reinach, Salomon. *Répertoire des reliefs Grecs et Romaines.* Paris, 1909.

———. *Répertoire de la statuaire grecque et romaine.* Paris, 1909.

Ripa, Cesare. *Iconologie,* Paris, 1644; translated by Jean Baudouin. Garland Press, New York, 1976.

Roccheggiani, Lorenzo. *Raccolta di cento tavole rappresentanti i costumi religiosi civili e militari degli antichi egiziani etruschi, greci et romani, tratti dagli antichi monumenti per uso de professori delle belle arti, disegnate ed incise in rame da Lorenzo Rocchegiani.* Rome, 1804.

———. *Nuova raccolta di cento tavole* Rome, 1805–09.

———. *Raccolta di sessante tavole* Rome, 1806.

Romantics to Rodin: French Nineteenth-Century Sculpture from North American Collections. Peter Fusco and H. W. Janson, eds.

Los Angeles and New York, 1980. Exhibition at the Los Angeles County Museum of Art, 4 March—25 May 1980.

Saint-John, Bayle. *The Louvre.* London, 1855.

Saunier, Charles. *Barye.* Paris, 1925.

———. *Barye.* Translated by Wilfrid S. Jackson. New York, 1926.

Savage, George. *Eighteenth Century German Porcelain.* New York, 1958.

———. *Seventeenth and Eighteenth Century French Porcelain.* London, 1960.

Sculptures by Antoine-Louis Barye: A Picture Book. New York: Metropolitan Museum of Art, 1940.

Seymour, Charles Jr. *The Sculpture of Verrocchio.* London, 1971.

Silvestre, Théophile. *Histoire des artistes vivantes, français et etrangers, études d'après nature.* Paris, 1857; 2d ed., 1886.

de Staël, Mme. *De l'Allemagne.* London, 1810; rpt. Paris, 1871.

Stevenson, R. A. M. *Rubens.* New York, 1939.

Thomas, Gabriel-Jules. *Notice sur Antoine-Louis Barye, lué dans la séance de l'Académie des Beaux-Arts du 18 nov. 1876.* Paris, 1876.

Trapp, Frank Anderson. *The Attainment of Delacroix.* Baltimore and London, 1971.

Visconti, Ennio Quirino. *Elgin Marbles.* London, 1816.

———. *Illustrazioni de monumenti scelti borghesiani gia esistenti nella villa sul Pincio.* Rome, 1821.

———. *Illustrazioni de monumenti scelti borghesiani. Monumenti gabini della Villa Pinciana.* Rome, 1835.

———. *Monumenti scelti borghesiani illustrati.* Milan, 1837.

———. *Musée français. Recueil des plus beaux tableaux, statues, et bas-reliefs qui existaient au Louvre avant 1815* Paris, 1829–30.

———. *Musée Pie-Clémentin* Milan, 1818–22. (*Il Museo Pio-Clementino illustrato e descritto* Milan, 1818–22.)

Visconti, Filippo Aurelio, and Giuseppe Antonio Guattani. *Il Museo Chiaramonti, descritto e illustrato.* Milan, 1820.

———. *Monumens du Musée Chiarimonti, décrits et expliqués par Phillipe-Aurèle*

Visconti et Joseph Guattani, traduit de l'Italien par A. F. Sergent-Marceau (Preface de Jean Labus). Milan, 1822.

Vitzthum, Walter. *Lo Studiolo di Francesco I a Firenze.* Milan, 1969.

Wainwright, Nicholas B. ed. *Sculpture of a City: Philadelphia's Treasures in Bronze and Stone.* New York, 1974.

Walters, William T., ed. *Antoine-Louis Barye, from the French of Various Critics.* Baltimore, Md., 1885.

Weihrauch, Hans R. *Europäische Bronze-statuetten, 15–18. Jahrhundert.* Braunschweig, 1967.

Wittkower, Rudolf. *Architectural Principles in the Age of Humanism.* London, 1952.

———. *Art and Architecture in Italy, 1600–1750.* London, 1958.

———. *Gian Lorenzo Bernini: The Sculptor of the Roman Baroque.* London, 1966.

———. *Studies in the Italian Baroque,* London, 1975.

Zieseniss, Charles Otto. *Les Aquarelles de Barye.* Paris, 1954.

———. *Les Aquarelles de Barye. Etude critique et catalogue raisonné.* Paris, 1956.

ARTICLES

Amaya, Mario. "Animal Sculptors of Paris." *Apollo,* n.s. 76 (1962): 710.

Annales du Musée et de l'Ecole moderne des Beaux-Arts . . . Salon de 1831. Paris, n.d.

"Antoine-Louis Barye." *Archives de l'art français, recueil de documents inédits* 4 (1910): 180–81.

Avery, Charles. "From David d'Angers to Rodin—Britain's National Collection." *Connoisseur* 179 (April 1972): 234.

"Baltimore: Animal Bronzes by Barye." *Art News,* 14 August 1937, p. 21.

"Barye." *Fine Arts Journal* 35 (1917): 87–94.

"Barye Exhibition at Alan Gallery." *Art News* 62 (December 1963): 14.

Beaulieu, M. "Deux bronzes romantiques d'inspiration classique." *Revue du Louvre* 25, no. 4 (1975): 271–74.

Bements, T. H. E. "Barye's Sketchbook." *Scribner's Magazine* 70 (July–December 1921): 151–56.

Benge, Glenn F. "A Barye Bronze and Three Related Terra Cottas." *Bulletin of the Detroit Institute of Arts* 56, no. 4 (1978): 231–42.

———. "Barye's Apotheosis Pediment for the New Louvre: *Napoleon I Crowned by History and the Fine Arts.*" In *Art the Ape of Nature: Studies in Honor of H. W. Janson* (New York, 1981), pp. 607–30.

———. "Barye, Flaxman and Phidias." In *Acts of the 24th International Congress of Art History,* vol. 6, Bologna, 1982, pp. 99–105.

———. "Barye's Uses of Some Géricault Drawings." *Journal of the Walters Art Gallery* 31–32 (1971): 13–27.

———. "The Bronzes of Barye." In Sladmore Gallery, *Catalogue* (London, England, 1972), pp. 1–5,

———. "Lion Crushing a Serpent." In Wainwright, ed., *Sculpture of a City,* pp. 30–35, 344–45.

———. "*Napoleon I Crowned by History and the Fine Arts;* The Drawings for Barye's Apotheosis Pediment for the New Louvre." *Art Journal,* 38, no. 3 (Spring 1979): 164–70.

Bonnat, Léon. "Barye." *Gazette des Beaux-Arts,* 3d ser. 1 (1889): 374–82.

Borgmeyer, C. L. "Among Sculptures, Antoine-Louis Barye's (1796–1875)." *Fine Arts Journal* 30 (June 1914): 279–86.

"Bronze Stag . . . Recently . . . Presented to the Syracuse Museum." *Syracuse Museum of Fine Arts Quarterly Bulletin* 2 (1941): 19.

Cann, Louise Gebhard, "The Animal Artists of France." *International Studio* 78 (1923): 169–73.

de Caso, Jacques. "Origin of Barye's 'Ape Riding

a Gnu': Barye and Thomas Landseer," *Journal of the Walters Art Gallery* 27–28 (1964–65; published 1968): 66–73.

Chancellor, E. B. "A Pre-eminent Sculptor: Antoine-Louis Barye." *Architectural Review* 51 (1922): 32–35.

Child, Theodore. "Antoine-Louis Barye." *Harper's Monthly Magazine* 70 (September 1885): 585–603.

Coombs, D. "Barye Exhibit, Sladmore Gallery, London." *Connoisseur* 180 (June 1972): 162.

"Corot, Barye Feature Auction of the James G. Shepherd Collection." *Art Digest* (1 November 1935), p. 11.

Crombie, T. "The French Animal Bronzes of the Nineteenth Century." *Connoisseur* 151 (December 1962): 245–47.

Dezarrois, André. "Le monument de Napoléon I^{er} à Grenoble par Barye: un Projet mysterieusement abandonné." *Revue de l'art* 71 (1937): 258–66.

"La Donation Jacques Zoubaloff aux Musées de France." *Les Musées de France* 4 (1916): 17–18, pls. 7–9.

Dowley, Francis H. "A Neo-Classic Hercules." *Art Quarterly* 15 (Spring 1952): 73–76.

Eaton, D. Cady, trans. "Barye the Sculptor, Bonnat's Criticism." *New Englander and Yale Review*, n.s. 51, vol. 15 (December 1889): 424–32.

Eckford, Henry. "Antoine-Louis Barye." *Century Magazine*, n.s. 9, vol. 15 (1885–86): 483–500.

Emeric-David, Toussaint-Bernard. "Sculpture française, Exposition de 1824." *Revue européene* 1 (1824): 668–72; 2 (1824): 176–88.

Gautier, Théophile. "Barye." *L'Illustration, Journal Universelle*, 19 May 1866, p. 315.

———. "Ventes d'aquarelles de dessins, et de tableaux de A. L. Barye." *Gazette des Beaux Arts*, 2d ser. 5 (1860): 234–36.

Geare, Randolph I. "The Remarkable Barye Bronzes." *New England Magazine* 29 (1903–04): 539–45.

Genevay, A. "A. L. Barye, 1796–1875." *L'Art, Revue hebdomadaire illustrée* 2 (1875): 361–68.

Guiffrey, J. "Barye." *Archives de l'art français,* n.s. 4 (1910): 181.

———. "Barye." *Nouvelles archives de l'art français*, 3d ser. 5 (1889): 180.

Guillaume, J. J. "Exposition des oeuvres de Barye à l'Ecole des Beaux-Arts." *Nouvelles archives de l'art français*, 3d ser. 5 (1889): 178–81.

Hamilton, George Heard. "The Origin of Barye's Tiger Hunt," *Art Bulletin* 18 (1936): 248–51.

Henley, W. E. "Louis-Antoine Barye [*sic*]." *Art Journal* 50 (1888): 20–24.

d'Henriet, Charles. "L'Art contemporain. Barye et son oeuvre." *Revue des Deux Mondes,* 1 February 1860, pp. 758–78.

Horswell, Jane. "Antoine-Louis Barye." In *Bronze Sculpture of 'Les Animaliers': Reference and Price Guide* (Woodbridge, Suffolk: Antique Collectors' Club, 1971), pp. 1–80.

Hubert, Gérard. "Barye et la critique de son temps." *Revue des Arts* 6 (1956): 223–30.

———. "Barye . . . ce meconnu." *Jardin des Arts*, no. 27 (1957): 153–218.

———. "Homme nu debout, ésquisse par Barye, nouvelle aquisition au Louvre." *Revue des Arts* 9 (1957): 30.

"Introduction to Three Sketchbooks from the Institute's Collection." *Minneapolis Institute of Arts Bulletin* 59 (1970): 60–63.

Johnson, L. "Delacroix, Barye and the Tower Menagerie, an English Influence on French Romantic Animal Pictures." *Burlington Magazine* 106 (September 1964): 416–17.

Johnston, William R. "The Barye Collection of the Walters Art Gallery, Baltimore." *Apollo*, n.s. 50 (November 1974): 402–9.

Lame, Emile. "Les Sculpteurs d'animaux, M. Barye." *Revue de Paris* 30 (15 February 1856): 204–19.

Lewis, C. Douglas, Jr. "The St. Petersburg Bronzes of Barye's *War* and *Peace*." *Pharos* '77 14, no. 1 (May 1977): 3–11.

Luc-Benoist. "Sculpture et romantisme." *L'Amour de l'Art* 9 (1928): 292–98.

Mantz, Paul. "Artistes Contemporains, M. Barye." *Gazette des Beaux Arts*, 2d ser. 1 (1867): 107–26.

McVey, W. M. "Animals, Animal Sculpture and Animal Sculptors." *National Sculpture Review* 19, no. 2 (Summer 1970): 9.

Millard, Charles. "Sculpture and Theory in Nineteenth-Century France." *Journal of Aesthetics and Art Criticism* 34, no. 1 (Fall 1975): 15–20.

"Obsèques de Barye." *L'Art, Revue hebdomadaire illustrée* 2 (1875): 238.

"One Hundred Sculptures by Barye, Who Mirrored the Struggle for Survival in Bronze." *Art Digest* 11 (1937): 12.

Pach, Walter. "Le Classicisme de Barye." *L'Amour de l'art* 13 (1932): 319–20.

Peognot, J. "Barye et le bêtes." *Connaissance des Arts*, no. 243 (May 1972): 116–21.

Phillips, J. G., Jr. "Gift of Two Medals." *Bulletin of the Metropolitan Museum of Art*, 30 (October 1935): 199–200.

Pingeot, Anne. "Jaguar Devouring a Hare," and "War." In *The Second Empire 1852–1870: Art in France under Napoleon III* (Philadelphia Museum of Art, 1978), pp. 209–11.

Planche, Gustave. "Exposition des Beaux-Arts." *Revue des Deux Mondes*, 1855, pp. 1160–61.

———. "Barye." *Revue des Deux Mondes* 3 (1 July 1851): 47–75.

Raynor, V. "Barye Exhibition at Alan Gallery." *Arts* 38 (December 1963): 64.

Read, Sir Herbert. "Contemporary Art: The Modern Viewpoint in Animal Sculpture." *Vogue*, 8 December 1928, pp. 100–101, 148.

Remington, Preston. "Sculptures by Barye, Recent Acquisitions," and "Lion About to Strike a Serpent Given to the Metropolitan." *Bulletin of the Metropolitan Museum of Art* 35 (1940): 34–36, 58.

Roberts, Keith. "Mallets at Bourdon House." *Burlington Magazine* 104 (1962): 507.

Ross, M. C. "Some Drawings by Barye." *Magazine of Art* 43 (1950): 142–43.

Schneider, Pierre. "Art News from Paris." *Art News* 55 (1956): 48.

Sylveire, Jean. "Nos artistes animaliers." *Art et les artistes*, n.s. 5 (1922): 261–70.

Taft, Lorado. "Sculpture of the Nineteenth Century, French Sculpture." *Fine Arts Journal* 34 (1916): 51–66.

"Three Terra Cotta Statuettes in the Louvre." *Drawing and Design* 4 (1925): 278.

"Two Barye Bronzes Lent by Mrs. Slade Peet." *Minneapolis Art Institute Bulletin* 29 (1940): 97–98.

"Two Barye Bronzes: 'Lion' and 'Bears' in the Indianapolis Museum." *John Herron Art Institute Bulletin* 12 (1925): 30, 32–33.

Veron, Eugène. "Exposition des oeuvres de Barye." *L'Art, Revue hebdomadaire, illustrée* 3 (1875): 49–51.

———. "Exposition des oeuvres de Barye au Palais des Beaux-Arts." *L'Art* 1 (22 November 1876): 25–30, 33–37.

Vitry, Paul. "Les accroissements de la salle Barye." *Les Musées de France* (1931), pp. 65–66.

———. "La Salle Barye au Musée du Louvre." *Les Musées de France* 2, no. 6 (1912): 93–96.

———. "Musée du Louvre . . . Modèles de Barye." *Les Musées de France* 5 (1933): 73–74.

———. "Une nouvelle donation d'oeuvres de Barye au Musée de Louvre." *Les Musées de France* (1914), pp. 17–18.

"Watercolors and Bronzes of Animals at the Metropolitan Museum." *Art News* 38 (24 February 1940): 11.

SALES AND EXHIBITION CATALOGUES

Barye's Bronze Catalogues

Bronzes Barye, Maison Brame, 31 rue Taihout, Paris, n.d. (CRT).

Bronzes de Barye, en vente dans ses magasins, rue Saint-Anastase, 10, à Paris (Marais). 113 works. (CRSA).

Catalogue des Bronzes de Barye, rue de Bou-

logne, no. 6 (Chaussée d'Antin), Paris, Années 1847–1848. 1ᵉʳ Septembre 1847. 113 works. (*CRB47*).

Catalogue des Bronzes de Barye, 12, rue Chaptal (Chaussée d'Antin), Paris. 113 works. (*CRC*).

Catalogue des Bronzes de Barye, Statuaire, Exposition Universelle, 1855, La Grande Médaille d'Honneur, quai des Célestins, 10, Paris. 197 works. (*CQC55*).

Catalogue des Bronzes de Barye, Statuaire, Exposition Universelle de 1855, Médaille d'Honneur, rue des Fossés-Saint Victor, 13, Paris. 152 works. (*CRF55*).

Catalogue des Bronzes de A. L. Barye, Statuaire, Exposition Universelle de 1865, La Grande Médaille d'Honneur, quai des Célestins, 4, à Paris. 230 works. (*CQC65*).

Other Sales and Exhibition Catalogues

Baltimore, Maryland Institute. *Exhibition of Paintings, Bronzes and Porcelains from the George A. Lucas Collection*, 1911.

Baltimore Museum of Art. *The George A. Lucas Collection of the Maryland Institute*, 12 October—21 November 1965. Baltimore, Maryland.

Barbedienne, F., ed. *Oeuvres de A. L. Barye*, 30, boulevard Poissonière. Paris, 1893.

———, ed. Leblanc-Barbedienne, Succ^r. *Oeuvres de A.-L. Barye*. 30, Boulevard Poissonnière, Paris. (*CFBLB*).

Bayonne, Musée de Bayonne. *Collection Bonnat*, par Antonin Personnaz et Georges Berges. Paris, 1925.

Benge, Glenn F. "Antoine-Louis Barye (1796–1875)." In *Metamorphoses*, pp. 77–107.

———. "Antoine-Louis Barye; Christophe Fratin; Pierre-Jules Mêne; Jules Moigniez." In *Romantics to Rodin*, pp. 124–41, 271–72, 302–3, 306–7.

———. "The Bronzes of Barye." In *Exhibition of the Sculpture of Antoine-Louis Barye, 1796–1875*, 14 June—8 July. London: Sladmore Gallery, 1972.

Bordeaux, Musée de Bordeaux. *Catalogue*, 1881, p. 217.

Buffalo, New York, Albright Art Gallery. *Master Bronzes*, February 1937.

Dunkerque, Musée de Dunkerque. *Catalogue*, 1892, p. 89.

Evry, Ferme du Bois Briard. *Bronzes de Barye*, 22–23 June 1973.

London, Sladmore Gallery. *Barye to Bugatti: French Animal Sculpture by 'Les Animaliers,'* n.d.

Lyon, Musée de Lyon. *Catalogue*, 1887, p. 1.

Marseilles, Musée de Marseilles. *Catalogue*, 1885, p. 176.

Minneapolis Institute of Arts. *The Collection of James J. Hill: A Loan Exhibition Celebrating the Minnesota Statehood Centennial*, 15 April—1 June 1958.

Montpellier, Musée Fabre. *Dessins de la collection Alfred Bruyas et autre dessins des XIXᵉ et XXᵉ siècles*. Paris, 1962.

New York, Alan Gallery. *Barye Bronzes*, 20 October—16 November 1963. Essays by George Heard Hamilton and Jacques de Caso.

New York, American Art Association. *Cyrus J. Lawrence Collection*, 21–22 January 1910.

New York, American Art Galleries, The Barye Monument Association of New York. *Catalogue of the Works of Antoine-Louis Barye*, 1889. (*NYBMA89*).

New York, Bernard Black Gallery. *Les Animaliers*, 1966.

New York, Fine Arts Society Building. *Catalogue of Bronzes in the A. L. Barye Loan Exhibition*, Febraury 1893.

New York, Grolier Club. *Exhibition of Bronzes and Paintings by Antoine-Louis Barye*, 11–27 March 1909.

New York, Parke-Bernet Galleries. *The Mrs. Henry Walters Art Collection*, 30 April—1–3 May 1941, pp. 252–54.

———. *Nineteenth-Century Works of Art: Animaliers by Barye* . . . , 5 March 1970.

———. *Bronzes by Antoine-Louis Barye: The Bernard Black—Hugues Nadeau Collections*, 3 December 1971.

New York, Shepherd Gallery. *Western European Bronzes of the Nineteenth Century*, 1973, nos. 17–19. Notes by Stuart Pivar.

New York, Sotheby Parke-Bernet. *A. L. Barye Bronzes*, 29 October 1975.

———. *A Collection of . . . Animalier Bronzes*, 4 December 1975.

Philadelphia Museum of Art. *Catalogue of Sculpture, Philadelphia Museum of Art Bulletin*, 1961.

Paris, Ecole National des Beaux-Arts. *Catalogue des dessins de l'école moderne exposés . . . au profit de la caisse de secours de l'Association*, February 1884.

———. *Catalogue des oeuvres de Antoine-Louis Barye, membre de l'Institut*, 1875.

———. *Catalogue des oeuvres de Antoine-Louis Barye, membre de l'Institut*, April 1889.

Paris, Exposition Universelle de 1865. *Catalogue des bronzes de Antoine-Louis Barye, statuaire*, 1865.

Paris, Galerie Georges Petit. *Catalogue des . . . bronzes de Barye*, 27 January 1897.

———. *Collection Charles Blanc, Bronzes de Barye*, 31 January 1891.

Paris, Galerie Tedesco Frères. *Aquarelles et dessins de Barye et Rodin*, 14–30 June 1949. Preface by Claude Roger-Marx.

Paris, Galerie Paul Rosenberg. *Exposition d'oeuvres importants de grands maîtres du dix-neuvième siècle*, 18 May—27 June 1931.

Paris, Hôtel Drouot. *Catalogue des oeuvres de feu Barye. Bronzes, aquarelles, tableaux, cires, terres cuites, marbres, plâtres. Modèles avec droit de reproduction. Dépendant de la Succession de M. Barye. Dont la vente aura lieu Hôtel Drouot, Salles nos. 7, 8, 9, Les Lundi 7, Mardi 8, Mercredi 9, Jeudi 10, Vendredi 11 et Samedi 12 Février 1876, à une heure et demie. Par le ministère de M. Charles Pillet, Commissaire-Priseur 10, rue de la Grange-Batelière, Assisté de M. Durand-Ruel, Expert, 16 rue Laffite, et de M. Wagner, fils, 2 bis, passage Vaucouleurs, chez lesquels se trouve le present Catalogue. Expositions: Particulière: le Samedi 5 Fèvrier 1876. Publique: le Dimanche 6 Février 1876. (COFB76).*

———. *Catalogue des bronzes de Barye . . . composant la collection de M. Auguste Sichel*, 27 February 1876. Preface, "Un Mot," par Edmond de Goncourt.

———. *Catalogue des bronzes de Barye (modèles) dont la vente aura lieu à Paris*, 24 April 1884.

———. *Catalogue of the Jourdier Sale*, 9 May 1885.

———. *Catalogue of the Jourdier Sale*, 2 February 1889.

Paris, Hôtel Charpentier. *Revue des Deux Mondes, Centennaire 1829–1929. Exposition des cents ans de vie française*, 1929.

Paris, Hôtel des ventes mobilières. *Catalogue des tableaux modernes composant la galerie du feu prince royal, bronzes d'art et bronzes dorés . . . le tout appartenant à S.A.R. Madame la duchesse d'Orlèans*, 16–20 January 1853. (The *surtout de table.*)

———. *Catalogue des Bronzes de Barye et Gayrard*, 27 December 1858.

Paris, Musée national du Louvre. *Barye. Sculptures, peintures, aquarelles des collections publiques françaises*, October 1956—February 1957. Essays by Gérard Hubert, Maurice Sérullaz, and Jacqueline Bouchot-Saupique.

———. *Catalogue de la collection Chauchard*, 1910.

———. *Catalogue sommaire des sculptures*, n.d., pp. 15 and 114.

———, Pavillon de Marsan. *Le Decor et la vie sous le second empire . . .* , 27 May–10 July 1922.

Paris, Musée de l'Orangerie, Cabinet des dessins du Musée du Louvre. *L'Aquarelle de 1400 a 1900*, 1936.

Paris, Musée de l'Orangerie. *Les Chefs-d'oeuvre du Musée de Montpellier*, March–April 1939. Preface by Paul Valery.

203

Paris, Palais des Beaux-Arts, Petit Palais. *Gros, Ses amis, ses élèves*, 1936.

Paris, Palais Galliera. *Bronzes par Barye*, 16 March 1972.

———. *Bronzes par A. L. Barye*, 9 June 1972.

———. *Bronzes de Barye*, 1973.

Paris, San Donato. *Sale Catalogue*, 21 April 1870.

San Antonio, Texas, Marion Koogler McNay Art Institute. *Antoine-Louis Barye, 1796–1875, Michelangelo of the Animals*, February 1965. Introduction by John Palmer Leeper.

Index

Barye's Sculpture

Page numbers printed in italics indicate the principal discussion of a work.

Persons Cited

Illustrations

Unless otherwise noted, photographs are provided through
the courtesy of the museum or collection indicated.

SCULPTURES

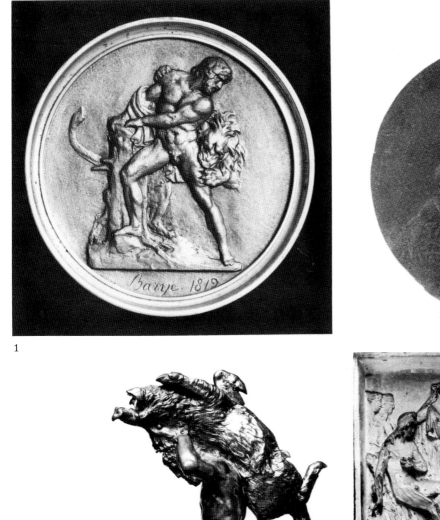

1. *Milo of Crotona Devoured by a Lion* (*Milon de Crotone dévoré par un Lion*), yellow bronze, relief medallion, signed and dated Barye 1819, d. 8.1 cm. Baltimore, Walters Art Gallery, 27.507.

2. *Portrait of a Young Girl* (*Portrait de Jeune Fille*), wax on slate, relief medallion, d. 12.1 cm. Musée du Louvre, RF 1667. Photo: author.

3. *Hercules with the Erymanthean Boar* (*Hercule tuant le Sanglier d'Erymanthe*), bronze, signed BARYE, about 1820, h. 15.5 cm. Baltimore, Walters Art Gallery, 27.105.

4. *Hector Reproaching Paris* (*Les Reproches d'Hector à Paris*), plaster relief sketch, 1823. Paris, Ecole des Beaux-Arts. Photo: Bulloz.

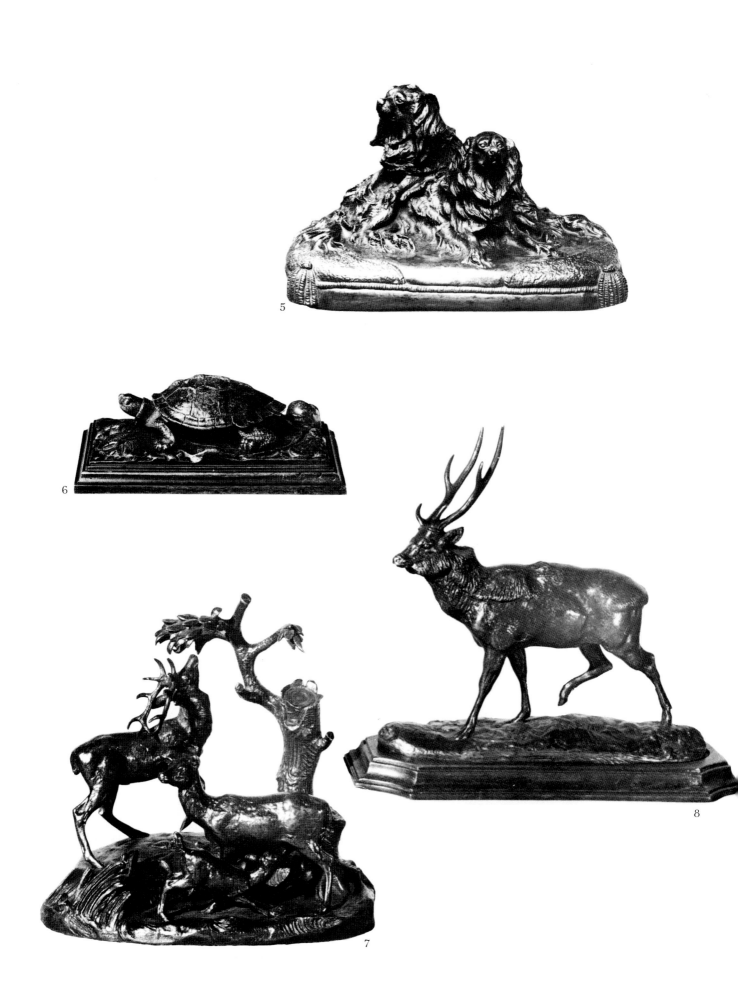

5

6

7

8

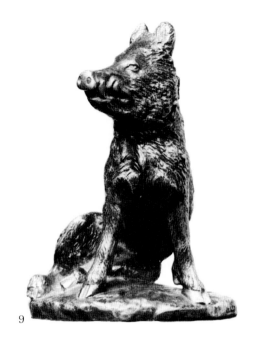

9

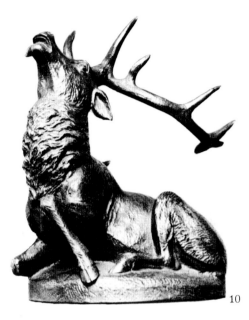

10

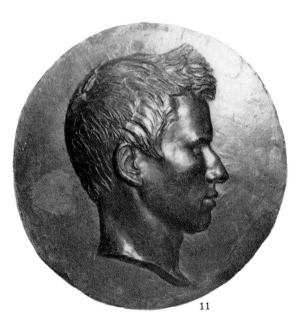

11

OPPOSITE:

5. *Two Spaniels on a Cushion* (*Deux Epagneuls sur un Coussin*), bronze, stamped BARYE, h. 12 cm. Baltimore, Walters Art Gallery, 27.193.

6. *Turtle on a Base* (*Une grande Tortue, sur plinthe, CRB47, no. 8*), bronze, signed BARYE; marked F. BARBEDIENNE, FONDEUR; a brass founder's mark, F.B., is inset on the base; l. 13.6 cm. Baltimore, Walters Art Gallery, 27.109.

7. *Stag, Doe, and Nursing Fawn, with a Tree* (*Cerf, Biche, et Faon avec arbre*), bronze, h. 18.1 cm. Philadelphia Museum of Art, given by George W. Elkins in memory of his brother, William M. Elkins, '51-115-34.

8. *Walking Stag, Right Hind Hoof Raised* (*Un Cerf, la jambe levée, CRB47 , no. 21*), bronze, h. 16.5 cm. Philadelphia Museum of Art, given by George W. Elkins in memory of his brother, William M. Elkins, '51-115-17.

9. *Seated Boar* (*Sanglier assis*), bronze, stamped BARYE, h. 10.5 cm. Baltimore, Walters Art Gallery, 27.32.

10. *Fallen Stag* (*Daim épuisé*), bronze, stamped BARYE, h. 10.8 cm. Baltimore, Walters Art Gallery, 27.33.

11. *Portrait of the Founder Richard* (*Richard, fondeur*), wax on plaster, relief medallion, inscribed in script and dated "Barye à son ami Richard, 1827"; d. 15.3 cm. Musée du Louvre, RF 1930. Photo: author.

12. *Poised Stag* (*Cerf*), bronze, signed and dated BARYE 1829, h. 48 cm. Baltimore, Walters Art Gallery, 27.160.

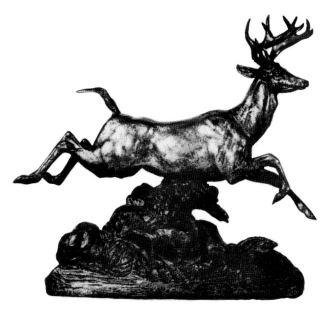

13. *Stag in a Flying Gallop* (*Cerf s'élançant*), silver-plated bronze, h. 24.2 cm. Philadelphia Museum of Art, given by George W. Elkins in memory of his brother, William M. Elkins, '51-115-23.

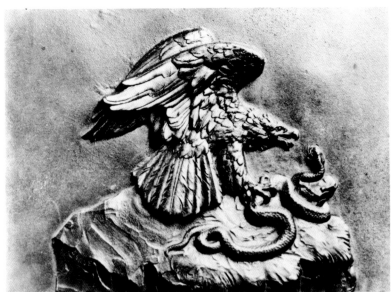

14

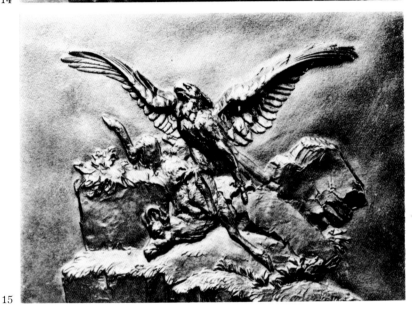

15

14. *Eagle and Serpent (Aigle et Serpent, bas-relief)*, bronze relief, signed BARYE in unusual Roman block letters with serifs, h. 10.5 cm. Baltimore, Walters Art Gallery, 27.189.

15. *Eagle and Chamois (Aigle et Chamois, bas-relief)*, bronze relief, signed BARYE in unusual Roman block letters with serifs; marked on back, F.F. FANNIERE F$^{res.}$; in letters raised in relief on back, the founder's name, Eck & Durand; h. 10.8 cm. Baltimore, Walters Art Gallery, 27.190.

16. *Owl with a Mouse (Hibou, CQC65, no. 199)*, bronze, signed BARYE, h. 9.8 cm. Baltimore, Walters Art Gallery, 27.140.

17. *Stork on a Turtle (Cigogne posée sur une Tortue)*, bronze, h. 7.3 cm. Baltimore, Walters Art Gallery, 27.139.

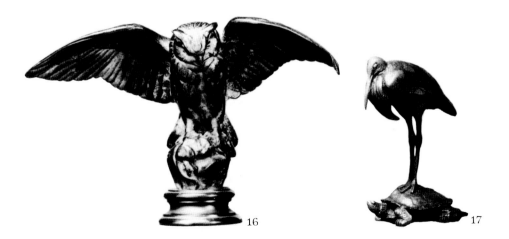

16

17

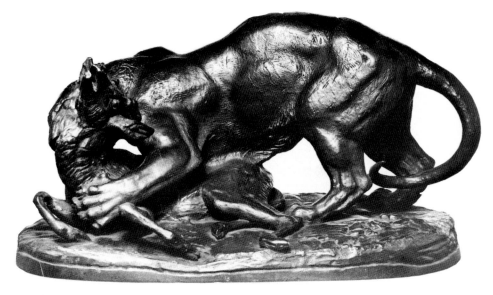

18. *Tiger Devouring a Stag* (*Tigre surprenant un Cerf*), plastic substitute for bronze, signed and dated BARYE 1830; also signed SOYER, h. 28 cm. Baltimore, Walters Art Gallery, 27.450.

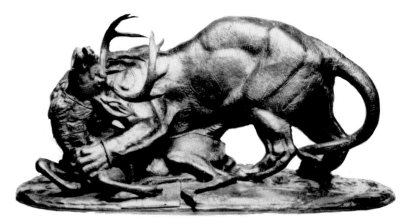

19. *Tiger Devouring a Stag* (*Tigre surprenant un Cerf*), bronze model in twelve pieces, h. 16 cm. Baltimore, Walters Art Gallery, 27.133.

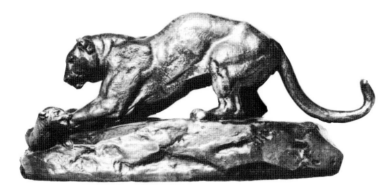

20. *Panther Attacking a Civet Cat* (*Panthère surprenant un Zibet*),
bronze, signed A L BARYE, h. 15 cm. Baltimore, Walters Art Gallery,
27.119.

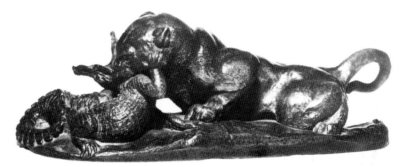

21. *Jaguar Devouring a Crocodile* (*Un Jaguar couchée, tenant un Caïman*),
bronze, signed BARYE, h. 8.3 cm. Baltimore, Walters Art Gallery, 27.91.

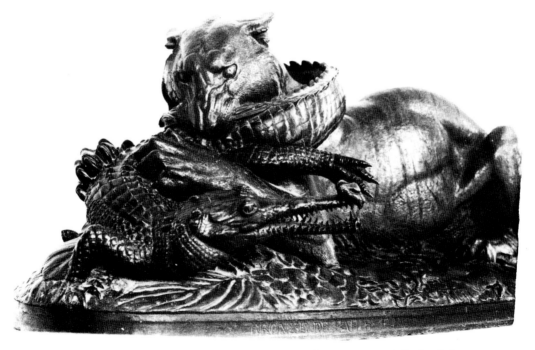

22. *Tiger Devouring a Gavial Crocodile of the Ganges* (*Tigre dévorant un Gavial*), detail, bronze,
signed in script, BARYE; inscribed BRONZE DE PARIS FONDU PAR HONORE GONON ET SES DEUX FILS AN 1832; h.
41.1, l. 103 cm; plaster awarded a second medal Salon of 1831, no. 2177. Musée du Louvre, Salle de
Barye. Photo: author.

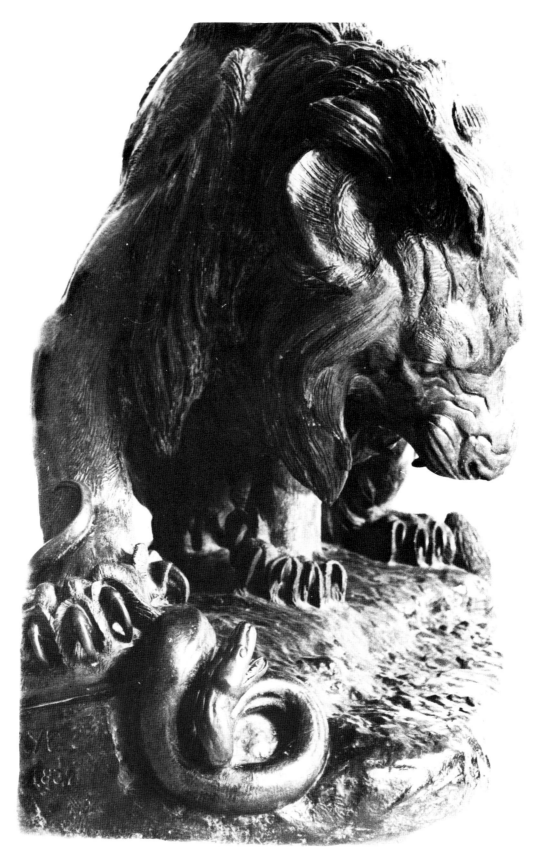

23. *Lion Crushing a Serpent* (*Lion des Tuileries; Lion au Serpent*), detail, bronze, signed and dated below the right forepaw, BARYE 1832; inscribed at the back, below the tail, FONDU PAR HONORE GONON ET SES DEUX FILS 1835; h. 1.38 m, l. 1.78 m; plaster in Salon 1833, no. 2458. Musée du Louvre, Salle de Barye, RF 1516 (AN O⁴ 1607). Photo: author.

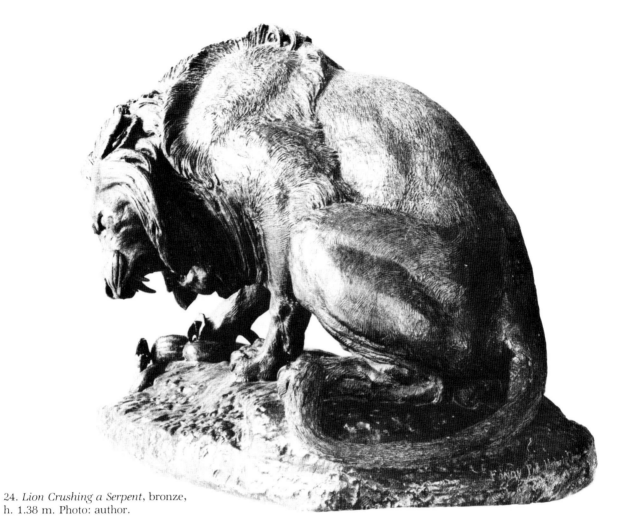

24. *Lion Crushing a Serpent*, bronze,
h. 1.38 m. Photo: author.

25. *Lion at the Zodiac* (*Lion du Zodiaque*, Bas-relief), bronze relief for the base of the July Column
Cenotaph, Place de la Bastille, 1835–40 (AN F^{13} 1244). Photo: author.

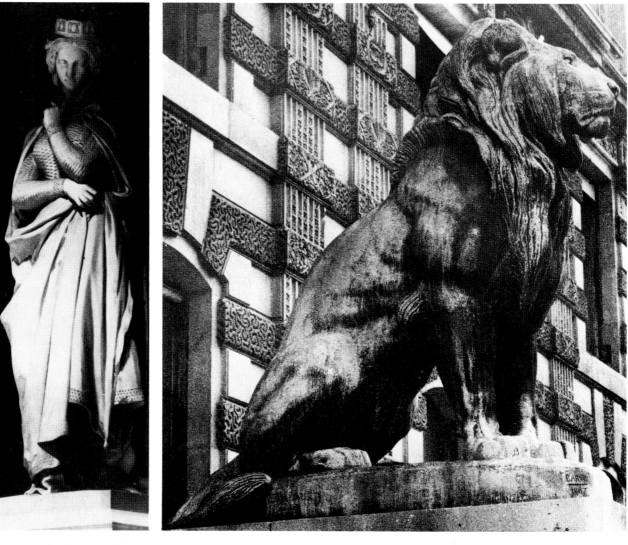

26. *Saint Clotilde* (*Ste. Clotilde*), marble, h. c. 3 m, for the first chapel on the right, Church of the Madeleine, Paris; 1840–43 (AN F^{21} 586, 1449). Photo: author.

27. *Seated Lion* (*Lion assis*), bronze, documented 23 December 1846; signed and dated BARYE 1847; inscribed LE BEAU FONDEUR À PARIS; installed at the quai-side portal of the Flore Pavilion, Louvre Palace, 1867 (AN O^{4} 2304, 2353). Photo: author.

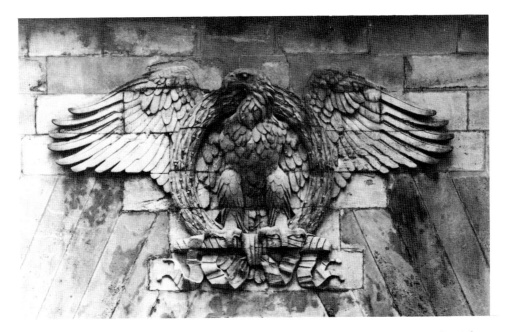

28. *Colossal Eagle* reliefs (*Aigles en pierre dure, grandeur colossales*), stone, c. 1849, for eight piers of the Jena Bridge, Paris (AN F[17] 22731). Photo: author.

29. *Jaguar Devouring a Hare* (*Jaguar et un Lièvre*), bronze, signed A L BARYE; h. 41.1 cm, l. 104.2 cm; plaster in Salon of 1850, no. 3172 (AN F[21] ser 6, 63). Baltimore, Walters Art Gallery, 27.180.

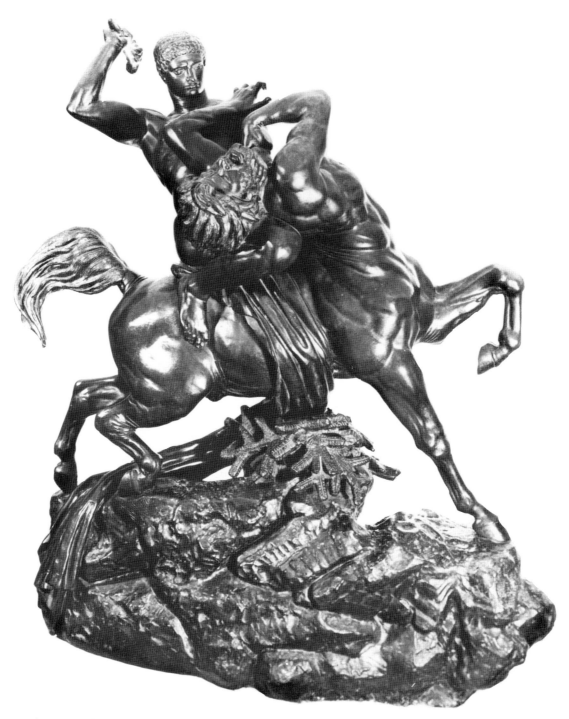

30. *Theseus Combating the Centaur Biénor* (*Thésée combattant le Centaure Biénor*), bronze, h. 1.27 m; plaster in Salon 1850, no. 3171 (AN F[21] ser 5, 14). Washington, D.C., in the collection of the Corcoran Gallery of Art, museum purchase, 74.68.

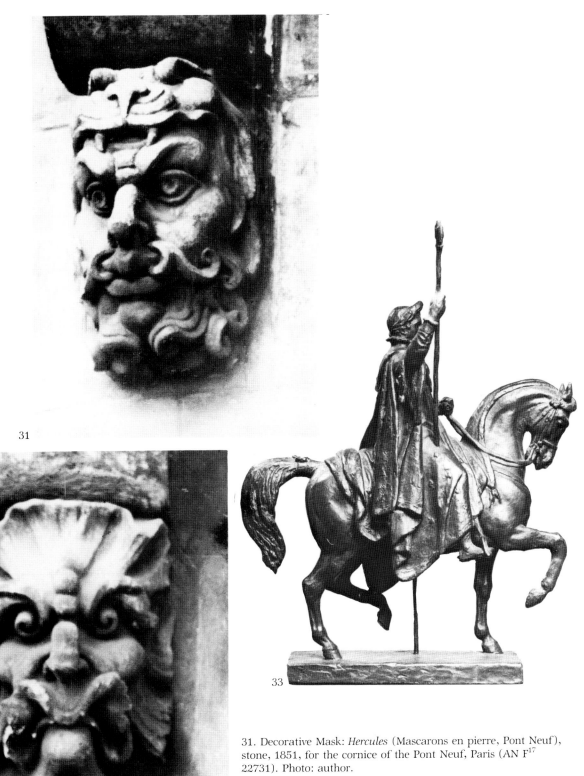

31

32

33

31. Decorative Mask: *Hercules* (Mascarons en pierre, Pont Neuf), stone, 1851, for the cornice of the Pont Neuf, Paris (AN F[17] 22731). Photo: author.

32. Decorative Mask: *Flower-Petal Demon* (Mascaron, Pont Neuf), stone, 1851, for the cornice of the Pont Neuf, Paris (AN F[17] 22731). Photo: author.

33. *Emperor Napoleon I, Equestrian, in Coronation Robes* (*Empereur Napoléon I, Statuette équestre*), presentation model in plaster and wax; inscribed, *Vu et approuvé Visconti*, c. 1853, h. 39.2 cm. Baltimore, Walters Art Gallery, 27.521.

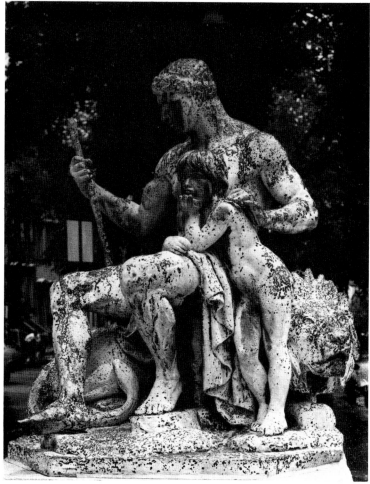

34. *Strength* (*Génie de la Force*, Esquisse), plaster sketch, signed on broken wax pellet, h. 26 cm, 1854, for a stone group on the Denon Pavilion façade, New Louvre Palace. Musée du Louvre (AN F^{21} 1746, 1750). Photo: author.

35. *Strength* (*Génie de la Force*), bronze proof, signed BARYE, inscribed F. BARBEDIENNE. FONDEUR, h. 1 m. Baltimore, Mount Vernon Square. Photo: author.

36. *Order* (*Génie de l'Ordre*, Esquisse), plaster sketch, signed on wax pellet, BARYE, h. 26 cm, 1854, for a stone group on the Denon Pavilion façade, New Louvre Palace. Musée du Louvre (AN F²¹ 1746, 1750). Photo: author.

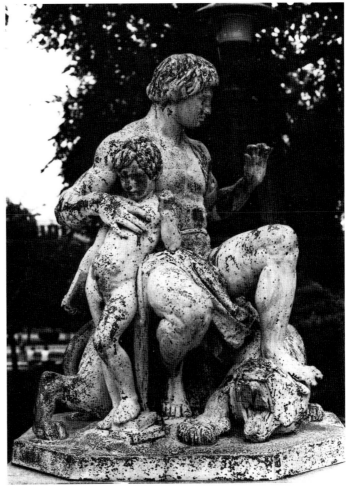

37. *Order* (*Génie de l'Ordre*), bronze proof, signed BARYE, inscribed F. BARBEDIENNE. FONDEUR, h. 1 m. Baltimore, Mount Vernon Square. Photo: author.

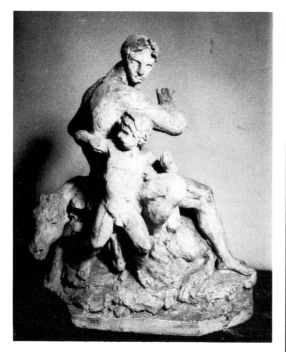

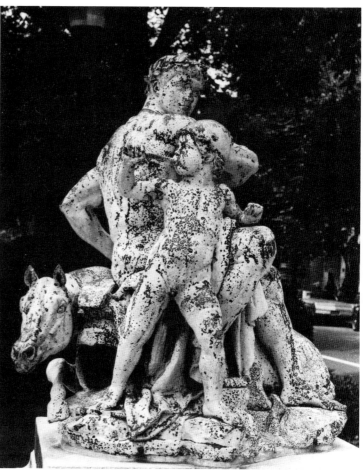

38. *War* (*La Guerre*, Esquisse), plaster sketch, signed on wax pellet, BARYE, h. 28 cm, 1855, for a stone group on the Richelieu Pavilion façade, New Louvre Palace. Musée du Louvre (AN F²¹ 1747, 1750). Photo: author.

39. *War* (*La Guerre*), bronze proof, signed BARYE, inscribed F. BARBEDIENNE. FONDEUR, h. 1 m. Baltimore, Mount Vernon Square. Photo: author.

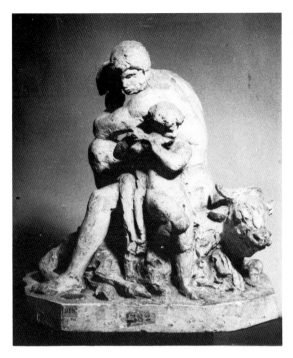

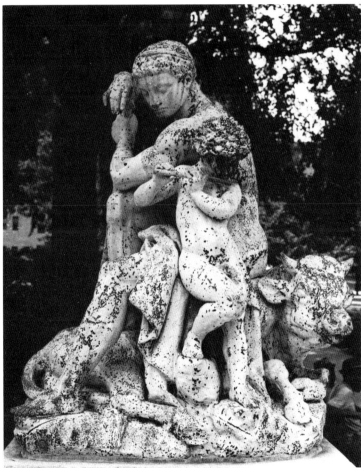

40. *Peace* (*La Paix*, Esquisse), plaster sketch, signed on wax pellet, BARYE, h. 26 cm, 1855, for a stone group on the Richelieu Pavilion façade, New Louvre Palace. Musée du Louvre (AN F^{21} 1747, 1750). Photo: author.

41. *Peace* (*La Paix*), bronze proof, signed BARYE, inscribed F. BARBEDIENNE. FONDEUR, h. 1 m. Baltimore, Mount Vernon Square. Photo: author.

42. *Napoleon I Crowned by History and the Fine Arts* (*Le Buste de Napoléon Ier entouré et couronné par les deux figures de l'Histoire et des Beaux-Arts*), stone, 1857, pedimental relief for the Sully Pavilion façade, New Louvre Palace (AN F^{21} 1749, 1750). Photo: author.

43. *Napoleon III as an Equestrian Roman Emperor* (*Napoléon III ème en Empereur Romain*, Bas-relief Equestre), presentation drawing for a bronze relief, c. 1861, for the Riding Academy façade, New Louvre Palace; destroyed in 1870–71 (AN F^{21} 1749). Photo: author.

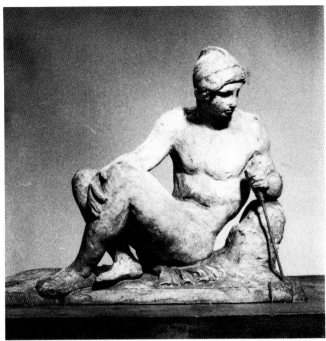

44. *Napoleon III Equestrian*, tracing of a model for the bronze relief, h. 22.5 cm. c. 1861. Baltimore, Walters Art Gallery, 37.2221.

45. *River God* (*Fleuve*, Esquisse), plaster sketch, signed on wax pellet, BARYE; for the left stone figure, Riding Academy façade, h. 21 cm. Musée du Louvre, RF 2006. Photo: author.

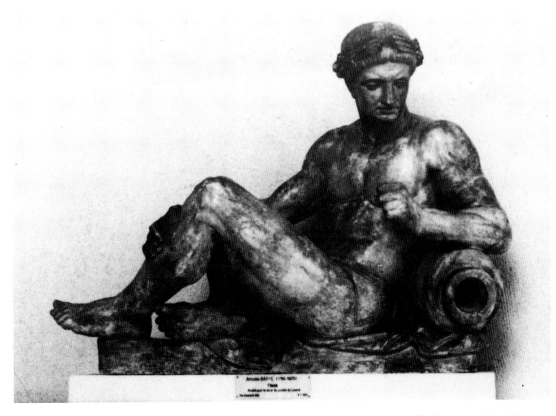

46. *River God*, model (*Fleuve*), plaster, left figure, h. 60 cm. Musée du Louvre, Salle de Barye, RF 1560.

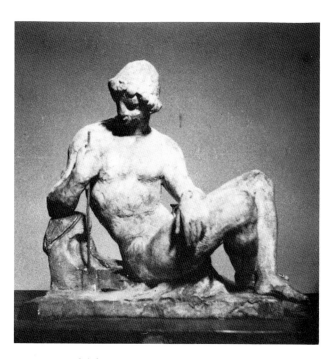

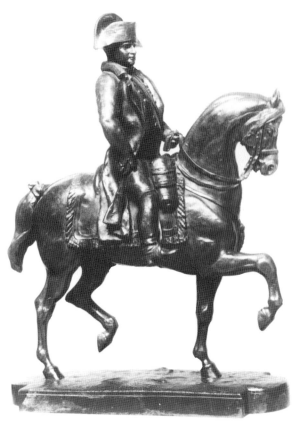

47. *River God* (*Fleuve*, Esquisse), plaster sketch, signed on wax pellet, BARYE; for the right stone figure, Riding Academy façade, h. 21 cm. Musée du Louvre, RF 2007. Photo: author.

48. *River God*, model (*Fleuve*), plaster, right figure, h. 60 cm. Musée du Louvre, Salle de Barye, RF 1561.

49. *General Bonaparte, Equestrian* (*Napoléon Iᵉʳ en Redingote, Statuette Equestre*), bronze, signed BARYE; model of 1862–66 for a monument in Grenoble, a project Barye abandoned in 1866; h. 35.7 cm. Baltimore, Walters Art Gallery, 27.163.

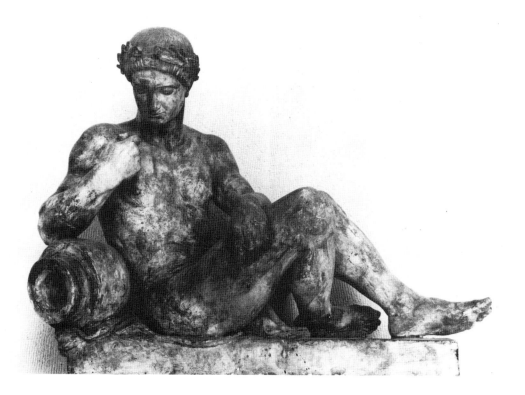

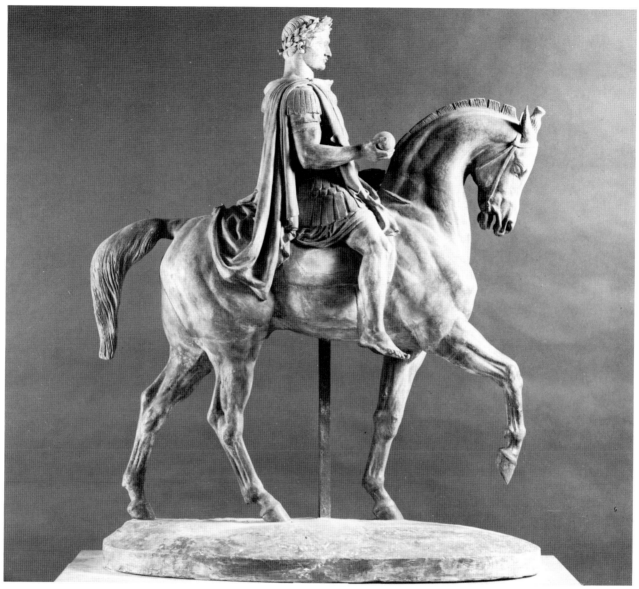

50. *Napoleon I as an Equestrian Roman Emperor* (*Napoléon Ier en Empereur Romain, Statue Equestre,* Maquette originale), plaster model on one-third scale, h. 1.35 m, c. 1860–61, for the Bonaparte family monument bronze in Ajaccio, Corsica. Musée du Louvre, Salle de Barye, RF 1562.

51. *Napoleon I as an Equestrian Roman Emperor* (*Napoléon Ier en Empereur Romain*), monumental bronze, dedicated 1865, Bonaparte family monument, Place du Diamant, Ajaccio, Corsica, after an old photograph.

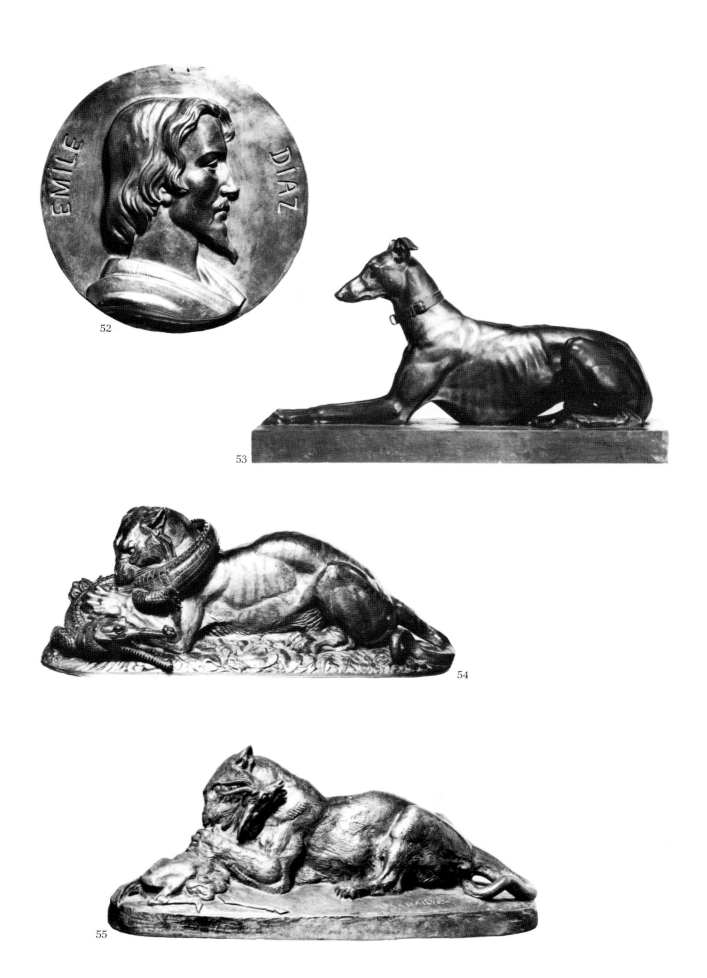

52

53

54

55

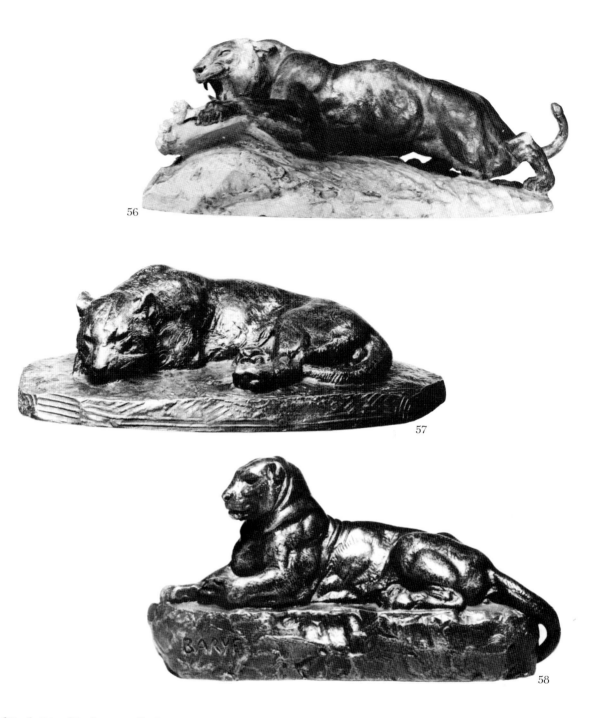

56

57

58

OPPOSITE:

52. *Portrait of Emile Diaz* (*Emile Diaz, fils du Peintre, Médaillon*), bronze relief tondo, d. 38.7 cm, c. 1860. Baltimore, Walters Art Gallery, 27.545.

53. *Recumbent Greyhound* (*Levrier couché*), bronze, signed BARYE, h. 44.5 cm. Baltimore, Walters Art Gallery, 27.475.

54. *Tiger Devouring a Gavial Crocodile, Reduction* (*Un Tigre dévorant un Gavial, réduction*), bronze, signed BARYE, h. 19.7 cm. Baltimore, Walters Art Gallery, 27.154.

55. *Tiger Devouring a Gazelle* (*Un Tigre dévorant une Gazelle*), bronze, signed BARYE, h. 13.3 cm, Salon of 1834. Baltimore, Walters Art Gallery, 27.112.

56. *Tiger Attacking a Peacock* (*Tigre dévorant un Paon*), plaster and wax, signed BARYE, l. 44.5 cm. Cambridge, Massachusetts, Harvard University, Fogg Art Museum, Grenville L. Winthrop Bequest, 1943.1023.

57. *Sleeping Jaguar* (*Un Jaguar dormant*), bronze, signed BARYE, h. 8.6 cm. Baltimore, Walters Art Gallery, 27.40.

58. *Panther of India, Reduction* (*Un Panthère couché; Panthère de l'Inde, réduction*), bronze, signed BARYE, h. 9.8 cm. Baltimore, Walters Art Gallery, 27.44.

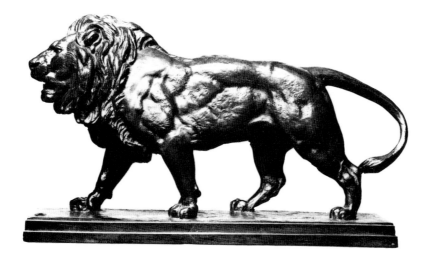

66. *Striding Lion* (*Un Lion qui marche*), bronze, signed BARYE, h. 23.2 cm. Baltimore, Walters Art Gallery, 27.127.

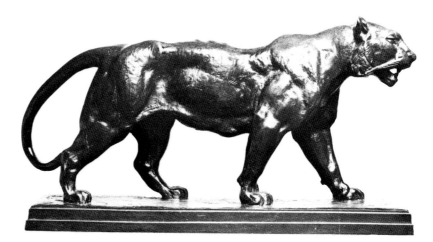

67. *Striding Tiger* (*Un Tigre qui marche*), bronze, signed BARYE, h. 21.3 cm. Baltimore, Walters Art Gallery, 27.48.

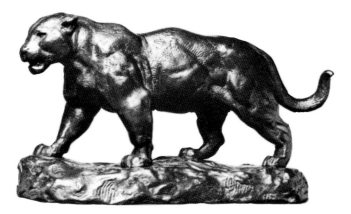

68. *Striding Jaguar* (*Un Jaguar qui marche*), bronze, signed BARYE, h. 12.4 cm. Baltimore, Walters Art Gallery, 27.95.

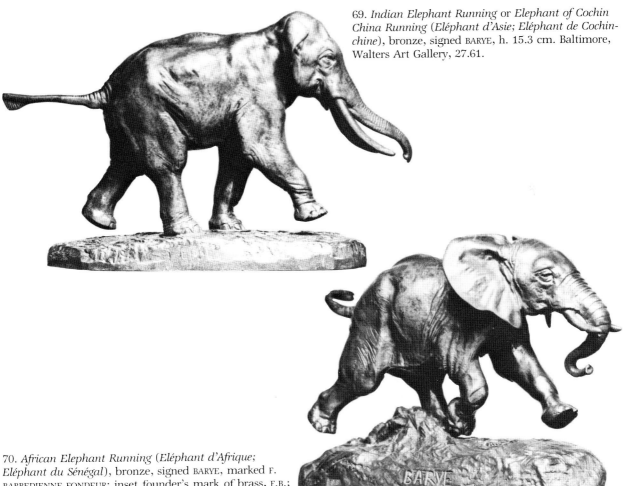

69. *Indian Elephant Running* or *Elephant of Cochin China Running* (*Eléphant d'Asie; Eléphant de Cochinchine*), bronze, signed BARYE, h. 15.3 cm. Baltimore, Walters Art Gallery, 27.61.

70. *African Elephant Running* (*Eléphant d'Afrique; Eléphant du Sénégal*), bronze, signed BARYE, marked F. BARBEDIENNE FONDEUR; inset founder's mark of brass, F.B.; h. 14 cm. Baltimore, Walters Art Gallery, 27.55.

71. *Walking Panther* (*Une Panthère*, bas-relief), unframed bronze relief, signed and dated BARYE 1831, h. 7.6 cm. Baltimore, Walters Art Gallery, 27.494.

72. *Stalking Jaguar* (*Jaguar*), terra cotta, h. 13.1 cm, 1831–32. Detroit Institute of Arts, Founders' Society Purchase, Robert H. Tannahill Foundation Fund, 76.93.

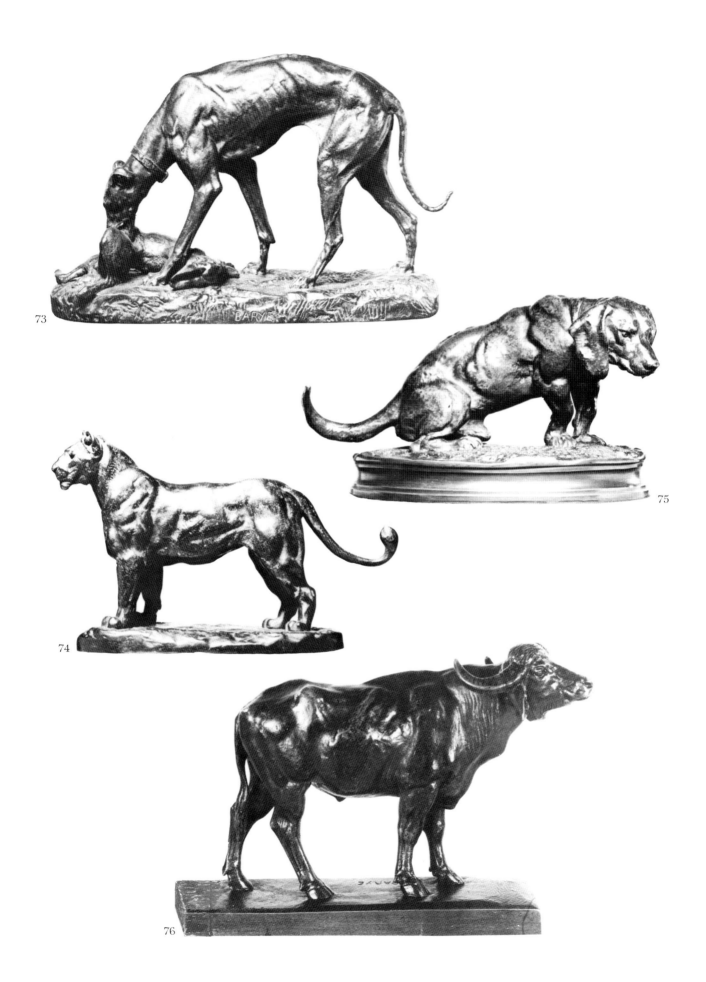

73

74

75

76

OPPOSITE:

73. *Greyhound Devouring a Hare* (*Levrette rapportant un Lièvre*), bronze, signed BARYE, h. 21.7 cm. Baltimore, Walters Art Gallery, 27.100.

74. *Lioness of Algeria* or *Lioness of Senegal* (*Lionne d'Algérie; Lionne du Sénégal*), bronze, signed BARYE, h. 20.1 cm. Baltimore, Walters Art Gallery, 27.107.

75. *Seated Basset* (*Un Chien Basset assis*), bronze, signed BARYE, h. 16.2 cm. Baltimore, Walters Art Gallery, 27.66.

76. *African Buffalo* (*Buffle*), bronze, signed BARYE; marked F. BARBEDIENNE FONDEUR; h. 15.3 cm. The George A. Lucas Collection of the Maryland Institute, College of Art, on indefinite loan to the Baltimore Museum of Art, L. 1964.15.57.

77. *Dromedary of Egypt, Harnessed* (*Dromadaire harnaché d'Egypte*), bronze, signed BARYE; stamped J.L.; h. 26 cm. Baltimore, Walters Art Gallery, 27.118.

78. *Listening Stag* (*Un Cerf, la tête levée; Cerf qui écoute*), bronze, signed and dated BARYE 1838; stamped BARYE 41; h. 18.8 cm. Baltimore, Walters Art Gallery, 27.449.

79. *Caucasian Warrior, Equestrian* (*Guerrier de Caucase*), bronze, signed on base, BARYE; stamped on left side of base molding, TIFFANY & CO.; stamped inside base, AD; by 1865, h. 19 cm. Baltimore, Walters Art Gallery, 27.71.

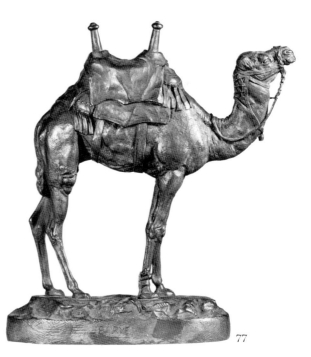

77

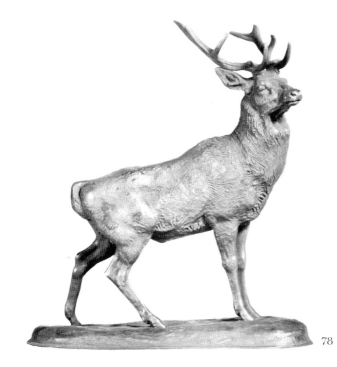

78

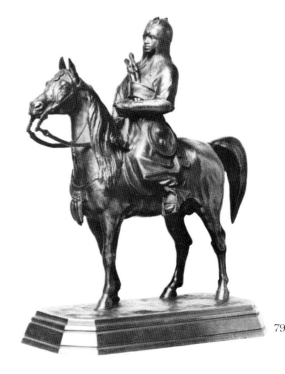

79

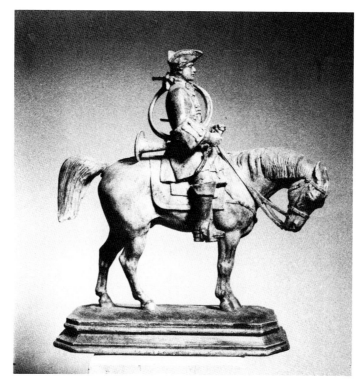

80. *Horseman in Louis XV Costume* (*Piqueur en costume Louis XV*), plaster, signed BARYE, h. 20 cm, by 1865; Barye Sale *Cat.*, 1876, no. 685, acquired by Goupil; Barbedienne Collection; gift of Jacques Zoubaloff, 1914; Musée du Louvre, RF 1595. Photo: author.

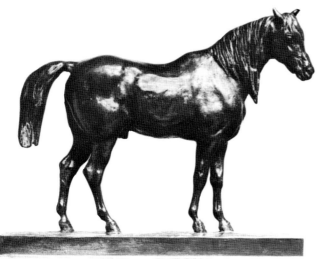

81. *Half-Blood Horse* (*Un Cheval demi-sang*), bronze, signed BARYE, h. 14 cm. Baltimore, Walters Art Gallery, 27.52.

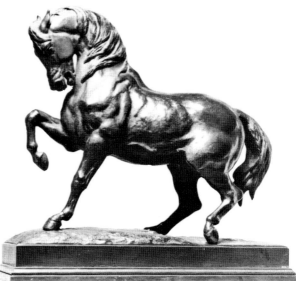

82. *Turkish Horse* (*Un Cheval turc . . . sur plinthe carrée*), bronze, signed BARYE; stamped 029 in numerals 3/16 inches high; h. 29.3 cm. Baltimore, Walters Art Gallery, 26.67.

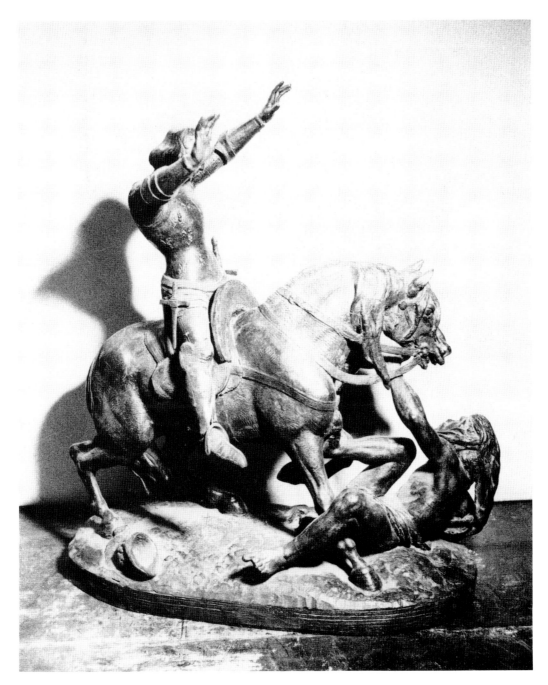

83. *Charles VI, Surprised in the Forest of Le Mans* (*Charles VI dans la forêt du Mans*), plaster and wax, h. 50 cm, Salon of 1833, no. 5236; Musée du Louvre, RF 1577. Photo: author.

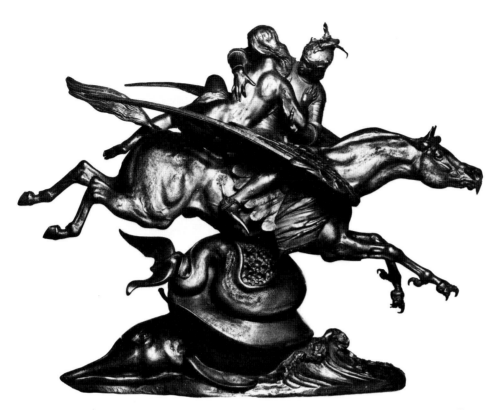

84. *Roger Abducting Angelica on the Hippogriff (Angélique et Roger montés sur l'Hippogriff)*, bronze, signed BARYE, h. 51.8 cm. Baltimore, Walters Art Gallery, 27.173.

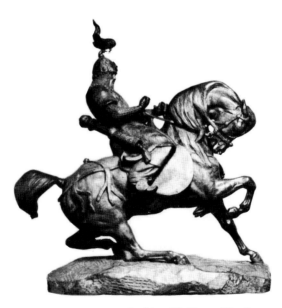

85. *Tartar Warrior Checking His Horse (Un Cavalier chinois; Guerrier tartare arrêtant son Cheval)*, bronze, signed BARYE, h. 38 cm. Baltimore, Walters Art Gallery, 27.122.

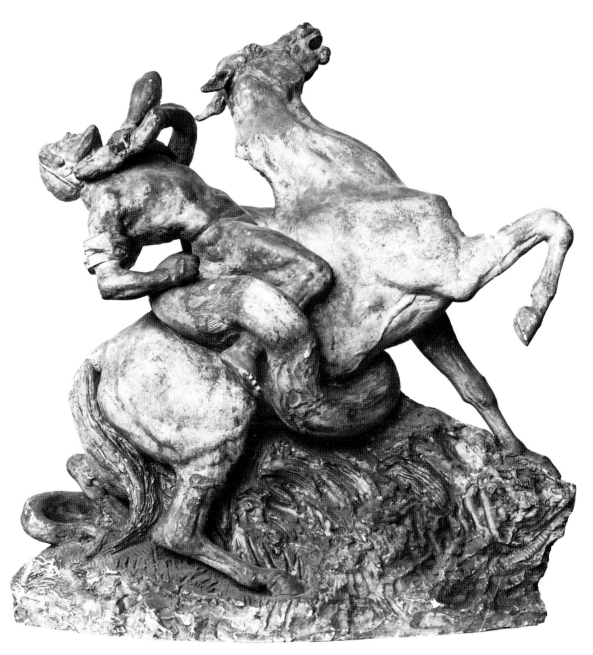

86. *Greek Rider Seized by a Python* (*Cavalier attaqué par un Serpent*), cast plaster, signed BARYE in letters 4 millimeters high on wax pellet beside left front hoof; c. 1835, h. 53 cm. Musée du Louvre, RF 2218.

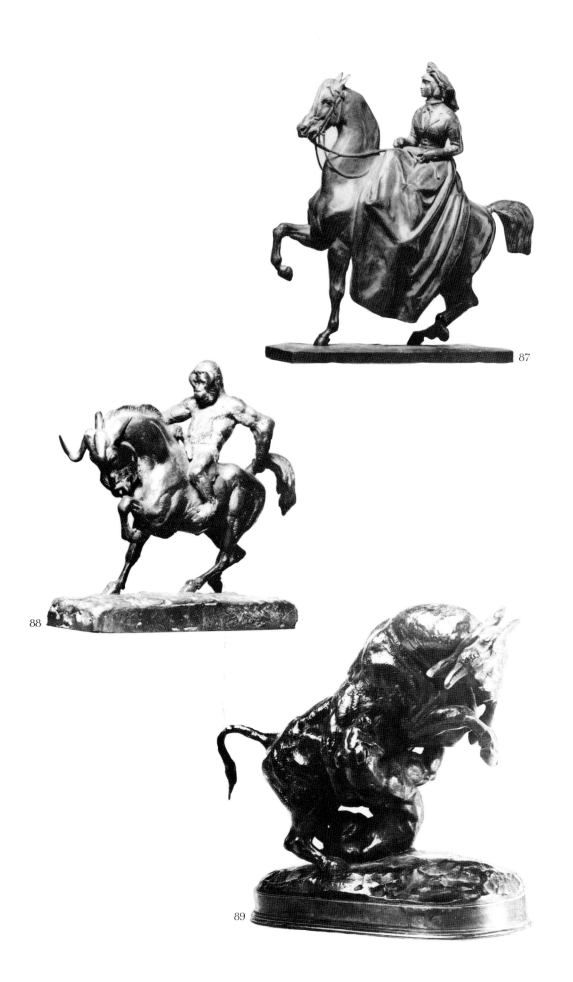

87

88

89

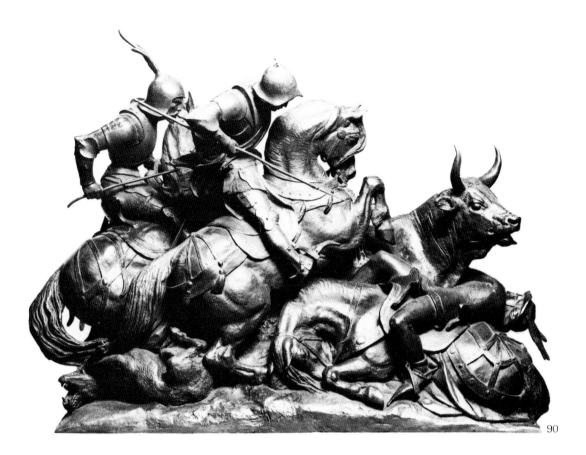

90

OPPOSITE:

87. *Amazon*, *Equestrienne* (*Une Amazone*), bronze, signed BARYE, h. 37 cm. Baltimore, Walters Art Gallery, 27.145.

88. *Ape Riding a Gnu* (*Un Orang-outang monté sur un Gnou* (*antilope*); *Singe monté sur un Antilope*), bronze, signed BARYE; stamped inside base, no. 50; h. 23.6 cm. Baltimore, Walters Art Gallery, 27.121.

89. *Bull Attacked by a Tiger* (*Un Taureau et un Tigre*), bronze, h. 23 cm. Washington, D.C., in the collection of Corcoran Gallery of Art, museum purchase, 73.81.

90. *Bull Hunt* (*La Chasse au Taureau sauvage*), bronze for the *surtout de table* of the Duke of Orléans; signed and dated BARYE 1838; inscribed BRONZE D'UN SEUL JET SANS CISELURE COULE A L'HOTEL D'ANGEVILLIERS PAR HONORE GONON ET SES DEUX FILS 1838; h. 47 cm; collection la duchesse d'Orléans. Baltimore, Walters Art Gallery, 27.178.

91. *An Arab Horseman Killing a Lion* (*Un Cavalier arabe tuant un Lion*), bronze, signed BARYE; stamped with a founder's mark, VP under a crown, perhaps that of one "Pressange, fondeur," cited in Emile Martin's Journal; h. 38.5 cm. Baltimore, Walters Art Gallery, 27.158.

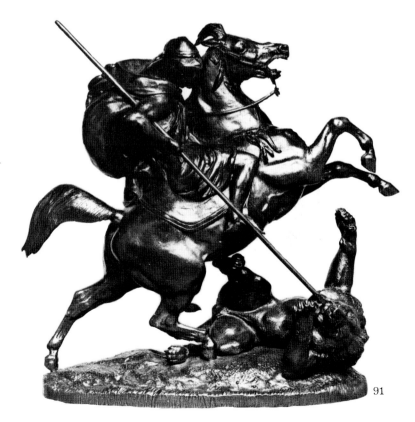

91

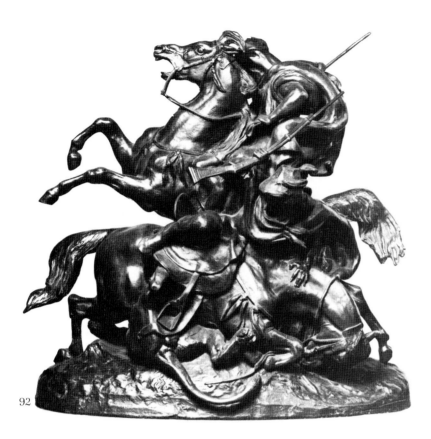

92

92. *Two Arabian Horsemen Killing a Lion* (*Deux Cavaliers arabes tuant un Lion*), bronze, signed BARYE, stamped BARYE 5; h. 38.2 cm. Baltimore, Walters Art Gallery, 27.162.

93. *An Arab Horseman Killing a Boar* (*Un Cavalier arabe tuant un Sanglier*), bronze, signed BARYE, h. 25.5 cm. Baltimore, Walters Art Gallery, 27.179.

OPPOSITE:

94. *Wounded Boar* (*Sanglier blessé*), bronze, signed BARYE; marked inside in black paint, SANGLIER BLESSÉ MODÈLE; paper label inside bears same inscription; h. 17.2 cm. Baltimore, Walters Art Gallery, 27.103.

95. *Python Attacking an African Horseman* (*Un Cavalier abyssinien surpris par un Serpent; Cavalier africain surpris par un Serpent*), bronze, signed BARYE, h. 22.6 cm. The George A. Lucas Collection of the Maryland Institute, College of Art, on indefinite loan to the Baltimore Museum of Art, L. 1964.15.72.

96. *Python Killing a Gnu* (*Python et Gnou*), autograph bronze for the *surtout de table* of the Duke of Orléans, signed BARYE, h. 21.6 cm, 1834–35; collection la duchesse d'Orléans; collection comte Alphonse d'Hautpoul. Baltimore, Walters Art Gallery, 27.152.

97. *Python Killing a Gazelle* (*Un Serpent étouffant une Gazelle; Python enlaçant une Gazelle*), bronze, signed A.L. BARYE; stamped BARYE and BAR; h. 15.5 cm. Baltimore, Walters Art Gallery, 27.151.

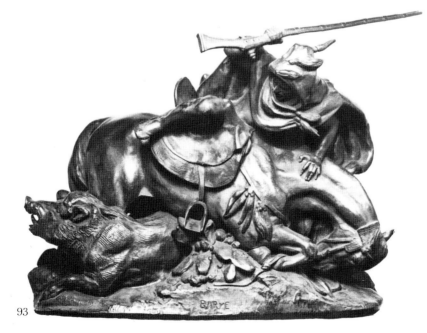

93

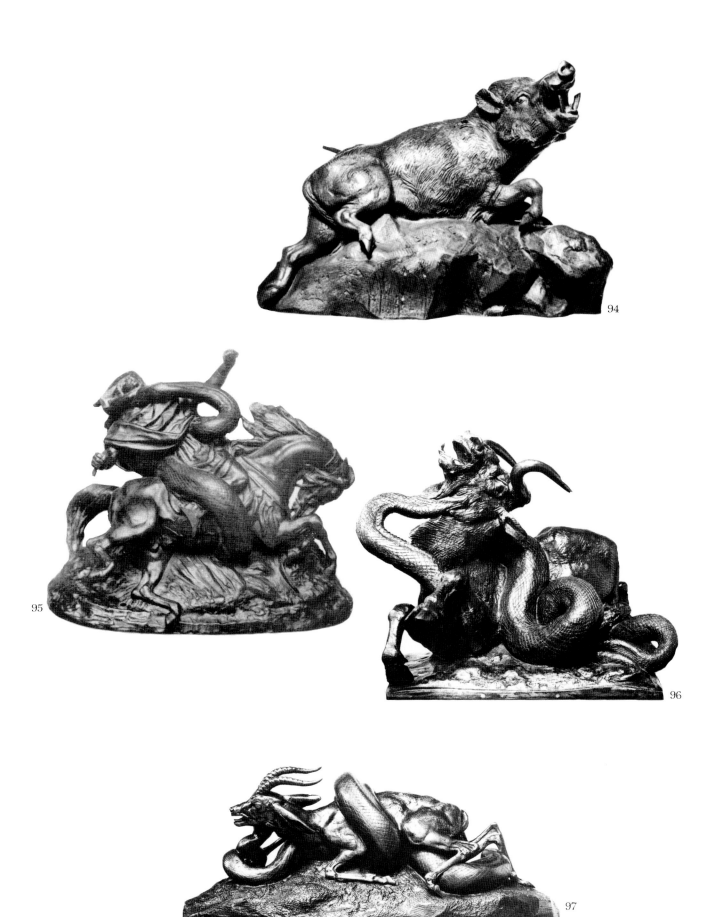

94

95

96

97

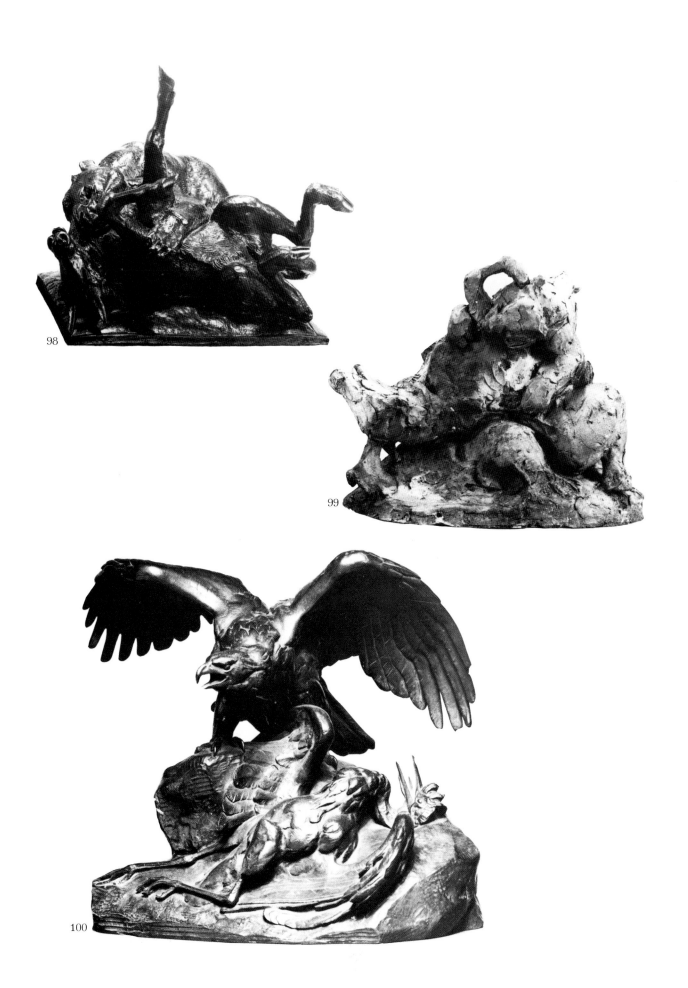

98

99

100

OPPOSITE:

98. *Tiger Overturning an Antelope* (*Tigre et Antilope*), autograph bronze for the *surtout de table* of the Duke of Orléans, h. 23.5 cm, 1834–35; private collection, Paris; Galerie de Bayser, Paris. Detroit Institute of Arts, Founders' Society Purchase, Robert H. Tannahill Foundation Fund, 76.92.

99. *Bear Overturning a Stag* (*Ours renversant un Daim*), terra cotta, h. 23.5 cm, 1830–35. Detroit Institute of Arts, Founders' Society Purchase, Robert H. Tannahill Foundation Fund, 76.90.

100. *Eagle Taking a Heron* (*Aigle tenant un Héron*), bronze, signed A L BARYE; h. 28.3 cm. Baltimore, Walters Art Gallery, 27.146.

101. *Ocelot Carrying a Heron* (*Un Ocelot emportant un Héron*), bronze, signed BARYE; h. 17.5 cm. Baltimore, Walters Art Gallery, 27.131.

102. *Tiger Attacking a Horse* (*Un Tigre dévorant un Cheval*), bronze, h. 26.7 cm. Baltimore, Walters Art Gallery, 27.79.

103. *Jaguar Overturning an Antelope* (*Jaguar renversant une Antilope*), terra cotta, 1830–37, h. 21 cm; marquis de Biron, Paris; comte de Loriol, Vaud, Switzerland; Heim Gallery, London. Detroit Institute of Arts, Founders' Society Purchase, Robert H. Tannahill Foundation Fund, 76.91.

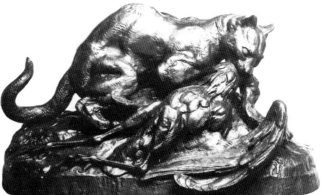
101

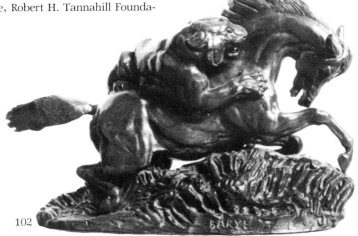
102

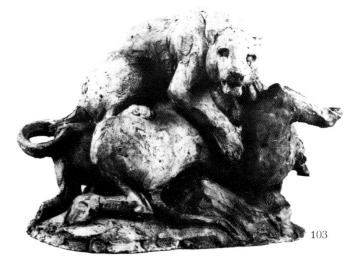
103

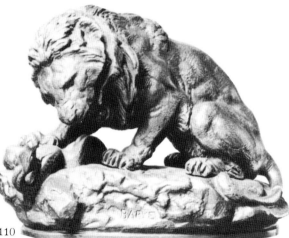

108. *Lion Crushing a Serpent, Sketch* (*Lion au Serpent, ésquisse*), bronze model in five pieces; stamped O BARYE 12 in letters 3 millimeters high; by 1832; h. 13 cm. Baltimore, Walters Art Gallery, 27.81.

109. *Lion Crushing a Serpent, Reduction No. 1* (*Lion au Serpent, réduction no. 1*), bronze model, h. 26 cm. Baltimore, Walters Art Gallery, 21.157.

110. *Lion Crushing a Serpent, Reduction No. 2* (*Lion au Serpent, réduction no. 2*), bronze model in four pieces, h. 20 cm. Baltimore, Walters Art Gallery, 27.92.

111. *Lion Crushing a Serpent, Reduction* (*Lion au Serpent. Jardin des Tuileries*), bronze, nonmechanical reduction, h. 57 cm. Baltimore Museum of Art, the Jacob Epstein Collection, 51.125.

112. *Lion's Head* (*Tête de Lion*), cast plaster and wax, signed and dated BARYE 1852, h. 14 cm. Musée du Louvre, RD 1569. Photo: author.

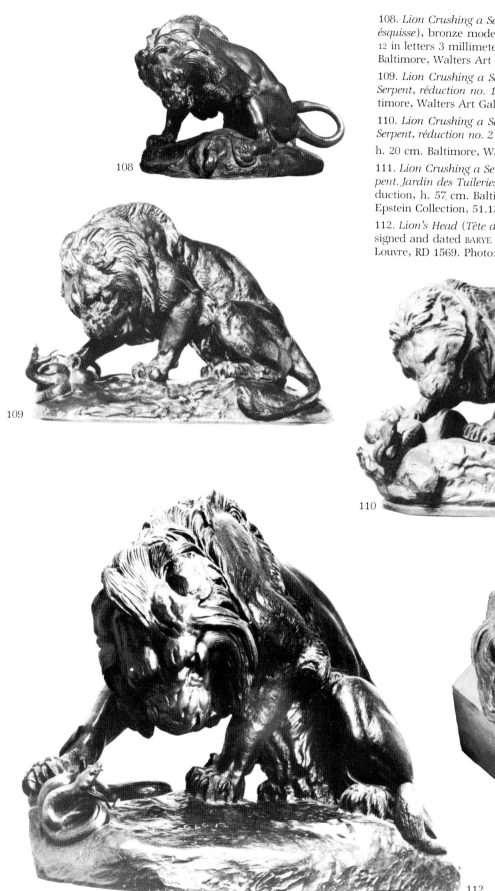

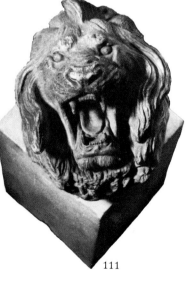

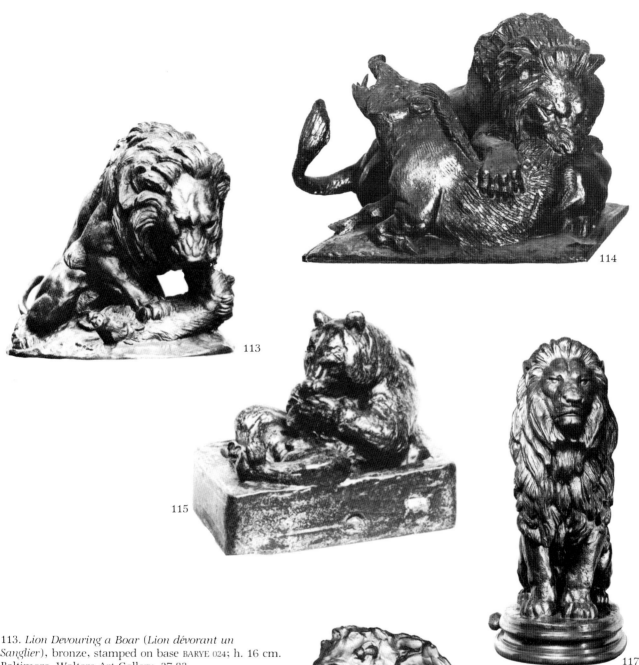

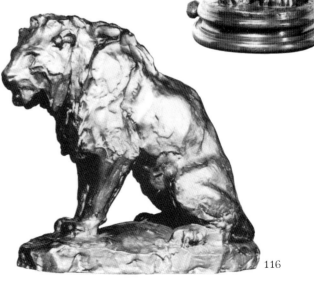

113. *Lion Devouring a Boar* (*Lion dévorant un Sanglier*), bronze, stamped on base BARYE 024; h. 16 cm. Baltimore, Walters Art Gallery, 27.83.

114. *Lion Devouring a Boar* (*Lion dévorant un Sanglier*), autograph bronze for the *surtout de table* of the Duke of Orléans; ca. 1830–35, h. 25 cm, collection la duchesse d'Orléans. Musée du Louvre, OA 5745.

115. *Bear in Its Trough* (*Ours dans son Auge*), bronze, signed BARYE; marked at back F. BARBEDIENNE FONDEUR; brass founder's mark inset at side, F.B.; Salon of 1834, no. 1970, h. 11.1 cm. Baltimore, Walters Art Gallery, 27.111.

116. *Seated Lion, Sketch* (*Lion assis, ésquisse*), bronze, by 1847, signed BARYE; marked F. BARBEDIENNE FONDEUR; h. 26.5 cm. Baltimore, Walters Art Gallery, 27.447.

117. *Seated Lion, Reduction* (*Un Lion assis faisant pendant au Lion des Tuileries*), bronze, signed BARYE, h. 35.7 cm. Baltimore, Walters Art Gallery, 27.120.

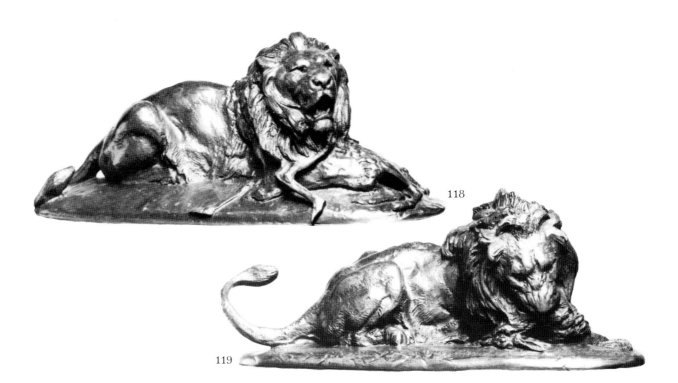

118

119

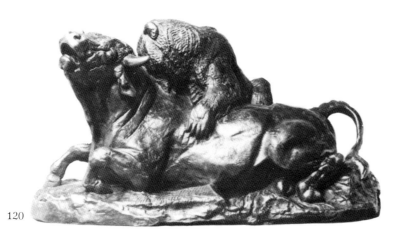

120

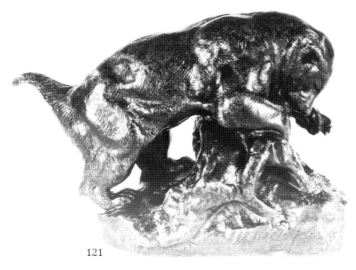

121

118. *Lion with a Guib Antelope* (*Lion tenant un Guib*), bronze, signed and dated BARYE 1835; stamped BARYE 17. Baltimore, Walters Art Gallery, 27.117.

119. *Lion devouring a Doe* (*Un Lion Dévorant une Biche*), bronze, signed and dated BARYE 1837; stamped BARYE at both sides of the lion; h. 14 cm. Baltimore, Walters Art Gallery, 27.39.

120. *Bull Attacked by a Bear* (*Un Taureau terrassé par un Ours*), bronze, stamped BARYE 1; h. 14.6 cm. Baltimore, Walters Art Gallery, 27.106.

121. *Ratel Robbing a Nest* (*Ratel dénichant des Oeufs*), bronze, h. 10.5 cm. The George A. Lucas Collection of the Maryland Institute, on indefinite loan to the Baltimore Museum of Art, L. 1964.15.16.

OPPOSITE:

122. *Standing Bear* (*Ours debout*), bronze, signed BARYE; Salon of 1831 or 1833, h. 24.8 cm. Baltimore, Walters Art Gallery, 27.98.

123. *Two Bears Wrestling* (*Deux Ours, groupe*), silver-plated bronze, signed BARYE, Salon of 1833, no. 5240, h. 21.3 cm. Baltimore, Walters Art Gallery, 27.77.

124. *Bear on a Tree, Devouring an Owl* (*Ours monté sur un Arbre, mangeant un Hibou*), bronze, signed BARYE, h. 19 cm. Baltimore, Walters Art Gallery, 27.78.

125. *Bear Hunt* (*La Chasse à l'Ours*), bronze for the *surtout de table* of the Duke of Orléans, signed and dated BARYE 1838; marked on base, FONDU A L'HOTEL D'ANGEVILLIERS PAR HONORE GONON ET SES DEUX FILS; h. 47.7 cm; collection la duchesse d'Orléans; comte Demidoff. Baltimore, Walters Art Gallery, 27.183.

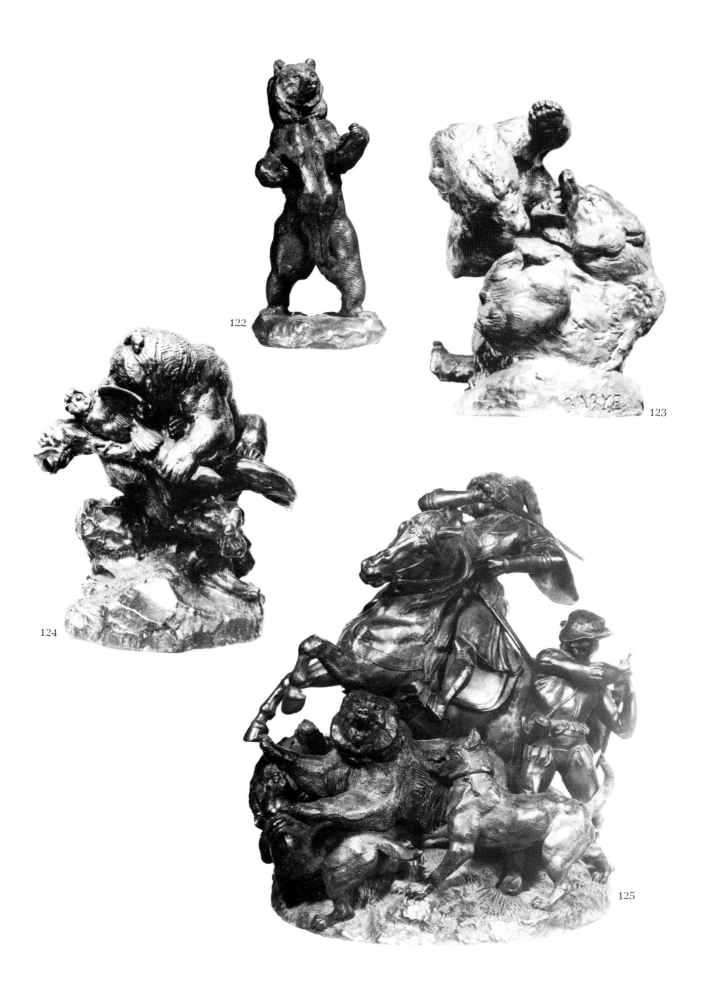

122

123

124

125

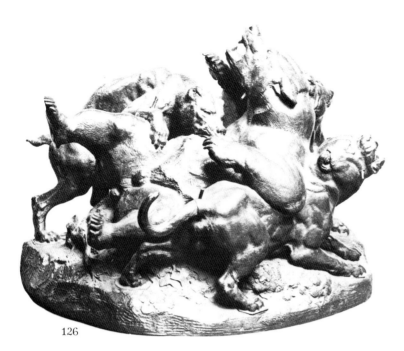

126

127

126. *Bear Overthrown by Three Dogs* (*Ours terrassé par des Chiens de grande race*), bronze model or unfinished proof, signed BARYE, h. 26 cm. Baltimore, Walters Art Gallery, 27.156.

127. *Tiger Hunt* (*La Chasse au Tigre*), bronze centerpiece for the *surtout de table* of the Duke of Orléans, signed and dated BARYE 1836; inscribed BRONZE D'UN JET SANS CISELURE FONDU A L'HOTEL D'ANGEVILLIERS PAR HONORE GONON ET SES DEUX FILS; h. 70.6 cm; collection la duchesse d'Orléans; comte Demidoff. Baltimore, Walters Art Gallery, 27.176.

OPPOSITE:

128. *Elk Hunt* (*La Chasse à l'Elan*), bronze for the *surtout de table* of the Duke of Orléans, signed and dated BARYE 1838; h. 49.6 cm; collection la duchesse d'Orléans; comte Demidoff. Baltimore, Walters Art Gallery, 27.175.

129. *Stag Brought Down by Two Large Greyhounds* (*Cerf terrassé par deux Lévriers de grande race*), bronze, signed and dated BARYE 1832; inscribed FONDU D'UN JET SANS CISELURE PAR HONORE GONON ET SES DEUX FILS; Salon of 1833, no. 5234; h. 34.3 cm; purchased of Alfred Spero in 1962. Oxford, Ashmolean Museum.

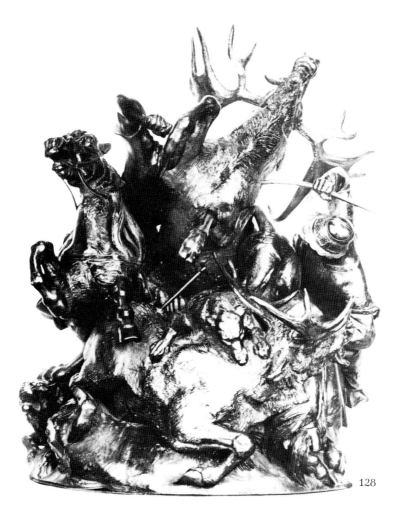

128

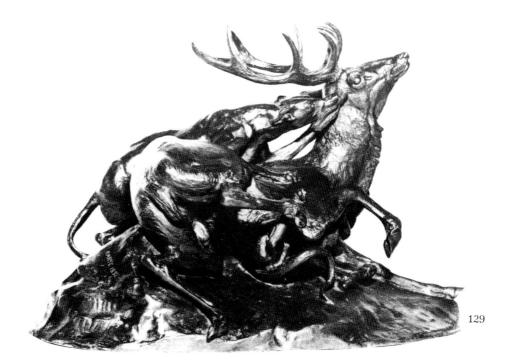

129

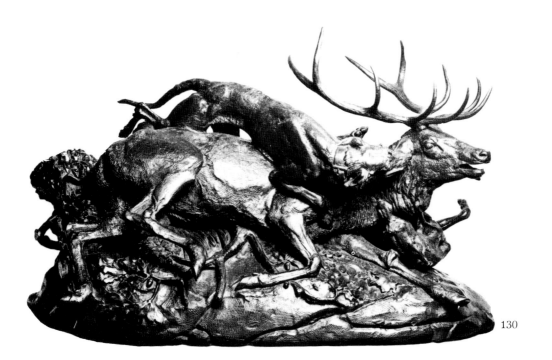

130

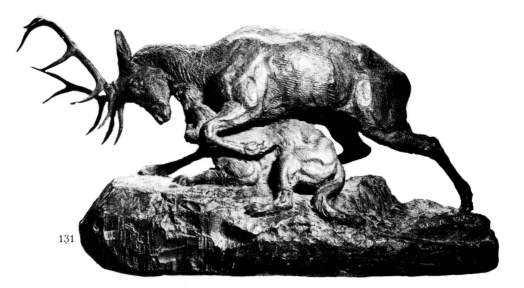

131

130. *Stag of Ten Points Brought Down by Two Scotch Greyhounds* (*Un Cerf dix-cors terrassé par deux Lévriers d'Ecosse*), bronze model, signed BARYE; marked inside, LUCAS; paper label inside marked with French title and term *Modèle*; h. 37 cm; collection of George A. Lucas. Baltimore, Walters Art Gallery, 27.184.

131. *Wounded Stag Seized at the Throat by a Wolf* (*Un Loup tenant à la gorge un Cerf blessé*), plaster model, signed and dated BARYE 1843; h. 22 cm; Barye Sales Cat., 1876, no. 628; acquired by Goupil. Musée du Louvre, Gift of Jacques Zoubaloff, RF 1587. Photo: author.

OPPOSITE:
132. *Stag Attacked by a Lynx* (*Cerf attaqué par un Lynx*), autograph bronze; marked in block capital letters raised in relief along sides of base, on right side, A L BARYE 1836; on left side, CERF ATTAQUE PAR UN LYNX; unusual founder's monogram inscribed at each end of base ⌖ ; possibly Salon of 1834; h. 20.7 cm. Baltimore, Walters Art Gallery, 27.148.

133. *Panther Seizing a Stag* (*Panthère saisissant un Cerf*), bronze, signed BARYE; h. 35 cm. Baltimore, Walters Art Gallery, 27.51.

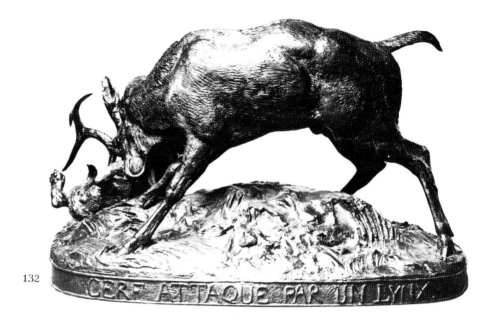

132

CERF ATTAQUE PAR UN LYNX

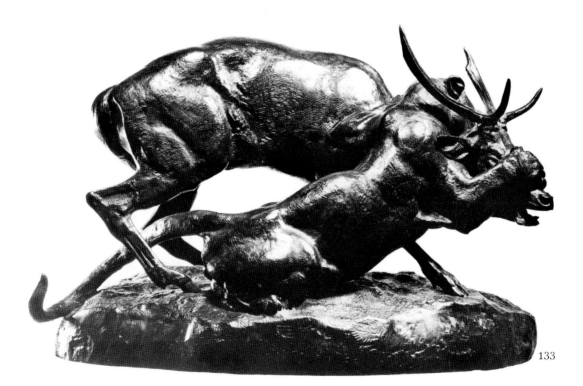

133

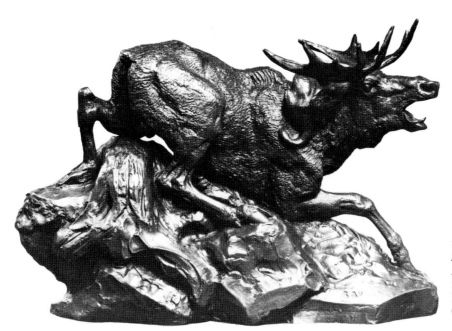

134. *Elk Attacked by a Lynx* (*Un Elan surpris et terrassé par un Lynx*), bronze, signed and dated BARYE 1838; Salon of 1834, no. 1975; h. 22.3 cm. Baltimore, Walters Art Gallery, 27.136.

135. *Fallow Deer Brought Down by Two Algerian Greyhounds* (*Daim terrassé par deux Lévriers d'Algérie*), autograph bronze, signed BARYE; inscribed inside base, DAIM TERRASSE PAR 2 LEVRIERS D'ALGERIE. PIECE UNIQUE. MODELE LUCAS; collection of George A. Lucas. Baltimore, Walters Art Gallery, 27.147.

136. *Fallow Deer Brought Down by Three Algerian Greyhounds* (*Daim terrassé par trois Lévriers d'Algérie*), autograph bronze, signed BARYE; marked inside base with title as above and, MODELE LUCAS; h. 27.1 cm; collection of George A. Lucas. Baltimore, Walters Art Gallery, 27.126.

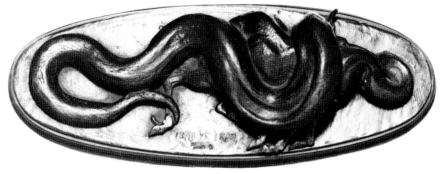

137. *Dead Gazelle* (*Gazelle mort*), bronze, signed and dated BARYE 1837; inscribed on base FONDU PAR HONORE GONON ET SES DEUX FILS. EPO141; Salon of 1833, no. 5242; h. 7.6 cm. Baltimore, Walters Art Gallery, 27.96.

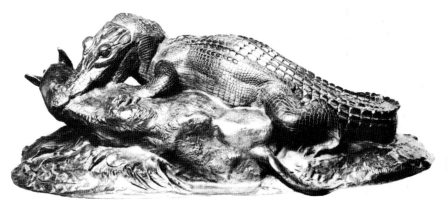

138. *Python Swallowing a Doe* (*Un Serpent avalant une Antilope; Serpent Python avalant une Biche*), bronze, signed and dated BARYE 1840; stamped BARYE 2; also stamped with a second, partly registered signature, BAR; h. 8.2 cm. Baltimore, Walters Art Gallery, 27.101.

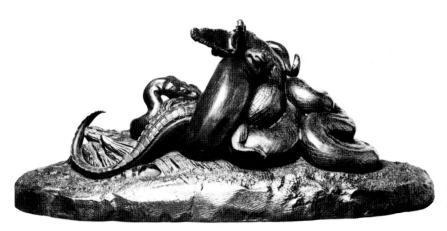

139. *Crocodile Devouring an Antelope* (*Une Grande Antilope surpris par un Crocodile; Crocodile dévorant une Antilope*), bronze, signed BARYE, h. 16.5 cm. Baltimore, Walters Art Gallery, 27.150.

140. *Python Suffocating a Crocodile* (*Un Serpent étouffant un Crocodile; Python étouffant un Crocodile*), bronze, signed A L BARYE; h. 16.2 cm. Baltimore, Walters Art Gallery, 27.153.

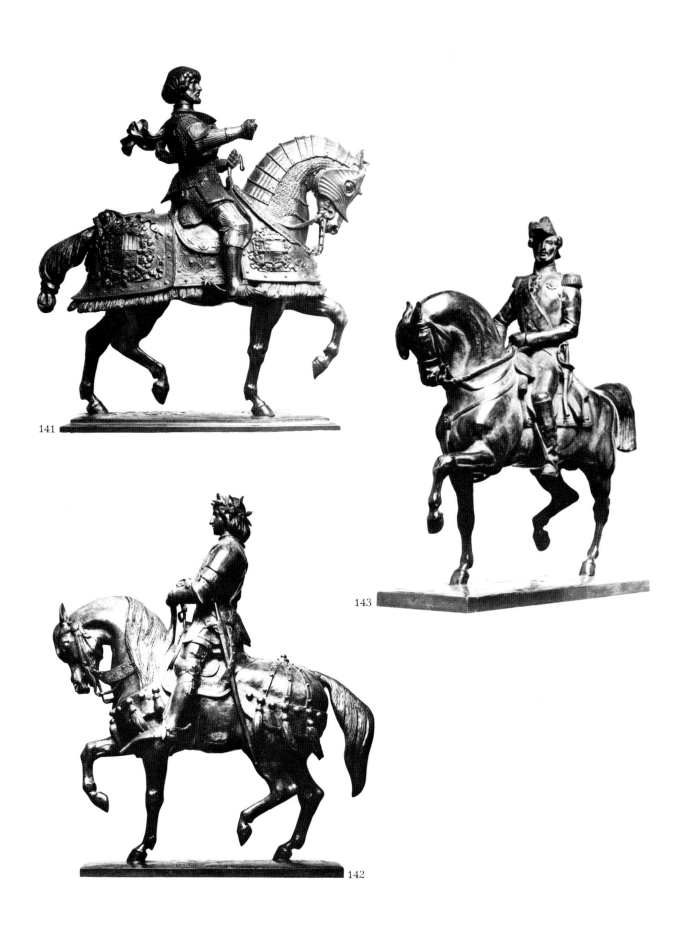

141

143

142

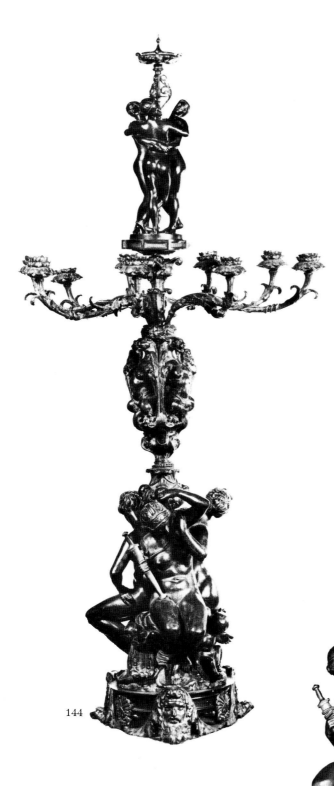

144

OPPOSITE:

141. *Gaston de Foix, Equestrian (Gaston de Foix)*, bronze, signed BARYE; h. 32 cm. Baltimore, Walters Art Gallery, 27.143.

142. *Charles VII, Equestrian (Le roi Charles VII, Statuette équestre)*, bronze, signed BARYE; possibly Salon of 1833; by 1836; h. 29 cm. Baltimore, Walters Art Gallery, 27.164.

143. *Duke of Orléans, Equestrian (Le duc d'Orléans, Statuette équestre)*, bronze, signed BARYE, h. 36.3 cm. Baltimore, Walters Art Gallery, 27.142.

144. *Candelabrum of Nine Lights (Un Candélabre à neuf branches, décoré de Figures, Mascarons et Chimères)*, bronze, signed BARYE, h. 87.3 cm. Baltimore, Walters Art Gallery, 27.168.

145. *Minerva (Minerve)*, gilt bronze, signed BARYE, h. 31.5 cm. Baltimore, Walters Art Gallery, 27.195.

146. *Juno (Junon)*, gilt bronze, signed BARYE, h. 31 cm. Baltimore, Walters Art Gallery, 27.141.

146

145

147. *Nereid* (*Une Neréide*), bronze, signed BARYE, h. 31.2 cm. Baltimore, Walters Art Gallery, 27.108.

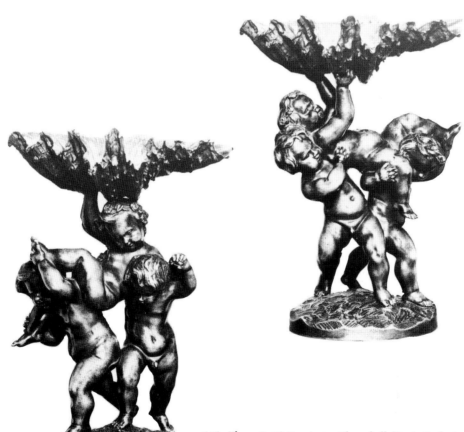

148. *Three Putti Bearing a Clamshell* (*Trois Enfants supportant une Coquille*), two paired groups, parcel-gilt bronze, stamped BARYE LE-VEQUE; h. 21 cm. Baltimore, Walters Art Gallery, 54.298 and 54.299.

DRAWINGS

149. *Milo of Crotona*, after Puget, Barye Album, RF 6073, page 72. Musée du Louvre, Cabinet des Dessins.

151. *Faun Carrying an Ox*, after Visconti, *Musée Pie-Clémentin*. Baltimore, Walters Art Gallery, 37.2271B.

150. *Face of a Feeding Lion*, after Rubens. Baltimore, Walters Art Gallery, 37.2176A.

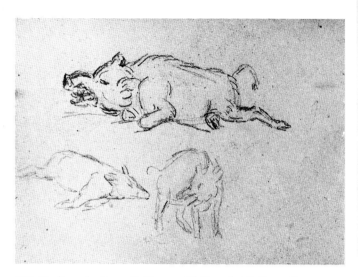

152. Studies of a Boar. Baltimore, Walters Art Gallery, 37.2033B.

153. Studies after John Flaxman's *Divine Comedy* Illustrations. Baltimore, Walters Art Gallery.

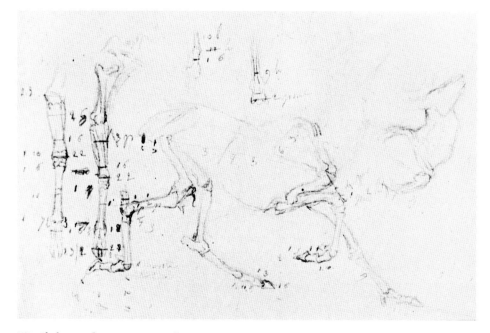

154. *Skeleton of a Stag*, Barye Album, RF 4661, folio 12 verso. Musée du Louvre, Cabinet des Dessins.

155. *Forepart of a Flayed Tiger*, Barye Album, RF 8480, folio 3 verso. Musée du Louvre, Cabinet des Dessins.

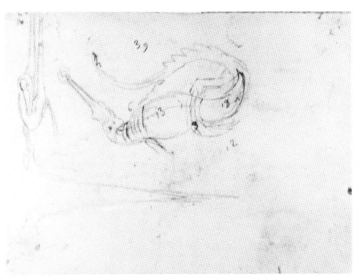

156. *Feline Predator Feeding*, Lucas Album, folio 27 recto. The George A. Lucas Collection of the Maryland Institute, College of Art, on indefinite loan to the Baltimore Museum of Art.

157. *Gavial Crocodile*, Lucas Album, folio 5 recto. The George A. Lucas Collection of the Maryland Institute, College of Art, on indefinite loan to the Baltimore Museum of Art.

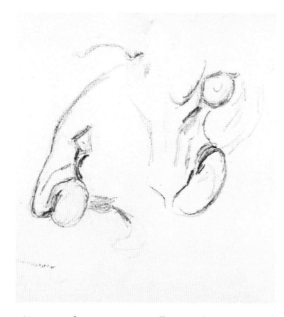

158. *Face of a Tiger*, Lucas Album, folio 28 verso. The George A. Lucas Collection of the Maryland Institute, College of Art, on indefinite loan to the Baltimore Museum of Art.

159. *Toying Lion*. Baltimore, Walters Art Gallery, 37.2248.

160. *Stalking Lion*. Baltimore, Walters Art Gallery, 37.2123.

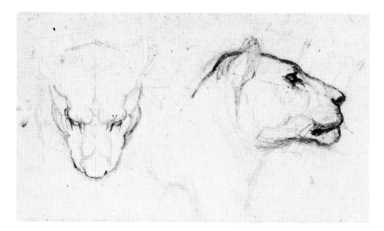

161. *Head of a Lioness*. Baltimore, Walters Art Gallery, 37.2218.

162. *Julia, Daughter of Augustus; Standing Nude,* Barye Album, RF 8480, folio 32 verso. Musée du Louvre, Cabinet des Dessins.

163. *Phidian Frieze of Riders.* Baltimore, Walters Art Gallery, 37.2318A.

164. *Borghese Mars.* Barye Album, RF 6073, page 86. Musée du Louvre, Cabinet des Dessins.

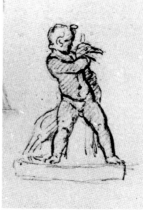

165. *Phidian Theseus from the Parthenon*, Barye Album, RF 6073, page 88. Musée du Louvre, Cabinet des Dessins.

166. *Boy with a Goose*, Barye Album, RF 6073, page 85. Musée du Louvre, Cabinet des Dessins.

168. *Enthroned Apollo-Napoleon*. Baltimore, Walters Art Gallery, 37.2207.

167. *Antiquities after Roccheggiani*. Baltimore, Walters Art Gallery, 37.121B.

169. *Standing Bull; Seated Figures Rejoicing*, Barye Album, RF 6073, page 21. Musée du Louvre, Cabinet des Dessins.

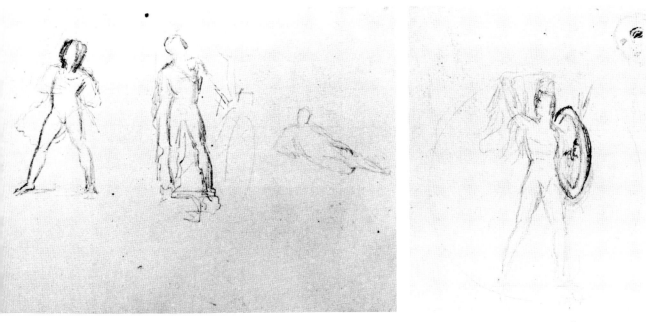

170. *Standing Mars*, Barye Album, RF 4661, folio 2 verso. Musée du Louvre, Cabinet des Dessins.

171. *Napoleon as Mars*, Barye Album, RF 6073, page 75. Musée du Louvre, Cabinet des Dessins.

178. *Deer Biting Its Side*, Barye Album, RF 4661, folio 7 recto. Musée du Louvre, Cabinet des Dessins.

179. *Indian Elephant.* Baltimore, Walters Art Gallery, 37.2232.

180. *Walking Panther.* Baltimore, Walters Art Gallery, 37.2193.

181. *Horse's Head with Windblown Mane*, Lucas Album, folio 15 recto. The George A. Lucas Collection of the Maryland Institute, College of Art, on indefinite loan to the Baltimore Museum of Art.

182. *Armored Riders*, after Rubens. Baltimore, Walters Art Gallery, 37.2289B.

183. *Robert Malatesta, Duke of Rimini.* Baltimore, Walters Art Gallery, 37.2298.

184. *Phidian Horse's Head.* Baltimore, Walters Art Gallery, 37.2139.

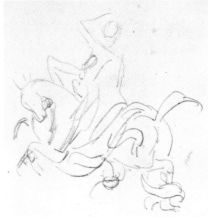

185. *Python Attacking a Horseman*, Lucas Album, folio 9 recto. The George A. Lucas Collection of the Maryland Institute, College of Art, on indefinite loan to the Baltimore Museum of Art.

186. *Rearing Horses with Groom and Rider*. Baltimore, Walters Art Gallery, 37.2175A and B.

187. *Charging Bull; Bull Attacked by a Predator*. Baltimore, Walters Art Gallery, 37.2246.

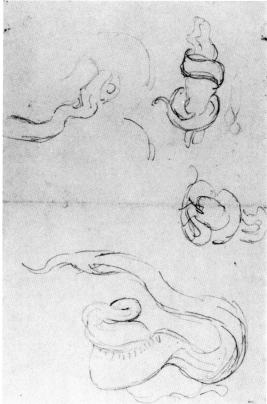

188. *Pieces of Armor*. Baltimore, Walters Art Gallery, 37.2225A.

189. *Python with Prey*. Baltimore, Walters Art Gallery, 37.2817A.

190. *Grappling Boxers*, after Géricault. Baltimore, Walters Art Gallery, 37.2060.

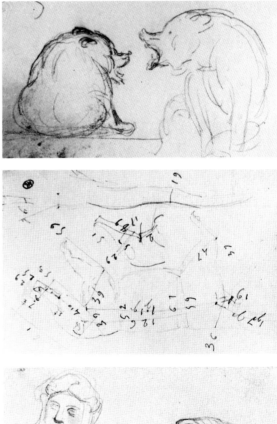

191. *Seated Bear*. Baltimore, Walters Art Gallery, 37.2234.

192. *Ratel*, Barye Album, RF 8480, folio 9 verso. Musée du Louvre, Cabinet des Dessins.

193. *Head of an Indian Tiger Hunter; Classical Head*. Baltimore, Walters Art Gallery, 37.2241.

194. *Stag Fleeing Four Hounds*, Barye Album, RF 4661, folio 16 recto. Musée du Louvre, Cabinet des Dessins.

195. *Study of an Elk*. Baltimore, Walters Art Gallery, 37.2166.

196. *Tumbling Hounds*, after Rubens. Baltimore, Walters Art Gallery, 37.2177A.

197. *Two Stags Pursued by Hounds.* Baltimore, Walters Art Gallery, 37.2244.

198. *Single Stag Brought Down by Hounds.* Baltimore, Walters Art Gallery, 37.2245B.

199. *Stag Attacked by a Lynx*. Baltimore, Walters Art Gallery, 37.2245A.

200. *Stag Attacked by a Lynx*. Baltimore, Walters Art Gallery, 37.2046B.

201. *Mannerist Female Nude*, Barye Album, RF 8480, folio 26 verso. Musée du Louvre, Cabinet des Dessins.

202. *Winged Putti with Clamshells*, Barye Album, RF 4661, folio 52 recto. Musée du Louvre, Cabinet des Dessins.

COMPARANDA

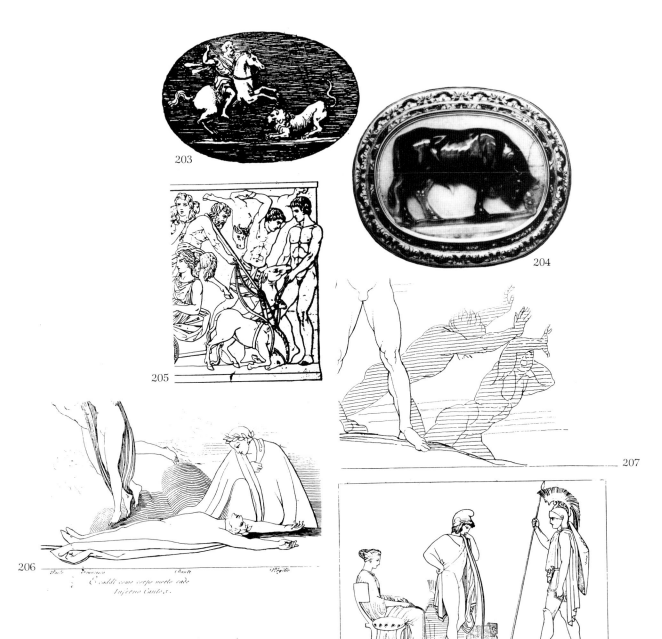

203. *Lion Hunter*, cameo, illustrated in Caylus.

204. *Bull Pawing the Earth*, cameo, Caylus Collection, Cabinet des Médailles, Bibliothèque Nationale, Paris.

205. *Faun Carrying an Ox*, illustrated in Visconti, *Musée Pie-Clémentin*.

206. John Flaxman, *Dante Fallen to the Earth*, from Dante's *L'Inferno.*

207. John Flaxman, *Schismatics Fleeing*, from Dante's *L'Inferno.*

208. John Flaxman, *Hector Chiding Paris*, from Homer's *Iliad.*

CHARMES·D'AMOVR.

226. *Charmes d'amour*, illustrated in Ripa.

227. *Apollo Crowned by a Winged Victory*, illustrated in Hamilton Collection.

228. François Lemot, *Henri IV*, bronze, Paris, Pont Neuf, 1816.

229. *Wolf Seizing a Hare*, bronze, illustrated in Caylus.

230. *Seated Dog*, illustrated in Visconti.

231. *Bull Deity Apis*, bronze, illustrated in Caylus.

232. *Standing Horse*, bronze, illustrated in Caylus.

233. *Centaur Relief*, bronze chest, illustrated in Caylus.

VERTV.

234. *Horse and Rider*, relief, illustrated in Caylus.

235. *Dolphin*, bronze, illustrated in Caylus.

236. *Vertu*, illustrated in Ripa.

237. *Greek Tomb Relief from Thyrea*, illustrated in Daremberg and Saglio.

238. Henry Fuseli, *Horseman Attacked by a Serpent*, watercolor, Zürich, Kunsthaus.

239. *Lion Hunt*, sarcophagus relief, illustrated in Caylus.

240. *Lion Hunt*, sarcophagus relief, illustrated in Caylus.

241. *Wounded Boar*, vase painting, illustrated in Caylus.

242. John Flaxman, *Polydamus Advising Hector*, from Homer's *Iliad*.

243. *Seated Monkey*, bronze, illustrated in Caylus.

244. *Bull*, bronze, illustrated in Caylus.

245. *Horse Attacked by a Lion*, illustrated in Reinach.

246. *Rearing Chariot Horse*, bronze, illustrated in Caylus.

247. *Hercules and Anteus*, relief, illustrated in Caylus.

248. Théodore Géricault, *Grappling Boxers*, Géricault Album, folio 13 recto. Margaret Day Blake Collection, The Art Institute of Chicago.

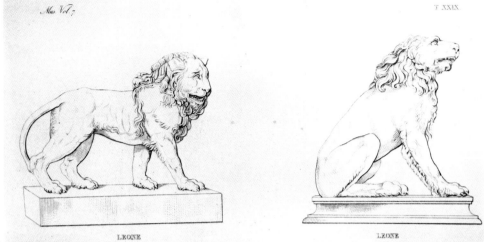

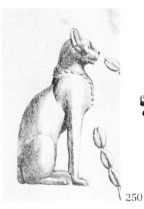

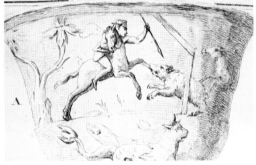

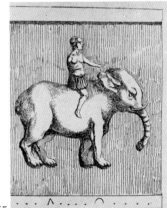

249. *Walking Lion; Seated Lion*, illustrated in Visconti, *Musée Pie-Clémentin*.

250. *Egyptian Cat Deity*, illustrated in Caylus.

251. *Recumbent Lion*, bronze, illustrated in Caylus.

252. *Recumbent Lion*, terra cotta, illustrated in Caylus.

253. *Head of a Tiger*, bronze, illustrated in Caylus.

254. *Bear Hunter on Horseback*, silver relief, illustrated in Caylus.

255. *Elephant and Rider*, marble relief, illustrated in Caylus.

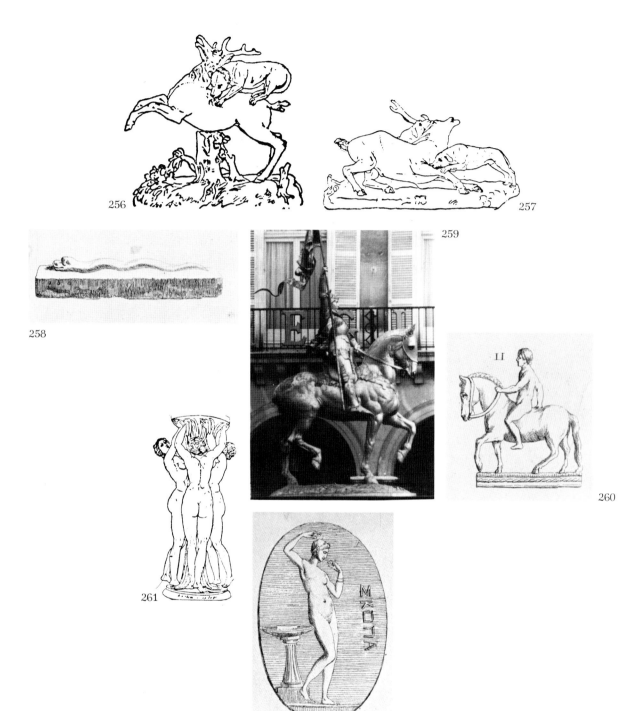

256. *Stag and Hound*, illustrated in Reinach.

257. *Stag and Hounds*, illustrated in Reinach.

258. *Serpent*, terra cotta, illustrated in Caylus.

259. Emmanuel Frémiet, *Joan of Arc*, bronze, Paris, Place des Pyramides, 1872–89.

260. *Mars as a Victorious Equestrian*, bronze, illustrated in Caylus.

261. *Three Nymphs as Caryatids*, illustrated in Reinach.

262. *Female Nude*, cameo, illustrated in Caylus.